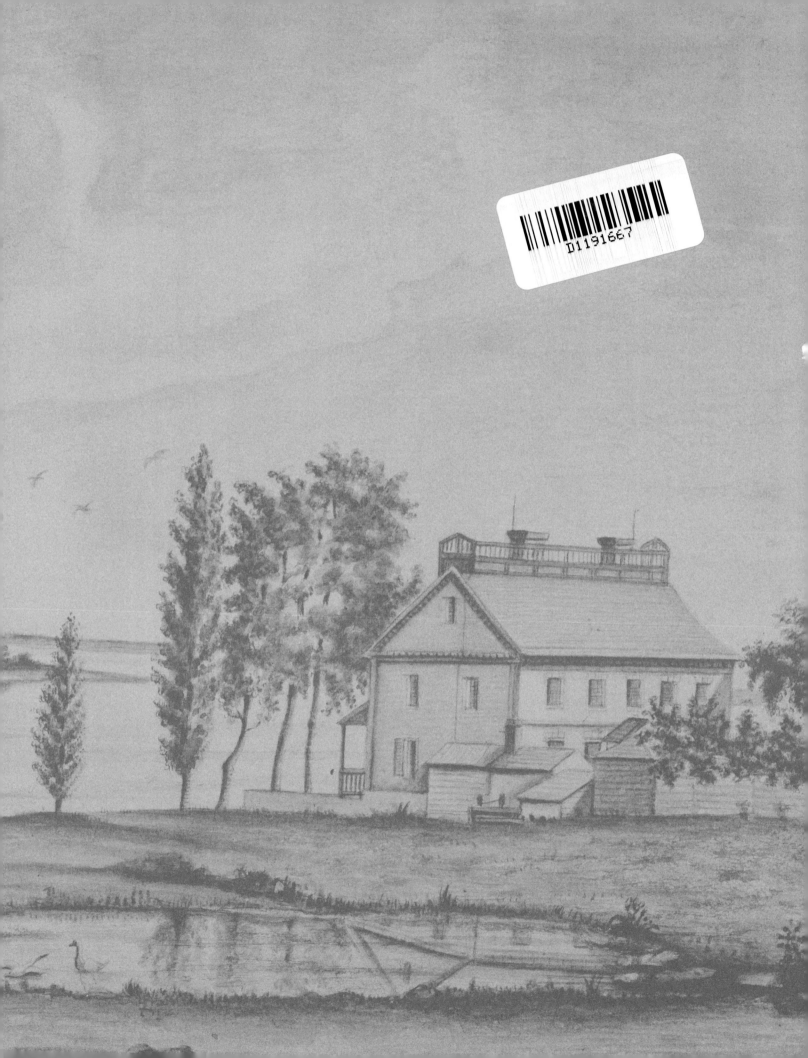

ARTIST in EXILE

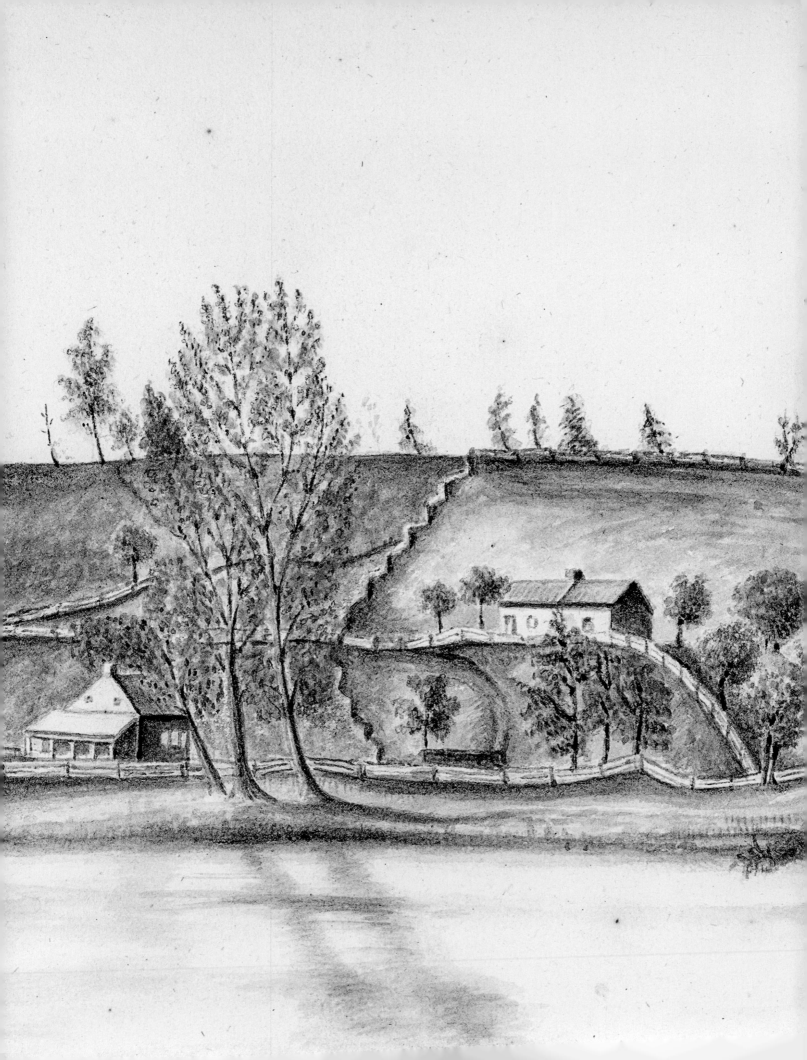

ARTIST *in* EXILE

The Visual Diary of Baroness Hyde de Neuville

Roberta J.M. Olson

With an essay by Charlene M. Boyer Lewis and assistance by Alexandra Mazzitelli

NEW-YORK HISTORICAL SOCIETY
MUSEUM & LIBRARY

g
GILES

New-York Historical Society

In association with D Giles Limited

Published on the occasion of the exhibition *Artist in Exile: The Visual Diary of Baroness Hyde de Neuville* on display at the New-York Historical Society from November 1, 2019–January 26, 2020

© 2019 New-York Historical Society

First published in 2019 by GILES
An imprint of D Giles Limited
66 High Street
Lewes, BN7 1XG, UK
gilesltd.com

ISBN: 978-1-911282-26-6

The Robert David Lion Gardiner Foundation provided lead funding for *Artist in Exile: The Visual Diary of Baroness Hyde de Neuville*, with important support given by the Wyeth Foundation for American Art. Additional support was provided by Furthermore, a program of the J.M. Kaplan Fund, the Greater Hudson Heritage Network, and a number of generous individuals.

For the New-York Historical Society:
Project Curator: Roberta J.M. Olson, Curator of Drawings
Project Editor: Anne H. Hoy
Photographs of objects in the N-YHS Collections are by Glenn Castellano

For D Giles Limited:
Copy-edited and proof-read by Sarah Kane
Designed by Alfonso Iacurci

Produced by GILES, an imprint of D Giles Limited
Printed and bound in China
All measurements are in inches and millimeters; height precedes width

Front cover: cat. no. 39 (detail)
Back cover: cat. no. 1 (detail)
Frontispiece: cat. no. 23 (detail)

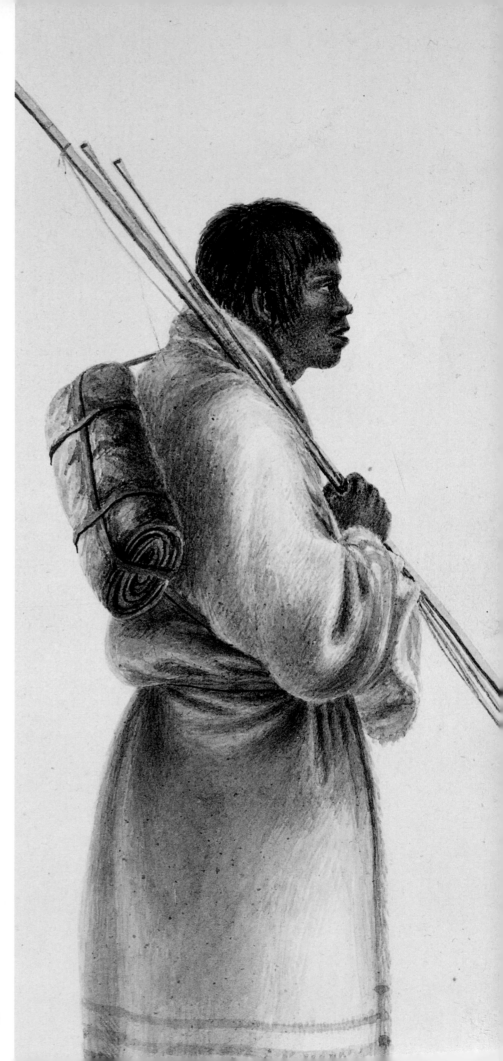

cat. no. 50 (detail)

CONTENTS

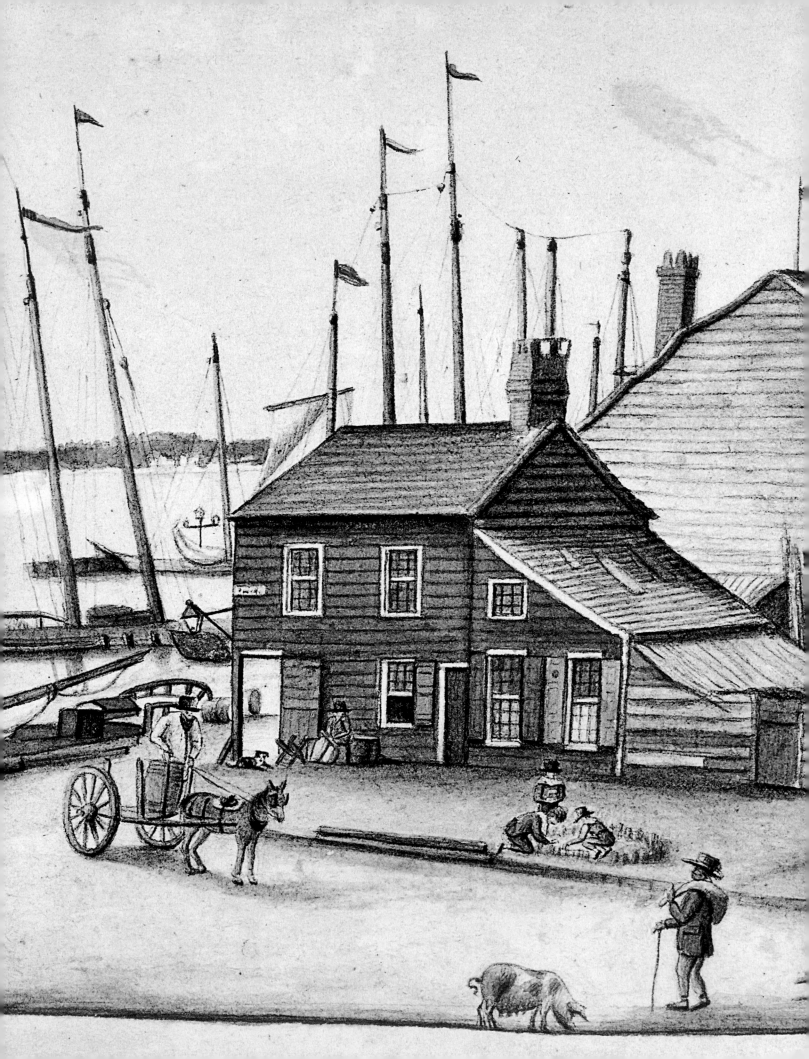

FOREWORD

When Baroness Hyde de Neuville arrived in New York City in June 1807 as an exile from Napoleonic France, she and her husband encountered a vibrant metropolis of 90,000 residents. A bustling commercial port fueled the local economy, while its citizens were beginning to create the city's first cultural institutions. In fact, just three years earlier, a group of men led by merchant John Pintard organized the New-York Historical Society to collect and preserve documents and objects for the study of American history "liable to be lost or destroyed by indifference or neglect." Neuville could never have envisioned that her visual diary—created as a personal record of her travels through and observations of the New World—would be of interest to, let alone one day join, the Historical Society collections. Yet, her drawings vividly evoke the national optimism and rapid expansion of the young United States and capture the diversity of its inhabitants. Today, her works are invaluable historical documents of the early republic.

It is entirely fitting that *Artist in Exile* is being presented in our Joyce B. Cowin Women's History Gallery, which opened in 2017 with the launch of New-York Historical's Center for Women's History, the first of its kind in the nation within the walls of a major museum. Through exhibitions, talks, and programs, the Center explores the lives and legacies of women who have had an impact on American history. As Dr. Olson reveals in this volume, Neuville's status as a woman, an outsider, and a refugee shaped her view of Americans and their built environment, making her a particularly keen and sympathetic observer of individuals from a range of socioeconomic and ethnic backgrounds. Although she arrived in America as an outcast from Revolutionary France, by the end of her second American sojourn, as wife of the French Minister Plenipotentiary, she was interacting with political leaders and making her mark on Washington, DC, society.

I am deeply grateful to Dr. Roberta J.M. Olson, New-York Historical's Curator of Drawings, for her exceptional work on this volume and the accompanying exhibition. Through indefatigable scholarly research in both North America and France, she has expanded the corpus of known works by Neuville, increased our institution's already strong holdings of her drawings, and enriched the historical record of the baroness's life.

This ambitious undertaking would have been impossible without the generosity of key supporters. The Robert David Lion Gardiner Foundation provided important lead funding for the exhibition and its catalogue, with additional support given by the Wyeth Foundation for American Art. Furthermore, a program of the J.M. Kaplan Fund also supported the catalogue, and the Greater Hudson Heritage Network funded conservation treatments of a group of drawings. We are also deeply indebted to Barbara E. Wagner, Helen Appel, Pam Schafler, David and Laura Grey, and Myron and Adeline Hofer. As always, we reserve deep gratitude for New-York Historical's dedicated and generous board of trustees, led by Chair Pam Schafler.

Margaret K. Hofer
Vice President and Museum Director
New-York Historical Society

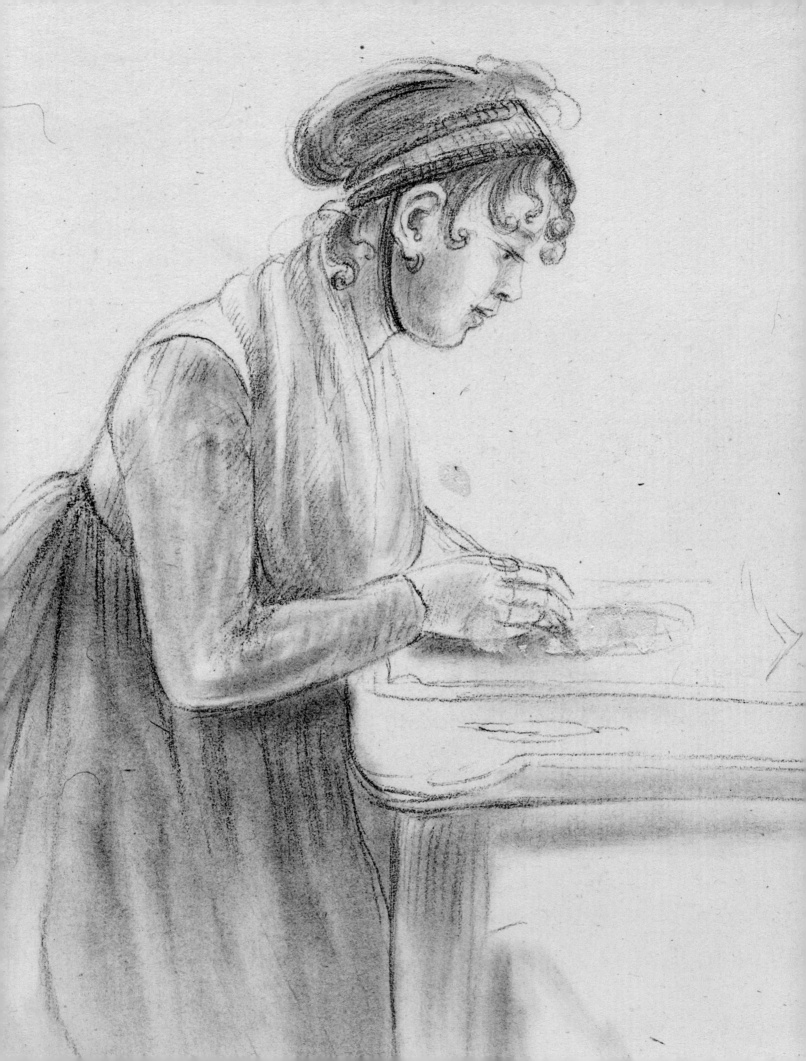

PREFACE

Artist in Exile ranks as the first serious consideration of the life and artistic oeuvre of Anne Marguérite Joséphine Henriette Rouillé de Marigny, Baroness Hyde de Neuville. It establishes not only her birthdate, chronology, and character, but also her early stylistic development during the fraught initial years of the French Revolution. The artist came to this country in 1807 and found herself on a journey of discovery into a virtual terra incognita. The catalogue sheds light on her unparalleled watercolors and drawings, which immeasurably enrich our understanding of America during the early republic. Research for *Artist in Exile* has yielded important new documentary evidence and more than forty previously unknown works. From this exciting material Henriette emerges as an artist who drew in seven countries, as well as on the high seas, and exerted her influence in political and social circles on both sides of the Atlantic. Sixty-six unpublished letters have come to light, and—together with numerous quotations by her husband in his *Memoirs* from lost letters and her unlocated written journals—are published here for the first time in the Documents section. They preserve Henriette's voice, which serves as a complement to her visual diary and enlarges our knowledge about her fascinating life—a life that, more than anything else, reads like a compelling historical novel.

In the past, a small selection of Neuville's art has been illustrated in articles, books, and catalogues, because of the invaluable information it contains about the people and places of early America. However, the lion's share has been reproduced without substantive comments about its historical context or Neuville as an artist. Therefore, *Artist in Exile* cites previous publications in the endnotes to the essays and the catalogue section only when they include important information or cogent observations about the artist and her subjects. What all previous publications about Neuville share is recognition of her fascinating biography, which is recounted largely with anecdotes about her American residency, and an admiration of her egalitarian and charming representations. By contrast, this catalogue seeks to spark serious consideration of her oeuvre.

The volume begins with three essays that examine different aspects of Neuville's life, artistic works, and the historical context in which she created them. The initial essay—"The Neuvilles in America and France"—introduces Baron and Baroness Hyde de Neuville and includes new documentary evidence. It traces their early lives, when the royalist baron was an outlaw during the treacherous days of the French Revolution, follows the couple into exile in America thanks to Napoleon Bonaparte, and climaxes with their later triumphs during the Bourbon Restoration, when the baron became Minister Plenipotentiary and the baroness a celebrated member of Washington's diplomatic society. The second essay—"The Baroness: Becoming an Artist in the Art World of 1800–1822"—establishes for the first time Henriette's struggle to become an artist in Revolutionary France, together with a consideration of women artists and amateurs in France, England, and America. This essay also explores her unique position as a female traveler-artist within the larger scope of the development of American art. In "The Role of Women in the New Nation 1800–1825," Charlene M. Boyer Lewis, Professor of History and Director of American Studies at Kalamazoo College, examines the place of women in America during the Federal period, when a definition of women's societal roles was more fluid. She also considers the parlor politics of Washington, DC, and such powerful political figures as Dolley Madison and Louisa Catherine Johnson Adams, who were both correspondents of Henriette.

Artist in Exile examines Neuville's artistic production in eighty-seven catalogue entries showcasing 110 drawings and watercolors. Prefacing these entries is a discussion of the intriguing, convoluted provenance of Henriette's works. The catalogue reproduces all of the 204 drawings and watercolors that as of this writing can be identified from her hand. Ninety-four of these sheets are not featured in the entries but are illustrated in the appendix, including eighteen that remain unlocated (appx. nos. 77–94). They are joined by three works formerly in the baroness's own collection by other artists, works that had previously been attributed to her (appx. nos. 95–97).

The volume thus reclaims the biography and oeuvre of an exceptional figure in the history of America and Revolutionary France in order to share it with a broader public. Because of her residencies in the United States—first as an émigré from political strife and then as the celebrated spouse of the Minister Plenipotentiary of France—Henriette attained a unique position on the international stage. She was a woman of the world and ahead of her time in celebrating the differences among the people she boldly encountered.

Artist in Exile is the result of a collaborative adventure among colleagues within the New-York Historical Society and outside it, including a host of individuals whose intelligence, skill, generosity, knowledge, and encouragement have been indispensable to the project. It has been my privilege to work with them to provide a fuller view of this significant artist-traveler. Her harrowing and triumphant story, the narrative of a strong and independent woman, inspired many of the people to whom I am deeply grateful.

Foremost among the valued colleagues at the New-York Historical Society whom I would like to thank is President Louise Mirrer, under whose leadership this thrilling project has come to fruition. Museum Director Margaret K. Hofer enthusiastically championed the exhibition and catalogue from their inception and has offered invaluable advice throughout their gestation. Research Associate Alexandra Mazzitelli has been pivotal in ensuring the success of every phase of this catalogue and its realization—ranging from keeping extensive and constantly evolving files of historical information, documents, and images, to pursuing the most minute historical facts and arcane bibliography. Her dedication to the project was indispensable and greatly appreciated. Researcher Sarah Snook's welcome assistance and intrepid sleuthing skills with Readex helped capture the flavor of New York in the early decades of the nineteenth century when the baroness was a resident, while volunteer Natalie Brody ably pursued genealogical data. N-YHS Museum interns Rachel Schwarz, Melissa Young, Chase Caldwell Smith, and Léa Blanchard—whose French language skills were essential to unraveling idiomatic eighteenth-century archival documents—helped to build the foundations for the catalogue and exhibition.

I am also grateful to conservator colleagues Alan Balicki and Heidi Nakashima, who weighed in on a variety of matters, including technical questions about media used by the baroness for her visual diary. The pair also supervised the treatments that independent conservator Clare Manias performed on a group of sheets, an endeavor supported by a grant from the Greater Hudson Heritage Network. For the catalogue preparation, Glenn Castellano photographed the baroness's visual diary, always with *sprezzatura*, and Eleanor Gillers coordinated the image orders with great efficiency and aplomb. Anne H. Hoy's *savoir-faire* and intelligence as editor show on every page, as does that of Sarah Kane, copy editor. Alfonso Iacurci's inspired design for the catalogue showcases Neuville's work, while the adept Giles publication team—Dan Giles, Jacqueline Decter, Allison Giles, Louise Parfitt, Louise Ramsay, and Liz Japes—orchestrated its production with great skill.

Also in the N-YHS constellation of museum colleagues, I am particularly indebted to Kira Hwang, Maura Spellman, Emily Croll, Richard Miller, Robert Sorenson, and Cheryl Morgan and her team of fundraisers—Natalie Meltzer, Blaine Todd, Alice Rhee, and Elizabeth Smith. They are joined by Library colleagues Marilyn Kushner, Edward O'Reilly, Valerie Paley, Mariam Touba, Joseph Ditta, Marybeth Kavanagh, and Jill Reichenbach, all of whom facilitated the research in the Library's stellar collections of American holdings about the Neuvilles, their associates, and their times.

Access to great library collections and staffs outside the Historical Society has been one of the privileges enjoyed by everyone involved in the research for this catalogue. New York City libraries collectively provide one of the finest clusters of research facilities in the world. My greatest debt is to Ken Soehner, Arthur K. Watson Chief Librarian, and the staff of the Thomas

J. Watson Library of the Metropolitan Museum of Art, whose rich resources I mined for this catalogue. In addition, the staffs of the Columbia University Libraries, the Frick Art Reference Library, the New York Public Library, Princeton University Libraries, and the libraries of Rutgers University have all played important roles in the quest to discover the baroness.

Colleagues from other institutions—scholars and curators, archivists, and librarians—generously shared ideas, advice, and source material from their various areas of expertise. Chief among them is Charlene M. Boyer Lewis, who contributed the insightful third essay in the catalogue, as cited above. Among the others to whom I am most grateful are: Catherine Allgor, Massachusetts Historical Society; Michael Bright and William Brown, Hyde Park Gardens, London; Lucas Clawson, Hagley Museum and Library; Loretta Deaver, Library of Congress; Cécile R. Ganteaume, National Museum of the American Indian, Smithsonian Institution; Margaret Glover, New York Public Library; Stephanie Herdrich, Metropolitan Museum of Art; Victoria Johnson, Hunter College; Valérie-Nöelle Jouffre, Recherches et Études Appliquées; Albert C. King, Rutgers University Libraries; Elizabeth Kornhauser, Metropolitan Museum of Art; James MacKinnon; Marjorie McNinch, Hagley Museum and Library; Constance McPhee, Metropolitan Museum of Art; Mary Ellen Pavlovsky, Proprietary House Historical Association, Perth Amboy, NJ; Anne Picone, Walter Elwood Museum; Caryn Radick, Rutgers University Library; Joanna Rios, Columbia University Library; Nancy Rosoff, Brooklyn Museum; Marjorie Shelley, Metropolitan Museum of Art; Jerry Snyder, Walter Elwood Museum; Ed Surato, New Haven Museum; Femke Speelberg, Metropolitan Museum of Art; Perrin Stein, Metropolitan Museum of Art; Scott Manning Stevens, Syracuse University; George A. Thompson, Hudson River Maritime Museum and Research Librarian at New York University; Jonny Yarker, Lowell Libson & Jonny Yarker Ltd; and Melinda Lacey Zoehrer, University of Delaware Botanic Gardens.

Several collectors and dealers enabled the N-YHS to assemble for the first time a well-rounded portrait of the baroness's artistic endeavors. Thanks go to Alexander Acevedo for his extraordinary memory of her works and persistence, as well as to Paul Worman for his eagle eye and perseverance. The generous gifts of Mark Emanuel, together with the PECO Foundation Fund for Drawings, broadened our panoramic view of Henriette's oeuvre via the addition of newly located drawings. Alexander Johnson journeyed with me on the baroness's trail from Sancerre to Paris and back again, with constant encouragement during the catalogue's four-year gestation.

For their hospitality in sharing the Neuvilles' residences in France and the United States, the N-YHS would like to thank Catherine Graillot, Rémy Graillot, and Joachim and Rita Messing. In addition, both Graillots generously shared illuminating information about the couple.

Last but by no means least, the New-York Historical Society extends sincerest thanks to the museums and institutions whose loans have greatly enhanced the catalogue and the exhibition *Artist in Exile*: Colonial Williamsburg Foundation, Abby Aldrich Rockefeller Folk Art Museum; Hagley Museum and Library; Metropolitan Museum of Art; Museum of the City of New York; Museum of Fine Arts, Boston; New York Public Library, the Miriam and Ira D. Wallach Division of Art, Prints and Photographs; and Princeton University, Firestone Library, Rare Books and Special Collections, Graphic Arts Collection.

Roberta J.M. Olson
Curator of Drawings
New-York Historical Society

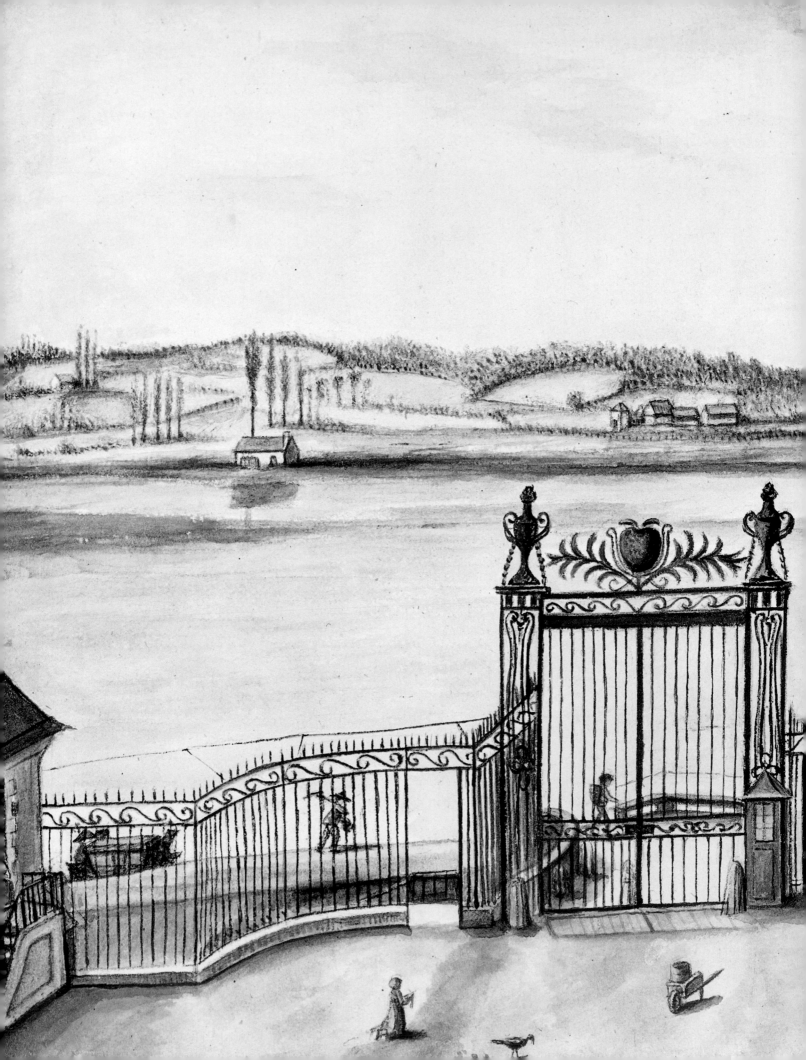

THE NEUVILLES IN AMERICA AND FRANCE

Roberta J.M. Olson

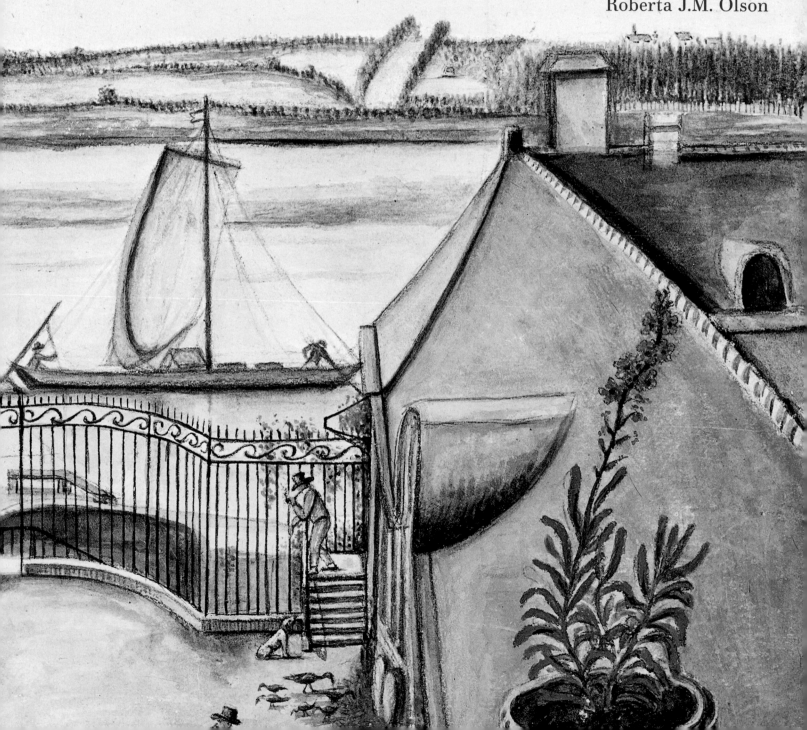

Introducing the Neuvilles

Before their arrival in New York City in 1807, Anne Marguérite Joséphine Henriette Rouillé de Marigny and Jean Guillaume Hyde de Neuville (figs. 1, 2) had already led several lives, both together and separately. They lived in a world of tumultuous political upheavals, including the American Revolution, with the founding of a new nation in its wake and the cataclysmic French Revolution, and survived a series of seismic stages—from the fall of the Bourbon monarchy in 1789 and the Reign of Terror (1793–94) to the Directory (1795–99), the Consulate (1799–1804), and the Empire (1804–14) under Napoleon, terminated by the Restoration of Louis XVIII (1814). After the return of the monarchy, the well-connected couple would become Baron and Baroness Hyde de Neuville in 1820. They resided in the United States, with two brief returns to France, until 1822, befriending major players on the historical stage on both sides of the Atlantic (see Chronology).

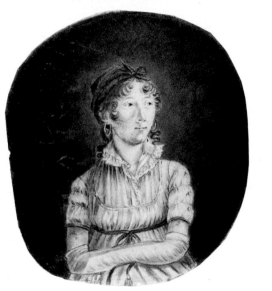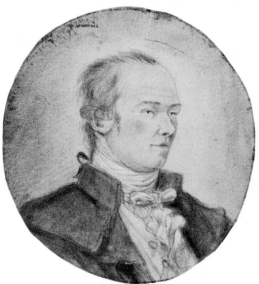

Meet the Baroness

In the literature on the artist, the birthdate of Anne Marguérite Joséphine Henriette Rouillé de Marigny was previously unknown and given variously between 1749 and 1761. With the French regional archives now available electronically, it can be definitively established that she was born in Sancerre (Cher) on March 10, 1771, to Étienne Jacques (alternatively called Jacques Étienne) Rouillé de Marigny, a wealthy salt tax collector of Sancerre, and Marie Joséphine Busson de Villeneuve, an aristocrat.[1] Their country residence, the Château de L'Estang or L'Étang ("The Pond"), belonged to her father's family; part of the property would descend to the future baroness after her father's death in 1802 and she would purchase other sections from his siblings and their descendants (figs. 3, 4, 20).[2] Although we do not know where the baroness was educated, she may have received her schooling in or around Paris, like her future mother-in-law in a Catholic convent boarding school,[3] the place where young French women of means frequently were educated outside their parental homes before the Revolution suppressed the churches and nationalized church property.[4] With the fall of the Bastille and the beginning of the Revolution

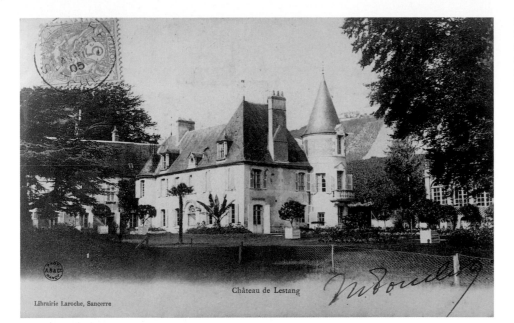

Fig. 3
Librairie Laroche, Postcard
of the Château de L'Estang,
Sancerre, sent April 26, 1905.
3 ½ × 5 ½ in. (89 × 140 mm).
N-YHS artist's file

Château de Lestang

Librairie Laroche, Sancerre

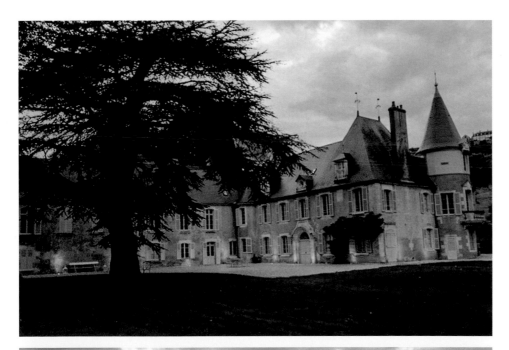

Fig. 4
Château de L'Estang,
Sancerre, 2017

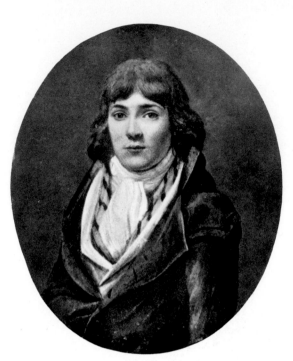

WILLIAM HYDE DE NEUVILLE AT THE AGE OF TWENTY.

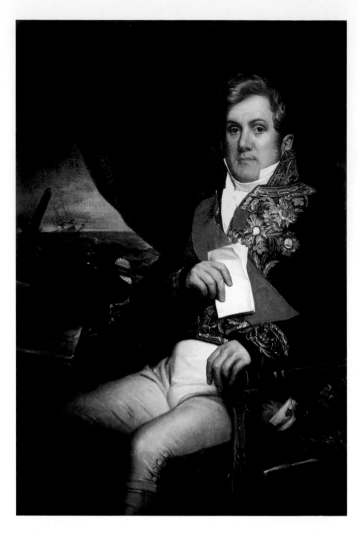

in 1789, she and her father returned to L'Estang, but her mother, who was socially and politically connected enough to feel safe, remained in Paris.

From the baroness's extant personal correspondence, we know that her intimates called her "Henriette," and she frequently signed her letters to them with that name or her initials "h r h n," "h h n," or variations thereof.[5] Throughout this catalogue, she will be referred to variously as the baroness, Henriette, Madame Neuville or Hyde de Neuville, and, when it pertains to works of art by her hand, Neuville. She died in Sancerre at L'Estang on September 14, 1849, and was buried in the crypt of the small chapel in the park of the château.[6]

Meet the Baron

A French aristocrat, diplomat, and politician, Jean Guillaume Hide was born in La Charité-sur-Loire (the Nivernais, today Nièvre) on January 24, 1776, to Guillaume Hide, master of the iron forge and director of the royal factory of La Charité, which made buttons and hardware, and Marie Roger.[7] His father, who was naturalized in 1766, descended from an English (Irish and Scottish) family that had immigrated to France with the Stuarts after the rebellion of 1745 and had settled near La Charité-sur-Loire, between Sancerre and Nevers, on the Loire River.[8] His grandfather, Sir James Hyde, was one of the Jacobites who had followed the Stuarts after the battle of Culloden. Sancerre, originally a Roman stronghold, was home to a considerable number of English refugees (as was La Charité) with the same royalist sympathies, drawn there by the tolerant religious attitudes of the partly Protestant, formerly Huguenot town.[9] After studying at the Collège Royal de Sainte-Marie at Bourges and at the Collège du Cardinal Lemoine, part of the ancient University of Paris, Jean Guillaume entered into the turbulent Revolutionary fray at the age of fifteen. A lifelong royalist, he was only seventeen when, in 1793, at the Revolutionary tribunal of Nevers, he successfully defended Pierre Maugue—who had spoken disrespectfully of

Maximilien de Robespierre and therefore was denounced by Joseph Fouché, Minister of Police. After his obvious opposition to the Jacobins, Jean Guillaume and his family were persecuted, and he became a fugitive for many years, living under assumed names (fig. 5).[10] His exile in America, where he was almost exclusively known as Guillaume, and his diplomatic career, wherein he earned the title of baron (fig. 6), would determine the trajectory of the Neuvilles' lives together. He died in Paris on May 28, 1857, and was interred with his wife, mother, and only brother Paul in the small freestanding chapel at L'Estang.[11]

Married Life: The Cloak and Dagger of Assumed Names

According to archival records, Anne Marguérite Joséphine Henriette Rouillé de Marigny married Guillaume Étienne Hide (a name change to conceal his identity) in Sancerre on August 23, 1794, shortly after the execution of Robespierre and the consequent end of the Reign of Terror. The witnesses were Marie Roger, the groom's mother and guardian; Étienne La Rue, his brother-in-law; Étienne Jacques Rouillé, the bride's father; Pierre Jean Rouillé, her paternal uncle; and Étienne Busson Villeneuve, her maternal uncle.[12]

At some juncture, the couple changed their surname to Hyde de Neuville, which seems to embody the pair's marriage bond. The editor of the baron's *Memoirs* explains that the extension to his surname, "de Neuville," derived from a small estate inherited from his mother.[13] Used by both Jean Guillaume and his brother Paul,[14] it probably was appended to aggrandize their heritage, as much as to obfuscate their identities during the politically charged period, when they also changed the spelling from "Hide" to "Hyde," creating a further smokescreen. Moreover, the "de Neuville" was not only parallel in format to Henriette's surname, Rouillé de Marigny, but also a clever variant on the last part of her mother's surname, de Villeneuve, a most fitting, prophetically modern in-joke to commemorate their wedding.

By all accounts, their marriage was a romantic union, a love match from beginning to end. Once they had married, their bond strengthened despite extended separations and dramatic trials that would have tested any relationship. Although her father purchased a house in Paris for the newlyweds in July 1796 on the rue Croix-des-Petits-Champs, they never lived there because the baron was in hiding. Later, Henriette would inherit a house with a carriage entrance on the rue de l'Université, as well as part of the estate and the château of L'Estang from her father, which passed down indirectly to the baron's relatives because the couple was childless.[15]

Sources and Documents for the Neuvilles

Since the couple lived unsettled, peripatetic lives during these tempestuous times, it is not surprising that scant documentary material survives. During the various phases of the French Revolution, the holdings of the Church and the aristocracy were devastated. Even civic and regional archives were not safe from destruction, including those of Paris, where attempts were made in the nineteenth century to reconstruct what had been lost, including the baron's death record. In addition to the regional archival sources that record the major milestones in the Neuvilles' lives, the majority of surviving documents regarding the couple were previously associated with the baron and his diplomatic career alone. The discovery of a substantial number of documents for the baroness can now be added to the mix. Among them, more than sixty-six letters from Henriette's correspondence, sixty-one in her hand, have been located, including those between her and the remarkable First Lady Dolley Payne Madison (fig. 39), the Washington author and social politician Margaret Bayard Smith (fig. 40), and her close friend Gabrielle

Joséphine de la Fite de Pelleport du Pont, known as Joséphine, whose surname the baroness spelled as "Dupont" (fig. 7). Joséphine du Pont kept at least fifty-six of the baroness's letters, as well as those from the baron with greetings or postscripts from her, which are not included here. In addition, in his *Memoirs* the baron quotes from letters—now lost—that the baroness wrote to him and to her family as well as from her now-unlocated journal (see Documents).

The major written source for Henriette's life and the Neuvilles' lives together is the baron's *Memoirs*, which he wrote using the name Guillaume Jean. Intending to recount the noteworthy saga of his life, he penned a four-page introduction in the first person—really an apologia—in the initial French edition, confessing:

> I am often urged to write my Memoirs; I have many scattered notes, and everything is fresh in my mind. . . . If ever a life were like a romance, it was mine. I have passed through good and evil. . . . Persecuted, outlawed, exiled, I weathered the tempests of the Revolution, only to find myself amid the storms of the Restoration. . . . I have remained true to my convictions . . . as ever, desiring RELIGION WITHOUT FANATICISM, MONARCHY WITHOUT ABUSES, LIBERTY WITHOUT LICENSE. I pass on to say why I refrain from publishing my Memoirs, and have decided to write only Notes and Recollections. Connected Memoirs would oblige me to speak severely of many. Now, I should wish, if it were possible, not to wound anyone, above all, not after my death; there is little courage, it seems to me, in shooting an arrow from the tomb. . . . My notes will leave me free to write without following any fixed method. I will take my Recollections as they come to my memory. . . .[16]

Despite good intentions, the baron never completed his *Memoirs*. His nieces, the daughters of his brother Paul—Pauline Henriette, Viscountess de Bardonnet, and Isabelle, Baroness Laurenceau—became the posthumous compilers. One wonders what they omitted. The more proactive Pauline served as the editor of the French edition, entitled *Mémoires et souvenirs de Baron Hyde de Neuville*, published in three volumes (1888–92). She calls him Guillaume Jean, underlining the fact that he was known as Guillaume during his residences in the United States, a lead this catalogue follows. The baron's *Mémoires* were popular in the early twentieth century because they were ostensibly a first-person account of all the phases of the French Revolution by someone who lived to tell the tale. There were three editions in French with multiple printings through 1912. An abridged English translation in two volumes by Frances Jackson followed in 1913. The baron's *Memoirs* are in the mode of the memoirs of another exiled French aristocrat in America, Henriette-Lucy (Dillon), Marquise de La Tour du Pin. A friend of Philip Schuyler, she came to America in the 1790s and settled near Albany, socializing with the Schuylers (see cat. no. 24), as well as the future prime minister of France, Talleyrand (Charles Maurice de Talleyrand-Périgord), during his American exile (1794–96).[17]

What makes the baron's *Memoirs* tantalizing for *Artist in Exile* is his comment that his wife, Henriette, kept a journal. He occasionally quotes from these now-lost diaries, although there is no way of knowing to what degree he and his nieces depended on them for his narrative and how much additional material the compilers had at their fingertips. As mentioned previously, in his *Memoirs* Guillaume quotes from now-vanished letters of the baroness, quotations that are published in the Documents section here, helping to recover more of Henriette's voice for posterity. They make the reader wish for more, and also underline the importance of her drawings and watercolors, her visual diary, which is the most significant record of her life.

The earliest comprehensive biography of the baron by Françoise Watel—*Jean-Guillaume Hyde de Neuville, 1776–1857: Conspirateur et diplomate*—appeared in 1987, followed in 2003

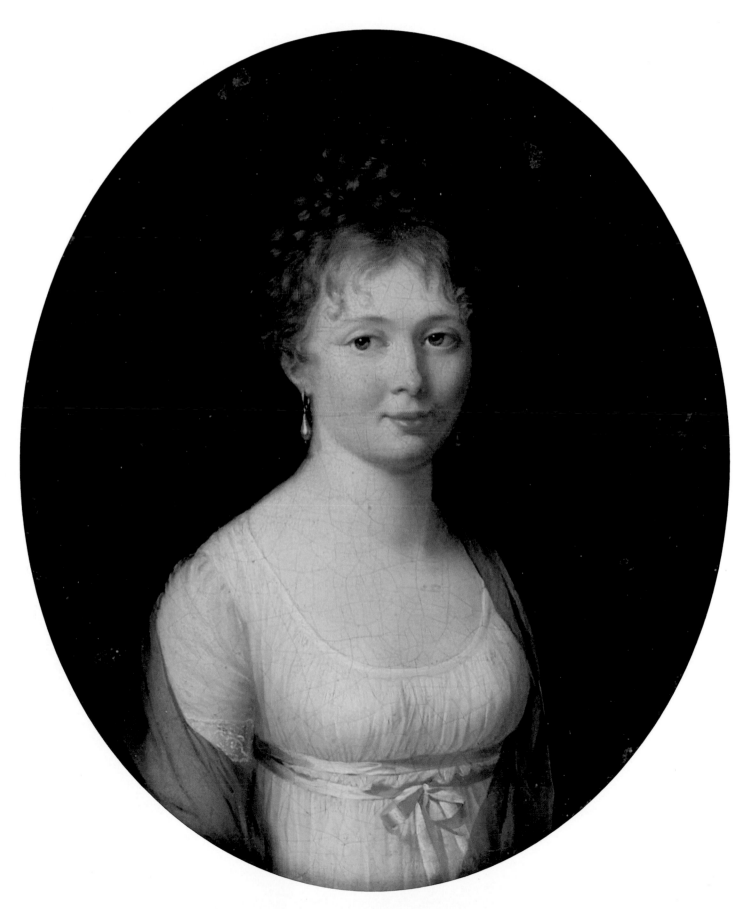

Fig. 7
Louis Boilly, *Gabrielle Joséphine de la Fite de Pelleport du Pont (1770–1837)*, 1794. Oil on canvas; 15 ½ × 13 ¾ in. (39.4 × 35 cm). Hagley Museum and Library, Wilmington, DE, 67.35

by Jacques Faugeras's *Hide de Neuville: Irréductible adversaire de Napoléon Bonaparte*.[18] The only study of the baroness and her work, outside of short articles and multiple reproductions of around two dozen of her works, is the thirty-seven-page catalogue for an exhibition in 1984 by Jadviga da Costa Nunes and Ferris Olin, *Baroness Hyde de Neuville: Sketches of America, 1807–1822*. The exhibition had venues at the New-York Historical Society and the Jane Voorhees Zimmerli Art Museum, Rutgers State University, New Brunswick, New Jersey. *Artist in Exile* fills this void by publishing all the known works by the baroness, including many recently discovered sheets that establish her artistic development. The present publication also assembles the documents relating to her life for the first time, including revelatory letters and sections of her lost journal. Together, these artworks and texts resurrect her as an individual and assure her place in the history and culture of the United States and France.

Incognito and the Baroness's Courageous Quest

By the time Jean Guillaume reached fifteen years of age (1791–92), he had been swept up by the complex events of the French Revolution and, like his father, was a confirmed and passionate royalist. In his *Memoirs*, the baron details some of the intrigues involving him, as well as the aliases he assumed and the places where he hid, together with justifications for his actions. He was clearly thrilled by his heart-stopping adventures in Paris and the threat of imminent danger, as well as committed to defending the monarchy and willing to face prison, or even worse, for his beliefs. Unfortunately, the instability of the times and the deceptions he adopted have obfuscated the trail for the Neuvilles' biographers. Later in his life, however, the baron's liberal tendencies led him to espouse a constitutional monarchy.

In the 1790s, Henriette spent most of her time at L'Estang, when it seems that she began to draw black chalk studies (see the next essay "The Baroness: Becoming an Artist . . . "). In 1798, she joined her husband in Paris, after an order was issued for his arrest. Hiding in a fourth-floor room in the house of an ironmonger on the rue de la Verrerie in the Marais, under the assumed surname of Roger (the maiden name of her husband's mother), Henriette gave lessons in order to earn a living. The couple avoided detection until neighborhood laundresses became suspicious of Madame Roger and her mysterious visitor, dressed as a workingman.[19] But after nine months of stealth punctuated by his wife's brave actions—once opening an umbrella in the faces of overly inquisitive sentries to facilitate a fast escape—the baron's current proscription was withdrawn, and the couple decamped for the comforts of the Neuville house on the rue de l'Université.[20] Henriette also resumed old friendships, like that with Anne Louise Germaine de Staël-Holstein, known as Madame de Staël—the writer, *salonnière*, brilliant conversationalist, and enemy of Napoleon—whose salon the baron praised.[21] Nevertheless, in 1800, because of the baron's involvement with the pamphlet "Les Adieux à Bonaparte," the baron's brother Paul and the baroness were incarcerated briefly in the notorious Temple prison—which had previously hosted the baron, as well as the former King Louis XVI and Queen Marie-Antoinette before their executions.

In 1803–04, the baron was condemned as an outlaw for his alleged part in an attempt to assassinate Napoleon in the "English" or "Pichegru Conspiracy," in which General Victor Marie Moreau was implicated, and he became a fugitive. From her mother-in-law's house in the Nivernais, where she and her husband had sought refuge at various times, Henriette made several trips to Paris, attempting to meet with Napoleon and influential officials to disprove the conspiracy charges, have this proscription overturned, and plead for a pardon. Unsuccessful, the Neuvilles fled Paris, departing down the Loire River from La Charité-sur-Loire at the factory she depicted in cat. no. 6, the pivotal work in which she became an artist-traveler. Arriving in the

outskirts of Lyon, the couple went into hiding from May to September of 1805 in nearby Couzon at the small house called "Fonbonne," which they rented under the assumed identities of Dr. and Madame Roland. Under this disguise, the baron studied and practiced medicine, promoting vaccinations for smallpox, and was even recognized for his work.[22] But despite his wife's many pleas for justice, the baron remained in mortal danger. The intrepid baroness decided to seek a pardon once more from Napoleon, this time by traveling across the battlefields of Germany and Austria on the trail of the emperor and his troops. The baron went with her as far as Constance, Switzerland, but it was not safe for him to continue farther. During their two months in Switzerland, she drew a view of that city (appx. no. 18) and copied depictions of two Swiss costumes (appx. no. 19).

On November 3, 1805, Henriette embarked on her quest—without a protective escort. Her sole companion was her lady's maid (*femme de chambre*), known only as Mademoiselle Gai. The courageous pair followed the military campaign's march through Augsburg, Munich (where she met with Talleyrand, who encouraged her),[23] Braunau, Linz, and down the Danube River to Melk. The two women survived many perils, including overturned carriages, as the baroness sought an audience to beg Napoleon for a pardon and her husband's life. In his *Memoirs,* the baron narrates this harrowing trek with quotations from his wife's lost letters, which lend first-person authenticity to his recounting of her heroic odyssey.[24]

In Vienna, following the Battle of Austerlitz, which was decided on December 2, 1805, Henriette reached her potential savior, who was headquartered at Schönbrunn Palace. After at least a month-long wait for an audience, she finally obtained three interviews with the emperor at unspecified dates in late December. The only terms to which he would consent were those they had discussed in Paris the previous year: that her husband should be exiled to the United States and that, upon his sailing, the state confiscation of their property would be rescinded. If the baron had been willing to swear fidelity to the emperor, the Neuvilles need not have become exiles. But Jean Guillaume preferred to suffer for his political convictions and would not take the oath. According to her account, Napoleon greatly admired Henriette's courage and remarked, "You are a worthy woman, I am sorry I cannot grant you more."[25] In a letter to her husband, the baroness confessed with striking frankness, "Ah! My friend, if you had signed that Act, drawn up by honourable men, we too should have been restored to our home; but you did right, one cannot carry scruples of honour too far; do not worry about me, I will follow you everywhere with joy, where could I find it without you!"[26] The baroness's wait in Vienna is commemorated in her watercolor of a young man sitting on an Empire *chaise* near a *kachelofen*, an Austrian Rococo faience stove, fending off winter's chill (cat. no. 7). By January 6, 1806, the Neuvilles were reunited at Constance.

Later, when remembering this epic chain of events, the baron recognized his wife's amazing spirit and persistence.

> I often thought of the privations to which I had exposed my poor wife, destined, had she married anyone else, to the tranquil enjoyment of a large fortune— now almost ruined, leading a wandering life, imprisoned, and consumed with anxiety on account of the author of her misfortunes. Certainly, these reflections did not cause me remorse, but they filled me with admiration for her courage and self-renunciation, which far surpassed, and continually stimulated my own.[27]

Out of Europe and into Exile in New York City

Leaving France as exiled émigrés, the Neuvilles traveled to Barcelona, Spain, where they embarked for the United States on *L'Alerte*. While on board, the baroness drew some of the ship's crew and her fellow passengers in delightfully spontaneous sketches, usually in her preferred early medium of black chalk (appx. nos. 82–84). On a calm day, she painted an early watercolor of a black youth, identified simply as "Dan" (appx. no. 85), which reveals her appreciation of her sitters' ethnicities. Unfortunately, their voyage on *L'Alerte* was short-lived, as pirates attacked the ship but were repulsed by the crew, necessitating a return to Cádiz.

Stranded for several months in Cádiz, the Neuvilles met the French Romantic writer and diplomat François-René de Chateaubriand, who would become a lifelong friend. It was probably during this period when Henriette copied meticulously prints of two Roman monuments near Barcelona (appx. nos. 20, 21), as well as two Spanish figures in traditional dress (appx. no. 22). They set sail again for New York City on May 2, 1807, on the American frigate *Golden Age*. After a forty-nine-day voyage on the Atlantic, their ship entered New York Harbor toward the Narrows, as recorded by the baroness in a watercolor that includes the Sandy Hook Lighthouse, the country's oldest extant light (cat. no. 8). The auspicious name of their vessel suggested prosperity to the couple and augured their success, while the baroness's watercolor forecasts the future importance of her early recordings of the country's landscapes and its cityscapes with their diverse populations. Whereas Henriette's watercolor chronicled their initial sight of land and their entry to the New World, the baron recorded their emotional reaction:

> We arrived in New York on Saturday, June 20th, at the most beautiful time of
> the year . . . crowded one against the other, tossed by all winds. The shores of
> the Hudson River, covered with the freshest verdure and charming dwellings,
> appeared most beautiful to us; but if the first sight of this strange land
> provided an agreeable sensation, we felt great pain in thinking that in this
> immense place where we had disembarked, not a parent, not a friend, waited or
> desired our arrival.[28]

That said, the baroness carried a letter of introduction to none other than Thomas Jefferson.[29]

At the time of their arrival, New York City was a bustling commercial center and growing so rapidly that by 1810 its population would reach ninety-six thousand. French culture and taste were in vogue.[30] Francis Guy's painting *Tontine Coffee House, New York City* (fig. 8), in which women and men wear costumes similar to those worn by the Neuvilles (cat. nos. 1, 2, 4), captures the lively buzz around the busy intersection of Wall and Water streets. Guy's New York was like the one that must have greeted the Neuvilles. The English traveler John Lambert wrote a verbal equivalent to the scene in 1807, the year of the Neuvilles' arrival.[31] In the first decade of the nineteenth century, most of Manhattan was forested and marked only by streams, hills, and scattered farms. Its settled center lay at the southern tip of the island (fig. 9). Just before the Neuvilles arrived, on April 3, 1807, the legislature commissioned Peter Maverick and William Bridges to draw a map of the island with an imposed grid system. That grid system indicates that the legislators expected the City to expand, but they did not imagine the explosive impact on New York of the Erie Canal's opening in 1825, three years after the Neuvilles' return to France.[32]

As part of her acclimation process, the baroness took out her drawing tools and watercolors to study and master her new surroundings. Her first known work in America dates from June 26, six days after the couple disembarked (appx. no. 86). In its inscription, she noted in pidgin Spanish-Italian that the charming house on Pearl Street belonged to "Senor Don Pablo" and a beautiful woman from Guadalupe.

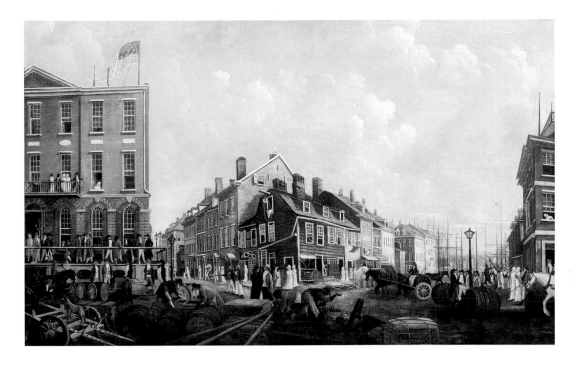

Fig. 8
Francis Guy, *Tontine Coffee House, New York City*, ca. 1803–04. Oil on canvas; 42 ¼ × 64 ¼ in. (107 × 163 cm). N-YHS, Durr Fund, 1907.32

Two weeks later, on July 10, the couple accepted the advice of friends to explore the country before settling, and began their grand tour of America. Like earlier travelers in pursuit of the country's natural wonders, they journeyed north to Albany (cat. nos. 9–11) and made their ultimate destination Niagara Falls—which the baroness sketched with color notes in graphite on the verso of cat. no. 18, capturing the power of the American Falls, including the Bridal Veil Falls. Henriette's limpid landscapes of the Hudson River and Highlands predate the watercolors of English artists trained in the topographical tradition (figs. 17, 26–28). Moreover, her works precede the first generation of widely circulated prints, such as those by John Hill after William Guy Wall's watercolors in *The Hudson River Portfolio* (1820–25), which etched this pilgrimage up the Hudson River permanently on the popular mind (figs. 10, 32, 48).[33] Wall's watercolors and Hill's hand-colored prints after them were finished, detailed views, which stressed the taming of the wilderness and the progress of domesticating it with settlements and bridges. By contrast, Henriette, who drew her view of the Hudson Highlands in graphite and gray watercolor, gave Romantic overtones of the Sublime to the magnitude of the Highlands and the seemingly tranquil yet powerful Hudson River. (See cat. no. 9, which also includes the baron's written comments.) Ever curious and attentive to historical and ethnic heritages, Neuville chronicled specific commercial enterprises in Albany and local buildings with characteristic stepped gables; she annotated the latter as "Dutch houses" (cat. no. 12).

Leaving Albany, the couple journeyed west to the central section of New York State, passing through Ballston Springs, Amsterdam, Schenectady, Utica, Buffalo, Owego, and Angelica. The baroness recorded places that piqued her interest (cat. no. 24), as well as people of various ethnicities, including black slaves (cat. no. 13), American Indians (among them cat. no. 71), and individuals from China that are among the earliest representations of their presence in the U.S. (cat. no. 43; appx. no. 92). Her watercolors and drawings of Indigenous people constitute some of the earliest ethnographically correct representations known (cat. nos. 14, 15, 19, 21, 49, 74–77). She also exhibited a keen historical sense by portraying subjects identified as the first inhabitant of a locale or its first building. Examples include *The First Settler of Allegany County; First Cottage*

Map of the Lower West Side of Manhattan (1810–1820)

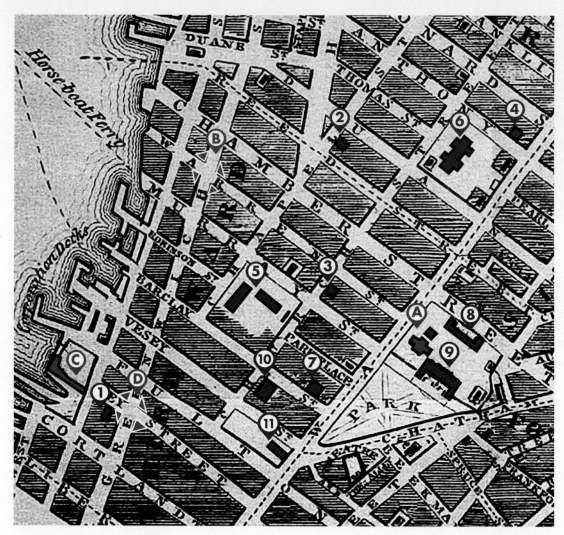

Residence and Landmarks

1. Hyde de Neuville Residence, 61 Dey Street

2. First location of the French Economical School, 56 Chapel Street

3. Second location of the Economical School and the Printing Office, 59 and 61 Church Street

4. Third and final location of the Economical School, Anthony Street near Broadway

5. Columbia College

6. New York and Maniac Hospitals

7. The College of Physicians and Surgeons

8. The American Museum, New York Academy of Arts, and New York Institution

9. City Hall

10. St. Peter's Roman Catholic Church

11. St. Paul's Chapel

New York City Places Represented in the Baroness's Drawings

A. Bridewell Prison, Charity School, and Board of Health, 1808

B. Corner of Warren and Greenwich, 1809

C. Dey Street on the Hudson River (wharf), 1810

D. Corner of Greenwich (and Dey Street), 1810

Adapted by Alexandra Mazzitelli and Maura Spellman

in Angelica, New York (cat. no. 30) and the Utica Hotel, the first brick structure in the town (cat. no. 17). Some of Henriette's views, among them *A Street in Owego, New York* (appx. no. 34), rank as the first record of a geographic location.[34] Others rate as perhaps the initial depictions of specific buildings—for example, St. Peter's Church in Perth Amboy, New Jersey (appx. no. 49), which was replaced by a second building in the 1850s.[35] Significantly, her watercolor of this Christian sanctuary preserves the original, historic building whose first service was held in 1685 and which both sides in the Revolutionary War used as barracks.

Since churches were frequently the first substantial structures that communities erected, Henriette dutifully recorded them (cat. nos. 18, 22, 29, 73). The baroness was a devout Catholic, as evidenced by contemporary accounts and the two chapels at L'Estang—a private chapel in the château and an additional freestanding chapel on the property, which the baron constructed in 1833 and where he and the baroness were buried.[36] John Quincy Adams remarked about the couple, "De Neuville is, politically, and his wife is piously, religious."[37] Since many of the structures Henriette portrayed are no longer standing, her depictions are invaluable historical documents (see cat. nos. 16–18, among others). Passing near Troy and Rome on their tour, the baron would later reveal not only his comprehension of the young democratic nation's reliance on Greco-Roman symbols to establish the republic, but also his sense of humor:

> One cannot take a step in the new world without being surrounded by the greatest memories, all Greek and Roman. This society which has neither a past nor a history draws from foreign annals of glory and fame. . . . Demosthenes, Cicero, Pompey, etc. have all given their name to a certain extent of territory, so that in looking at a map of the United States, one is tempted to believe that the land was the patrimony of all the great men of antiquity. . . . We are now only twelve miles from Rome and will spend the evening in Paris. We have passed close to Palmyra, and in detouring a little, we would arrive easily at Pamplona. . . . Nevertheless, do not be seduced by these brilliant names; the Paris of America is only a hole with twenty or thirty houses.[38]

Fig. 9
Map of Lower Manhattan, 1810–20. Adapted by Alexandra Mazzitelli and Maura Spellman

Fig. 10
William Guy Wall, *Preparatory Study for Plate 18 of "The Hudson River Portfolio": View Near Fort Montgomery, New York*, 1820. Watercolor, scratching out, selective glazing, and touches of gouache and black ink on paper, laid on card, laid on canvas; 14 × 21 in. (356 × 533 mm). N-YHS, James B. Wilbur Fund, 1941.1124

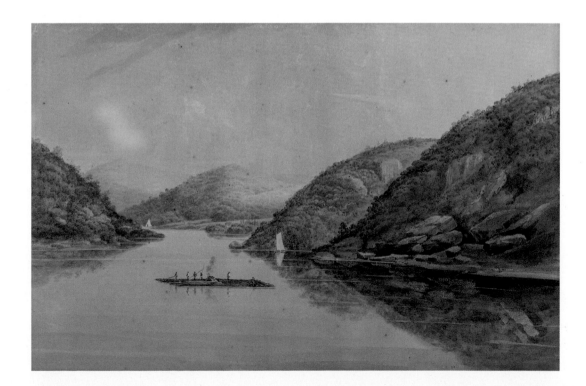

The baroness too was an astute observer of outward appearances, and she also communicated the flavor of life in the New World by concentrating on how Americans had transformed the landscape: everywhere their diligence and industry resulted in prosperity and material progress. When the Neuvilles visited Ballston Springs in July of 1807, Henriette ignored the renowned hotels of the fashionable spa, known for its mineral springs and glamorous clientele, in favor of Mount Marino, a summerhouse near the Sans Souci hotel (cat. no. 13), and the commercial center of the vibrant village (fig. 11). According to the baroness's untraced journal, it was here that the Neuvilles met the Moreaus (see cat. no. 35).[39] Like the British traveler and aristocrat William Strickland (fig. 50), who focused on the destructive girdling method of clearing trees from the land,[40] the baroness was struck by the deforestation of the area. Similarly, the baron criticized the abuse of nature involved in settlement, but remarked with a sense of wonder, "this is a land truly full of miracles."[41] Bridges (cat. nos. 27, 28; appx. no. 48), carriages (cat. nos. 13, 16, 28, 65), and modes of transportation like ferries (cat. no. 23) and steamboats (cat. no. 33), the last of which Robert Fulton had made commercially viable in 1807, likewise fascinated Henriette.

In 1808, the Neuvilles spent the summer in Angelica, a town in western New York State 250 miles west of Albany. It was already an enclave of French culture, the place where the second wave of émigrés from the French Revolution settled, whereas the first had gravitated toward Albany and Schenectady. By 1808, Victor Marie du Pont de Nemours decided to try his hand at farming and merchandising in Angelica, the town that Philip Schuyler Church had laid out on French design principles (cat. no. 24). He resided there with other members of his family, including his wife, Joséphine (fig. 7), who would become a lifelong correspondent of Henriette. In September of 1808 the baroness painted a watercolor portraying the Du Ponts' busy farm (fig. 12).[42] Bankruptcy, however, interrupted Victor du Pont's plans in upstate New York. Victor therefore joined his brother, Éleuthère Irénée, who had built on their Huguenot heritage to found one of the most prominent American families and one of its most successful corporations, E.I. du Pont de Nemours, initially as a gunpowder manufactory in Wilmington, Delaware. Victor moved his wife and children from Angelica to Delaware, where they established residency at "Louviers," across the Brandywine Creek from Eleutherian Mills, the house and powder plant of his brother (cat. nos. 31, 32). The Victor du Ponts became fast friends of the Neuvilles, who would later host and supervise one of their daughters, Amélie Élisabeth, and her education in New York City (cat. no. 44; appx. nos. 46, 47). The Neuvilles met Victor's brother in Delaware, and, at one point in 1810, they seriously contemplated buying a nearby farm on the Brandywine Creek (also called the Brandywine River).

Enraptured by the Streets of New York City

Sensitively attuned to metropolitan daily life, Henriette captured the urban rhythms of New York streets while conveying Americans' energy and determination. She portrayed important institutions, such as Bridewell Prison and the Charity School, St. Paul's Episcopal Chapel and St. Peter's Roman Catholic Church, the construction of City Hall (cat. no. 40), as well as the swine that ran rampantly through the streets, much to the consternation of many pedestrians (cat. nos. 40, 42).[43] Her watercolors contain a wealth of information about lower Manhattan Island. Not only did Henriette illustrate its topography, but she also captured the dynamism of its urban life and the variety of its domestic architecture, which at the time consisted of wooden structures punctuated by more permanent brick edifices (cat. nos. 42, 43).

The baroness also portrayed the seasonal effects of snow on the bustling scene near the Neuvilles' house at 61 Dey Street (cat. no. 42), where they resided in 1810–14 and were listed in

Fig. 11
Anne Marguérite Joséphine
Henriette Rouillé de Marigny
Hyde de Neuville, *Ballston
Springs, New York*, 1807.
Watercolor on paper;
7 × 9 ¾ in. (178 × 248 mm). N-YHS,
Gift of an anonymous donor,
1947.449 (appx. no. 23)

Fig. 12
Anne Marguérite Joséphine
Henriette Rouillé de Marigny
Hyde de Neuville, *The Du Ponts'
House, Angelica, New York*,
1808. Watercolor, black chalk,
and gouache on paper;
7 5/16 × 13 in. (185 × 330 mm).
Musée franco-américain
du château de Blérancourt
(appx. no. 71)

City directories under the name G.H. Neuville, the surname that they used in New York, no doubt appreciating its symbolism that approaches "nouvelle ville." (In some documents, such as the letters of Thomas Jefferson and the journals of Gouverneur Morris, the name is spelled Neufville.⁴⁴) Their residence would have had a view of the Hudson River, perhaps a little farther east than the view in cat. no. 42. It was within walking distance of many important fixtures of lower Manhattan (fig. 9): the Merchants' Exchange, Vauxhall Gardens, the Église Française du Saint-Esprit, Trinity Church, the Park Theatre, and the College of Physicians and Surgeons (where the baron was a member). The college was one block east and south of Columbia College, then occupying a single, large, pre-Revolutionary edifice. It is interesting to note that in the transfer of the Dey Street property in 1814, Henriette was listed jointly with her husband (see cat. no. 42), whereas in France she was the primary landowner because the properties descended from her father's family. While Henriette was involved with drawing for her visual diary, the baron was engaged in a voluminous correspondence regarding his twin interests, in agriculture and medicine; the latter culminated in his election to the Philo Medical Society in 1810.⁴⁵

The Economical School (*École Économique*)

A man of the Enlightenment, especially when it came to education, Guillaume Hyde de Neuville was instrumental in the founding of the Economical School in New York City "to promote instruction, to render it economical, and to afford some education to the children of French emigrants and other strangers."[46] Likewise, his wife was a strong advocate, her drawings and watercolors revealing her concern with people reading and writing (cat. nos. 3, 26, 44, 85; appx. nos. iv, 8, 10, 11, 14, 24, 29v, 36, 38, 42, 44, 45, 51, 54, 61, 62, 75, 78). This theme runs as the strongest thread throughout her figural oeuvre.[47] The baron—who was a great admirer of American democratic education and the concept of schooling underprivileged individuals—first conceived of the Economical School in 1808, together with other like-minded French émigrés. Already by February 1809, the school was functioning in rooms at 56 Chapel Street, and by June of that year counted one hundred students.[48] In anticipation of its formal organization, in October 1809 the trustees petitioned the New York Common Council for the use of a schoolhouse. They advertised early for female students in the *Mercantile Advertiser*, noting that "The committee will admit the persons who will make applications without distinctions of nations, fortune or religion; and will pay only the most scrupulous attention to their character."[49]

The *École Économique*, as the French exiles called the school, was incorporated by the New York State Legislature on March 14, 1810, as the Society of the Economical School of the City of New York, and because it was a charity intended to educate "paupers," was also granted funds.[50] Among its board members were President Reverend Benjamin Moore (also President of Columbia College), Vice President Victor Moreau, Secretary G. Hyde de Neuville, Treasurer Charles Wilkes, John R. Murray (the first settler and namesake of Murray Hill), Thomas Eddy, and Moore's son Clement Clarke Moore (famous for penning "Twas the Night Before Christmas").[51] At the school's opening, it boasted an enrollment of more than two hundred students. Four months later, the school petitioned the Common Council for a lot on which to erect its own school.[52] At the time this motion was made, Neuville was cited as the "principal conductor" of the school. Its progress was reported in the *Columbian* (May 18, 1811), which noted that all the children, including poor scholars attending gratis, were receiving the most useful and economical education. "The greatest proportion of them can now translate, read, and speak with equal facility, the French and English languages. They learn also Geography, History, and the elements of Mathematics. A School of Needle Work is added to this institution." Most interestingly, an article the following year announced that "The trustees considering the utility of drawing, in a commercial city, have established, a month since, a school for this purpose. . . ."[53] Children of refugees from the West Indies, and all other foreigners in unhappy circumstances, had preference.[54] In 1814, DeWitt Clinton became the school's president.[55]

The Economical School had an ambitious publishing office with a printing press, which also offered its students vocational training. All books in English and French used as school manuals were printed there, and students worked in the office to learn a trade, including printing. Known by various names, including the "Office of the Economical School" and "l'Office Économique," it was first located at 56 Chapel Street (now West Broadway) and later at 59 and 61 Church Street, between Duane and Reade streets. Most of its publications were textbooks, and many were bilingual;[56] one of Henriette's sketches of a young boy with a bilingual inscription may mirror this approach (appx. no. 43).[57] The books' subjects included language and grammar,[58] history and mythology,[59] and religion (both Protestant and Catholic),[60] some with a decidedly royalist slant. The press also published an edition of the *Fables* of La Fontaine,[61] as well as a treatise on raising Merino and other breeds of sheep.[62] The

Economical School's publications leaned toward works that featured moral or ethical themes or had a philanthropic purpose, for example, to benefit the Economical School itself and the Orphan Asylum Society through their sales.[63] The City's Common School Fund contributed support to the Economical School and the Orphan Asylum, as well as the New-York Free School and other incorporated religious societies that supported so-called "charity schools,"[64] and later the Female Association;[65] hence all of them were also called "Common Schools."[66] The Economical School press continued publishing through 1812 under its own imprint and then under that of Joseph Desnoues until 1821.[67]

The Economical School's press also issued a bilingual literary periodical, the *Journal des dames (ou, Les souvenirs d'un vieillard)*, a kind of *Readers' Digest* for French émigrés, to which the baron sometimes contributed poems.[68] While borrowing its name from the influential *Journal des dames et des modes*, which was published in Paris (1797–1839), the Economical School's *Journal des dames* offered none of the fashionable appeal of its namesake, although it was meant to attract the generosity of philanthropic women.[69] Its offices were at 56 Chapel Street and then at 6 Carlisle Street, when Dr. Francis Durand was its editor.[70] The press released only twelve numbers of the *Journal des dames*: from January 1810 through December 1810.[71] The baron published the journal under the nom de plume L'Hermite du Passaic ("The Hermit of Passaic"), referring to the Neuvilles' New Jersey farm, although he is variously credited on its cover. One poem, assigned to another nom de plume, "THEODORE," meaning God-given, was copied by the baroness in very deliberate calligraphy (fig. 14).[72] It is entitled "LINES WRITTEN AFTER A VISIT TO THE BANKS OF THE B********E [*sic* Brandywine] STREAM," and commemorates a memorable visit the Neuvilles made in 1810 to the Victor du Ponts, who then lived on the Brandywine Creek in Delaware, when the couple was deciding whether to purchase a farm in the area (as mentioned above).

Pastoral Life at "The Farm" in New Brunswick

Instead of buying a country home in Delaware, in 1811 the Neuvilles purchased land along the banks of the Raritan River on the Easton Turnpike in what is now Somerset, New Jersey. They lived in "The Cottage" (cat. no. 39), before building a larger house, "La Bergerie," no doubt missing their Château de L'Estang and the charms of rustic life. The location was increasingly more accessible after 1808, when Robert Fulton's *Raritan* began making a regular, rapid run between the City and New Brunswick.[73] Henriette recorded that very steamboat in her view of Perth Amboy (cat. no. 33). In this idyllic country setting, the baron continued his medical and agricultural studies, as well as supervising the breeding of Merino sheep, which earned him the status of "Agricultural citizen," according to Thomas Jefferson.[74] Nearby was the house of their American friends, the Simonds (cat. nos. 52, 82; appx. no. 30), which they had visited as early as May of 1809, when the baroness recorded the residence and its beautiful setting and perhaps herself and Madame Simond strolling in the foreground (appx. no. 88). Country life appealed to the baron, who contrasted it with the nation's materialism: "Americans are too fond of money."[75]

Among the Neuvilles' other friends were General and Madame Moreau (see cat. nos. 35, 41), with whom they shared the bonds of exile, French culture and taste, and the Economical School venture. Moreau, the republican, and Hyde de Neuville, the royalist, found common ground in their hatred of Napoleon. The baron wrote an anonymous published oration for Moreau's 1813 funeral service in Russia but was critical of the general in his *Memoirs*: "He was cold and not very expansive and so an intimacy did not develop easily. But ultimately one could become very attached to him, through the respect he inspired rather than by his brilliant qualities which were concentrated on a single theme: his ambitions to be a military hero."[76] The Moreaus' country

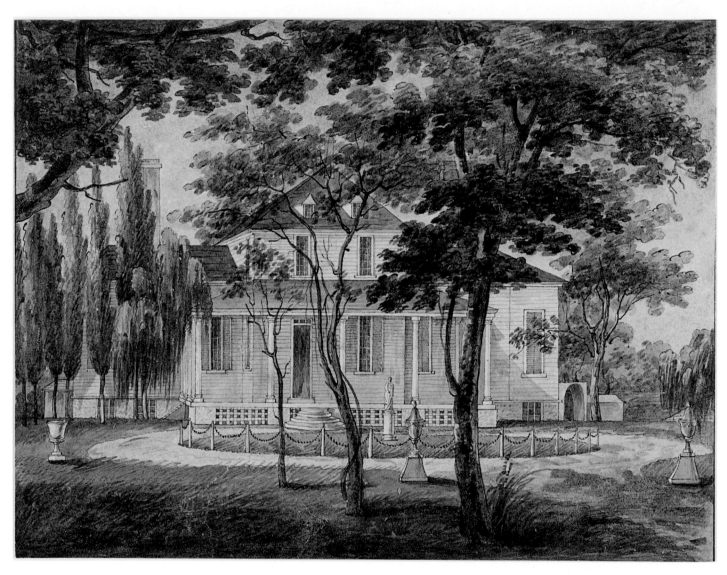

Fig. 13
Pavel Petrovich Svinin, *The Moreau House, Morrisville, Pennsylvania*, ca. 1811–13. Watercolor and gouache on paper; 7 1/16 × 9 3/16 in. (179 × 233 mm). Metropolitan Museum of Art, New York, 42.95.49

Ye verdant vales and smiling bowers;
Ye wood-crown'd hills and opening glades;
Unclouded flew the social hours
Beneath your hospitable shades.

And, as the mystic union grew
Of souls congenial with my own,
Each object took a fairer hue,
And every sound a softer tone.

For rising friendship's genial power
Bids joys unwonted 'round us spring;
Hope smiles in that auspicious hour,
And Fancy plays on lightest wing.

Nature, then rob'd in purer light,
With lovelier tints appears to shine;
The orb of day, the stars of night
Beam with effulgence more divine.

Behold, sweet friends, with tints how true
The landscape glows in yonder stream;
The solemn woods, the 'welkin blue,
The western fires, the moon's pale beam.

So true, within my heart shall rest
The image of your kind abode;
The smiles that claim'd me for your guest;
The fond attentions you bestow'd.

Yes, ever to my grateful soul
Shall memory trace your lovely vale,
Where limpid streams their waters roll,
And life and health breathe in the gale;

Where mingled charms contrasted meet,
Like vision rais'd by magic spell;
Where manly virtues hold their seat,
And all the softer graces dwell;

Where nature's wildest scenes are crown'd
By fairest works of art refin'd;
Where 'midst rude rocks and woods, are found
The gentle heart and cultur'd mind.

house (cat. no. 34) in Morrisville, Pennsylvania, which was also recorded by Pavel Petrovich Svinin (fig. 13), was thirty miles down the Lower Post Road (now Route 1) from the Neuvilles' farm. Thus, it was predictable that the two couples visited Philadelphia together, stopping at Madame Rivardi's (Maria von Born) Seminary in 1811 to gather information for their Economical School venture.[77]

The Neuvilles and the New-York Historical Society

Since New York City was a small town in the early decades of the nineteenth century, the Neuvilles were in touch with many leaders of the community and founders of assorted institutions, among them the City's first museum, the New-York Historical Society.[78] The N-YHS counted as members the Neuvilles' friend Louis Simond (see cat. no. 82), who designed the Historical Society's membership diploma featuring Henry Hudson's *Half Moon*, engraved by Asher B. Durand. The Neuvilles also befriended some of the N-YHS's founders, among them DeWitt Clinton, who later served not only as president of the Historical Society but also as president of the Economical School Board, and whose carriage the baroness depicted at Palatine Bridge (cat. no. 28). Since Chancellor Robert R. Livingston had been Minister Plenipotentiary to France (1801–05) as well as a member of the N-YHS, it was logical that the baroness also visited Clermont, his country estate, which we know from her portrait of a young woman, "Elie-Anne," which she inscribed "Clermont" (appx. no. 26). Other members on the board of the Economical

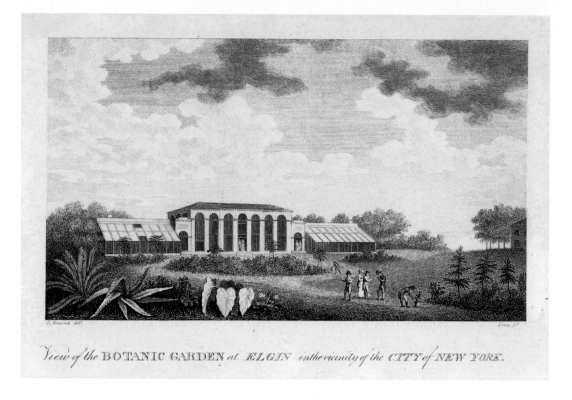

School and friends of the Neuvilles, as well as N-YHS members, were John Murray, Benjamin and Clement C. Moore, and Charles Wilkes.

From his diaries, we know that Gouverneur Morris, the N-YHS's second president and former Minister Plenipotentiary to France, was a friend of the couple. At his rural estate Morrisania, today in the Bronx, Morris dined with Guillaume alone or together with his brother Paul.[79] He also had dinner and breakfast with the baron and baroness in 1807 and 1810, and visited them in New York in 1807,[80] as well as in 1816, forty-eight hours after their return to the United States.[81] Another entry in Morris's diary states that he visited Mrs. Waddington's house and Madame de Neuville; this reference sheds light on another relationship of the baroness, who, in 1814, drew the Waddington house, belonging to Joshua Waddington, one of the founders of the Tontine Coffee House (fig. 8), and his wife on the East River near Hell Gate (appx. no. 89).[82] Most unusual for the mores of the time, the independent baroness also dined alone with Morris in New York City on at least one occasion in 1810.[83]

Botanical Studies by the Baroness and the Elgin Botanic Garden

The fourth president of the N-YHS, from 1820 to 1827, was Dr. David Hosack—an indefatigable polymath, a practicing medical physician, and professor of *materia medica* at Columbia College—who in 1801 founded the Elgin Botanic Garden, the first botanical garden in the United States, on the site of today's Rockefeller Center. A man of prodigious energy, Hosack was involved with many institutions in the City, although botany and the medicinal use of plants were his enduring passion.[84] Even though he never met Alexander von Humboldt during the German's American visit in 1804, the two were kindred spirits and correspondents.[85] Hosack gathered and traded specimens with him, Thomas Jefferson, Aaron Burr, and European botanical specialists who came to New York, such as François André Michaux (1802) and the French imperial botanist Alire Raffeneau Delile (1807), who visited the year of the Neuvilles' arrival.[86] Along with DeWitt Clinton, Hosack was also a founder of the Literary and Philosophical Society, for which Henriette's friend Louis Simond designed a membership certificate (see cat. no. 51). Moreover, Simond created the design for an engraving showcasing the Elgin Botanic Garden's central greenhouse and its two flanking hothouses, each sixty feet long (fig. 15).[87] It is virtually impossible that the Neuvilles and Hosack would not have known each other, given the baron's passion for medicine—both he and Hosack were members of the College of Physicians and Surgeons (then located at Barclay Street and Broadway) and both advocated in favor of smallpox

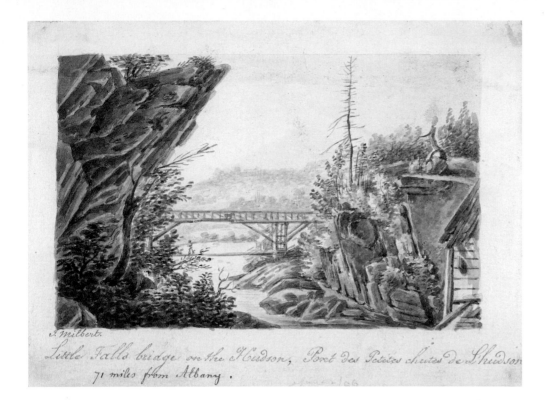

Fig. 16
Jacques-Gérard Milbert, *Little Falls Bridge, Sacandaga, New York: Study for Plate 25 in "The Picturesque Itinerary of the Hudson River and the Peripheral Parts of North America"*, 1818. Brown ink and wash over graphite on paper; 5 × 6 ¾ in. (127 × 171 mm). N-YHS, Gift of Daniel Parish Jr. 1906.20

vaccination[88]—and the baroness's interest in botany (cat. no. 45; appx. no. 68), as well as their mutual friends, such as Gouverneur Morris. It also seems inconceivable that the baroness did not visit the Elgin Botanic Garden. Moreover, Hosack lived at 65 Broadway (about five blocks from the Neuvilles), where the bon vivant held court at his Saturday night salon and entertained many of New York City's notables on a regular basis.

Also important for this discussion is a friendship the Neuvilles forged with Jacques-Gérard Milbert. As a naturalist and artist, Milbert's love of exploration and travel took him to America in November of 1815, where he remained for eight years (figs. 16, 62).[89] In 1817, he visited the Elgin Botanic Garden and found it chaotic, writing in his *Itinéraire pittoresque du fleuve Hudson et des parties latérales de l'Amérique du Nord*, "The conservatory alone bears witness to its original location."[90] Milbert had been commissioned by the baron in his position as Minister Plenipotentiary of France (1816–22) to gather natural history specimens along the Hudson River for King Louis XVIII's collections. After completing this seven-year task, Milbert returned to France in 1823 and presented the impressive number of specimens that he had collected (7,868 in fifty-eight shipments), which eventually came to the Muséum national d'histoire naturelle in Paris (see cat. no. 45).[91] According to the 1824 report on his mission by Baron Georges Cuvier, Milbert had been "fired with enthusiasm by Monsieur Hyde de Neuville. . . ."[92]

Interlude in New Haven, England, and France

The Neuvilles' first stay in America ended in the spring of 1814 with the fall of Napoleon and the restoration of King Louis XVIII. But before they returned to France, the couple stayed for several months in New Haven, Connecticut. The baroness recorded views of the town, Yale College, the lighthouse, and wax figures in Mix's Museum, including those of a 739-pound man and Indigenous Americans from Alaska (cat. nos. 54–57). Before their departure, the couple took a trip on the East River, where Henriette drew one of its characteristic mansions, including one belonging to her friend Mrs. Gertrude Gouverneur Ogden Waddington (appx. no. 89). The Neuvilles had become so immersed in their American lives that later Henriette declared to Joséphine du Pont, with whom she enjoyed a lengthy correspondence: "America is our second country" ("L'amerique est notre seconde Patria").[93]

When the Neuvilles departed New York in May 1814, DeWitt Clinton, then president of the Economical School, wrote a letter to the baron in which he thanked him for the time, money, and inexhaustible good will he had lavished on the school. Clinton considered it an inestimable

contribution to the cultural life of New York. The letter deeply moved the baron.[94] Without the Neuvilles at the helm, the Economical School would close in 1825 due to lack of funds to support its function.

During the voyage to England on the Portuguese ship *Amigo Protector*, the baroness recorded several incidents on board, as well as some of its passengers (cat. nos. 59–62; appx. no. 60). After sighting land and a lighthouse off the English coast (cat. no. 62), the ship arrived in Liverpool on July 8,1814.[95] The Neuvilles proceeded to France. But later in August they went to England to stay with the Simonds, then residing in the London suburb of Richmond.[96] During this period the Neuvilles became extremely peripatetic, especially the baron, who commuted between London and Paris.

In October 1814, the couple departed for Italy on a secret diplomatic mission to warn the rulers in Turin and Florence about Napoleon's plans for escaping his incarceration on the island of Elba. Back in England in 1815, during the unrest preceding Napoleon's "Hundred Days," the baron feared for his wife's safety and encouraged her to remain there during Napoleon's return to France (March 20 to July 8, 1815). The baroness sojourned in Newhaven in East Sussex, which she ironically termed her "prison" (appx. no. 90). The couple also visited the elegant spa of Brighton, where Henriette recorded the original appearance of the Royal Pavilion and its characteristic Indo-Islamic architecture (cat. no. 63), as well as another charming building in the resort town (appx. no. 76). She also depicted scenes near Kensington Palace in London (cat. no. 64), while staying in Richmond with the Simonds.[97]

Back in France during July after Napoleon's final defeat, the baron devoted himself to promoting the Bourbon monarchy. He received the order of Saint-Louis and the Legion of Honor for his service, and he also served in the Chamber of Deputies. On January 14, 1816, King Louis XVIII appointed him Minister Plenipotentiary to the United States and bestowed upon his coat of arms the motto "Tout pour Dieu et le Roi legitime." The baroness was then presented at court on April 8, an august event that she recounted with some amusement.[98] During this time, she also continued to draw, inscribing one work with their address rue d'Antin No. 10 (appx. no. 62) and depicting the garden of their residence (cat. no. 65). Before the Neuvilles sailed to the U.S. from Brest on May 16, 1816, Henriette had the time to draw a trio of small occupational genre scenes (appx. nos. 64–66).

To the U.S. Capital

The notification of Guillaume Hyde de Neuville's appointment as Minister Plenipotentiary traveled to Washington before the couple arrived in the U.S. capital, and the *Daily Intelligencer* passed the information along to its readers.[99] On the voyage to New York on the ship *Eurydice*, the baroness recorded the high style in which they sailed as official representatives of France (cat. no. 66). She also revealed her sense of humor in a caricature of a fellow passenger, an insufferable "Savant" or scholar, who believed, according to her inscription, that the temperature of the water in the Bahama Channel was boiling (appx. no. 67). Although caricature was a very popular genre at the time, it did not usually interest the egalitarian baroness. In one other sheet, however, she let fly some well-aimed visual and verbal barbs, calling her lampooned sitter, a Mr. de Ponthieu, "an old coxcomb" (appx. no. 25).

After stopping in New York and New Brunswick, the couple went to Baltimore briefly, before moving to Washington in order to be closer to leaders of the federal government. At that time, the British minister was the only other diplomat living in the new, rather desolate capital. The baron's tenure coincided with the end of James Madison's presidency and the "Era

of Good Feelings" of James Monroe's administration, when French culture and taste were at their zenith in America,[100] and John Quincy Adams served as Secretary of State.[101]

Among the baron's accomplishments during his diplomatic tenure were creating a vast improvement in Americans' attitude toward the Bourbon monarchy, serving as liaison between Spain and the United States in the Florida Treaty negotiations, and making progress in international trade relations. Remarkably, he discovered a portrait of Napoleon by Baron François Pascal Simon Gérard that had been stored out of sight in the French legation, and sent it to the former emperor's brother, Joseph Bonaparte, who called himself the Count of Survilliers, at his estate Point Breeze in Bordentown, New Jersey.[102]

In the newly minted capital, then known as Washington City, we notice a shift in the baroness's focus in her work to include more important public buildings. They reflect not only the Neuvilles' official status but also Henriette's fascination with the seemingly artificial city rising from the ruins of the War of 1812 in an area that was still unsettled and rural. She recorded significant structures that had recently been reconstructed after being ravaged by the British—chief among them, the executive mansion (cat. no. 67). George Heriot also documented the White House in 1815, terming it "The President's Palace" (fig. 17). Henriette's two drawings of the Entrance Gate to the White House gardens (cat. no. 69) are especially rare and historically significant. The second sheet also features a view of the unfinished U.S. Capitol building under construction in the distance. The first of her two views of F Street (cat. nos. 67, 72) includes a three-story building on the right-hand corner (inscribed "Bank Metropol"), which today houses the Bank of America and is the oldest extant commercial structure in Washington's downtown area. Although most of Washington City was undeveloped in the Federal era, Neuville's bird's-eye view of Lafayette Square features one of its most important and prominent buildings: St. John's Episcopal Church on the northwest corner of 16th and H streets, designed by Benjamin Henry Latrobe (cat. no. 73). The baroness recorded other noteworthy features in the environs of Washington: most remarkably the first tomb of George Washington, with a view of his house at Mount Vernon (cat. no. 70). Another of her watercolors preserves the substantial brick residence of the French ambassador (fig. 18; appx. no. 73)—today the site of the Hotel Washington—where the Neuvilles entertained regularly. At the ambassador's residence, the Neuvilles hosted famous Saturday night suppers, which continued the tradition of Dolley Madison's Wednesday "squeezes."[103] Together with the fêtes given by Mary Bagot, wife of the English ambassador, the baroness's drawing room parties filled the gap left by the end of Dolley's "jams" and the lack of social entertainment offered by the reclusive Monroes (fig. 41).[104] Louisa Catherine Johnson Adams (fig. 42) appreciated the Neuvilles' "handsome" settings and "cheerful hospitality,"[105] and John Quincy Adams found them "gay."[106] Known for their lavish dinners and entertainments, the couple caused a minor scandal by hosting balls on Saturday evenings, which was not in line with Puritan views. In her comments about the baroness, the hostess Margaret Bayard Smith (fig. 40) documented the wildly social whirl of the Neuvilles, which must have left little time for artistic endeavors:

> I have no stranger this winter for whom I feel so much interest as Madm. Neuville. I could love her, if our intercourse could be social enough to allow it. They have company I believe almost every day to dinner, or of an evening. Always on Saturday—we have had a general invitation for that evening. I believe she is completely weary of this eternal dissipation. I love her for her kindness. . . . [107]

The two women became friends, as three letters from Henriette to Smith are known and one letter from Smith to the baroness survives (see Documents).

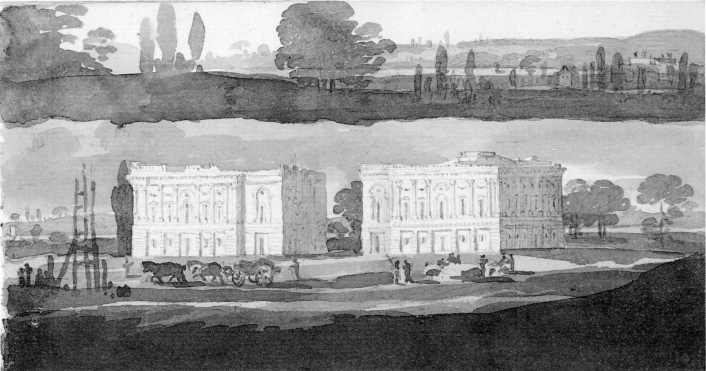

Fig. 17
George Heriot, *The White House ("The President's Palace") in Washington, DC, and Another View with the Potomac River, Folio 25r in a Sketchbook* and *The Capitol at Washington, and Another View with the Potomac River, Folio 20r in a Sketchbook*, 1815. Watercolor and graphite, bound into a sketchbook; 4 ⅛ × 8 in. (104 × 203 mm), each sheet. N-YHS, James B. Wilbur Fund, 1944.430.1

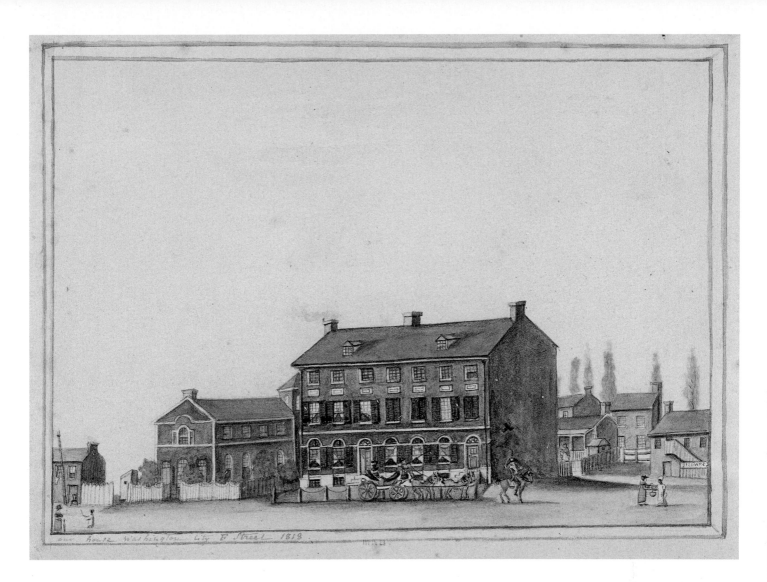

Fig. 18
Anne Marguérite Joséphine
Henriette Rouillé de Marigny
Hyde de Neuville, *House of
the Ambassador of France in
Washington, DC (Maison de
l'Ambassadeur de France à
Washington)*, 1818. Watercolor,
black chalk, and gouache on paper;
6 ⅛ × 8 ⅜ in. (156 × 212 mm). Musée
franco-américain du château de
Blérancourt (appx. no. 73)

Apparently, Henriette's reputation for sophistication and elegance was common knowledge, as was her ability as a *salonnière* to alleviate the reputed social formality under the francophilic Monroes.[108] The niece of Margaret Bayard Smith, Mary Kirkpatrick, writing to her mother on December 5, 1816, was entranced with the Neuvilles' sartorial refinement:

> Mr. Neuville and suite were there in most splendid costume—not their court dresses however. Blue coats cover'd with gold embroidery. The collar and back literally cover'd with wreaths of fleurs de lys with white underclothes and large chapeaux with feathers. The minister's feather was white, the secretaries black, and their dress, tho' on the same style not so superb as his. Madam and Mademoiselle were very handsomely dress'd in white sattin.[109]

These sentiments were shared by others, among them William Winston Seaton, who, bedazzled by the baroness, commented in December 1819: "At the drawing-room Madame de Neuville was exquisitely dressed in a white satin under-slip, with silver lace tunic, head-dress of superb pearls and lace."[110] But more important, the writer observed in May 1819:

> There has been more gayety than I have ever known here in the summer, caused by the farewell dinners, the private and public balls, given to Monsieur and Madame de Neuville, who have by their unaffected kindness to their equals and their munificence to the poor won upon the popular esteem and gratitude ... Monsieur de Neuville making a very impressive little speech of thanks to the citizens ... we have spent many agreeable hours in their hospitable house.[111]

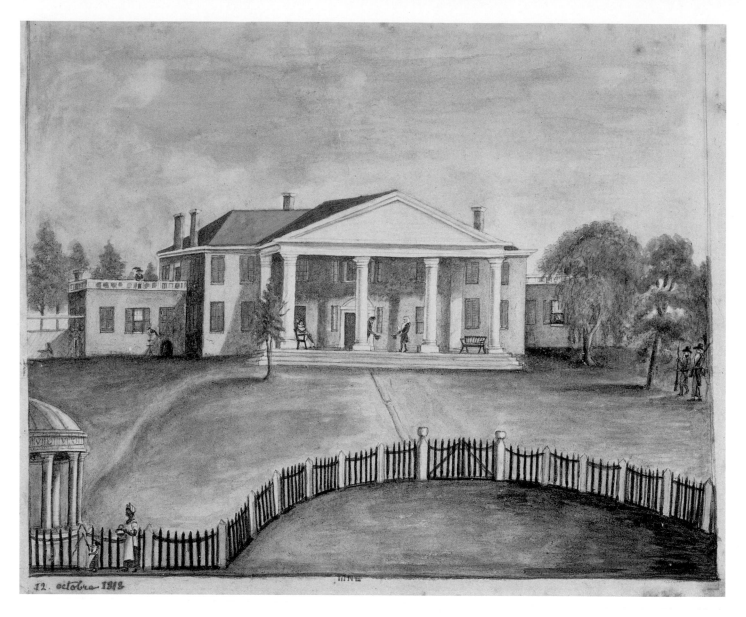

For his part, the baron had become something of a celebrity, as his portrait was advertised with those of notable Americans, as well as the British ambassador Charles Bagot, in Delaplaine's Philadelphia gallery in 1820.[112]

While in Washington, the Neuvilles also befriended Dolley (fig. 39) and James Madison, who were resident in the White House until 1817.[113] They continued their friendship and visited the Madisons' country estate Montpelier in Virginia, which the baroness represented on October 18, 1818 (fig. 19). As Catherine Allgor has concluded, "Any person or family of note considered a visit to the former president de rigueur."[114] On its front porch, Henriette represented Dolley seated in a chair at the left, while the baron doffs his hat to the white-haired President Madison. Henriette and Dolley continued their relationship via correspondence between 1818 and 1830, even after the Neuvilles had returned to France, as demonstrated by two letters from the baroness and three from Dolley (see Documents).

In 1820, the Neuvilles returned to France for a brief, roughly eight-month hiatus as Henriette recorded in her lost journal, when Guillaume was awarded the title of baron. They departed May 30, 1820, from Annapolis, Maryland, on the French corvette *La Seine*,[115] and returned on February 9, 1821, on the French ship *Tarn* to Norfolk, Virginia.[116] During that time, Henriette drew the country house "Les Fouchardières" near Courtalain and Châteaudun northwest of Sancerre in the department of Eure-et-Loir (appx. no. 94), where her inscription notes they stayed for ten days in October. She may have also painted the watercolor of her sister-in-law and her niece in the garden of the Hôtel de la Chancellerie in Versailles (appx. no. 70). Before departing for the U.S. from Brest, Neuville drew a socially conscious scene of the poor of that town (appx. no. 69).

Upon their return to the United States, they resided most of the year in Washington but sojourned at their beloved New Jersey estate occasionally and began to sell off parts of the property.[117] In August 1821, they moved into Washington's historic Stephen Decatur House and commissioned additions to the residence, mainly a back wing to accommodate members of the French delegation and servants. The couple lived there until the following August.[118] The baroness kept a watercolor of the historic residence, made famous by Decatur's naval prowess in the War of 1812, and inscribed the work in brown ink: "Maison du Commodore Stephen Decatur Washington June 1822. By Mr. E. Vaile" (appx. no. 96).[119] In an unfinished watercolor, Henriette also documented an important current event on November 29, 1821, when Indigenous Americans performed the "Indian War Dance" for President Monroe at the White House (see cat. no. 71), as well as later at the Neuvilles' residence. In the background, she lightly sketched figures who may represent her husband, wearing a feathered bicorne hat, President Monroe, and two other men. That same year, the baron successfully concluded negotiations for the ratification of the Adams-Onís Treaty, in which Spain ceded Florida to the U.S.

On August 13, 1822, the Neuvilles departed the United States for the final time on the American ship *Sir Brother's*, bound for France, leaving behind much good will. "No foreign minister who ever resided here has been so universally esteemed and beloved; nor have I ever been in political relations with any foreign statesman of whose moral qualities I have formed so good an opinion," wrote John Quincy Adams, who is not remembered for generously praising his fellow statesmen.[120] When the Neuvilles entered the port of Le Havre on August 13, 1822, the baron noted that this mercantile city welcomed warmly the negotiator of the commercial treaty between France and North America.[121]

The Neuvilles' Later Fortunes

On July 6, 1823, King Louis XVIII of France appointed the baron, who had become a Grand Officer of the Legion of Honor, ambassador to Portugal, and the Neuvilles transferred to Lisbon in August. After the baron successfully saved King João VI of Portugal from a military coup d'état on April 30, 1824, the king bestowed the title Count of Bemposta on him. He was subsequently awarded the Grand Cross of the Legion of Honor of France. Returning to Paris on January 23, 1825, the couple embraced a new rhythm of life, alternating between the city in the winter—where the baron served in the Chamber of Deputies and after 1828 as Minister of the Marine (Navy)—and L'Estang. Until 1830, it was a rather uneventful existence, with the baroness presiding over an influential salon at their Parisian hôtel in the Faubourg-du-Roule, except for a severe injury to her right leg that she suffered in a grave fall on March 10, 1828.[122] In the Revolution of 1830, the baron opposed the exclusion of the Duke of Bordeaux, the rightful Bourbon claimant, from succession to the throne. Therefore, shortly after Louis Phillipe's assumption of the crown, the baron retired completely from political life to build a farm on their estate and to tend his vineyard at L'Estang (fig. 20), the baron now signing his letters to friends "the Vine-dresser of Lestang."[123] In the front courtyard of that château grows a mammoth Cedar of Lebanon tree (*Cedrus libani*), which Chateaubriand had planted, balanced in the rear by a Giant Sequoia (*Sequoiadendron giganteum*) that the Neuvilles had brought back from America. Notwithstanding this self-imposed exile, Guillaume was imprisoned for fifteen days, beginning June 16, 1832, after the June Rebellion or Paris Uprising,[124] and he is recorded as traveling to Prague in 1836 to visit the last Bourbon of direct descent, the exiled Charles X.[125]

Henriette may have retired her pen and brushes because no works of art are known after her final return to France, although in 1830 she gave an altar-cloth that she had hand-embroidered to the Church of Notre-Dame in La Charité-sur-Loire.[126] She remained a brilliant hostess,

Fig. 20
Château de L'Estang,
Sancerre, 2017

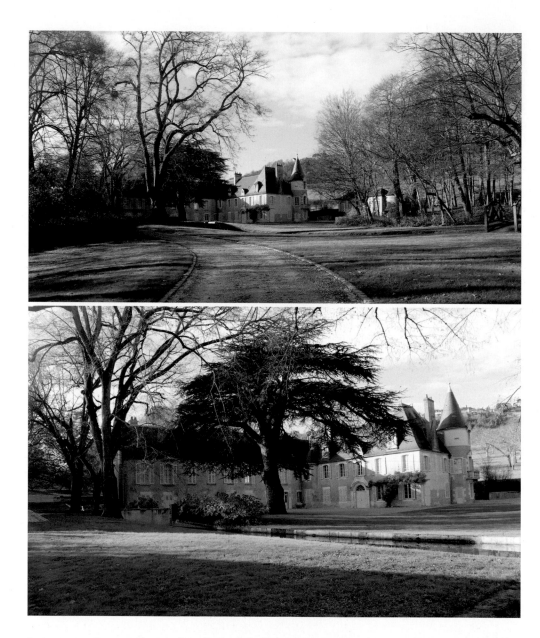

however, and, according to the editor of the baron's *Memoirs*, also true to her ideologically egalitarian inclinations: "The salon of the Baroness Hyde de Neuville was frequented by the most distinguished persons in Paris, irrespective of their political opinions."[127]

As her visual diary proves, Henriette was more than a gifted hostess: she was a unique artist and woman of substance who, in many ways, seems very modern. In a discussion of female monarchs that took place in Washington in 1818, her husband asserted that no women should reign, but she presciently responded to her husband's statement by declaring that, for her part, she had but one wish, "and that was to see an American Lady elected President."[128] Above all, the Neuvilles as international citizens were *avant la lettre* (ahead of their times).

Endnotes

1. Archives départementales et patrimoine du Cher, Sancerre Registres paroissiaux et état civil (1766–1780), 3E1035, 308–309, no. 135. Her godparents were Sr. Claude François Busson de Villeneuve and her aunt, Dame Marguérite de Rolland (representing the baby's grandmother, Dame Anne Marguérite Pérrinet de Longuefin Rouillé de L'Étang, her namesake).

2. See *Château de Lestang* 2018, 1: 69–71.

3. *Mémoires* 1888–92, 1: 3; *Memoirs* 1913, 1: 2.

4. *Mémoires* 1888–92, 1: 3; *Memoirs* 1913, 1: 2. See also Jean Bloch, "Discourses on French Education in the Writings of Eighteenth-Century French Women," in *Women, Gender, and Enlightenment*, ed. Sarah Knott and Barbara Taylor (Houndmills, England, and New York: Palgrave MacMillan, 2005), 243–244, which observes that if girls received an education in seventeenth- and eighteenth-century France, it was normally from the parish *petites écoles*, the convent boarding schools, or the parental home. In convent schools, students were taught piety and were prepared with skills to run a household, including the sewing arts, while aristocrats were also educated in draftsmanship and decorative arts. Da Costa Nunes and Olin 1984, 1, notes that the baroness "undoubtedly received the traditional upbringing accorded genteel young women during the second half of the eighteenth century, an education which most likely included some drawing."

5. For example, Anne Marguérite Joséphine Henriette Rouillé de Marigny Hyde de Neuville, Paris, France, to Dolley Payne Todd Madison, Montpelier, VA, July 20, 1820, Dolley Payne Madison Papers, LoC.

6. Archives départementales et patrimoine du Cher, Sancerre Registres décès (1843–52), 3E2402, 386, no. 200. Faugeras 2003, 446, lists the individuals that were interred in the chapel. See also *Château de Lestang* 2018, 1: 15–16.

7. Nièvre Conseil Départemental, Etat Civil, La Charité, Paroisse de Saint Pierre, Registre des Baptêmes, Mariages, et Sépultures (8 janvier 1771-20 décembre 1780), 4E59 art. 21, 51–52.

8. *Mémoires* 1888–92, 1: 2; *Memoirs* 1913, 1: 1–2, claims that the family first went to Vevey, Switzerland. They descended from Richard, the grandson of Edward Hyde, Earl of Clarendon, Lord Chancellor of England in 1661.

9. For the history of the city, see Gustave Bourra, *Histoire de Sancerre depuis son origine jusqu'à nos jours* (Sancerre, France: Librairie Bourra, 1877).

10. *Mémoires* 1888–92, 1: 60; *Memoirs* 1913, 1: 35.

11. Archives de Paris, Fichiers de l'état civil reconstitué, Hyardin-Hymbert, V3E/D 764, no. 21. It lists him as Jean Guillaume Hyde de Neuville. Faugeras 2003, 446, lists the individuals interred in the chapel. See also n. 6 above.

12. Archives départementales et patrimoine du Cher, Sancerre Registres paroissiaux et état civil (1793–96), 3E1037, 192–194, nos. 87–88.

13. *Mémoires* 1888–92, 1: 2 n. 2; *Memoirs* 1913, 1: 1 n.1. See also Watel 1987, 4.

14. For a portrait of Paul Hide de Neuville in a private collection, see Faugeras 2003, 125, ill.

15. For a history of the property from 1573 and a list of its owners, see *Château de Lestang* 2018, 1: 2–39, followed by the documents. See also Watel 1987, 5 (for Henriette's properties in France); Faugeras 2003, 373–374 (for L'Estang).

16. *Mémoires* 1888–92, 1: vii–x; *Memoirs* 1913, 1: xiii–xv.

17. She was published as Henriette Lucie Dillon La Tour du Pin-Gouvernet, *Memoirs of Madame de La Tour du Pin*, ed. and trans. Felice Harcourt (New York: McCall, 1971).

18. See Watel 1987; Faugeras 2003. There are also several Ph.D. dissertations on various aspects of the baron's life.

19. *Mémoires* 1888–92, 1: 199; *Memoirs* 1913, 1: 92.

20. *Mémoires* 1888–92, 1: 202–203; *Memoirs* 1913, 1: 94.

21. *Mémoires* 1888–92, 1: 173, 179, 503, 3: 61; *Memoirs* 1913, 2: 16, 123. Watel 1987, 17. See Harkett 2014 for the salons of aristocratic ladies and their influence on art and politics. In Restoration France they had a conciliatory effect, mediating between public and private spaces, especially the salon of Madame de Staël.

22. *Mémoires* 1888–92, 1: 398; *Memoirs* 1913, 2: 195–196.

23. *Mémoires* 1888–92, 1: 403–404; *Memoirs* 1913, 1: 197–198.

24. *Mémoires* 1888–92, 1: 403–414; *Memoirs* 1913, 1: 199–207.

25. *Mémoires* 1888–92, 1: 415; *Memoirs* 1913, 1: 207.

26. *Mémoires* 1888–92, 1: 416; *Memoirs* 1913, 1: 207.

27. *Mémoires* 1888–92, 1: 333; *Memoirs* 1913, 1: 154.

28. *Mémoires* 1888–92, 1: 451–452; *Memoirs* 1913, 1: 231–232.

29. Henriette arrived with a letter she was instructed to deliver to President Thomas Jefferson, which praised her qualities together with pleading the case of the Neuvilles: Élisabeth Françoise Sophie Lalive de Bellegarde, Countess of Houdetot, France, to Thomas Jefferson, Washington, DC, August 16, 1806, LoC. See also https://founders.archives.gov/documents/Jefferson/99-01-02-4180; Faugeras 2003, 114–117.

30. See Margaret K. Hofer, "Empire Abroad: The French Taste in New York 1800–1840," in Roberta J.M. Olson and Margaret K. Hofer, *Seat of Empire*, exh. cat. (New York: New-York Historical Society, 2002), 27–36.

31. Quoted in Bayrd Still, *Mirror for Gotham: New York as Seen by Contemporaries from Dutch Days to the Present* (New York: Fordham University Press, 1994), 74. The coffee house played host to auctions, banquets, balls, and after-hours gambling. It was also a place for the registration of ship cargo and the trading of slaves. The Tontine was classless and served individuals from all social strata who were engaged in civil and economic affairs.

32. Stokes 1915–28, 1: 542–549.

33. See Olson 2008, 166–168.

34. Koke 1982, 2: 200. Owego is on the Susquehanna River in New York near the Pennsylvania border.

35. Koke 1982, 2: 201, notes that it is on a knoll overlooking Raritan Bay and interprets the work's inscription ("Mde angelica C. Window in her absence august 1809. Amboy") as referring to Mrs. Angelica Church, daughter of Philip Schuyler. He also reports that the cemetery contains the graves of many early settlers of the region, including the portrait painter John Watson and the artist, historian, and playwright William Dunlap.

36. See *Château de Lestang* 2018, 1: 73; 2: pl. 54, for the chapel constructed by the baron, which was dedicated on October 15, 1833. See also: http://www.culture.gouv.fr/public/mistral/mersri_fr?ACTION=CHERCHER&FIELD_1=RFF&VALUE_1=IA18002582 (accessed July 16, 2018). The entry notes that the baron was a very charitable man and that he created an infirmary and a hospice in a new building he had constructed to the south of his castle in what is today Ménétréol-sous-Sancerre.

37. Adams 1875, 5: 137.

38. *Mémoires* 1888–92, 1: 454–455.

39. *Mémoires* 1888–92, 1: 470; *Memoirs* 1913, 1: 233.

40. See Olson 2008, 73–75.

41. *Mémoires* 1888–92, 1: 455; *Memoirs* 1913, 1: 234.

42. Da Costa Nunes and Olin 1984, 12, identifies the house in the 1808 watercolor without any supporting evidence, as possibly the residence of Madame Jeanne Marie Nancy d'Autremont, known as the "Retreat." The Musée franco-américain du château de Blérancourt identifies it as the house of Victor Marie du Pont.

43. See Rock 1979.

44. For various spellings, see nn. 74, 79–81 below.

45. *Mémoires* 1888–92, 1: 480; *Memoirs* 1913, 1: 245. Samuel Latham Mitchell, a friend of the Neuvilles, was active in this society.

46. Economical School 1810.

47. Auricchio 2014, 36, points out that the baroness operated in the influential circles of New York women who founded, supported, and led institutions such as free schools, orphan asylums, and vocational training centers. See also Paula Baker, "The Domestication of Politics, Women and American Political Society, 1780–1920," *American Political Review* 89:3 (June 1984): 593–619.

48. *Mercantile Advertiser*, June 24, 1809.

49. Ibid. For additional reading on female education, see Kelley 2006.

50. Economical School 1810; Stokes 1915–28, 5: 1522. *Longworth's* 1813, 40, lists the Economical School under Benevolent Institutions.

51. Economical School 1810.

52. Rock 1979, 110, notes that the granting of a lot for construction of an Economical Free School for children of French and Spanish immigrants on Augustus Street was blocked by a petition of Sixth Ward residents, who complained of the noise, confusion, and loss of property value.

53. *New York Evening Post*, January 14, 1812.

54. *National Advocate*, June 29, 1816; *Commercial Advertiser*, January 7, 1818. The Economical School embraced the Lancastrian System or Bell-Lancaster method of instruction, which became globally popular in the nineteenth century. Also known as "mutual instruction," it was based on the use of advanced pupils as teachers' assistants. See Economical School 1810.

55. *Columbian*, May 10, 1814. See also Walter Bennett, *Catholic Footsteps in Old New York* (New York: Thomas R. Knox, 1885), 338–340; Thomas F. Meehan, "Catholic Literary New York (1800–1890)," *Catholic Historical Review for the Study of Church History of the United States* 4:4 (1919): 403. See also Watel 1987, 70–76. By 1814, the school had moved to Anthony Street (now Worth) across from the Old New York Hospital (New York and Maniac Hospitals) grounds near Broadway.

56. For example, Economical School, *Abrégé historique: An historical abridgement followed by a moral catechism for the use of children who learn French and English, or either of the two languages* (New York: Printed for the benefit of the Economical School, 1810).

57. Appx. no. 43 has an inscription on its verso that reads: "our lord ascended into heaven / notre Seigneur est monté au ciel. . . ."

58. For example, C.F. L'Homond, *Élémens de la grammaire française* (New York: De l'imprimerie de l'École Économique, 1810).

59. Economical School, *Abrégé de mythologie, imprimé originairement en France, par ordre de Louis XVI, pour servir à l'éducation des élèves de l'École Royale et Militaire, ré-imprimé plusieurs fois en Angleterre* (New York: Printed at the Economical School Office, 1811).

60. For example, Chevalier Ramsay and François de Salignac de La Mothe-Fénelon, *Catechism on the foundations of the Christian faith, for the use of both the young and the old, followed by the celebrated conversation of Mr. de Fenelon with Mr. de Ramsay, and by several extracts on the existence of God . . .* (New York: Printed at the Office of the Economical School, 1810).

61. Jean de La Fontaine, *Excerpta ou Fables choisies de La Fontaine, avec des notes nouvelles*, ed. Jean-François de La Harpe (New York: De l'imprimerie de l'Économical School, 1810). It was advertised in the *New York Evening Post*, July 19, 1810.

62. Alexandre Henri Tessier, *A Complete Treatise on Merinos and Other Sheep* (New York: Printed at the Economical School Office by Joseph Desnoues, 1811). An advertisement in the *Columbian*, December 13, 1810, states that the volume will be an English translation of the recently published treatise by Alexandre Tessier, Inspector of the Rambouillet Sheep Folds, in Paris by order of the government. It was dedicated to the Agricultural Society of the United States (see also cat. no. 58). The announcement of its publication and availability at the Economical Printing-Office at 61 Church Street appeared in the *Columbian*, July 9, 1811.

63. *Benevolent purposes: Proposals for republishing by subscription, the essays and poems of Miss Jane Bowdler. For the benefit of the Orphan Asylum and Economical School of the City of New-York* (New York: Economical School, 1810); Miss Jane Bowdler, *Poems and Essays* (New York: Printed at the Office of the Economical School, 1811); and Orphan Asylum Society, *The annual report and account current of the Orphan Asylum Society of New-York, for April, 1811, with a list of new subscribers, and of those whose names were omitted last year* (New York: Printed at the Economical School Office, 1811).

64. *Columbian*, July 7, 1814.

65. *Commercial Advertiser*, October 5, 1815.

66. *New York Spectator*, February 22, 1822.

67. Watel 1987, 67, claims they published through 1821, although Wilfred Parsons, *Early Catholic America, 1729–1830* (New York: Catholic Publication House, 1939), xv–xvi, clarifies the situation with Desnoues and refines the dates. See also Joseph Alfred Scoville [pseudonym Walter Barrett], *The Old Merchants of New York City* (New York: Carleton Publisher, 1865), 338–340.

68. *Mémoires* 1888–92, 1: 481–482; *Memoirs* 1913, 1: 246, quotes a poem by the baron first published in the *Journal des dames*.

69. Auricchio 2014, 43.

70. *New York Evening Post*, July 19, 1810.

71. See Watel 1987, 62–67. See also Samuel J. Marino, "The French-Refugee Newspapers and Periodicals in the United States, 1789–1825" (Ph.D. diss., University of Michigan, 1962), 171.

72. The paper is mounted on a blue sheet that resembles the paper the baroness used for many of her Economical School drawings (cat. no. 44; appx. nos. 35–46), and whose verso bears a black stamp with an escutcheon and the word *REGISTRE*.

73. Deák 1989, 1155. For a notice of its schedule, see the advertisement in the *New York Public Advertiser*, July 7, 1810.

74. Thomas Jefferson, Monticello, VA, to James Madison, Montpelier, VA, October 31, 1812, NA. Jefferson also terms him "Monsr. de Neufville a person of distinction from France."

75. *Mémoires* 1888–92, 1: 453; *Memoirs* 1913, 1: 232.

76. *Mémoires* 1888–92, 1: 486–487; *Memoirs* 1913, 1: 251.

77. Madame Rivardi, Philadelphia, PA, to E.I. du Pont, place unknown, August 9, 1811, HML. See Mary Johnson, "Madame Rivardi's Seminary in the Gothic Mansion," *Pennsylvania Magazine of History and Biography* 104:1 (January 1980), 6 n. 12.

78. See R.W.G. Vail, *Knickerbocker Birthday: A Sesqui-Centennial History of The New-York Historical Society, 1804–1954* (New York: New-York Historical Society, 1954).

79. Morris 2018, 518 (dinner with "Messrs Deneuville" on November 12, 1807); 526 (dinner with "Mr. Deneuveilles" on January 10, 1808); 527 (dinner with "Messrs Deneuvilles" on January 31, 1808); 594 (dinner with "Mr. de Neuville" on April 30, 1809); 739 (dinner with "Mr. de Neufville" on April 26, 1812).

80. Ibid., 519 (visits "Mons. and Mde. Neuveille" in New York, November 25, 1807); 518 (dinner with "Messrs de Neuville and Madame de Neuville," November 13, 1807); 638 (breakfast with Moreaus and "Monsieur de Neuville and his Lady," May 13, 1810).

81. Ibid., 869 (visit in New York to "Monsieur & Madam de Neufville" on June 17, 1816).

82. Ibid., 641 (visit "Mad.e de Neuvilles and Mrs. Waddington's," June 6, 1810). Peter Maverick published a similar view made from Riker's Island and entitled *View of the East River* in the December 1810 issue of *The Port Folio*. It was copied by Orra White Hitchcock; see Robert L. Herbert and Daria D'Arienzo, *Orra White Hitchcock, 1796–1863: An Amherst Woman of Art and Science* (Amherst, MA: Mead Art Museum, Amherst College, 2011), fig. 49.

83. Morris 2018, 641 (in New York City "Dine with Mad.e de Neuville," June 8, 1810).

84. See Johnson 2018. When the Elgin Garden was foundering in 1818, Hosack housed its herbarium at the N-YHS; ibid., 281. For Hosack, see also Christine Chapman Robbins, *David Hosack: Citizen of New York* (Philadelphia: American Philosophical Society, 1964).

85. For Humboldt's time in the United States, see Andrea Wulff, *The Invention of Nature: Alexander von Humboldt's New World* (New York: Vintage Books, 2014), 108–125.

86. Johnson 2018, 132–134, 186–187, 190–191, respectively.

87. For additional information on the garden, see Marshall A. Howe, "New York's First Botanical Garden," *Journal of the New York Botanical Garden* 10 (March 1929): 49–58. See also David Hosack, *A Statement of Facts Relative to the Establishment and Progress of the Elgin Botanic Garden, and the Subsequent Disposal of the Same to the State of New York* (New York: C.S. Van Winckle, 1811); Addison Brown, *The Elgin Botanic Garden: Its Later History and Relation to Columbia College . . .* (Lancaster, PA: New Era, 1908).

88. Johnson 2018, 4, 217, 246–247 (on the merger of the College of Physicians and Surgeons with Columbia College), 271.

89. For background, see *Le voyage en Amérique: Milbert, Lesueur, Tocqueville, 1815–1845*, exh. cat. (Giverny: Musée d'art américain, 2001).

90. Johnson 2018, 278.

91. See Jacques Milbert, *Picturesque Itinerary of the Hudson River and the Peripheral Parts of North America*, trans. Constance D. Shearman (Ridgewood, NJ: Gregg Press, 1968), 1–9, for the report and listing; Justin J.F.J. Jansen, "The Bird Collection of the Muséum national d'histoire naturelle, Paris, France: The First Years (1793–1825)," *Journal of the National Museum (Prague)*, Natural History Series, 184:5 (2015): 94–101.

92. Milbert 1968, 9. For context, see also Richard W. Burckhardt, Jr., "Naturalist's Practices and Nature's Empire: Paris and the Platypus, 1815–1833," *Pacific Science* 55:4 (2001): 327–341, espec. p. 331 for the baron and Milbert.

93. Anne Marguérite Joséphine Henriette Rouillé de Marigny Hyde de Neuville, New Brunswick, NJ, to Joséphine du Pont, Wilmington, DE, June 26, 1816, HML, W3-5465.

94. *Mémoires* 1888–92, 1: 507; *Memoirs* 1913, 1: 261; Faugeras 2003, 129–130; Deák 1989, 1156, also discusses it.

95. *Mémoires* 1888–92, 1: 509; *Memoirs* 1913, 1: 261. They were in London on July 10.

96. *Mémoires* 1888–92, 2: 56, 62, 85.

97. *Mémoires* 1888–92, 2: 62; *Memoirs* 1913, 2: 28.

98. *Mémoires* 1888–92, 2: 191; *Memoirs* 1913, 2: 73–75. She was given a diamond fleur-de-lis by the royal family, which became a family heirloom.

99. *Daily Intelligencer*, March 27, 1816

100. See Wendy A. Cooper, *Classical Taste in America 1800–1840*, exh. cat. (Baltimore: Baltimore Museum of Art; New York: Abbeville, 1993), 29–31, about James Monroe and Elizabeth Kortright Monroe, who brought French taste back from Paris (having lived there in 1794–96 and 1803–07), where he served as American Minister Plenipotentiary to France. Their real impact on American taste, however, dates from 1817, when they occupied the recently rebuilt White House and embellished it with elaborate French furnishings, which made a significant impact on all visitors.

101. For the background of the society and political landscape in Washington for women, see Catherine Allgor, *Parlor Politics: In Which the Ladies of Washington Help Build a City and a Government* (Charlottesville: University of Virginia Press, 2000).

102. *Mémoires* 1888–92, 2: 212; *Memoirs* 1913, 2: 82. For Joseph Bonaparte, Count of Survilliers, in America, see Roberta J.M. Olson and Margaret K. Hofer, *Seat of Empire,* exh. cat. (New York: New-York Historical Society, 2002); Patricia Tyson Stroud, *The Man Who Had Been King: The American Exile of Napoleon's Brother Joseph* (Philadelphia: University of Pennsylvania Press, 2005).

103. Allgor 2006, 34–35.

104. Merry Ellen Scofield, "Assumptions of Authority: Social Washington's Evolution from Republican Court to Self-Rule, 1801–1831" (Ph.D. diss., Wayne State University, 2014), 135–136; see also pp. 130–131, about Adams's request to have the baroness serve as his hostess, instead of his ill wife, at a presidential dinner, from his diary of May 20, 1820.

105. Diary of Louisa Catherine Johnson Adams, December 18, 1819, Adams Family Papers, MHS, microfilm, reel 265.

106. Quoted in John T. Morse, Jr., *John Quincy Adams* (Boston and New York: Houghton, Mifflin, 1898), 102–103.

107. Margaret Bayard Smith, Washington, DC, to Mrs. Jane Kirkpatrick, Washington, DC, January 19, 1817, Margaret Bayard Smith Collection, LoC. See Smith 1906, 140–141.

108. For more information about the Monroes' taste, see Margaret Brown Klapthor, *Official White House China: 1789 to the Present* (New York: Harry N. Abrams, 1999), 40–47.

109. Postscript in a letter from Margaret Bayard Smith, Washington, DC, to Mrs. Jane Kirkpatrick, Washington, DC, December 6, 1816, Margaret Bayard Smith Collection, LoC. See Smith 1906, 134.

110. Josephine Seaton, ed., *William Winston Seaton of the "National Intelligencer," A Biographical Sketch* (Boston: James R. Osgood, 1871), 145.

111. Ibid., 143.

112. *Poulson's American Daily Advertiser*, February 3, 1820. Although only the surnames of the artists are mentioned, the painter of the baron's portrait was no doubt young Charles Bird King, who that same year advertised his skills as a portrait painter.

113. In her lost journal, the baroness first recorded her husband's visit to Montpelier in June 1816: *Mémoires* 1888–92, 2: 196; *Memoirs* 1913, 2: 76–77.

114. Allgor 2006, 364.

115. *Mémoires* 1888–92, 2: 446–447. On April 24, 1820, in her lost journal, the baroness noted that "three French corvettes arrived in the Chesapeake, the *Loire*, the *Seine*, and the *Prudente*. . . . It is on the *Seine*, this name is auspicious, that we are going to embark. . . ." She added later: "We sailed on May 30, and arrived at Lorient July 1, 1820, after a very happy and fast crossing of twenty-nine days."

116. *Mémoires* 1888–92, 2: 473, 489.

117. They started to sell parcels of their landholdings in 1818; the last dispersal, in 1825, was supervised by Charles Wilkes, brother of Frances Wilkes Simond. For the dispersal of property, see Papers of Robert Boggs received from and relating to Jean Guillaume Hyde de Neuville, Robert Morris Papers, Box 20, and Jean Guillaume Hyde de Neuville letters received (Ac. 738), both in Special Collections and University Archives, Rutgers University Libraries, New Brunswick, NJ.

118. De Kay et al. 2018, 220, 313–315.

119. "Vaile" was a self-trained artist whose style resembles that of Neuville; he was probably Eugene Vail, an American from a French diplomatic family. His main occupation seems to have been as an art dealer in the nation's capital. He is mentioned as a procurer of art in a letter from Ellen Wayles Randolph Coolidge, Washington, DC, to Thomas Jefferson, Monticello, VA, March 22, 1822, private collection. The watercolor is cited as by the baroness in Kennedy and Company, New York, *An Exhibition of Contemporary Drawings of Old New York and American Views*, sale cat., New York, 1931, no. 27. She also kept three botanical watercolors of flowers mounted on another sheet by an unknown artist, perhaps one of her friends; see appx. no. 97; De Kay et al. 2018, 313, ill., attributes it to Neuville, but the watercolors are not by her and do not resemble her botanicals in cat. no. 45.

120. Adams 1875, 5: 137.

121. *Mémoires* 1888–92, 3: 15.

122. *Mémoires* 1888–92, 3: 383–384; *Memoirs* 1913, 2: 211–212.

123. *Mémoires* 1888–92, 3: 576; *Memoirs* 1913, 2: 275. For the relationship, see Marie Jeanne Durry, ed., *Chateaubriand et Hyde de Neuville, ou Trente ans d'amitié: Correspondance inédite* (Paris: Le Divan, 1929).

124. *Mémoires* 1888–92, 3: 495–501; *Memoirs* 1913, 2: 255–257, as related by the baroness in her lost diary.

125. *Mémoires* 1888–92, 3: 517; *Memoirs* 1913, 2: 275.

126. Faugeras 2003, 464.

127. *Mémoires* 1888–92, 3: 517; *Memoirs* 1913, 2: 275.

128. Louisa Catherine Johnson Adams Journal, January 19, 1818, Adams Family Papers, MHS.

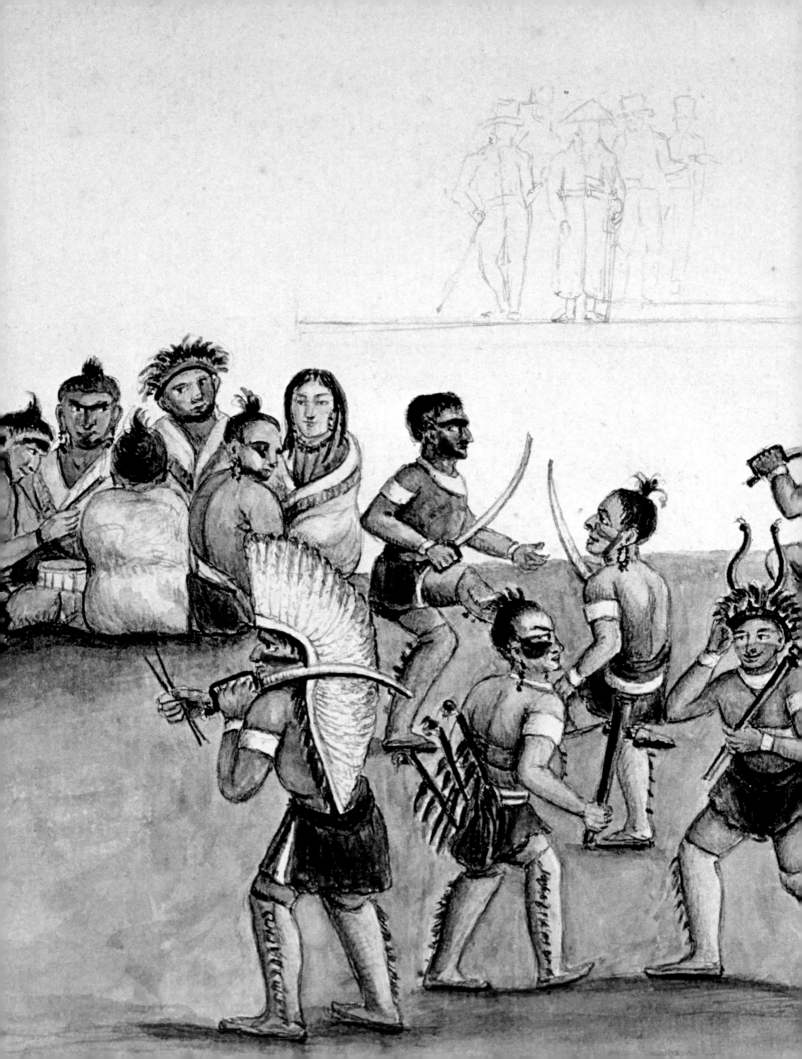

THE BARONESS: BECOMING AN ARTIST IN THE ART WORLD OF 1800–1822

Roberta J.M. Olson

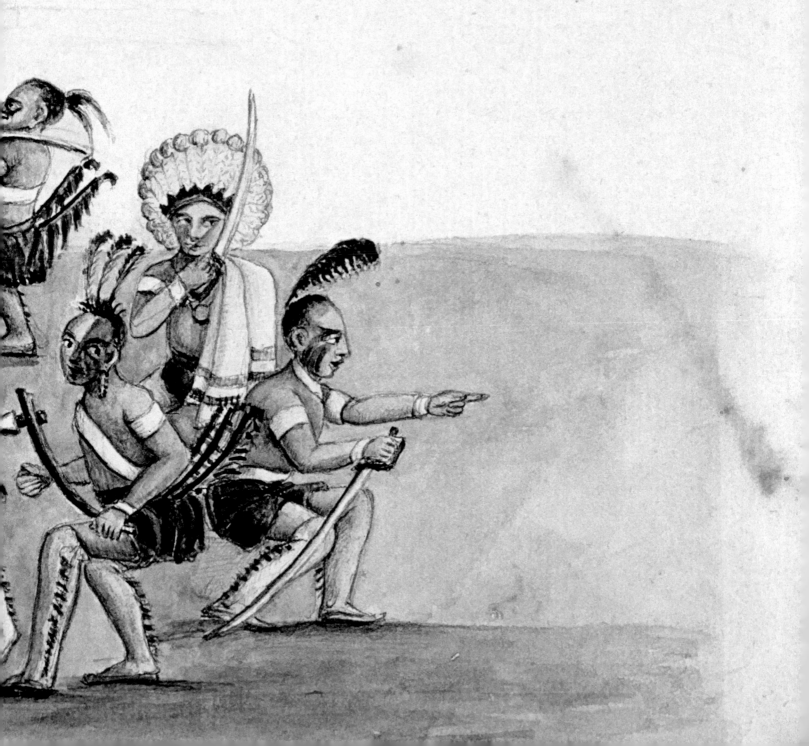

Backdrop: Women Artists in Late-Eighteenth-Century France

Although the evidence for her education is lost to history, her drawings and watercolors let us attempt to reconstruct the artistic self-education of Anne Marguérite Joséphine Henriette Rouillé de Marigny Hyde de Neuville. Like many other women of her class, Henriette probably received rudimentary lessons in draftsmanship and perhaps watercolor. At the time, drawing was a highly valued skill; it was standard in the curriculum of academies and female seminaries in Europe and America; and it would be required as well at the Neuvilles' Economical School in New York (cat. no. 44).[1] Even though Henriette possessed a visual talent, her aristocratic class and the disruptive events of the French Revolution, especially in her peripatetic youth, would have discouraged her from pursuing a career in the arts. Nevertheless, her family would have known of the support for more gender equality in education emerging by the 1760s and 1770s. As a French aristocrat observed in 1772, one year after the artist's birth: "It is quite evident that men and women are of the same nature and the same constitution . . . so the weakness of our constitution and our organs belongs surely to our education and is a result of the condition that we have been assigned in society."[2]

Like other women artists of her time, among them Élisabeth Vigée Le Brun, who was also an autodidact but a professional artist,[3] Henriette would never have been allowed to study from live male models, as required in the academic tradition open to men.[4] Vigée Le Brun was born a generation earlier than Henriette and to an artist father, a portrait and fan painter who facilitated her early artistic impulses. By contrast, Henriette's parents no doubt intended that she become an accomplished head of a household in Paris or her native Sancerre. Whereas Le Brun married an artist and important dealer and became a celebrated portraitist and member of the Académie royale de peinture et de sculpture (one of only fifteen women granted full membership between 1648 and 1793), Henriette espoused a hot-headed royalist sought by various Revolutionary factions. While Guillaume lived on the run or was imprisoned, Henriette, with her father, fled the main theater of the French Revolution in Paris for the relative safety of Sancerre in 1789. That same year, with the arrest of the royal family, Vigée Le Brun escaped France, and resided successively in Italy, Austria, Russia, and Germany. She remained in exile until 1802, when her name was removed from France's list of counter-Revolutionary émigrés.

Several other well-known French female artists deserve mention as foils for the baroness, although there were a goodly number of women artists in late-eighteenth-century France.[5] In spite of their gender and the times, they managed to survive, albeit in a diminished capacity given the fall of the *ancien régime* and royal patronage, with some turning to natural history illustration and related occupations.[6]

Also of a generation before Henriette, Adélaïde Labille-Guiard hailed from a bourgeois background and became a miniature painter. After marrying, she was able to apprentice herself to the renowned pastel portraitist Maurice Quentin de La Tour; she learned oil painting, and eventually qualified for membership in the Académie royale de peinture et de sculpture in 1783. She survived the Revolution to become an activist for female artists and the first woman to establish a studio for herself and her pupils in the Louvre.[7]

Anne Vallayer-Coster, again a generation older than Henriette, achieved early recognition and admittance to the Académie in 1770. Despite the low status of her specialty, flower painting, she garnered recognition from the court and Queen Marie-Antoinette, and later executed portraits and genre subjects. Although she too survived the bloodshed, the fall of her aristocratic patrons caused her reputation to decline.[8]

The Revolutionary years were paradoxical at best for France's female artists, and although the annual Salon exhibitions were opened to all—in fact, 207 women exhibited between 1791 and 1815—other opportunities disappeared.[9] Whereas the Académie had established a quota

of four female members, the Revolutionary-era art institutions ultimately barred all women from membership on the grounds that professional artmaking was incompatible with virtuous republican femininity.[10]

In the Wings: The Self-Taught Artist

From the evidence provided by newly discovered works, Neuville began drawing in earnest when she was around eighteen years old. She was at L'Estang, her family's rural estate near Sancerre, where she had escaped with her father at the outbreak of the Revolution. By examining her extant drawings, we can chart her self-education as she explored different media and experimented. In the countryside, removed from Paris or any regional center, Henriette lacked access to sophisticated artists' supplies. In addition, her choices of materials were probably limited by the scarcity of supplies in Paris—unlike the situation in England with its well-stocked "colourmen." Because of the conflicts between France and England and the eventual blockade of goods, graphite was unavailable, among other artistic commodities, inspiring Nicolas Jacques Conté in 1795 to invent and patent the ancestor of the pencil, as well as the Conté crayon, a mixture of powdered graphite and clay.[11] Neuville therefore turned to basic black chalk as her primary early medium, occasionally supplementing it with white and red chalks (cat. nos. 3, 4; appx. nos. 2, 4–8). In her earliest works, she frequently outlined the figures first and then laid in gray watercolor to create volume via chiaroscuro, sometimes applying it mixed with more opaque pigment. She drew mostly on beige wire rack paper.[12]

For her early choices of subject matter, Henriette eschewed decorative work, portraits, or fancy pieces, which were the customary provinces of women, opting instead to study the people around her engaged in activities or occupations, a sociological focus that she maintained throughout her oeuvre.[13] Many of her subjects may have been family members, such as the pair she depicted in the nocturnal studies in cat. no. 3, lovingly portrayed sitting on the same *fauteuil* and lit by identical candlesticks. Tellingly, she did not represent them formulaically but varied their poses, drawing the man from the side (also studying him in appx. no. 8) and the woman from the front. Her earliest drawing is dated 1793 ("fait a Villeneuve en 93.") and depicts an elderly seated man (appx. no. 77). From the start, she was attracted to people reading or writing (cat. nos. 3, 26, 44, 85; appx. nos. 1v, 8, 10, 11, 14, 24, 29v, 36, 38, 42, 44, 45, 51, 54, 61, 62, 75, 78), sometimes drawing with their quill feather or pen (for example, cat. nos. 44c, 44dv, 44e, 44f; appx. no. 75). Some of her sitters were clearly country folk, such as the woman in traditional peasant attire (appx. no. 4) or the boys wearing wooden shoes (appx. nos. 1v, 5, 6). Other subjects were probably domestics (appx. no. 2) or servants in the household, whom she identified affectionately, among them Lisette and Fanchette (appx. no. 3). In several early drawings, she studied elderly men, at least one in the nearby town of La Charité-sur-Loire, the village where her future husband was born (appx. no. 1). A few sitters, such as the stately men in powdered wigs, were aristocrats (appx. nos. 7, 11).

In these early candid sketches, Henriette explored the potentials of black chalk, occasionally stumping and hatching for shadows and volume, varying her fingers' pressure on the chalk and the sharpness of its points to create diverse effects and emphases. As mentioned previously, after outlining her subjects, she applied gray watercolor wash boldly and often with a dry brush to suggest three-dimensionality. She then drew over these broader areas in black chalk to add further definition and details. The young autodidact developed this style based on what her eye had perceived rather than on any methodology gleaned from formal technical instruction.

As she gained access to more sophisticated media, Neuville began to widen her horizons. Her experiments on several sheets with the traditional eighteenth-century French three-crayon medium (*trois crayons*) culminated in her delicate portrait of Guillaume Hyde de Neuville

reading, wearing a hat and pince-nez (cat. no. 4). She also added pastel in a tentative manner to several sheets; for example, the blue pigment defining the upholstery pattern on the chair in one drawing (appx. no. 8) and other colors elsewhere (appx. no. 10). In a black chalk and gray watercolor drawing of a young woman reclining on a sofa, she applied thick gray gouache to her hair, the bodice of her dress, and the back cover of the book she holds (appx. no. 14). Henriette's conceptions became more nuanced at the same time that her media grew in complexity (appx. no. 16). She delineated a profile portrait on blue paper (appx. no. 12), and began thinking about miniatures, frequently painted by women—amateurs and professionals alike—executing two oval portraits reflective of the genre (nos. 5v, 10).

Casting her artistic net more widely, Henriette employed parchment in two unfinished portraits (cat. no. 5; appx. no. 11), a support she may never have used again. The former work—a refined but unfinished likeness of a woman identified only as Madame Heuters—represents a watershed moment in which Henriette orchestrated a symphony of subtle media to convey her sitter's haunting psychological and physical state. Here again the artist employed the eighteenth-century French *trois crayons* medium, but this time over an underdrawing in graphite. This is the first instance we can identify of her use of graphite, suggesting that the baron had obtained it for her in England, which he began visiting in 1799. She reinforced the snake-like curls plastered to Heuters's forehead—in the fashion Jacques-Louis David immortalized in his portrait of Madame Récamier (fig. 21), an influential *salonnière* and friend of the Neuvilles[14]—by articulating them with strokes of brown and black ink, expanding her use of media, which may have included Conté crayon. Subsequently, she added thin red accents to the sitter's ears, rheumy eyes, and under her nose to suggest ill health, as well as gray watercolor overlaid with graphite to the proper right of the sitter's visage. These touches not only put the woman's face in relief, but also suggest the shadow that has fallen across her life.

Fig. 22
Anne Marguérite Joséphine
Henriette Rouillé de Marigny Hyde
de Neuville, *Copies of Two Classical
Sculptures: Reclining Etruscan
Woman with Oil Lamp or Fan and
Vulcan at His Forge*, 1800–05. Black
chalk and graphite on paper;
6 ³⁄₁₆ × 4 ³⁄₁₆ in. (157 × 106 mm).
N-YHS, Purchase, 1953.287g (appx.
no. 13)

As noted previously, the study of the nude human figure was taboo for women in the eighteenth and early nineteenth centuries. But the study of statues of nude males and females was not. In fact, such study was obligatory for all academically trained artists. Henriette's extant drawings establish that she turned to casts and other works of art to fill this gap in her self-education. For example, on one sheet she sketched two classical figures: a reclining woman holding a fan or oil lamp, studied from the lid of an Etruscan sarcophagus or funerary urn, above a relief representing the semi-nude Greco-Roman god Vulcan—the sponsor of ironmongers in the eighteenth century—at his forge (fig. 22). On the versos of two additional trimmed sheets from this period, the baroness drew other ancient sculptures (appx. nos. 3, 6). Most astounding of this group is the bold partial facial profile modeled on the Aphrodite of Milos (Musée du Louvre, Paris), commonly known as the Venus de Milo (appx. no. 78), which she sketched below and overlapping her study of an elderly bewigged man reading. In all these instances, there is no way of determining whether the baroness was looking at the actual sculptures or plaster casts, or reproductions in books or prints.

Two other studies on a single sheet demonstrate that Henriette also drew after two-dimensional works of art; the sheet's inscription ("Vieux Dessins retrouvez à Lestang") reveals that her prototypes were drawings that she found at L'Estang (cat. no. 47). In these academic studies after two unknown old master drawings, she followed the time-honored method of learning by copying works by earlier artists. The studies juxtapose a two-thirds-length, seated ancient philosopher type in profile, which an unidentified artist may have copied from a sculpture, with a foreshortened frontal skull, modeled in deep chiaroscuro. Forbidden the naked model, Henriette not only copied works of art at hand to teach herself life drawing: she also must have seen a drawing manual, because her portrayals of individuals frequently show that she first plotted the volumes of their faces in an

An irregular base forming bays & promontories.

The summit regularly varied.

Fig. 23
William Gilpin, *Two Diagrams for Drawing Woods on the Horizon*, etching and aquatint in *Remarks on Forest Scenery, and Other Woodland Views* (London: R. Blamire, 1791), vol. 1, pl. opp. p. 229. Thomas J. Watson Library, Metropolitan Museum of Art, New York

underdrawing with centering and proportional schematic lines: see, for example, cat. nos. 44e, 44g; appx. nos. 1, 43, 47.

For the next several decades, Henriette continued to copy works that impressed her. For instance, while sojourning in Switzerland, before seeking a pardon from Napoleon for her husband, she copied in detailed watercolors two colorful Swiss canton costumes (appx. no. 19). In the process she not only honed her skills with the medium, but also, as with her copies of Spanish costumes (appx. no. 22), sharpened her interest in occupational portrayals and in dress as an evocative feature. Likewise she executed watercolors and drawings after architectural models—from Roman ruins in Spain (appx. nos. 20, 21) to the chinoiserie Pagoda in the park of the château of Chanteloup. This modus operandi prepared her to forge a unique style upon her arrival in America. In order to study landscape when she was in New York, she consulted one of the most popular drawing manuals in circulation: the Reverend William Gilpin's *Remarks on Forest Scenery, and Other Woodland Views* (figs. 23, 24). She duplicated one oval grisaille vignette in Gilpin (fig. 63) almost exactly, although she left the composition unfinished (cat. no. 51). She also used this manual more innovatively in her copy of a rectangular equine composition that she adapted to an oval format (cat. no. 53; fig. 65), and to which she added two trees to its right middle ground, trees derived from another oval vignette in Gilpin's treatise (fig. 24). In addition, she copied drawings that were models for illustrations by her artist-friend Louis Simond (cat. no. 52), as well as portraits of Indigenous Americans by Charles Balthazar Julien Févret de Saint-Mémin (cat. no. 49), and anonymous prints of American Indians (cat. no. 48).

Around 1805 Henriette acquired a more varied range of watercolors, precipitating a sea change in her oeuvre. Her first full extant watercolor records the Neuvilles' departure down the Loire River, fleeing for their lives in Revolutionary France and bound for Lyon in 1805 (cat. no. 6). Perhaps not accidentally, her use of a broader palette appears in her first known landscape. Such works produced on the fly by artists and artist-travelers became possible in 1781, when William Reeves of London developed ready-to-use hard cakes or pans of watercolor.[15] Their advent coincided with aesthetic theories that signaled the decline of tinted drawings and the emergence of painterly watercolors produced by professionals, amateurs, and a proliferating number of drawing instructors. The baroness probably had a portable painter's box, such as those sold at art suppliers and stationers, like Ackerman's at 101 The Strand in London (fig. 25).[16] It is likely that the baron, during one of his trips to London beginning in 1799, had purchased this important artistic tool for his wife.

In subsequent years, Henriette continued to use all the media mentioned above in various combinations, depending on her intentions, and frequently in a highly complex mix. With her 1805 watercolor of the factory at La Charité, however, one senses that she has grasped the essential future goal of her art: to capture vividly and report succinctly—in a different manner from the words she penned in her long-lost journal—the people and places that piqued her interest, preserving them for herself and posterity. Like other women artists, she may have given some of her works as gifts, but there is no evidence that she followed this practice on a regular basis; the only hint that she considered the question is found in an inscription on one watercolor (cat. no. 21) that she ended up not sending ("Envoyé à Mde Boisgrand"). Since neither her gender nor the course of history in Revolutionary France allowed Henriette to pursue her latent ambitions and talent, she developed distinctive shorthand styles in her peregrinations for her visual diary—among them, one employing watercolor for more finished scenes (cat. no. 67) or portraits (cat. no. 81) and another for sketching figures that are in the

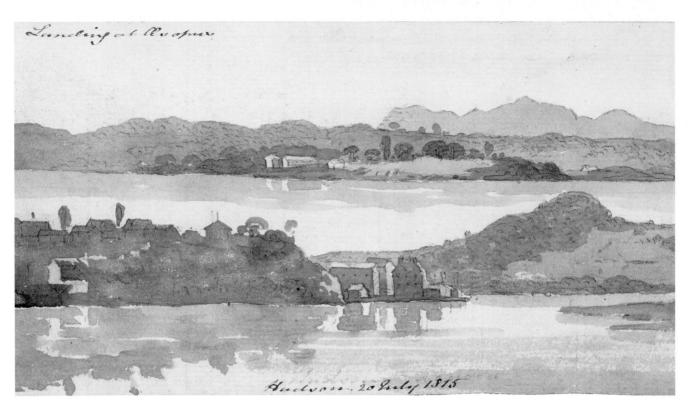

Landing at Asopus

Hudson. 20 July 1815

mode of today's courtroom, eye-witness artists' drawings of judicial procedures off-limits to cameras (cat. no. 44). Since these styles suited her purposes, she apparently felt no need to acquire additional skills.

Despite the fate of her works—many sheets were severely trimmed later or cut from larger sheets, some were laid down badly, and others were haphazardly sewn together by unknown individuals—those with identifiable watermarks argue that she liked fine papers and therefore had ambitions for her works.[17] Forty-five sheets have discernible watermarks, eighteen of which can be identified. Nine drawings bear English marks, including six with the watermark of the finest watercolor paper then available: J WHATMAN, four with the date of 1801.[18] Other sheets produced by mills in East Anglia and Kent are marked FELLOWS 1814, G & R MUNN 1815, and I TAYLOR.[19] Two papers have the American mark AMIES and were made in Lower Merion, Pennsylvania,[20] while two have a D AMES watermark from a mill in Springfield, Massachusetts,[21] and three others with the T G & Co mark were produced by the Gilpin mill in Wilmington, Delaware.[22] (The self-taught French artist John James Audubon used American paper for only three watercolor models for *The Birds of America*: he chose Gilpin paper rather than his customary Whatman support.[23]) Henriette used only one sheet watermarked LYDIG & MESSIER, the mark of a mill on the Bronx River near what is today the New York Botanical Gardens.[24] In addition, she drew on a number of sheets with Netherlandish marks, including J KOOL (on at least one sheet).[25]

Women Artists, Amateurs, and the Ascent of Drawing in England

One wonders whether Henriette knew about the few eighteenth-century English women whose artistic achievements stood out then, especially since her husband was spending time in England. Among them was Swiss-born Angelica Kauffmann (Maria Anna Angelika), whose career as an international celebrity was launched in Rome and played to the hilt in England, where she was one of two women elected as founding members of the Royal Academy.[26] Most late-eighteenth-century women fell into the category of amateur painters, meaning artists who worked without receiving monetary recompense, but whose genteel accomplishments were encouraged. Ladies of rank and fortune had been drawing and painting for at least two hundred years, but in the second half of the eighteenth century the practice became fashionable. An ability to draw and paint was deemed useful in other spheres. For example, a young lady accompanying her family or husband on a grand tour would not dream of setting

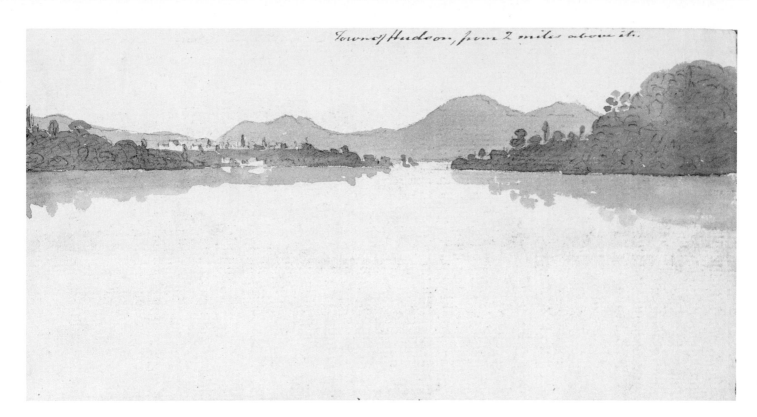

off without her sketchbook and paints. Ready-to-use watercolors could be purchased after 1781, as mentioned above, and the boxes for them could hold up to forty colors and came equipped with everything required to paint outdoors or while traveling.[27]

The vast increase in the number of amateur artists from the mid-eighteenth century did not go unnoticed by the world of industry and commerce, which began to produce a range of drawing manuals, such as *The Art of Drawing in Perspective* and *The Complete Drawing Book*, both published in 1755, as well as those of the Reverend Gilpin (one of which is mentioned above). A multitude of treatises exclusively on watercolor were also published in England in the first half of the nineteenth century, but only one was printed in America during this time: Fielding Lucas's *The Art of Colouring and Painting Landscapes in Water Colours* (1815).[28] In response to the same demand, artists who needed to supplement their income also took advantage of the flocks of genteel ladies seeking instruction. By 1800, the drawing masters in England employed by the gentry numbered in the hundreds. Amateurs could not sell their works at the Royal Academy, but they could exhibit them with the title "Honorary" attached to their names.[29] In 1804, the Society of Painters in Water-Colours was founded, and England seemed to become a paradise for the accomplished amateur. Women first exhibited in 1805, and the following year Anne Byrne became the first woman admitted to membership, as a "Fellow Exhibitor." Women members were at this point allowed, rather gallantly, a share in any profits that the society made, but they were not liable for any of its debts. In its attitude towards "Lady Members" the society was far more supportive than the Royal Academy.[30]

The elevation of the ability to draw as a prerequisite of the well-educated person can be traced back to Baldassare Castiglione's book *The Courtier* (written in 1513–18 and published in 1527); the Italian stress on *disegno* (drawing and design); and the Renaissance idea that art is an intellectual and liberal pursuit, not a handicraft.[31] The eighteenth-century proliferation of art manuals and tutors in England included those teaching calligraphy and marketing drawing not only as a polite and useful art, but also as a universal language.[32] In that century in England, the practice of drawing as an adjunct to scientific inquiry and knowledge was de rigueur for the Lunar Society and the Royal Society, whose members submitted drawings to be engraved as illustrations for their scientific articles in the *Transactions of the Royal Society*. Equally exacting, topographical drafting also ranked as one of the most significant skills in the curricula of military academies. Military men, once bitten by the drafting bug, went on with the help of commercial manuals to teach themselves other kinds of drawing, among them George Heriot (figs. 17, 26) and Joshua Rowley Watson (figs. 27, 28), who both toured America in the second decade of the nineteenth century.[33]

Fig. 26
George Heriot, *Three Views of the Hudson River, Folios 18v-19r in a Sketchbook*, 1815. Watercolor and graphite with scratching-out on two sheets of paper, bound into a sketchbook; 4 ¼ × 8 in. (107 × 203 mm), each sheet. N-YHS, James B. Wilbur Fund, 1944.430.2

99

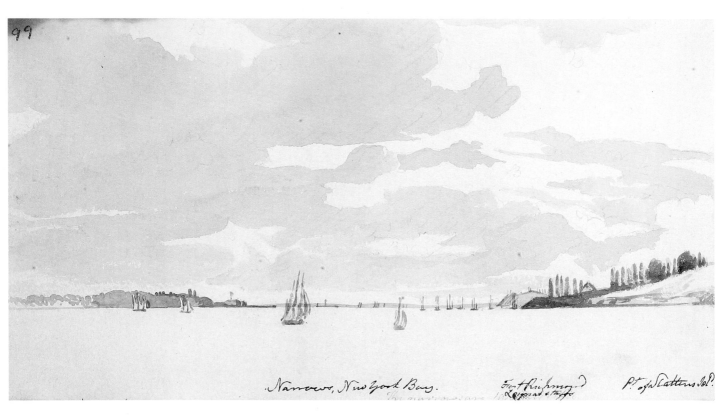

Narrows, New York Bay. Fort Richmond Pt. of S.t Catterus Isd.

Part of the Palisadoes with the high lands of the Hud

Fig. 27
Joshua Rowley Watson, *The Narrows of New York Bay, Folio 92v in a Sketchbook*, 1816. Watercolor, graphite, and black ink wash on two sheets of paper, bound into a sketchbook; 4 ⅞ × 8 ⅞ in. (124 × 225 mm), irregular. N-YHS, Beekman Family Association Fund, 1958.85

Fig. 28
Joshua Rowley Watson, *The Palisades with the Hudson Highlands in the Distance, Folios 80v-81r in a Sketchbook*, 1816. Watercolor, graphite, and black ink wash on two sheets of paper, bound into a sketchbook; 4 ⅞ × 8 ⅞ in. (124 × 225 mm), each sheet, irregular. N-YHS, Beekman Family Association Fund, 1958.85

An important moment in the introduction of drawing into civilian education had come in the last decade of the seventeenth century, when drawing was included in the curricula of the London Charity School and the Royal Writing School, both at Christ's Hospital.[34] Kim Sloan has shown that charity schools and private academies led the way in promoting drawing, and their example was followed after the mid-eighteenth century by public schools, setting the tone for the Neuvilles' Economical School (cat. no. 44).[35] The pedagogical repositioning of drawing as consistent with the idea of its usefulness led to its carrying a moral significance. These ideas were in tune with the Neuvilles' Economical School and its separate school for teaching drawing, as discussed in the first essay of this catalogue, and as illustrated by the baroness's portrayal from the "Economical School Series" of a young pupil named Pélagie drawing a life-size head, which she has colored in pinkish gouache to suggest flesh (fig. 29). Individuals drawing or sketching were another one of Henriette's favorite themes: see, for example, cat. nos. 44, 57, 66; appx. no. 28 verso.

During the early nineteenth century, the previous barriers between the amateur art world and the professional one grew softer thanks to their burgeoning commercial links. In his magazine *Repository of the Arts*, the art supplier extraordinaire Rudolph Ackerman announced in 1810: "Drawing, the ground-work of refined taste in the arts, is now considered, and very rightly, as an indispensable requisite in the education of both sexes."[36] The increasing importance of accomplishments for women, among them the ability to draw and paint, has also been associated with expanding criteria in the marriage market.[37]

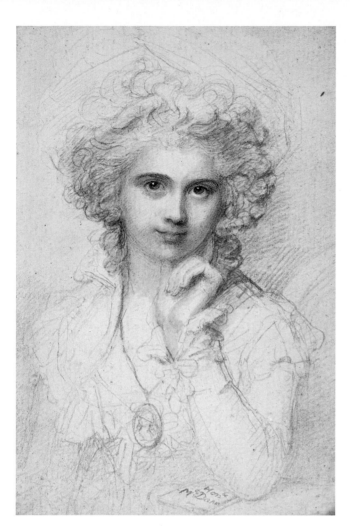

Fig. 30
Richard Cosway, *Maria Hadfield Cosway (1760–1838)*, 1785.
Graphite and watercolor on paper;
6 ½ × 4 ¾ in. (165 × 120 mm).
Private collection

One of the prime examples of an artist who walked the tightrope between amateur and professional was Maria Luisa Caterina Cecilia Hadfield Cosway, the Italian-born, ultra-chic, and celebrated *salonnière*, who was the wife of English artist Richard Cosway (fig. 30). Not only did Cosway have the same number of names as Henriette, but common interests as well: education and religion. Like the baroness, she was an international citizen and practiced her art in England and France (where she founded a girls' school, 1803–09). In Italy, after separating from her husband, Cosway established a Catholic convent and girls' school in Lodi, which she directed as long as she lived. (Cosway also had a romantic relationship with Thomas Jefferson when he was in Paris and kept up a correspondence with him until his death.[38])

A Sketch of Art in America During the Neuvilles' Residencies

In the late eighteenth century and the first two decades of the nineteenth, American art was still linked to England, where many of the country's artists were born. But slowly during the Neuvilles' residencies in the United States, American artists began asserting their own identities in three East Coast cities: Boston, New York, and Philadelphia. William Dunlap in his two-volume *History of the Arts of Design in the United States* would chart in some detail that development up to 1834.[39] Closer to the baroness's time, the artist and diplomat Pavel Petrovich Svinin used much broader strokes to assess the status of the fine arts in America during his visit in 1811–13.[40] His article, published after his memoir, *Voyage pittoresque aux États-Unis de l'Amérique* (1818), falls in line with Dunlap's more extensive appraisal of the period in question.[41] The article, which acknowledges the American penchant for portraits, amounts to a Who's Who for the period. Svinin lists the top painters as Benjamin West, John Trumbull, and Gilbert Stuart. At this juncture, it is important to note that Henriette knew Trumbull, as proven by a letter from the artist to Thomas Jefferson, stating "I learn from Madame Neuville" (which incidentally occurs in the same sentence as a mention of Maria

Cosway).[42] Moreover, Trumbull also socialized with the Neuvilles, attending a gala ball they gave in Washington on February 18, 1817.[43]

When discussing the Peale family in Philadelphia, Svinin mentions female miniaturists and singles out "Angelica" (Angelica Kauffmann Peale) and "Sappho" (Sophonisba Anguissola Peale), christened after the two prominent women artists.[44] Svinin also believed that knowledge of the fine arts was important for a good education and, like the Neuvilles, that American education was democratic and that women should receive the same education as men.

> Recently this art [painting] was included in the disciplines required for a good education, and because education here is mostly equal for all classes of society, that is to say that the daughter of a leading banker attends the same school as the daughter of a day labourer, there is hope that a taste for the fine arts soon will become universal and will demonstrate a substantial success. Even now mothers praise the talents of their daughters in painting and show off the creations of their brush. Many beautiful American women even paint in oils and proclaim themselves patrons of the fine arts.[45]

In his discussion of American art academies, the Russian artist remarked that the New York Academy of Fine Arts was civically owned, unlike the privately held Pennsylvania Academy of the Fine Arts, and ranked as New York City's most important art organization.[46] The New York Academy, which had been established in 1802, was incorporated in 1808 as the American Academy of Arts. Friends of the Neuvilles were at its helm on the board: Robert R. Livingston, president, and John Trumbull, vice president, with DeWitt Clinton, John R. Murray, Charles Wilkes, David Hosack, and William Cutting; Louis Simond and Robert Fulton were added in 1813.[47] It was located in the Customs House until that structure was razed in 1815; and it then moved to the second floor of the New York Institution, formerly the Alms House, on the north side of City Hall Park, facing Chambers Street in the Neuvilles' neighborhood. Its name changed multiple times, and in 1817 it was renamed the American Academy of the Fine Arts.[48] Its first public exhibition, in conjunction with the Society of the Artists of the United States, opened on May 6, 1811, followed by a second in 1817.[49] Eight women exhibited at the academy through 1824, the majority showing miniatures, an accepted province for women.[50] Among them were the acclaimed miniaturist Ann Hall;[51] Trumbull's wife, Sarah Hope Harvey, who exhibited flower and fruit pieces in 1816 and 1817;[52] and Mary Prevost Robertson, wife of Alexander Robertson, who exhibited works in several categories, including literature and mythology.[53]

In the early decades of the nineteenth century, issues surrounding the Academy of Fine Arts, in addition to the exhibition and the acquisition of paintings by institutions, were occasionally discussed in the press, and there were a few announcements of commercial exhibitions. Miniature painters and portraitists soon began to advertise their services,[54] among them a number of well-known artists such as Charles Willson Peale, Rembrandt Peale, and John Wesley Jarvis, as well as female miniaturists like Mary Way.[55] Women art teachers exhibiting works by their female pupils also purchased advertisements,[56] as did many artists who offered courses for tuition or claimed to be opening an art or drawing academy.[57] It was an entrepreneurs' and amateurs' art world.

One of the most newsworthy art topics was Trumbull's *Declaration of Independence, July 4, 1776*, which he began painting in Paris at Jefferson's prompting in 1786 (fig. 31). The work, which endured a long gestation, drew press attention in 1808, as public pressure to complete it mounted and assured that the Neuvilles would have been aware of its importance.[58] Then, in 1817, Congress commissioned the artist to paint four eighteen-foot-long historical paintings for the U.S. Capitol Rotunda, including a larger version of the *Declaration of Independence*. After

Fig. 31
John Trumbull, *Declaration of Independence, July 4, 1776,* 1786–1820. Oil on canvas; 20 7/8 × 31 in. (53 × 78.7 cm). Yale University Art Gallery, New Haven, 1832.3

showing it in New York, Trumbull took his nearly finished canvas to Washington and hung it in the House of Representatives, where Congress could view it before approving the commission for a larger composition in 1817. The series remained a topical issue in the press during the Neuvilles' Washington residence.[59] Trumbull completed the four works in 1824, although they were not installed in the Capitol until 1827.[60]

In his appraisal of the fine arts in America, Svinin also noted that there were a number of good painters among the private art teachers, although he did not name the other academies.[61] In fact, New York was blessed with many drawing masters and teachers of art, including Archibald and Alexander Robertson, who established the Columbian Academy of Painting in 1792 at 79 Liberty Street. Among its other teachers was the successful female miniaturist Ann Hall.[62] Its pupils included amateurs and professionals, women and men, and it advertised until 1802,[63] the year that Archibald published the first comprehensive art instruction manual in America, *Elements of the Graphic Arts.*[64] The same year, the brothers split and Alexander opened his own academy at 17 Dey Street, the Academy of Painting and Drawing. His brother Archibald renamed the Columbian Academy the Academy of Painting.[65] In 1816, Alexander became director of the American Academy of the Fine Arts, and the next year his brother joined its board. The idea that drawing is the foundation of the arts unites these academies, and their proliferation reflects the American adoption of European models. A tangible link between this academic art world and the Neuvilles was their friend Jacques-Gérard Milbert (figs. 16, 62), who was listed in the New York directories as a drawing instructor at various addresses between 1817 and 1822 (see cat. no. 50).[66]

A number of important English artist-travelers trained in the topographical tradition also operated along the East Coast. Like Milbert, they drew their own grand tour of America a decade after the baroness, but they serve as good comparisons.

Among contemporary artist-travelers, the aforementioned Heriot served as postmaster general of British North America. He visited the United States during the summer of 1815, six months after the end of the War of 1812, before returning to England in 1816. His trip was ostensibly to investigate the possibility of re-establishing a regular passage for the British mail, but he was apparently also drafted to undertake intelligence work and to obtain

THE JUNCTION OF THE SACANDAGA AND HUDSON RIVERS.

(N.º 2) of the Hudson River Port Folio

Published by H.I. Megarey & W.B. Gilley New York & John Mill Charleston S.C.

Fig. 32
John Hill after William Guy Wall,
*Junction of the Sacandaga and
Hudson Rivers, Plate 2 of "The
Hudson River Portfolio"*, 1821–22.
Hand-colored aquatint;
18 ¾ × 25 ½ in. (47.6 × 64.8 cm).
N-YHS Library

Fig. 33
Alexander Jackson Davis, *The Rotunda, Chambers Street, New York*, ca. 1828–29. Black ink and wash over graphite on paper; 10 ¾ × 8 ½ in. (273 × 216 mm). N-YHS Library

information about American harbors and shipping. In New York, he discussed mail routes with the city's postmaster and in Washington with the American postmaster general. In his two small sketchbooks, dating from 1815–16, nearly a decade after Neuville began her work (cat. no. 9), he recorded American landscapes, some only outlined in graphite, including views along the Hudson River, but with similar sentiments of awe regarding the country's majestic expanses (fig. 26). Heriot also documented some of the same buildings in Washington that Henriette drew (see fig. 17).[67]

As for Captain Watson, this military and amateur gentleman-draftsman filled two larger sketchbooks during his American adventure in 1816–17. His sense of discovery paralleled that of the baroness (figs. 27, 28).[68] The works of Neuville, Heriot, and Watson all predated *The Hudson River Portfolio* (1820–25), with its hand-colored etchings by John Hill (fig. 32) after watercolors by William Guy Wall (fig. 10). *The Portfolio* established the grand tour of America via the Hudson River in the public mind and prefaced the advent of mass tourism, facilitated by the steamboat, which sounded the death knell to the country's once pristine wilderness areas.

Until the defeat of Napoleon Bonaparte in 1814, there were also French exile artists working in New York City as well as French artist-travelers, whom the Neuvilles may have known. Among them was Saint-Mémin, the renowned and elegant portraitist and self-trained engraver who based himself in New York and New Jersey but also traveled (see cat. no. 49; figs. 52, 54–58). Unlike the baroness, he became a U.S. citizen, but renounced his citizenship when he returned to France with the downfall of Napoleon in 1814, at the same time as the Neuvilles.[69] In addition to their friend Milbert, Charles-Alexandre Lesueur was in the country drawing American landscapes, scenes, and natural history specimens. His sojourn extended from 1816 to 1837.[70]

Panoramas for New York's Populace

During the first two decades of the nineteenth century, New Yorkers enjoyed spectacles related to art and major historic events, which thrilled the public while purporting to educate it. One of the most sensational was staged at 234 Broadway opposite the New York Theater in 1810, a year when the Neuvilles could have seen it. The exhibition consisted of two twelve-foot-long canvases: *The Defeat of the Spanish Armada* and *The Great Fire of London*. The *Commercial*

Fig. 34
John Vanderlyn, *Panoramic View of the Palace and Gardens of Versailles*, 1818. Oil on canvas; 12 × 165 ft. (3.6 × 49.5 m). Metropolitan Museum of Art, New York, 52.184

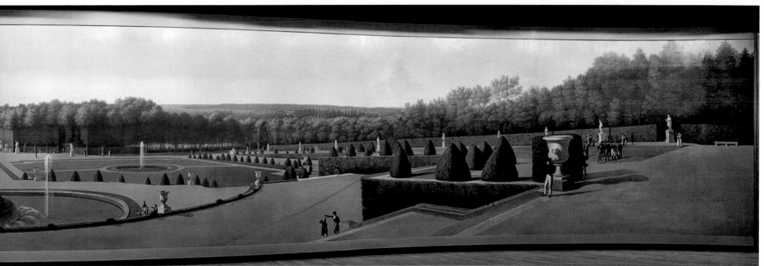

Advertiser announced that both huge paintings were based on smaller works by Philip James de Loutherbourg and exuded sentiments of the Sublime.[71] The pricey admission of fifty cents for adults and twenty-five cents for children testified to their perceived importance.[72] This exhibition was the precursor to 360-degree panoramas, which had made their early appearance in New York in 1795, but became the pinnacle of obsessive, immersive entertainment for early-nineteenth-century audiences,[73] such as one depicting the Battle of Algiers "Exhibited next door to the corner of Franklin Street and Broadway" in December of 1818.[74]

When the Neuvilles returned to New York from Washington during their second residency (1816–22), they could not have missed the round building erected for John Vanderlyn's panorama (fig. 33), whose construction in City Hall Park was announced in 1817 and in 1818 with the statement that "Of all exhibitions of painting, panoramas are the most popular."[75] Vanderlyn's Rotunda, on the northeast corner of Chambers and Cross streets, was a brick structure erected as an art gallery with a forty-foot-high dome. It was based on Parisian prototypes and the Roman Pantheon.[76] Constructed in 1818–19, it was designed by Alexander Jackson Davis to display the gigantic circular panorama of the garden and palace of Versailles that Vanderlyn was then painting (fig. 34).[77] Since Vanderlyn did not finish it by the time the Rotunda opened in 1818, in its stead he installed an earlier panorama representing the city of Paris by the phenomenon's alleged inventor, Robert Barker. This panorama was followed by another representing the Battle of Paris (March 30, 1814), which opened in January 1819, and then by Robert Ker Porter's depiction of the Battle of Lodi.[78] Vanderlyn finally installed his panorama on May 26, 1820, opening it a month later to the acclaim of the press.[79] Not only was it a novel spectacle for those Americans who had never traveled to France, but for the sentimental Neuvilles this evocation of their homeland, at a time when French culture was in vogue, was one the couple would not have wanted to miss.

The Baroness in the Spectrum of American Art

Against a complicated international political tapestry, the artist-traveler Henriette Hyde de Neuville created her impressive corpus of drawings and watercolors. Previously, her oeuvre was thought to originate almost exclusively in America, but the new evidence presented in this catalogue reveals that the baroness produced her art in at least seven countries, as well as on the high seas over at least three decades. Despite being self-trained and working when most women painted only miniatures or flower pieces, Neuville accomplished remarkable things for a woman of her time. What adds to her singular stature is that, like Maria Cosway and Angelica Kauffmann, she associated with many of the leading personages of her period in the salons and corridors of power, in her case in both Europe and the United States. Although she never intended to exhibit her works publicly, she used her access to eminent social circles and intellectual networks to exert a documented cultural influence. Her landscapes and cityscapes prefigure those by male self-trained artist-travelers operating in early America—including Heriot (figs. 17, 26), Watson (figs. 27, 28), Milbert (figs. 16, 62), Lesueur, and even Wall (figs. 10, 48).[80] While the style of her landscapes approaches those of Lesueur and the architect Benjamin Henry Latrobe (fig. 35),[81] Neuville has been rightly recognized as "one of the most interesting" of the artist-travelers.[82]

Moreover, Henriette did not just take a grand tour of America—like Latrobe, she lived in the country and contributed to its development. Her two lengthy residencies provided the baroness with a unique opportunity to produce sociologically penetrating works of convincing authenticity. She drew her subjects with a matter-of-fact objectivity that illuminates American life and attitudes in the opening decades of the nineteenth century. Her works document architecture, people, customs, and landscapes that have vanished, subjects special to her and

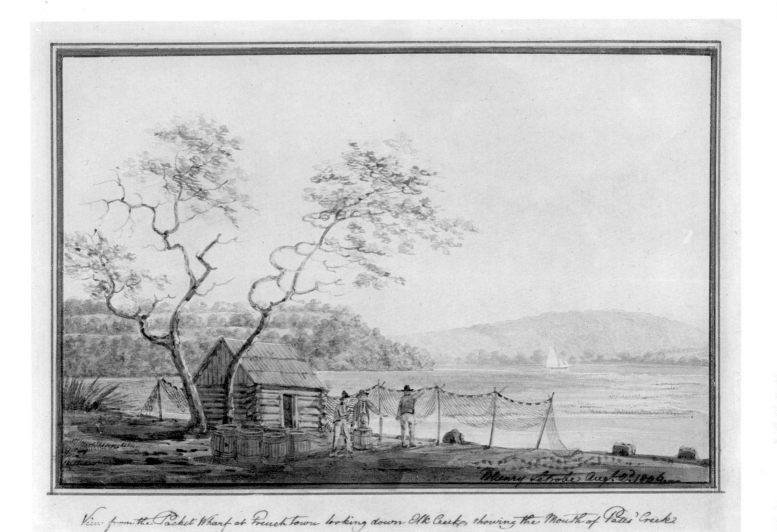

View from the Packet Wharf at French town looking down Elk Creek, showing the Mouth of Pates' Creek

undertaken by few contemporary artists—native or foreign, professional or amateur, male or female. Furthermore, many of her scenes have intriguing narratives transpiring among the figures with which she populated them. At the same moment, her ethnographic portrayals of Indigenous Americans anticipate Charles Bird King's portrait series of American Indians (1822–42) and the works of Karl Bodmer and George Catlin dating from the 1830s, as well as the representations of Tuscarora artist David Cusick.[83]

American art came of age in the decade after the Neuvilles departed, when its wilderness landscapes gave way to settlement and steamboats. That same decade saw the end of the fluid gender roles of the elite—which Charlene Boyer Lewis discusses in her essay in this catalogue—and the rise of the middle-class characterization of women as morally superior, wholly dependent, and primarily domestic creatures, a view that would become prominent in the Victorian era. By contrast, the baroness was no mere appendage to her husband's career. She made her own distinctive contributions in the public sphere, and her egalitarian drawings and watercolors have a power and charm grounded in their unpretentiousness. In this catalogue, her engaging images are studied and organized somewhat chronologically to demonstrate her artistic development and joined to previously unpublished documents that convey her written voice. Together, they provide an invaluable glimpse into a critical era of American history and depict an ever-curious and plucky artist who transformed her "exile" in the New World into a vivid, revelatory chapter in a fascinating life.

Fig. 35
Benjamin Henry Latrobe, *View from the Packet Wharf at Frenchtown Looking Down Elk Creek*, 1806. Watercolor, pen and iron-gall ink, and graphite on paper; 8 ½ × 12 in (216 × 305 mm). Metropolitan Museum of Art, New York, Morris K. Jesup Fund, 1993.281

Endnotes

1. Stebbins 1976, 94. See also Kelley 2006.
2. Louise Florence Pétronille Tardieu d'Éschavelles d'Épinay, as quoted in Mary D. Sheriff, "The Woman-Artist Question," in Pomeroy et al. 2012, 26.
3. See Joseph Baillio, Katherine Baetjer, and Paul Lang, *Vigée Le Brun: Woman Artist in Revolutionary France*, exh. cat. (New York: Metropolitan Museum of Art, 2016).
4. For two seminal books on the topic of female painters' struggles for success and the obstacles they faced, see Linda Nochlin and Ann Sutherland Harris, *Women Artists 1550–1950*, exh. cat. (Los Angeles: Los Angeles County Museum of Art, 1976); Germaine Greer, *The Obstacle Race: The Fortunes of Women Painters and Their Works* (London: Tauris Parke, 2001). For French women artists of the period, see Pomeroy et al. 2012; Chapman 2017.
5. See Melissa Lee Hyde, "Looking Elsewhere: Women and the Parisian Art World in the Eighteenth Century," in Pomeroy et al. 2012, 33–41.
6. A case in point is Madeleine Françoise Basseport; see Pomeroy et al. 2012, 54–55.
7. See Laura Auricchio, *Adélaïde Labille-Guiard: Artist in the Age of Revolution*, exh. cat. (Los Angeles: J. Paul Getty Museum, 2009).
8. See Eik Kahng, Marianne Roland Michel, et al., *Anne Vallayer-Coster, Painter to the Court of Marie-Antoinette*, exh. cat. (Dallas, TX: Dallas Museum of Art; New Haven: Yale University Press, 2002).
9. Laura Auricchio, "Revolutionary Paradoxes: 1789–94," in Pomeroy et al. 2012, 24.
10. See ibid., 23–29, for more detail.
11. For a discussion of black media and also the state of the graphic arts in America at the time, see Shelley 2002, 51–60.
12. For artists' materials and their practices during the period, see ibid.
13. She was no doubt aware of the tradition of "The Cries," which were particularly popular in France and England; see cat. no. 78.
14. For the baron's comments about Madame Récamier's beauty and virtues, see *Mémoires* 1888–92, 2: 462; *Memoirs* 1913, 2: 105. For Récamier's salon and its importance, see Harkett 2014.
15. Shelley 2002, 65, 69.
16. See Chapman 2017, fig. 45, for another example of a watercolor box by Reeves & Woodyer from ca. 1820.
17. For a discussion of papers available in America during this period, see Shelley 2002, 36–43.
18. Cat. nos. 10, 11, 19, 24, 26, 77. See Bower 1996, 61–74; Balston 1998, 247–249, 251–253.
19. Cat. nos. 46, 69; appx. no. 30, respectively.
20. Cat. no. 21; appx. no. 62.
21. Cat. no. 50, 72.
22. Cat. no. 45d; appx. nos. 56, 58.
23. Roberta J.M. Olson, *Audubon's Aviary: The Original Watercolors for "The Birds of America"* (New York: Rizzoli, 2012), 131 n. 69.
24. Cat. no. 36.
25. Appx. no. 61.
26. See Wendy Wassyng Roworth, "Documenting Angelica Kauffmann's Life and Art," *Eighteenth-Century Studies* 37:3 (Spring 2004): 478–482; Bettina Baumgärtel et al., *Angelika Kauffmann*, exh. cat. (Ostfildern-Ruit: Gerd Hatje, 1998); eadem, *Angelika Kauffmann: Unbekannte Schätze aus Vorarlbergen Privatsammlungen*, exh. cat. (Munich: Hirmer, 2018).
27. Chapman 2017, 172–173.
28. Fielding Lucas, *The Art of Colouring and Painting Landscapes in Water Colours* (Baltimore: J. Robinson Printers, 1815). For a summary of the status of watercolor in America during the early nineteenth century and bibliography, see Olson 2008, 22.
29. Chapman 2017, 174–176.
30. Simon Fenwick and Greg Smith, *The Business of Watercolour: A Guide to the Archives of the Royal Watercolour Society* (Aldershot, Hants, and Brookfield, VT: Ashgate, 1997), 37–38.
31. See Bermingham 2000, 4–14, for background.
32. Ibid., 44.
33. See Gerald E. Finley, *George Heriot*, ed. Dennis Reid (Ottawa: National Gallery of Canada, 1979); idem, *George Heriot: Postmaster-painter of the Canadas* (Toronto: University of Toronto Press, 1983); Foster 1997, respectively.
34. Bermingham 2000, 84–85.
35. Kimberly Mae Sloan, "The Teaching of Non-Professional Artists in Eighteenth-Century England" (Ph.D. diss., Westfield College, University of London, 1986); eadem, "Drawing—A Polite Recreation in Eighteenth-Century England," *Studies in Eighteenth-Century Culture* 11 (1982): 217–240.
36. Rudolf Ackerman, "Observations on Fancy Work. As Affording an Agreeable Occupation for Ladies," *Repository of the Arts* (March 1810): 192–193.
37. Bermingham 2000, 208–227.
38. See Gerald Barnett, *Richard and Maria Cosway* (Tiverton, Devon: Westcountry Books in association with Lutterworth Press, 1995); Stephen Lloyd, *Richard and Maria Cosway: Regency Artists of Taste and Fashion* (Edinburgh: Scottish National Portrait Gallery, 1995); Tino Gipponi, *Maria e Richard Cosway* (Turin: Umberto Allemandi, 1998); Carol Burnell, *Divided Affections: The Extraordinary Life of Maria Cosway: Celebrity, Artist and Thomas Jefferson's Impossible Love* (Lausanne, Switzerland: Column House, 2007).
39. Dunlap 1834. For discussions of artists and draftsmen working in the late eighteenth and early nineteenth centuries in America, see Stebbins 1976, 36–84; Avery 2002, 84–142; Olson 2008, 54–208.
40. See Yarmolinksy 1930, 33–43; Svinin 2008, 122.
41. Pavel Petrovich Svinin, "The Observations of a Russian in America: A Look at the Free Visual Arts in the United States of America," *Notes of the Fatherland* (May to July 1829)—taken from Svinin's manuscript of *Voyage pittoresque* and published in the Russian literary magazine he founded; Svinin 2008, 122–142, 180–194. See Yarmolinsky 1930, 33–43, for comments.
42. John Trumbull, Washington, DC, to Thomas Jefferson, Monticello, VA, March 3, 1817, NA. See Thomas Jefferson, *The Papers of Thomas Jefferson, Retirement Series*, ed. J. Jefferson Looney (Princeton: Princeton University Press, 2014), 11: 166–167; https://founders.archives.gov/documents/Jefferson/03-11-02-0119. Trumbull is credited with introducing Jefferson and Cosway in Paris, and for three years all correspondence between them went through Trumbull; Jaffe 1975, 99–101.
43. Jaffe 1975, 195–196.
44. Svinin 2008, 128.
45. Ibid., 130.
46. Ibid., 140–142.
47. Dunlap 1834, 1: 419–420; Jaffe 1975, 206–208; as well as *Commercial Arts*, February 10, 1813. In 1825, more progressive artists split from it to found the National Academy of Design.
48. The names were the New York Academy of the Fine Arts (1802–04), the American Academy of Arts (1808–17), and the American Academy of the Fine Arts (1817–42). See Cowdrey 1953, 1: 3–22; Jaffe 1975, 207, 265. For more information, see Carrie Rebora Barratt, "The American Academy of the Fine Arts, New York, 1802–1842," 2 vols. (Ph.D. diss., City University of New York, 1990).
49. *Commercial Advertiser*, April 7, 1817. See also Dunlap 1834, 2: 285–276.
50. See Cowdrey 1953; see also William H. Gerdts, *Women Artists of America, 1707–1964*, exh. cat. (Newark, NJ: Newark Museum, 1965), 7–10, who notes that Sarah Cole, sister of Thomas Cole, was almost the only woman known for landscapes.
51. Cowdrey 1953, 2: 164–165.
52. Ibid., 360.
53. Ibid., 304.
54. *Long Island Star*, June 8, 1809 (John Wesley Jarvis offered to paint miniatures and portraits of many types, including those of the deceased); *New York Evening Post*, February 21, 1812; and *Public Advertiser*, March 4, 1812, for example.
55. *New York Evening Post*, February 21, 1812; Way was located at 95 Greenwich Street.
56. *New York Evening Post*, August 8, 1816, for one who exhibited at the Charity Asylum.
57. *Mercantile Advertiser*, June 18, 1812, announced an academy for teaching drawing, painting, and drawing maps at 178 Broadway. L. Binse also offered private lessons in clients' residences.
58. See Helen A. Cooper et al., *Life, Liberty, and the Pursuit of Happiness: American Art from the Yale University Art Gallery*, exh. cat. (New Haven: Yale University Press, 2008), 2, 25–26, 66, 80, 86–87, 94, 96, 219, no. 33, ill. See also the article in the *New York Evening Post*, July 30, 1808, urging the government to support Trumbull in order to complete the painting.
59. *New York Herald*, June 5, 1817; *American Monthly Magazine Critical Review* (June 1817); *Mercantile Advertiser*, September 28, 1818 (large canvas to be exhibited in New York before taken to Washington);

Commercial Advertiser, October 6, 1818. Trumbull issued proposals for publishing an engraving of the painting and selling it by subscription in the *New York Daily Advertiser*, February 13, 1818, and the *New York Spectator*, February 24, 1818 (Asher B. Durand engraved it in 1820–23). Positive reviews of the large *Declaration of Independence* for the series appeared in the *New York Daily Advertiser*, October 8, 1818, and *National Advocate*, November 13, 1818. In opposition, a series of articles taking issue with the persons included in the painting appeared in the *New York Daily Advertiser*, October 14, 28, 1818; the *National Advocate*, October 13, 15, 22, 26, 27, 28, 1818; and the *New York Evening Post*, October 23, 1818.

60. Jaffe 1975, 234–263; see also eadem, *Trumbull: The Declaration of Independence* (New York: Viking Press, 1976).

61. Svinin 2008, 130.

62. Dunlap 1834, 1: 425; 2: 368–370.

63. *New York Gazette*, March 2, 1802, where the ad was unusually illustrated with a woodcut featuring a radiant palette with brushes.

64. Archibald Robertson, *Elements of the Graphic Arts* (New York: David Longworth, 1802).

65. See Olson 2008, 92–94, 116–117; Megan Holloway Fort, "Archibald and Alexander Robertson and Their Schools, The Columbian Academy of Painting, and The Academy of Painting and Drawing, New York, 1771–1835" (Ph.D. diss., City University of New York, 2006).

66. *Longworth's* 1817, 310, at 17 N. Moore; 1818, 231, at 20 Maiden-lane; 1819, 279, at Provost opposite Varick; 1820, 312, at 56 Provost; 1821, 309, at Maiden-lane. See Olson 2008, 129–131. *New York Evening Post*, May 1, 1816, has an advertisement for an Academy of Drawing and Painting at 24 Park Place, established by Milbert, John Vanderlyn, and Louis Antoine Collas.

67. See Finley, *George Heriot*, 1979; idem, *George Heriot*, 1983; Olson 2008, 75–77.

68. See Foster 1997; Olson 2008, 112–115.

69. See Miles 1994; Olson 2008, 104–111.

70. For drawings by Lesueur in the Muséum national d'histoire naturelle, Paris, that are close in style to drawings by the baroness, see *Le voyage en Amérique: Milbert, Lesueur, Tocqueville, 1815–1845*, exh. cat. (Giverny: Musée d'art américain, 2001), figs. 9–17.

71. William Smith, "Exhibition of Paintings," *Commercial Advertiser*, January 2, 1810.

72. Other spectacles included the "Marvellous Gallery" with views of Rome, and portraits of famous people through the ages, including Napoleon and Maria Louisa of Austria, dramatically lit, sometimes by the Sun as well as the Moon; *Mercantile Advertiser*, July 3, 1812.

73. See Stephan Oettermann, *The Panorama: History of a Mass Medium*, trans. Deborah Lucas Schneider (New York: Zone Books, 1997), 313–314.

74. *New York Daily Advertiser*, December 22, 1818.

75. *National Advocate*, April 8, 18, 21, 1818.

76. See also another drawing of Vanderlyn's Rotunda by Alexander Jackson Davis in the N-YHS, inv. no. 1917.37; Koke 1982, 1: 252.

77. Avery and Fodera 1988; Oetterman, *The Panorama*, 314–317.

78. Avery and Fodera 1988, 20.

79. For reviews, see ibid., 43 n. 43. Edwin G. Burrows and Mike Wallace, *Gotham: A History of New York City to 1898* (Oxford: Oxford University Press, 1998), 468, notes that eventually the public became displeased with it, preferring American rather than European scenes.

80. Olson 2008, 166–169.

81. Avery, *American Drawings and Watercolors*, 100–101.

82. Stebbins 1976, 57. Even to have been included in this landmark survey, published in the Bicentennial year, many decades ago, speaks volumes about the baroness's status and accomplishments.

83. Charles Bird King placed an advertisement in the *Daily National Intelligencer*, December 12, 1820, as a painter of portraits. His rooms in Washington, DC, were on the corner of F and 12th streets, several blocks from the French ambassador's residence on F Street. He probably painted a portrait of the baron the same year that was exhibited at Delaplaine's Gallery and advertised; see also "The Neuvilles," pp. 38, 43 n. 112.

THE ROLE OF WOMEN IN THE NEW NATION 1800–1825

Charlene M. Boyer Lewis

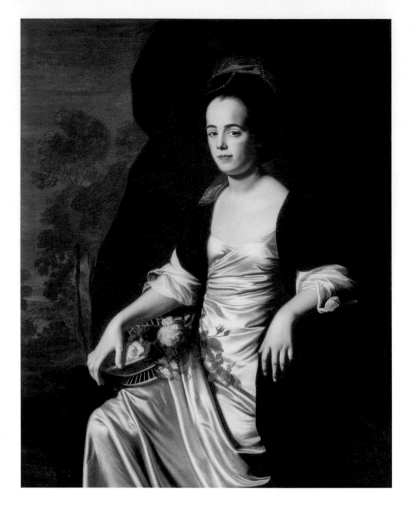

When Baroness Hyde de Neuville arrived in the United States in 1807, she encountered a society still trying to make sense of the goals and ideas of the American Revolution and put them into practice. Women joined men in determining the meanings of republicanism and national identity in the decades around 1800. These political ideals had an impact on women's place in the republic since women "helped constitute the public" and, moreover, they "ratified and legitimated the proceedings of the new national government" in their roles as citizens, according to one scholar.[1] Many women earnestly believed that they could not only participate in politics, but also help shape the identity and culture of the new nation. In fact, many considered it essential for elite women to play such a role. In dining rooms and ballrooms, not just in the halls of government, American men and women engaged in forthright, even strident debates over the place of aristocratic or democratic ways in the new nation's republican culture. Even though they could not vote or hold public office, women thought about republicanism, nationalism, and citizenship just as men did. In this period, citizenship possessed various meanings, not just in strict political terms, but also in powerful social and cultural ones.[2] Women from all levels of society played active roles in the shaping of the new nation, but elite women—the ones in the baroness's social circle—participated in the cultural debates and greatly influenced the formation of a national identity.

When the Neuvilles lived in the U.S. (1807–14; 1816–22), the roles women played in their families, society, and nation had been and remained very much in flux. An increasingly child-centered family was being presided over by a newly redefined mother. As affection, love, and sensibility came increasingly to be viewed as positive characteristics, women, who were believed to possess innately those attributes more than men, came to be seen as the parent more naturally suited to educating young children, especially in Christian values and good citizenship, and to attending to their special needs. The controlling authority and patriarchal power of the father in all American families—rich or poor, black or white—diminished. Instead, maternal love and mothers received far more praise than paternal control and fathers. Neither the increased regard for mothers nor the Revolution's emphasis on liberty and equality, however, had transformed the basic philosophy of women's legal status: the concept of coverture, which affected all women

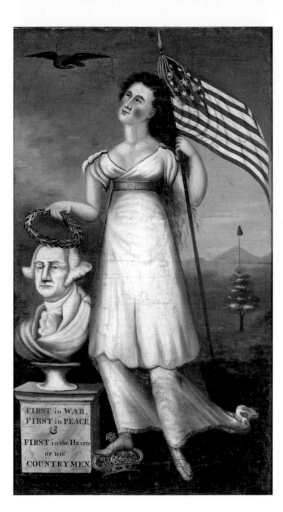

Fig. 37
Unidentified American artist,
Window shade with Lady
Liberty and Washington,
1800–10. Oil on canvas;
73 × 43 ½ in. (185.5 × 111.5 cm).
Fenimore Art Museum,
Cooperstown, NY, N0535.1948

regardless of class or race. Under coverture, a woman's legal identity was "covered" by her husband at marriage; married women possessed no separate legal identity. For decades after 1800, husbands still retained all of the economic and legal power; they still controlled the wealth and the children. Legally, most women, young or old, were regarded as dependents, first of a father, then of a husband.

In the decades before the Neuvilles arrived, the American Revolution had provided women with acceptable ways of taking part in party politics and had changed ideas of femininity and women's roles. During those decades, writes one historian, "women's opinions, issues, and needs" became an essential part of the new nation's identity.[3] At this time, some upper-class women, such as Judith Sargent Murray (fig. 36), worked with some reform-minded men, such as Benjamin Rush, to shape new roles for women as "republican wives" and "republican mothers." They argued that republican virtue had to be instilled in men as small children. And who better than mothers to perform this all-important task? This ideal proclaimed that women could best serve the republic by marrying virtuous men and raising sons to become good republican citizens. Through this new civic role emphasizing their independent patriotism, women became crucial members of the republic, as reflected in images such as the personification of Lady Liberty (fig. 37).[4] While this ideal had not disappeared by 1807, over the years of the Neuvilles' stay Americans became more aware of the transformations in women's roles and their growing identity as political beings. At the same time, a conservative, "revolutionary backlash" spread throughout society and brought forth a definition of femininity primarily based in the domestic and maternal realms, which formally removed women from partisan politics. Yet some strands of the earlier gender identity survived, especially the emphasis on women's involvement in society and contributions to public opinion.[5] Throughout the 1810s and 1820s, many women firmly believed they had important social *and* political roles to fulfill in the nation.

In this era of gender transformations, upper-class women in particular developed alternative, competing ideas about what their roles could be. Though many genteel women lived their lives within the expectations of republican motherhood, not every woman aspired to become such a mother. Status and wealth afforded elite women options that were unavailable to their more

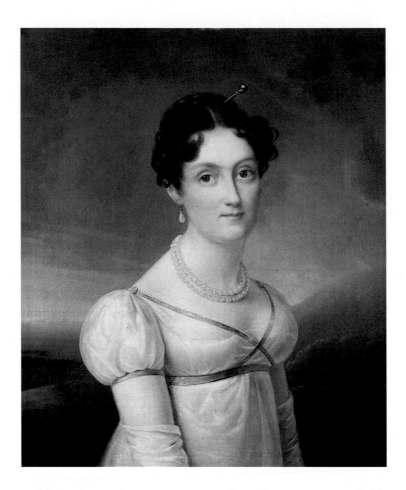

middle- or lower-class counterparts. These alternatives extended beyond the domestic and familial to the social and public realms of "civil society," a world that included both women and men, the public and the private, and offered multiple ways for women to function publicly. "Polite" society, a phrase used at the time, was more exclusive, limited to those ladies and gentlemen who possessed the ideas, behaviors, and accoutrements associated with gentility and refinement. Polite society created a transgressive space by conferring power on its female members; in fact, women came to control much of that space. Their crucial involvement in polite society made them public figures in their own right—social and intellectual equals of men, if not their political peers. Men accepted their influence and control, regarding their concerns with refinement of manners and fashion as natural characteristics of women.[6] Importantly, then, women could do more than raise virtuous sons for the republic or manage the domestic sphere.

The changing nature of gender definitions in this era, along with the influence and even power provided by polite society, allowed many elite women in the baroness's circle to focus their energies on bringing refinement to American culture and contributing to the public debates about the proper character for the young nation. In these efforts, some women, such as Anne Willing Bingham, Martha Custis Washington, and Elizabeth Patterson Bonaparte (fig. 38), modeled the role of the French *salonnière*; others, such as Judith Murray, Mercy Otis Warren, and Susanna Haswell Rowson, became writers; and still others, such as Dolley Payne Madison (fig. 39), Margaret Bayard Smith (fig. 40), and Elizabeth Kortright Monroe (fig. 41), envisioned themselves as cultural arbiters for the nation. In the first quarter of the nineteenth century,

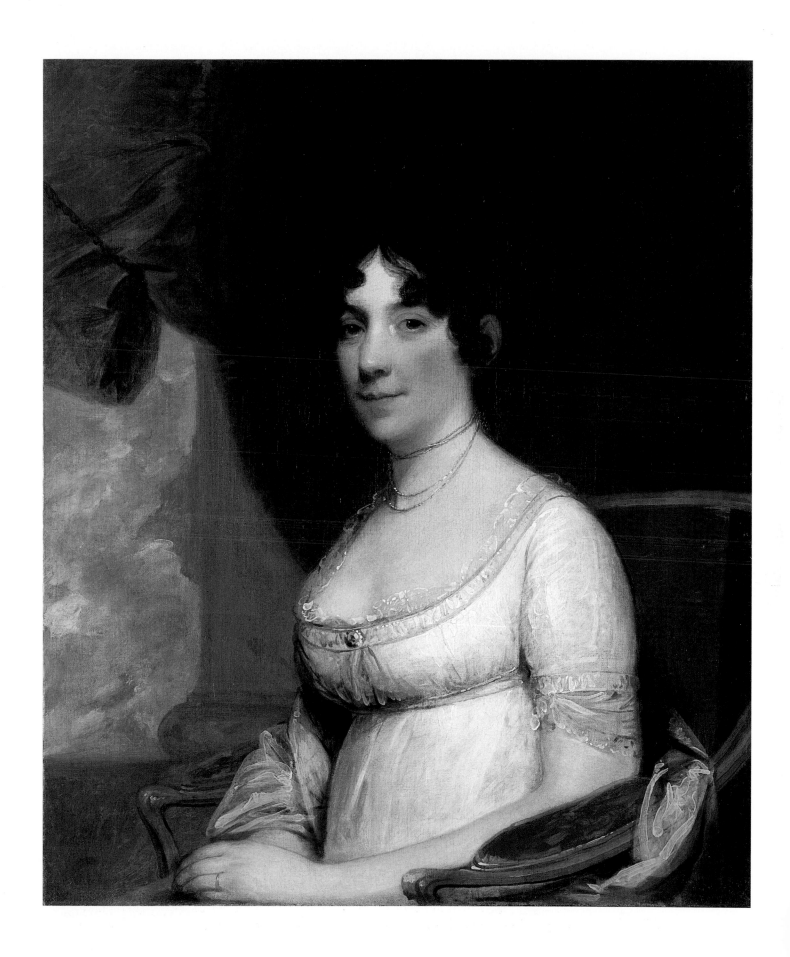

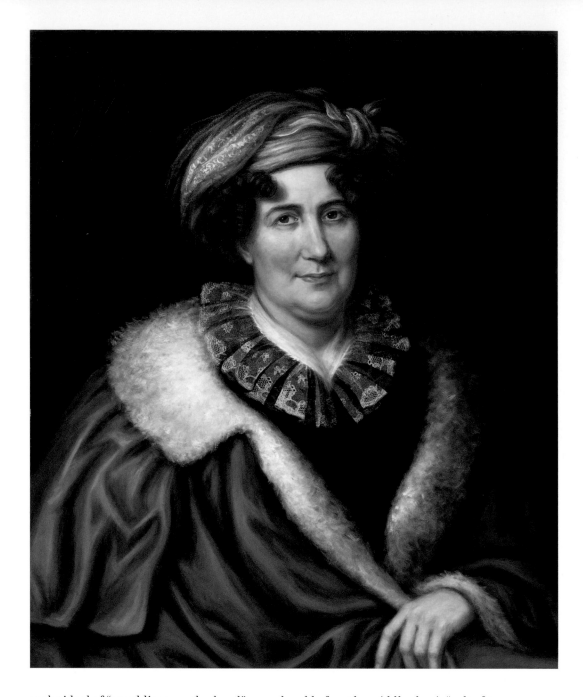

as the ideal of "republican motherhood" waned and before the middle class's "cult of true womanhood" solidified, elite women had some freedom to choose the social and political roles that they would play and to articulate the nature of their relationship to both American culture and the nation.[7]

The women in polite society had been well prepared to take on various roles. For three decades after the American Revolution, genteel families generally agreed on the importance of education for girls and young women. Schools and academies opened at a furious pace, especially in the North and in Atlantic Coast cities. In addition to learning the customary subjects for elite girls (reading, writing, "ciphering," French, needlework, drawing, music, and dancing), young women increasingly mastered subjects previously only taught to young men: history, geography, natural science, geometry, rhetoric, and, in a few progressive academies, even Latin and Greek.[8] Intended to prepare them to become good republican mothers, their education also opened up new ideas about women's potential and the roles they might play in society. Of course, this redirection of women's education was extremely limited in its extent. Most American women— on farms, in small towns, on the frontier, not to mention in slave quarters—never heard of republican motherhood or had a chance to attend an academy. However, even without advanced schooling, literacy rates rapidly expanded across the United States in the early 1800s, reaching

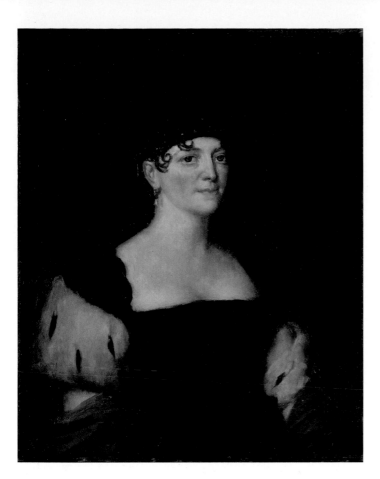

Fig. 41
Eben F. Comins after John
Vanderlyn, *Elizabeth Kortright
Monroe (1768–1830)*, 1932
after original of 1816–20.
Watercolor on paper;
30 ³/₁₆ × 24 in. (76.7 × 61
cm). White House Historical
Association (White House
Collection), Washington, DC,
933.1214.1

deep into white society and including some free blacks. Many young women, even those of the working class, became avid readers, and not only of the romantic novels for which they were often denigrated, but also of poetry, histories, classical works, and even radical books, such as Mary Wollstonecraft's *A Vindication of the Rights of Women* (1792). Large numbers of educated young women prepared themselves to become key members of civil society and even influential contributors to public debates in the new republic.[9]

The expectations of polite society supported the education of women for the benefit of society and community as much as for the republic. In refined spaces, men and women were not divided by gender nor did they divide political conversations from social interactions. As they mingled and discussed the latest news from Congress or Europe in drawing rooms and ballrooms, these educated men and women did not try to define separate realms, but to find common ground and emotional and intellectual rapport, believing men and women could come together through a mutuality of sentiment. Genteel society brought men and women together in convivial heterosociability. The notion of separate spheres for men and women emerged only later, in the 1820s and 1830s. Home was not yet known as a "refuge" or "haven" from a "heartless" world; it was not yet seen as distinct from the public domain. Separated from the rest of society by race and class, this world of sociability brought elite men and women together across lines of sex.

Atlantic Coast cities afforded the best environments for polite society and for women's political and cultural power as they provided greater opportunities for the mixed-gender socializing and entertainments where elite women held sway. Not surprisingly, genteel women who sought a life beyond the roles of wife and mother, such as Elizabeth Patterson Bonaparte (fig. 38) and Margaret Bayard Smith (fig. 40), especially congregated in the cities. Within the urban enclaves of polite society, ambitious women pursued various kinds of power—some more political and some more cultural.

Female leaders of society in Washington excelled at creating a *political* space in social arenas where men *and* women came together for discussions of local, national, and international matters.[10] These mixed-gender gatherings of the wealthy and educated in presidential dining rooms and congressional boardinghouse parlors assured some women a recognized and meaningful part in the political culture of the early republic. In the capital, powerful women,

Fig. 42

Charles Bird King, *Mrs. John Quincy Adams (Louisa Catherine Johnson, 1771–1852)*, ca. 1824. Oil on canvas; 51 ½ × 39 ⅝ in. (130.8 × 100.6 cm). Smithsonian American Art Museum, Washington, DC, Adams-Clement Collection, Gift of Mary Louisa Adams Clement in memory of her mother, Louisa Catherine Adams Clement, 1950.6.5

such as Dolley Madison (fig. 39) and Louisa Catherine Johnson Adams (fig. 42), used sociability in urbane society for political brokering. At dinners, balls, receptions, and other gatherings, the wives of congressmen and cabinet members and especially First Ladies facilitated conversations with men to influence opinions or secure political favors. As First Lady, Madison organized wonderful entertainments that brought men from different political parties together on convivial terms, while also seeking political appointments for relatives and friends or hoping to change the thinking of certain politicians on specific bills or other issues. Madison hid her political brokering so well that contemporaries regarded her more as a consummate hostess than a politician (fig. 43), even after she and the former president left the capital and returned to the Madison estate of Montpelier (fig. 19).[11]

The baroness visited and resided in America during an era when it was not at all rare for women to act as political beings, possessing their own "political will and judgment"—in the words of one historian—like men.[12] Women participated in political parades, heard and discussed speeches, and even joined in toasts to "the rights of women." They read political newspapers and tracts and discussed political questions with their husbands, male friends,

Fig. 43
Attributed to Whartenby & Bumm,
Tea and coffee service with water
pitcher used by Dolley and James
Madison, 1816–18. Silver;
13 ½ in. (34.3 cm) height of pitcher.
N-YHS, Gift of Miss Mary Madison
McGuire, 1939.544–.549

and each other at parties and dinners and in letters. These "female politicians" who chose politics as a part of their lives were easily visible in the early decades of the republic. This role became part of their sense of themselves as women as they participated in debates on political issues, ranging from the man who should be president in 1800 to the appropriate response to European conflicts in the early 1810s. In 1806, for example, Catherine Akerly Mitchill, the wife of a New York congressman, reported that the "debates in the house of representatives" were "quite a fashionable place of resort for the Ladies." She found attendance at them "a very agreeable way of spending the morning" whenever there was "any interesting subject of debate."[13] These were women who pursued their political identities, even if they could not vote. When the baroness lived in New York and the capital, women with political interests and identities were not uncommon and were not generally viewed as violating the bounds of acceptable behavior for ladies.

Women also knew they could contribute to the new nation by helping to shape its culture. They would use polite society to lend grandeur to the new capital being carved out of a wilderness. "Women no less than men were expected to engage in the cultural work of nationalism," asserts one scholar.[14] Using their educations, women might serve along with men as cultural arbiters, creating, advocating for, and strengthening the contours of American culture in this period. While some women conveyed their ideas through published writings and plays, many more grounded their influence in the "institutions of sociability"—the tea tables, dining rooms, parlors, and other semi-public spaces of polite society—that not only included women, but often were controlled by them.[15] These important sites of public opinion and even politics provided clear means for elite women in the capital and other cities to play significant roles in the new nation beyond wife or mother. Through their efforts, these women helped shape the nation in their attempts "to reform manners, cultivate taste, and critique culture," as noted by two historians.[16] Fashion, interior decoration, the arts, and literature became vehicles by which these powerful women could display the cultural forms that they considered suitable for the American republic.

Women's gender and elite class supported their concerns with cultural expressions and encouraged their cultural "borrowing" from Europe. Perhaps more so than American men at the time, American women in the capital and in major cities seemed convinced that their new republic could have elements of aristocracy including luxurious accoutrements without becoming corrupt. In fact, they believed these elements could only elevate the culture of the fledgling country. As the initial First Lady, for example, Martha Washington headed a growing network of French-style, female-led salons, which included that of Anne Bingham, centered in New York City and later Philadelphia (fig. 44).[17] These women sought to use certain aspects of

aristocratic, especially French, culture to improve the new nation; patriotism and nationalism, not materialism, motivated them. Later First Ladies Elizabeth Monroe (fig. 41) and Louisa Catherine Adams (fig. 42), each of whom had spent years at various European courts, as well as Dolley Madison, who never traveled to Europe, saw the adoption of certain European ways at the executive mansion as a means of giving elegance and authority to the nation's capital, of bringing European-style refinement to a rude town.[18] According to them, this was the proper role of good republican women. They adapted aristocratic European forms of refinement to an American milieu, which would celebrate the new nation over monarchies, or so they believed, and bring courtly luxury safely within the bounds of republican simplicity.

Engaging in the cultural work of nationalism or in political brokering offered many elite women not only respite from their domestic duties, but also a sense of importance in the larger world. After complaining in her diary about the chores that consumed her days, or at least required her supervision—food to prepare, clothes to make or mend, a house to put in order—Washington's Margaret Bayard Smith decried the "limited circle which it is prescribed for women to tread."[19] Smith found escape in the fashionable society of the capital, though its demands were often at odds with her domestic "interest or duty."[20] Yet she never stopped participating in the public whirl or bringing it into her home. Not surprisingly perhaps, many of her friends who performed these influential roles for the nation were childless, such as Anna Brodeau Thornton, or were women whose children had grown into adulthood, such as Madison. Few were actively raising young sons or daughters; serving as a cultural arbiter or a female politician was too difficult to manage while birthing, breastfeeding, and nurturing young children. The women who could pursue a public role through polite society, then, were almost all at a fairly mature point in their lives, of a certain class, a certain education, and a certain mindset.[21]

The women in the baroness's circle enjoyed presiding over the tea table or salon and attending parties, balls, formal dinners, concerts, and plays. They relished polished manners, fashionable dress, and witty conversation with educated people. They held cultural power and wielded it effectively. Most important, they also firmly believed that women had crucial roles to play in the shaping of American culture and society. Of course, women from the lower orders, including servants and slaves (who often appear in the baroness's sketches), sometimes challenged those above them and, through those challenges, also influenced the crafting of a new culture. Soon

after the baroness's return to France in 1822, however, these influential women faced strong challenges to their power. First, as women's political actions intensified partisan tensions between Hamiltonian Federalists and Jeffersonian Republicans, men began characterizing women as dangerous and questioning whether women should act politically. Because women had become involved in political battles by the 1810s, it now seemed to the men that these female politicians had to leave the scene to offer their spouses some relief at home from the tensions and conflicts that plagued party politics.

The second challenge to politically influential women came from those who increasingly cast women as strictly domestic beings. By the 1820s, more and more writers urged women to become nonpartisan citizens who might and should help resolve the bitterness of party conflicts. Popular opinion and literature increasingly directed women away from politics and flattered them as domestic peacemakers within their families.[22] The early republic's era of gender role fluidity, which had given elite women power and room to experiment with different models of womanhood in the new nation, came to an end as the powerful middle-class notion of "separate spheres" arose and would become a prominent feature of Victorian times. The new model "elevated" women as morally superior, wholly dependent, and primarily domestic creatures. Women could still play vital roles in the nation, but those roles would be completely transformed.

Endnotes

1. Lewis 1999, 124–125.
2. See, especially, Zagarri 2007; Susan Branson, *These Fiery, Frenchified Dames: Women and Political Culture in Early National Philadelphia* (Philadelphia: University of Pennsylvania Press, 2001); Allgor 2000. See also Allgor 2006; Nancy Isenberg, *Sex & Citizenship in Antebellum America* (Chapel Hill: University of North Carolina Press, 1998); Zagarri, *A Woman's Dilemma: Mercy Otis Warren and the American Revolution* (Wheeling, IL: Harlan Davidson, 1995).
3. Branson, *These Fiery, Frenchified Dames*, 5.
4. See Ruth H. Bloch, "The Gendered Meanings of Virtue in Revolutionary America," *Signs* 13 (Autumn 1987): 37–59; Jan E. Lewis, "The Republican Wife: Virtue and Seduction in the Early Republic," *William and Mary Quarterly* 44 (October 1987): 689–721. For the patriotic window shade, see Margaret K. Hofer and Roberta J.M. Olson, *Making It Modern: The Folk Art Collection of Elie and Viola Nadelman*, exh. cat. (New-York Historical Society in association with D Giles Limited, London, 2015), 150–151.
5. Zagarri 2007, 2; Kelley 2006, 26. See also Lewis 1999, 122–151.
6. See Boyer Lewis 2012; Kelley 2006; Mary Catherine Moran, "From Rudeness to Refinement: Gender, Genre and Scottish Enlightenment Discourse" (Ph.D. diss., Johns Hopkins University, 1999).
7. For works that examine some of the elite women who pursued alternatives to republican womanhood, see Allgor 2000; Boyer Lewis 2012; Susan Branson, *Dangerous to Know: Women, Crime, and Notoriety in the Early Republic* (Philadelphia: University of Pennsylvania Press, 2008); Wendy Anne Nicholson, "Making the Private Public: Anne Willing Bingham's Role as a Leader of Philadelphia's Social Elite in the Late Eighteenth Century" (M.A. thesis, University of Delaware, 1988); Marion Rust, *Prodigal Daughters: Susanna Rowson's Early American Women* (Chapel Hill: University of North Carolina Press, 2008); Sheila Skemp, *First Lady of Letters: Judith Sargent Murray and the Struggle for Independence* (Philadelphia: University of Pennsylvania Press, 2009); Zagarri 2007.
8. Kelley 2006, espec. 66–111.
9. Ibid.; Lucia McMahon, "'Of the Utmost Importance to Our Country': Women, Education, and Society, 1780–1820," *Journal of the Early Republic* 29 (Fall 2009): 475–506.
10. See Allgor 2000; Lewis 1999.
11. Allgor 2006. For the Madisons' coffee and tea service, see Margaret K. Hofer with Debra Schmidt Bach, *Stories in Sterling: Four Centuries of Silver in New York*, exh. cat. (New York: New-York Historical Society in association with D Giles Limited, London, 2011), 257–258.
12. Zagarri 2007, 75.
13. Catherine Akerly Mitchill, Washington, DC, to Margaret Akerly Miller, New York, NY, April 3, 1806, Catherine Akerly Cock Mitchill Family Papers, LoC.
14. Kelley 2006, 78.
15. Ibid., 7.
16. David S. Shields and Fredrika Teute, "The Republican Court and the Historiography of a Women's Domain in the Public Sphere," *Journal of the Early Republic* 35 (2015): 171.
17. See David S. Shields, *Civil Tongues and Polite Letters in British America* (Chapel Hill: University of North Carolina Press, 1997), 320–322; Fredrika Teute and David S. Shields, "The Confederation Court," *Journal of the Early Republic* 35 (2015): 215–226; Patricia Brady, *Martha Washington: An American Life* (New York: Viking, 2005), 160–212; for Philadelphia, Ethel Rasmusson, "Democratic Environment-Aristocratic Aspiration," *Pennsylvania Magazine of History and Biography* 90 (April 1966): 155–182.
18. Allgor 2000, 63–77; eadem 2006. See also Caroline Winterer, *The Mirror of Antiquity: American Women and the Classical Tradition, 1750–1800* (Ithaca, NY: Cornell University Press, 2007), 102–141; Shields and Teute, "The Republican Court," 171.
19. Margaret Bayard Smith Diary, September 17, 1806, Margaret Bayard Smith Papers, LoC.
20. Margaret Bayard Smith Diary, March 23, 1806, Margaret Bayard Smith Papers, LoC.
21. See Boyer Lewis 2012, espec. 110–152.
22. Zagarri 2007.

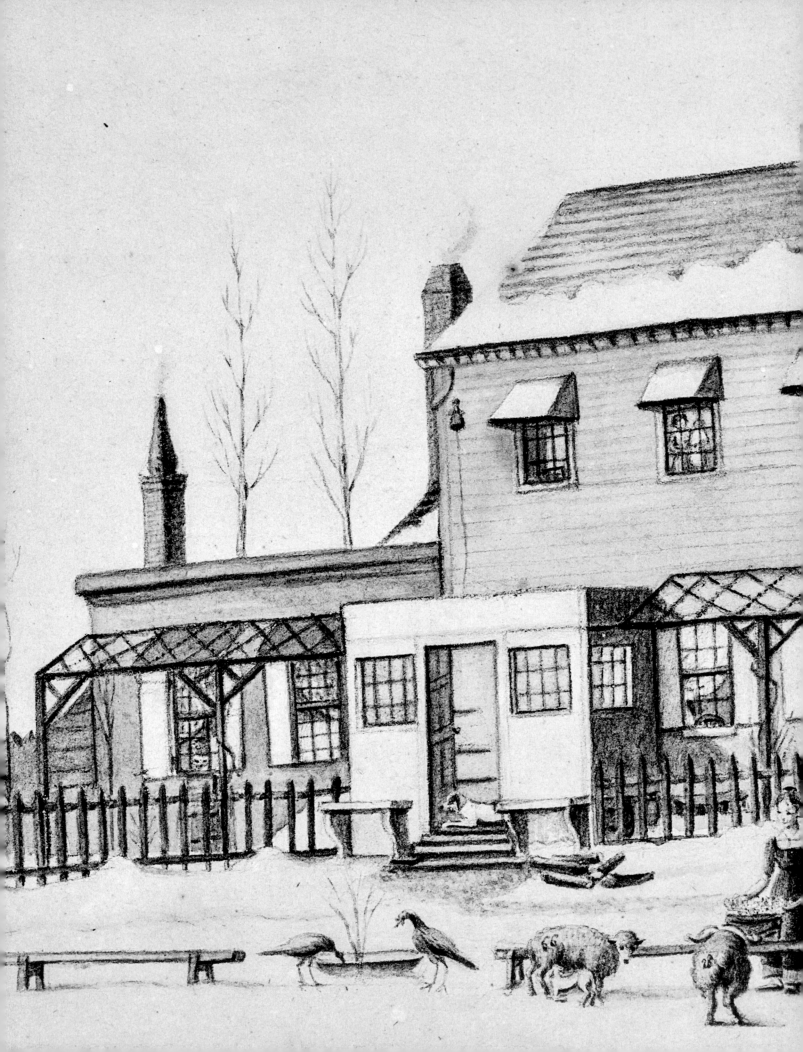

CATALOGUE

Roberta J.M. Olson

The Provenance of Drawings and
Watercolors by Baroness Hyde de Neuville

In the Family

From the labyrinthine evidence regarding the oeuvre of Anne Marguérite Joséphine Henriette Rouillé de Marigny Hyde de Neuville (1771–1849), it is now possible to trace the provenance of her works, at least partially. When, in 1822, the Neuvilles returned to France from their second American residency, the baroness took most, if not all, of her treasured drawings and watercolors back to L'Estang, their château near Sancerre.[1] As she predeceased her husband, at Guillaume's death in 1857 the château passed to his dead brother Paul's daughters—Pauline Henriette, Viscountess de Bardonnet-Hyde de Neuville, and Isabelle, Baroness Laurenceau—who were also the compilers/editors of the original French edition of his *Memoirs*. Although Pauline's childless son, Guillaume Henry, died in 1913, and Isabelle was childless, Paul's eldest daughter, Henriette Mary, who died in 1848, left children and great-grandchildren to carry on the family line, who held L'Estang until 1928. In 1960, the château was sold to Jean Gibert and his wife, after whose death it passed to one of their two daughters, from whom the current owner acquired the property in 2013.[2] He found only one work of art in the château: the baron's portrait by Jean-Baptiste Paulin Guérin (fig. 6).[3]

The American Migration of the Baroness's Works

The convoluted dispersal of the treasured works, which the baroness took home to L'Estang, can be dated from around 1928, although the exact number of works is unknown. I.N.P. Stokes and D.C. Haskell in their *American Historical Prints* state that Stokes found a group of thirty-four drawings by the baroness (thirty of American subjects) in Paris, which E. De Vries, probably a dealer or antiquarian, had purchased from the Neuville family in 1928. However, the baroness's works may have left the château before that date.[4]

Pursuing these breadcrumbs of information, Richard J. Koke attempted to trace the early ownership of the trove, but he was only partly successful and did not present the data in a chronological manner.[5] Koke stated that Stokes brought the thirty-four sheets he purchased in Paris to New York, and retained some of them; six are now in the Print Room of the New York Public Library (cat. nos. 16, 33, 40, 43, 67, 68).[6] Partly relying on Stokes, Koke claimed that another group from De Vries was on the market; it was subsequently dispersed by Kennedy and Company in New York City (whose name changed to Kennedy Galleries in 1952). The group circulated for years among dealers. In 1929, the Columbia Bibliographic Bureau offered to sell the Historical Society ninety drawings by the baroness.[7] This bookstore specialized in rare books and textbooks, as well as French books, and was located at 2929 Broadway, across the street from Columbia University but unaffiliated with it. The N-YHS declined the Bureau's offer. The ninety sheets had no provenance, although one sheet was mounted with an announcement of the 1813 Columbia College Commencement (fig. 45), suggesting that the baroness had attended the event.[8] The group was featured, among other items, in a small catalogue published by the Columbia Bibliographic Bureau listing the subjects and dates of nineteen of the ninety sheets (fig. 46).[9] According to Koke, the N-YHS acquired this same collection in 1953 from the Old Print Shop in New York City, but he noted it lacked three of the original ninety works on the list.[10] Notwithstanding his claim, the N-YHS did acquire the missing trio, because in 1953 ninety works by the baroness were recorded as purchased with the Accessions Sales Fund. That acquisition, however, included many more than ninety sheets, as drawings in clusters were counted as single sheets. Koke noted that in 1931 Kennedy and Company had secured another lot of thirty sketches[11]—from which the N-YHS acquired one watercolor in 1947 (appx. no. 23).[12] Acknowledging the confusing and contradictory nature of this information, he stated: "Over the years it would seem there was quite a bit of interchange and intermingling of the Neuville

sketches among dealers."[13] Indeed, his provenance description lacked a fascinating missing link and left lacunae.

Sometime before 1929, the bibliophile and collector Julien J. Champenois bought another trove of works by the baroness containing an unspecified number of drawings.[14] It may have been part of a group that he obtained either from De Vries or the baroness's family, which makes Champenois the missing link in their dispersal. Beginning in 1918, Champenois had lived in the United States during the winter. Through his business, United French Publishers, Champenois secured books and textbooks from French publishers for American colleges and universities, and he dealt in, as well as collected, rare manuscripts and books. According to a friend, "As the business grew and his contacts widened here and abroad he found opportunities to secure desired collections for American libraries, public and private."[15] In 1928, Champenois and his company organized an exhibition in New York and published a catalogue with a title page reading: "*French Manuscripts, Rare books, Recent Editions*, exhibited by the United French Publishers and Dr. Julien J. Champenois, December 18–24, 1928, at the Museum of French Art, French Institute in the United States." Since its publisher was the same one used for the Columbia Bibliographic Bureau catalogue, it seems likely that Champenois supplied the Bureau with the Neuville sheets that they offered in 1929. When Champenois returned to France in 1938, he left Henriette's drawings wrapped in brown paper with a friend in New York. During the blitzkrieg beginning of World War II, Champenois remained in France, working for the Resistance; he was captured, imprisoned in Buchenwald, and tragically killed in the liberation of the German concentration camp in 1945. Around 1953, with the permission of Madame Champenois, his cache joined other drawings by the baroness at the Old Print Shop, from which individuals purchased works as late as 2018.[16]

History of N-YHS Acquisitions of Works by the Baroness

The New-York Historical Society currently holds 165 watercolors and drawings by Neuville, the largest collection of her works in the world. As noted above, in 1947 the N-YHS acquired its first example by her hand (appx. no. 23). This accession whetted the appetite for the additional "ninety" purchased by the museum in 1953 with the Accessions Sales Fund from the Old Print Shop. Since some of the works were grouped together, instead of the ninety sheets there were 116, one of which was not by the baroness but from her collection (appx. no. 95). A botanical watercolor of a lichen species, which has been assigned the accession number INV.14853 (cat. no. 45b) because of its unknown provenance, may have come into the collection with the Old Print Shop material in 1953. Then, in 1967, another watercolor (cat. no. 22) joined the Neuville cache, purchased by the Watson Fund from Kennedy Galleries. Four additional watercolors, all with provenances from Kennedy Galleries, were purchased in 1982 at auction with the Thomas Jefferson Bryan Fund (cat. nos. 42, 58, 63, 72).[17] Recently, in February 2018, the N-YHS acquired seven additional works with the PECO Foundation Fund for Drawings; their provenances can be traced to the Old Print Shop. About two months later, in May 2018, a group of twenty-four more works surfaced: only two of them belonged to the group of nineteen untraced works formerly held by Kennedy Galleries (three of which were offered at the Old Print Shop in 1961)[18] and by Lawrence Fleischman.[19] Mark Emanuel generously donated the twenty-four to the Historical Society. And then, in the eleventh hour, when the catalogue was in press, Mark Emanuel offered an additional dozen, swelling its works by the artist to 165.

Today, only four of Neuville's works are in France. Appropriately, they are held by an institution that links France and the United States: the Musée franco-américain du château de Blérancourt.

Endnotes

1. For Sancerre, see Vincent Poupard, *Histoire de Sancerre* (Péronnas: Éditions de la Tour Gile, 1998).

2. Faugeras 2003, 373–374. Today the Château de L'Estang is owned by Rémy Graillot, and the farm and chapel built by the baron, by Jean Pierre Graillot. My thanks go to Catherine Graillot and Rémy Graillot for their hospitality and for sharing the history of this magical place.

3. *Château de Lestang* 2018, 1: 35.

4. A tantalizing record in the inventory taken on September 25, 1900—after the death of Viscountess de Bardonnet, when the contents of the château were deaccessioned before the property was sold outside the family in 1928—included the entry "Un album de dessin prisé cinq francs" (Archives départementales du Cher, E 31538, no. 35). See *Château de Lestang* 2018, 1: 85, for the album; 82–94, for other inventories and sales. Stokes and Haskell 1932, 85–86, without knowledge of the inventories assigned the purchase date to 1928.

5. Koke 1982, 2: 189.

6. Richard J. Koke, undated notes in object file, N-YHS.

7. The defunct Columbia Bibliographic Bureau advertised in the *Columbia Spectator*, January 9, 1930; March 6, 1930. In addition to its main office near Columbia University, it had a branch at 148 East 50th Street. The owner was Jacques O'Hana.

8. N-YHS, inv. no. 1953.287a.

9. Columbia Bibliographic Bureau, New York, *Collection of Rare Old French Books, Americana, Manuscripts, Voyages, and Other Scarce Items*, sale cat. (New York: French Printing and Publishing, 1929), 1–3, no. 1. The brochure includes three reproductions of watercolors "From the collection of Baroness Hyde de Neuville." It is held by the N-YHS in the artist's file, which includes an invitation from Jacques O'Hana for an exhibition of the same title, beginning December 21, 1929, at the Bureau's 148 East 50th Street branch.

10. Richard J. Koke, undated notes in the object file, N-YHS.

11. Kennedy and Company, New York, *An Exhibition of Contemporary Drawings of Old New York and American Views*, sale cat. (New York, 1931), lists thirty-two drawings, all accounted for except nos. 20 (House Philadelphia) and 32 (Houses, Guadalupe), which may be a misunderstanding of the inscription in appx. no. 86.

12. Richard J. Koke, undated notes in the object file, N-YHS.

13. Koke 1982, 2: 189.

14. Frank Monaghan, "The American Drawings of Baroness Hyde de Neuville," *Franco-American Review* 2:4 (Spring 1938): 217–220.

15. Letter from Robert A. Gibney, New York, NY, to Fenwick Beekman, New York, NY, June 4, 1954, in the artist's file, N-YHS. Dr. Fenwick Beekman was president of the N-YHS in 1954.

16. Ibid., recounts in much detail the fascinating but tragic life of Champenois and his widow's wish to have Gibney sell the drawings.

17. Sotheby Parke Bernet, New York, *American 19th Century and Folk Paintings, Drawings and Sculpture*, sale, January 27, 1982, lot 45.

18. Old Print Shop, New York, *Old Print Shop Portfolio* 21:3 (November 1961): 64, no. 27, ills., "67 Original Watercolors and Drawings largely by the Baroness Hyde de Neuville." Unfortunately, it only illustrates three drawings, but adds: "There are a few 18th Century drawings which may not be by the Baroness de Neuville." Some of these have proven to be her earliest works.

19. According to the Frick Photoarchive, Frick Art Reference Library, New York. See also the Detroit Institute of Arts, *The French In America 1520–1880*, exh. cat. (Detroit: Detroit Institute of Arts, 1951), 171–172, nos. 453–458.

Prelude: The Neuvilles on the Path to Exile

1

Self-Portrait (1771–1849), ca. 1800–10

Black chalk, black ink and wash, graphite, and Conté crayon on paper; 6 ½ × 5 ¾ in. (165 × 146 mm), irregular
N-YHS, Purchase, 1953.238

Like Neuville's small portrait of her husband (cat. no. 2),
this intimate, half-length self-portrait is akin to a miniature
in both its shape and dimensions.[1] Small-scale, precious
keepsake portraits were intended for travel or display in
private quarters as a memento of the sitter. The baroness may
have created the grisaille work for her husband before one of
their lengthy separations. The portrait was cut in an irregular
shape from a larger sheet of paper, suggesting that it was once
framed and matted, perhaps in a circular presentation.

Henriette carefully delineated her attire, including her
high- or empire-waist muslin dress, tied with a ribbon, whose
bare neckline is filled by a chemisette, or half-blouse, for
daytime. The scarf around her hair mirrors the fashion of the
times, while her hoop earrings were *à la mode* accoutrements
of Revolutionary France during the Directory (1795–99) and
Consulate (1799–1804). At the time, fine jewelry had staged
a comeback but, due to the scarcity of gems, it tended to be
simple gold shapes that were large and geometrical. Earrings
reflecting the general interest in classicism were designed
to complete hairstyles *à la grecque* and complement the
flimsy white dresses inspired by the wet drapery of classical
sculpture. Those worn by the baroness help to date her
likeness. They are related to *poissardes*—earrings named
after the fishwives of Les Halles market in Paris, who played
a significant role in the French Revolution—which were
fashionable from 1790 to 1800.[2] In a later watercolor, of 1816,
the baroness depicted herself wearing three-tiered earrings
set with gemstones, a style that came into vogue after the
coronation of Napoleon in 1804 (cat. no. 66b).

With her casual pose, arms crossed and covered in
au courant fingerless mitts, the artist emphasized her
composure. Her eyes do not gaze at the viewer, which is
atypical for self-portraits, where the artist usually draws
directly from a mirror. In figure 47, by contrast, Neuville
apparently did gaze into a mirror to execute her self-portrait,
in which she wears the identical costume but is posed
closer to the picture plane. Henriette consulted this work
in a rectangular format when delineating the more formal
portrayal featured in this entry.

These two early likenesses are the only portraits of the
baroness known, although she also included images of herself
in at least three watercolor scenes (cat. nos. 27, 39, 66b).

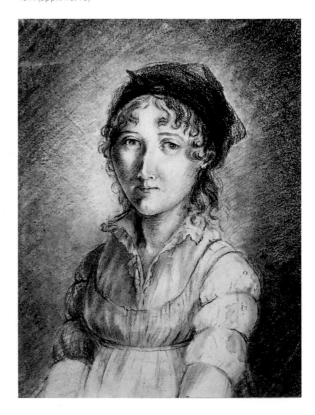

Fig. 47
Anne Marguérite Joséphine
Henriette Rouillé de Marigny Hyde
de Neuville, *Self-Portrait (1771–
1849)*, ca. 1800–10. Black chalk on
paper; 5 ¼ × 4 ½ in. (133 × 114 mm).
Formerly Kennedy Galleries, New
York (appx. no. 79)

1. N-YHS 1974, 2: 574, ill.
2. Daniela Mascetti Amanda Triossi, *Earrings: From Antiquity to the Present* (New York: Rizzoli, 1990), 86–87.

Jean Guillaume Hyde de Neuville (1776–1857), ca. 1805–10

Watercolor, pastel, black chalk, graphite, and touches of black ink on paper; 3 ⅝ × 3 ⁵⁄₁₆ in. (92 × 84 mm)
N-YHS, Purchase, 1953.239

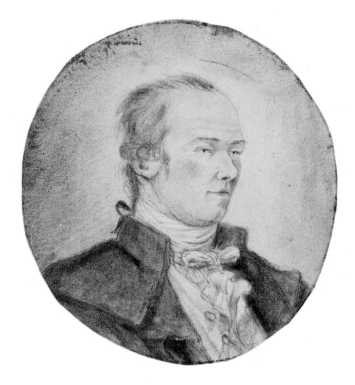

Henriette's intimate, bust-length watercolor portrait of her husband is not a pendant per se of cat. no. 1, and its circular format is even more indebted to the miniature tradition.[1] Perhaps she rendered it as a remembrance of his visage before one of their separations. An earlier likeness of a boyish Hyde de Neuville at age twenty—a now-lost oval miniature by Frédéric Dubois—was engraved by Paul Dujardin and reproduced as the frontispiece to the third volume of the *Mémoires* and the first volume of the abridged English *Memoirs* (fig. 5).[2] Neuville drew another early portrait of her husband wearing a hat and reading that is here published for the first time (cat. no. 4), and she included him in several watercolor scenes (cat. nos.

27, 39, 66a). Later, after he was awarded the title of Count of Bemposta, Jean-Baptiste Paulin Guérin painted an official portrait of the baron, which hung at L'Estang (fig. 6), their château near Sancerre. Guérin's portrait of the baron dressed in full regalia was also engraved by Dujardin and reproduced as the frontispiece to the second volume of both editions of his *Memoirs*. Guérin—who studied with François Pascal Simon Gérard, was awarded the Legion of Honor, and became Director of Drawing and Painting at the Maison d'éducation de la Légion d'honneur—was the logical choice to portray the baron, who had received all five orders of the Legion of Honor by 1825.[3]

Henriette's husband was a liberal royalist, a seemingly contradictory characterization, whose stressful life under the Terror (1793–94) had left him somewhat complacent but reactive, albeit still idealistic and intractably royalist. In 1820, when he served as Minister Plenipotentiary of France in Washington, DC, John Quincy Adams wrote a measured assessment of his fellow statesman:

> The diverting part of his character is the conflict between his Bourbon royalism and his republican fancies. . . . No foreign Minister who ever resided here has been so universally esteemed and beloved; nor have I ever been in political relations with any foreign statesman of whose moral qualities I have formed so good an opinion. . . . He has not sufficient command of his temper, is quick, irritable, sometimes punctilious, occasionally indiscreet in his discourse. . . . But he has strong sentiments of honor, justice, truth, and even liberty. . . . He is neither profound, nor sublime, nor brilliant; but a man of strong and good feelings, with the experience of many vicissitudes of fortune, a good but common understanding, and good intentions. . . .[4]

1. N-YHS 1974, 2: 573–574, ill.
2. *Mémoires* 1888–92, 3: frontispiece; *Memoirs* 1913, 1: frontispiece.
3. For the baron's biography, see Watel 1987; Faugeras 2003.
4. Adams 1875, 5: 137; see also ibid., 4: 303.

3a
***Woman Wearing a Cap Writing by Candlelight**; verso:
man holding a pole, ca. 1790–1802*

Black, white, and red chalk with stumping and gray watercolor on beige
paper; black chalk; 4 ⅝ × 5 ¼ in. (117 × 133 mm), irregular
N-YHS, Gift of Mark Emanuel, 2018.42.3

3b
***Man Writing at a Folding Secretary by
Candlelight**, ca. 1790–1802*

Black and white chalk with stumping and gray watercolor on beige paper;
6 ¼ × 8 ⅛ in. (159 × 206 mm), irregular
N-YHS, Gift of Mark Emanuel, 2018.42.4

3a

Neuville drew this pair of nocturnal portraits primarily in
the medium she first preferred, black chalk. Already, her
interest in people engaged in studying, reading, writing,
or drawing—one of the themes running throughout her
oeuvre—appears in these early studies. Both sitters wear
spectacles, occupy the same *fauteuil* (armchair), and write by
the light of the same candlesticks, implying that the baroness
drew them in a common domestic setting. The cap worn by
the elderly woman also underlines the intimate domesticity
of the two scenes, suggesting that her subjects were older
family members, perhaps even her parents. Reinforcing
this conclusion is the artist's warm attitude toward the pair
and the more highly finished, albeit tentative, nature of the

drawings, implying that she studied them over time. In this
quality, the works are distinct from her more notational
sketches of other subjects, such as those in the "Economical
School Series" (cat. no. 44; appx. nos. 35–46). The powdered
hair or wig worn by the gentleman, who has a mole on
his proper right cheek, and the Louis XVI *fauteuil* are
reminiscent of the *ancien régime* and support an early date
for the sheets. Furthermore, Neuville represented the same
male sitter and chair on another sheet in similar media with
the addition of blue pastel and red chalk (appx. no. 8).

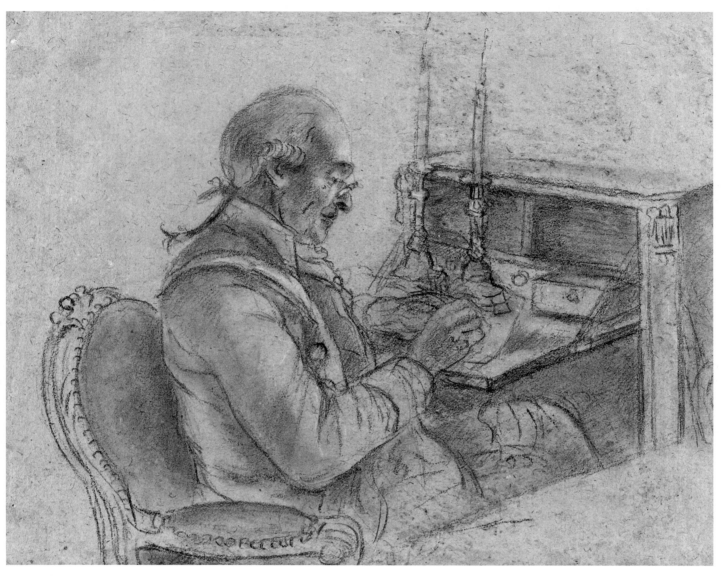

3b

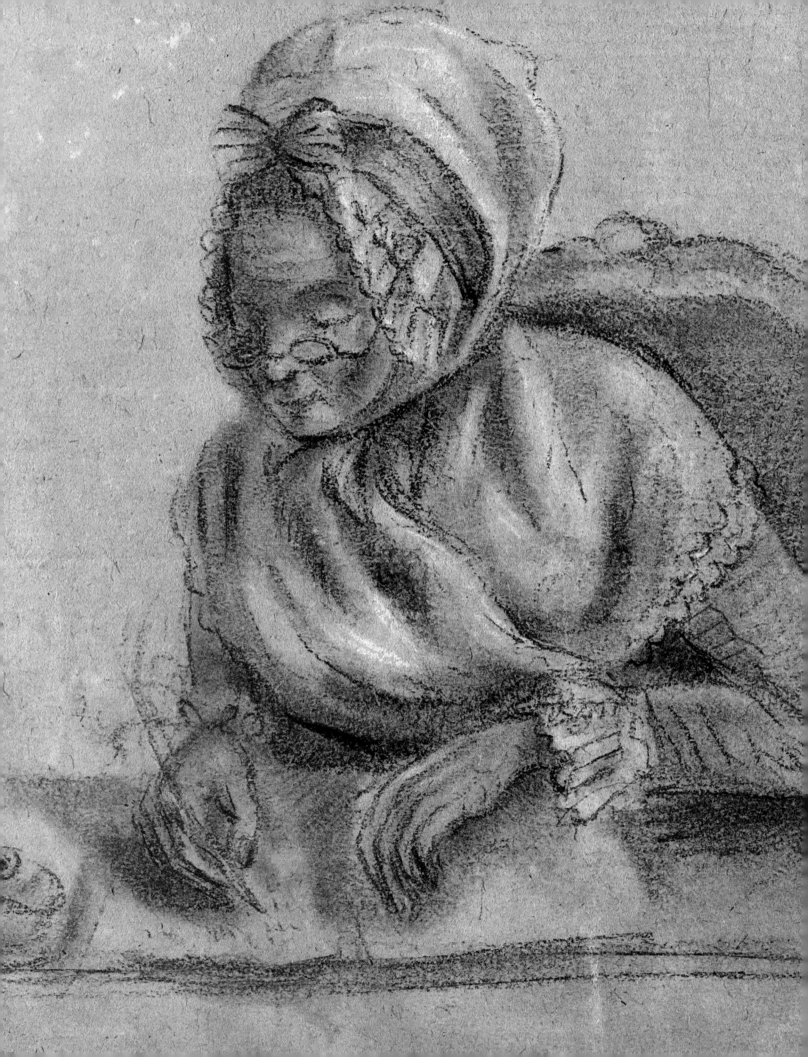

4

Jean Guillaume Hyde de Neuville (1776–1857); **verso: man with a powdered wig, ca. 1800–06**

Black, white, and red chalk and gray watercolor on beige paper; black chalk; 7 ⅞ × 6 in. (200 × 152 mm), irregular
Watermark: Crown and fleur-de-lis
Inscribed at upper right in graphite: *1* (encircled)
N-YHS, Gift of Mark Emanuel, 2018.42.2

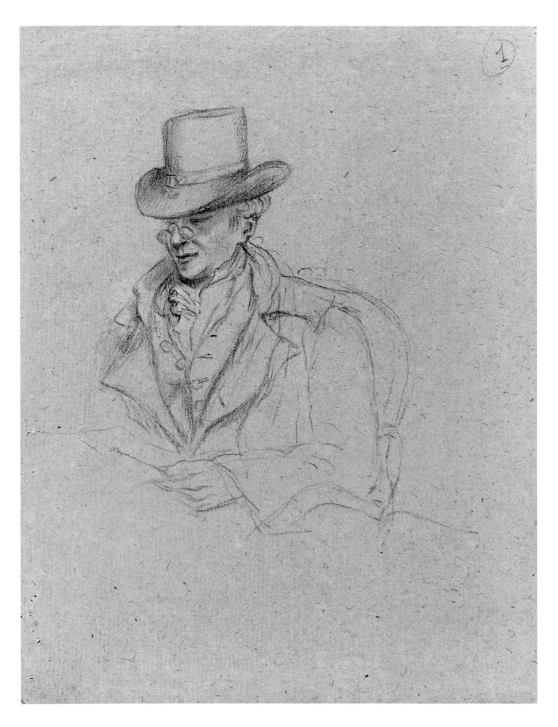

The subject of this casual portrayal, which lacks an inscription, can be identified as the baron (wearing pince-nez and reading) by comparison with other portraits of him, especially cat. no. 2. The telltale cleft in the sitter's chin, as well as his nose, mouth, and youthful ruddy cheeks cinch the identification. Since he sports a top hat and an overcoat, the baroness may have drawn her husband's likeness on the road during their travels. She used the traditional eighteenth-century French medium of three-colored chalks (*trois crayons*) to capture him in this quickly rendered image.

5

Madame Heuters, ca. 1800–06

Black, white, and red chalk, graphite, gray watercolor, and black, brown, and red ink on parchment; 6 × 3 ¹⁵⁄₁₆ in. (152 × 100 mm), irregular
Inscribed at lower center in graphite: *Mde. Euters*
N-YHS, Gift of Mark Emanuel, 2018.42.15

In this refined portrait, the baroness experimented with different media and a nearly unique use of a parchment support. Although she first employed the traditional French eighteenth-century *trois crayons* (three-colored chalks) over an underdrawing in graphite, she strengthened her portrayal of the sitter's highly finished head with three different inks. With broad strokes of brown and black ink she reinforced the sitter's snaky curls, plastered to her forehead, and added thin red accents to her rheumy eyes, her ears, and under her nose, perhaps to suggest sickness or fatigue. As background Henriette painted gray watercolor to the proper right of the sitter's head, not only putting it in relief but also suggesting a psychological shadow. Despite the baroness's inscription, which appears to be her subject's surname, the sitter's identity remains a mystery because "Euters" is no known surname. Rather, it is probably Neuville's phonetic transcription of what she heard with a silent "H": "Heuters," not "Euters." The woman's haunting, aloof expression contrasts with her lightly sketched costume and intricate coiffure, whose stylized curls frame her face in a manner fashionable during the Consulate period in France, as seen in Jacques-Louis David's portrait of Madame Récamier, who was a friend of the Neuvilles (fig. 21).[1] Further evidence for the portrait's date is provided by another likeness, whose sitter is similarly attired, which the artist inscribed retrospectively, as she fondly remembered the occasion on which she drew it: *Mme. Guitton Louyon—"Happy Time"—1805* (appx. no. 81; see also its preparatory study: appx. no. 18v).[2]

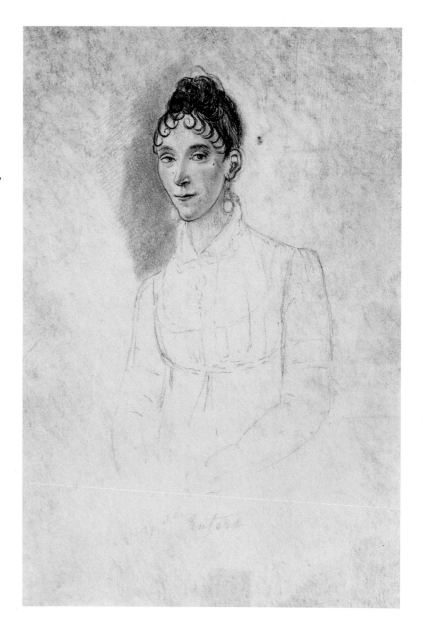

1. For the baron's praise of Madame Récamier's beauty and virtues, see *Mémoires* 1888–92, 2: 462; *Memoirs* 1913, 2: 105.
2. Frick Photoarchive, Frick Art Reference Library, New York, records this inscription at the lower right.

View of the Loire from the Factory in La Charité-sur-Loire, **1805**

Watercolor, black and brown ink, black chalk, graphite, and metallic pigment with touches of gouache on paper extended on two sides, laid on composite sheets of paper; 7 ½ × 10 ³⁄₁₆ in. (190 × 259 mm), irregular
Inscribed along right edge vertically in brown ink: *La Manufacture de la charité. d'où nous Sommes Partis en avril. 1805.*
N-YHS, PECO Foundation Fund for Drawings, 2018.21.1

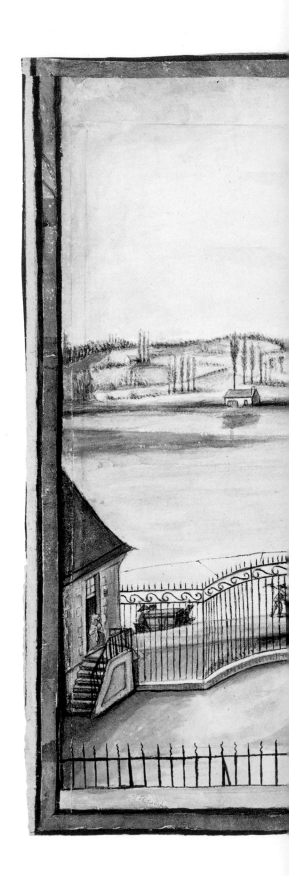

La Charité-sur-Loire, the birthplace of Henriette's husband, was very close to the Neuville estate of L'Estang. The storied town in the Nièvre district of France, south of Paris, was built on an important fortified site near the earliest stone bridge crossing the Loire River, and it enjoyed excellent river access for the shipping of goods. The factory to which the baroness refers in her inscription, and whose courtyard she depicts in this bird's-eye view, is probably the one owned by her father-in-law, Guillaume Hide, who was master of the iron forge and director of the royal factory of La Charité, which made buttons and hardware. The small town had become industrial in the mid-eighteenth century, and English developers hoped to make it the "Birmingham of France."[1]

The faience pot that the artist painted in the right foreground may have been produced by the La Charité-sur-Loire faience factory, which operated from 1802 to 1812. Francis Warburton, an English Staffordshire potter from a line of potters from Cobridge, founded this factory, which produced creamware—a refined, cream-colored earthenware with a lead glaze over a pale body, and frequently decorated.[2] The faience factory was headquartered in the Burgundian Romanesque remains of a powerful Benedictine priory, founded in 1059, as part of the Cluniac order. The abbey and town became a stop on the Romanesque pilgrimage route to Santiago de Compostela in Spain and in the sixteenth century a Huguenot safe haven.

As the artist's inscription narrates, the Neuvilles—fleeing for their lives in April 1805—left L'Estang and departed from La Charité-sur-Loire via the factory's river access and escaped down the Loire River. After arriving in Lyon, they lived in disguise from May through September in nearby Couzon, residing at the rented house "Fonbonne," where the baron called himself "Dr. Roland" and experimented with vaccinations for smallpox.[3] In the same year, Antoine Augustin Parmentier, Inspector-General of the Health Service, began the first mandatory campaign for smallpox vaccinations under Napoleon.

1. Albert Edward Mussan and Eric Robinson, *Science and Technology in the Industrial Revolution* (London: Gordon and Breach, 1969), 222.
2. See Bernard Guineau, *La manufacture de faïences fines de la Charité-sur-Loire (Nièvre), 1802–1812* (Charité-sur-Loire: Association des "Amis de la Charité-sur-Loire," 2004).
3. *Mémoires* 1888–92, 1: 398; *Memoirs* 1913, 1: 195.

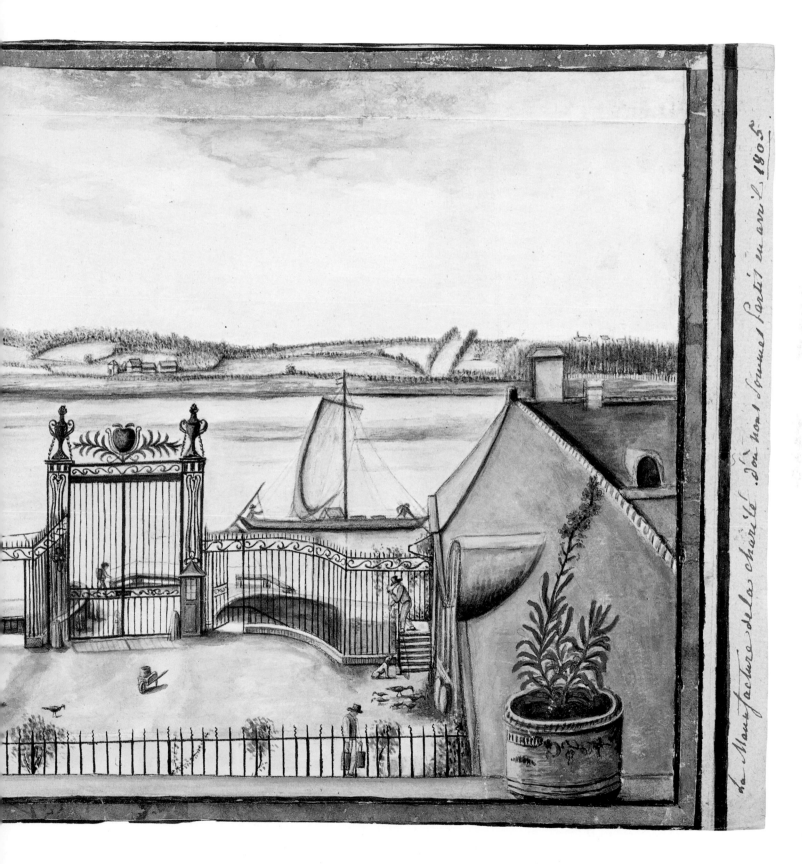

La Manufacture de la Charité, don't nous sommes sortis en avril 1805.

Young Boy at the Perle d'Or Inn, Vienna, Austria, 1805–06

Watercolor, graphite, black and brown ink, and black chalk on paper, laid on paper; 7 ¼ × 5 ½ in. (184 × 140 mm), irregular
Inscribed below in brown ink: *garcon D'Auberge de la Perle D'or Vienne 1806.*
N-YHS, PECO Foundation Fund for Drawings, 2018.21.2

In late 1805 or early 1806, at a crucial juncture in her life, the artist portrayed this unidentified young man, naming the location as the "Perle d'Or" inn in Vienna and dating the sheet 1806. She had traveled courageously without protection from Switzerland to the Austrian capital accompanied only by her lady's maid (*femme de chambre*), Mademoiselle Gai, to seek a pardon for her husband from Emperor Napoleon Bonaparte. Evidently the youth, probably an employee of the inn, had piqued her interest during her month-long wait for an audience with the emperor, which she finally obtained in late December. Neuville recorded the young man sitting on an Empire *chaise* and warming himself near a *kachelofen*, an Austrian Rococo faience stove. Henriette may have stayed in the inn mentioned in her inscription, the Golden Pearl, but this hotel cannot be traced through guidebooks of the time either in Vienna or near Schönbrunn Palace, Napoleon's headquarters. In the Vienna street directories of 1798 and 1816, however, there are listings of a certain Johann Prindel living at the sign of the "Goldene Perle" in the St. Ulrich district around the parish church of St. Ulrich and the Consolation of Mary, which may have been the site of the baroness's watercolor.[1] In any case, the sheet provides invaluable evidence of her pivotal Viennese residence after her approximately month-long journey—beginning in November 3, 1805, from Constance, Switzerland, where she left the baron, through Germany to the Austrian capital—as narrated by the baron with quotations from her letters in his *Memoirs*. In one letter, she mentions an unnamed inn opposite Schönbrunn.[2] By January 6, 1806, she was reunited with the baron at Constance (see appx. no. 18).

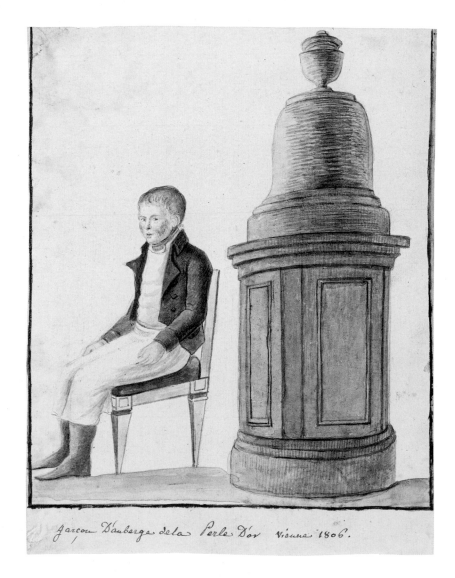

1. *Vollständiges Verzeichniss aller in der k.k. Haupt- und Residenz-Stadt Wien*, 1798, 202; ibid., 1816, 310, list the address as at 27 Gegen der Kirche (near the church). Thanks go to Sarah Kane for pointing out these directories.
2. *Mémoires* 1888–92, 1: 413; *Memoirs* 1913, 1: 206.

The First Sojourn and a Grand Tour of the Hudson and New York State

8

View of New York Harbor from the "Golden Age" with Sandy Hook Lighthouse, New Jersey, **1807**

Watercolor, black chalk, graphite, and brown and black ink on paper; 6 ⅜ × 9 ⅞ in. (162 × 251 mm)
Inscribed below in brown ink: *fanale de new-york 20 Juin 1807 .déssiné sûr L'âge D'or* [illegible] *americain (golden age)*
N-YHS, Purchase, 1953.272

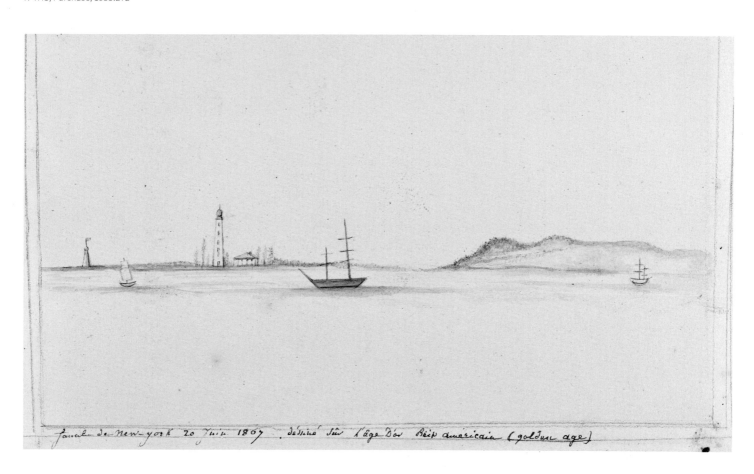

After a lengthy voyage of forty-nine days on the Atlantic Ocean from Cádiz, Spain, the American frigate *Golden Age* sailed into New York Harbor toward the Narrows on June 20, 1807. From this calm maritime view, one can sense the baroness's relief as the Neuvilles began a new life of promise in the United States. Certainly the auspicious name of their vessel, the *Golden Age*, augured good fortune for the couple. Looking across the lower harbor toward the sea, Henriette depicted Sandy Hook peninsula on the left and the area now known as Breezy Point, on Jamaica Bay, on the right. The Sandy Hook Lighthouse, built by Isaac Conro in 1764, still stands and is the country's oldest working light. Constructed to aid mariners entering the southern end of New York Harbor, it was initially called the New York Lighthouse because it was funded through a New York Assembly lottery and by a tax on all ships entering the Port of New York.

9

Hudson Highlands from Newburgh Bay, New York, **1807**

Graphite, gray watercolor, brown ink, and black chalk on paper; 7 ¼ × 13 ⅜ in. (184 × 340 mm)
Inscribed at lower right in brown ink: *view on hudson river taken from the albany Sloop diana / – october 1807 –*
N-YHS, Purchase, 1953.202

On July 10, 1807, a month after their arrival in America, the Neuvilles began their first extended excursion: from New York City to Albany, they explored the legendary sites of their new homeland. The baroness executed this plein air sketch on the couple's descending journey on the Hudson, at that time also called the North River. Within a little over a month, on August 17, the entrepreneur Robert Fulton would pioneer his revolutionary *North River Steamboat*, later renamed the *Clermont*, which ran between New York and Albany. The *Diana*, the Neuvilles' vessel, was a Hudson River single-mast sloop based on a seventeenth-century Dutch design, a type that had been the main means of transportation between the two urban centers for more than two hundred years. A journey via this mode of transportation could take anywhere from twenty-four hours for a fast trip to several days, depending on wind and weather conditions. In his *Memoirs*, Baron Hyde de Neuville wrote: "The Hudson River is very beautiful, truly imposing and its banks are as picturesque as they are romantic."[1]

The baroness drew her view of the Highlands at the Wind Gate, Butter Hill—now known as Storm King Mountain—which is on the right, while Breakneck Mountain is at the left. Her river landscape predates the panoramic vista of the river that Captain Joshua Rowley Watson painted in a watercolor of 1816 (fig. 28).[2] Most importantly, her landscape foreshadows scenes in the iconic *Hudson River Portfolio* (1820–25) engraved by master printmaker John Hill (fig. 32) after original watercolors by the Irish-born William Guy Wall (fig. 10).[3] In fact, her sketch is close in spirit to one of Wall's on-the-spot preliminary studies for his more finished watercolors (fig. 48). From her inscription and the work's vantage point, Henriette at least began it on board the *Diana* in transit down the river, which adds to its immediacy.

1. *Mémoires* 1888–92, 1: 452 (quotation translated from the French).
2. See Foster 1997; Olson 2008, 112–115.
3. Eight preparatory watercolor models survive by Wall for the twenty plates of *The Hudson River Portfolio*. These models are held by the N-YHS; see Olson 2008, 166–168.

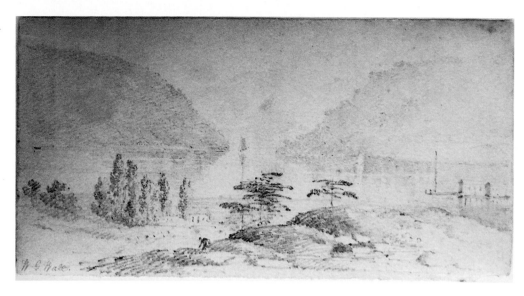

Fig. 48
William Guy Wall, *Landscape of the Hudson River*, ca. 1818–20. Graphite on heavy paper; 4 ³⁄₈ × 8 ³⁄₁₆ in. (111 × 208 mm). N-YHS, Gift of Mr. Whitney Hartshorne, 1979.45

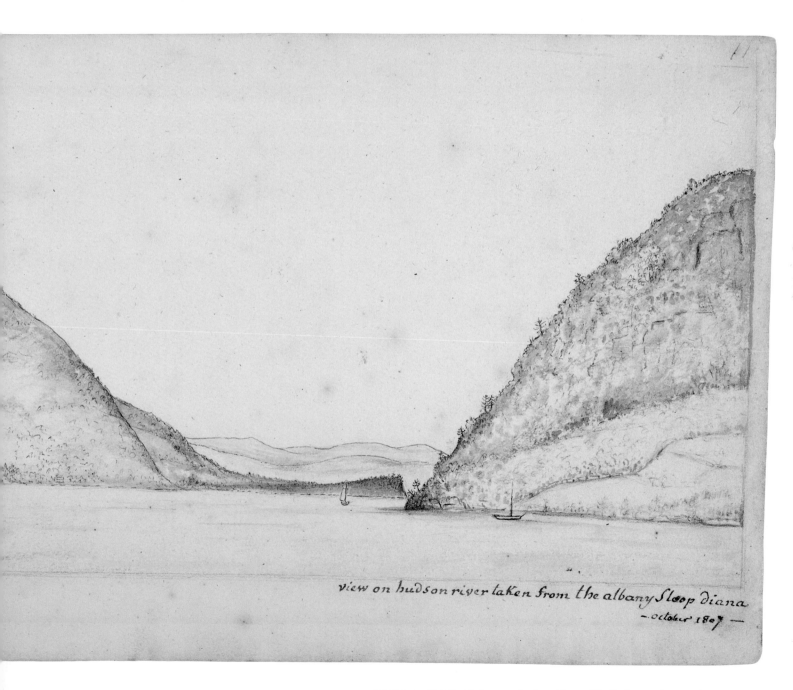

view on hudson river taken from the albany Sloop diana
– october 1807 –

Major van Rensselaer's House "Crailo" near Albany, New York, 1807

Watercolor, brown ink, graphite, and black chalk with touches of white gouache on paper; 7 ⅜ × 6 ⅛ in. (187 × 156 mm)
Watermark: J W[HATMAN]
Inscribed at lower left in brown ink: *view of major rensselaer's house near albany. 1807.*
N-YHS, Purchase, 1953.221

This watercolor is the first known record of the Neuvilles' trip up the Hudson River to Albany, judging by the sloop heading south past the Rensselaer house shown here and the likelihood that the couple's vessel was passing it on the right, and thus was northbound. From the deck of the sloop, Henriette delineated the brick manor house named "Crailo," which still exists today in much the same condition, minus the small white front porch (fig. 49). "Crailo," from a Dutch word meaning Crow's Woods, refers to the family's eponymous estate in Holland. At the time of the Neuvilles' journey, the house belonged to John Jeremias van Rensselaer—a military figure, politician, and reformer, who descended from Hendrick van Rensselaer, the builder of the residence in 1707. For the baroness, the house was a landmark of newly minted America, and it is interesting to note that

the verses for the song "Yankee Doodle" were composed on this spot in 1758.[1] Today, the site is a National Historic Landmark, operated by the State of New York as a museum of colonial Dutch culture.

For this watercolor the baroness used the finest watercolor paper of the time, which bears the watermark either of J WHATMAN or J WHATMAN TURKEY MILL, two related English mills. The sheet's partial mark proves that it was cut from a larger sheet of the costliest English wove paper available (see cat. no. 11).[2]

Fig. 49
"Crailo" State Historic Site, Rensselaer, New York

1. Koke 1982, 2: 196.
2. See Bower 1996, 61–74; Balston 1998, 247–249, 251–253.

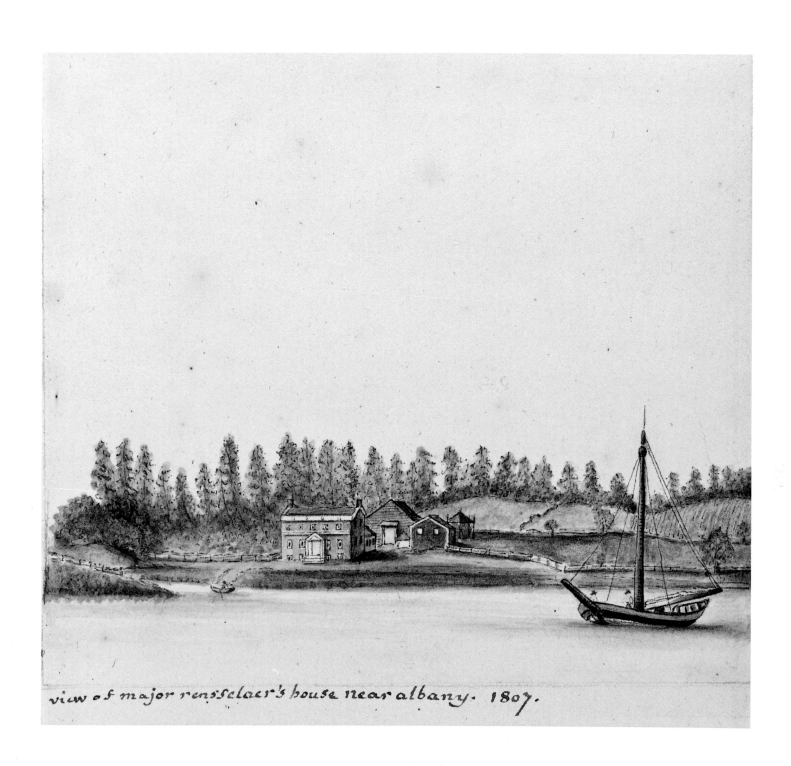

view of major rensselaer's house near albany. 1807.

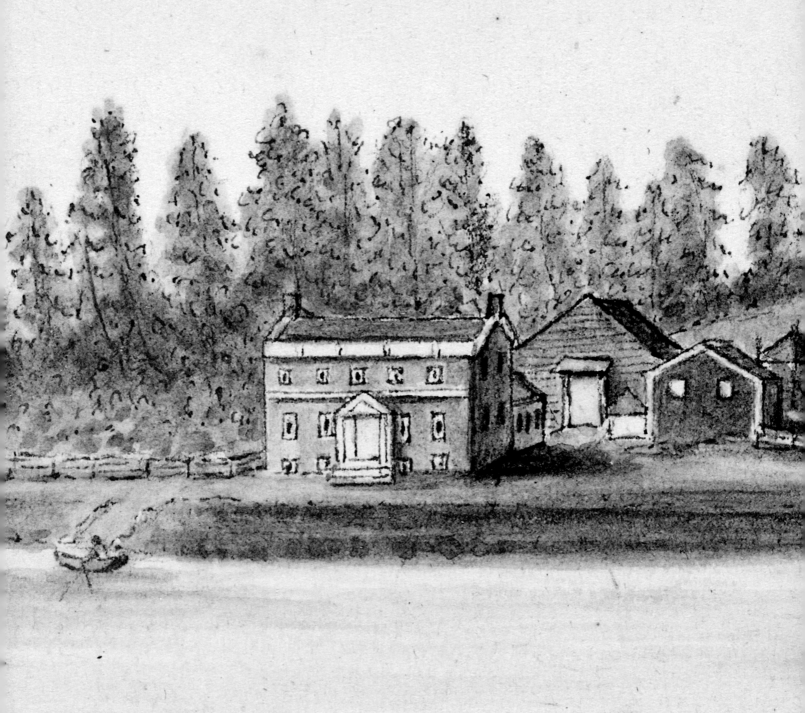

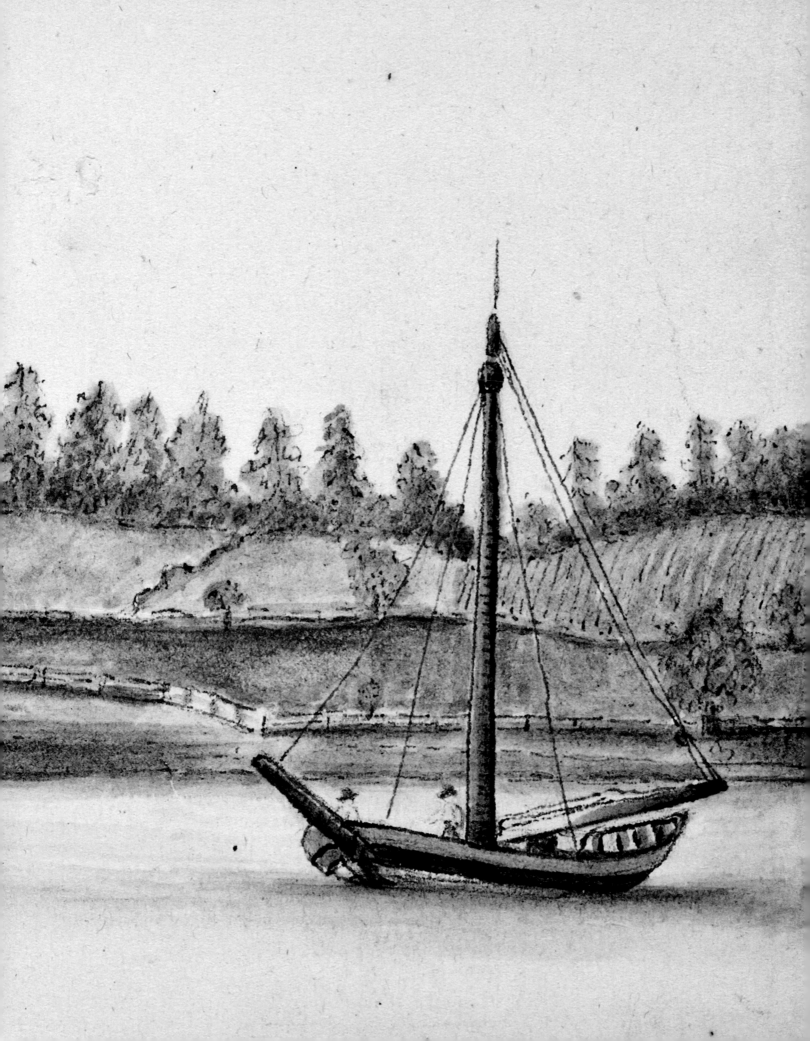

11

Distant View of Albany from the Hudson River, New York, 1807

Watercolor, brown ink, black chalk, and graphite with touches of gouache on paper; 7 ¼ × 7 ½ in. (184 × 190 mm)
Watermark: [J] WHATMAN / 1801
Inscribed at lower left in brown ink: *distant view of albany october 1807.*
N-YHS, Purchase, 1953.242

Neuville drew this panoramic view from the Hudson River sloop *Diana*,[1] which in October of 1807 carried the couple downriver to New York City from Albany, seen on the left, after their first exploratory trip in their country of exile. In her atmospheric vista, here seen in a detail, Henriette has conveyed with great immediacy the majestic sweep of this formidable body of water, together with reflections on the water's surface.

Albany, founded as the Dutch city of Beverwijck, is 150 miles north of New York City. At the time of the Neuvilles' visit, the city was one of the ten most populous in the United States and had been made the New York State capital in 1796. It was strategically positioned at the northernmost navigable point on the river, ten miles south of its confluence with the Mohawk River.

Like cat. no. 10, the sheet bears a partial, dated watermark WHATMAN 1801, indicating it was cut from a larger sheet of the finest and most expensive English wove paper sold at that time, the product of one of the two related English paper mills with their own watermarks: J WHATMAN and J WHATMAN TURKEY MILL.[2] Their smooth-surfaced, hot-pressed finish without discernible grain made them ideal for painting in watercolor. Neuville's choice of such high-end artists' paper for her limpid landscape and other works (cat. nos. 10, 11, 19, 24, 26, 77) demonstrates the ambitious nature of her visual diary.

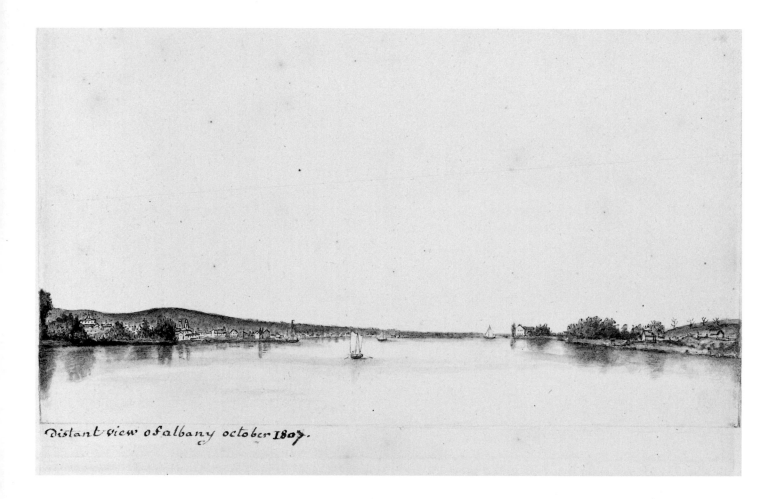

distant view of albany october 1807.

1. See inscription on cat. no. 9.
2. See Bower 1996, 61–74; Balston 1998, 247–249, 251–253.

"Dutch Houses" on State Street, Albany, New York, 1807

Watercolor, black chalk, graphite, and brown ink on paper; 5 ½ × 7 in. (140 × 178 mm)
Inscribed below in brown ink: *Dutch-houses, State Street albany october – 1807 –*; below two figures: *L'Ecorcheur gré . . .*
N-YHS, Purchase, 1953.229

Underscoring the baroness's unique choices of subjects is her one-of-a-kind record of two Dutch commercial structures in the oldest part of Albany, a warehouse and a store, on one of the town's main streets leading to the State Capitol building. The work also demonstrates Neuville's powers of observation: note the open shutter, as well as the characteristic crow-stepped gables and the hearts decorating the pink building at the right, which may have been a store with a residence above.[1] The stepped gable testified to Albany's Dutch background and typified the Dutch colonial houses that prosperous merchants built in America in imitation of those in Amsterdam, Utrecht, and Leiden. At the right, Henriette represented two figures standing before a pavilion sketched in graphite. As

suggested by the artist's incomplete inscription below, they may have been involved in a commercial negotiation. She also inscribed a signboard on the building at the right *IZ. TOWSED. STORE*, identifying the commercial property that had passed to Isaiah Townsend by 1803. Townsend and his brother were two important Albany merchants.[2] The structure on the left, whose sign she inscribed as *W. CODWEL WARE HOUSE*, was owned by William Caldwell, scion of one of the most successful retail merchants in Albany and an early developer of the Lake George area.[3] Since many of the buildings erected by the early Dutch settlers were destroyed in a series of fires during the early nineteenth century, Henriette's watercolor constitutes an important record of Albany's lost architectural heritage.

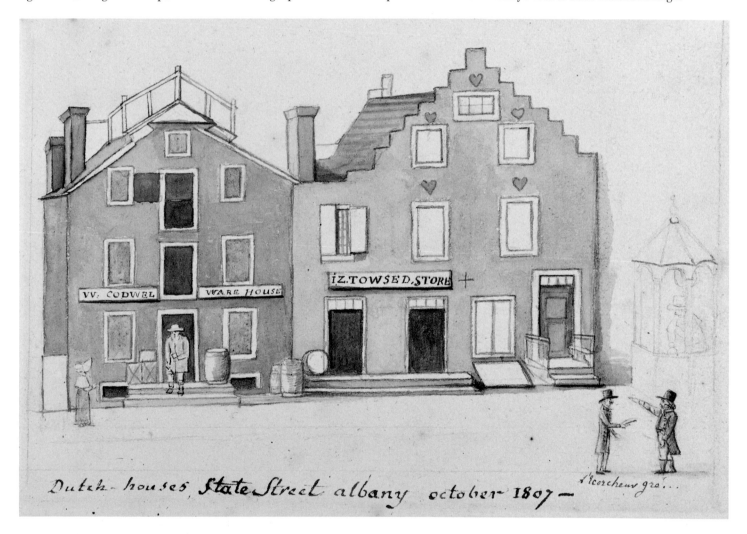

1. Koke 1982, 2: 196, identifies them as 60 and 62 State Street.
2. http://www.nysl.nysed.gov/msscfa/sc10441.html (accessed May 2018).
3. http://www.nysl.nysed.gov/msscfa/sc20327.htm (accessed May 2018).

Adolphe, Age 13 Years, from Guinea; Mount Marino Summer House near Sans Souci, Ballston Springs, New York, 1807

Watercolor, graphite, and black chalk on paper; 6 ⅞ × 13 in. (175 × 330 mm)
Inscribed at lower left in brown ink: *adolphe agé de 13 ans né a la côte de guinèe conduit à cayenne / acheté par mr. viguè, a retrouvé à ballston Spring ou nous etions avec / Son maître, Le capitaine negrier qui la apporté d'afrique.*; at lower right: *mount-marino Summer-house adjoining the Sans Souci hotel en ballston Spa. 1807*
N-YHS, Purchase, 1953.204

Unfortunately, we know nothing about thirteen-year-old Adolphe—whom the artist portrayed at the left of the sheet—beyond what her confusing inscription tells us. He was born on the Guinea coast and taken to Cayenne (in French Guiana); bought by Mr. Vigué, and brought to Ballston Springs, where the Neuvilles were staying with his master, the slaver captain who brought him from Africa. The baroness portrayed Adolphe sympathetically, seated on a trunk to emphasize his transient condition, with which she must have identified. On the right two-thirds of the paper, she depicted a summerhouse named Mount Marino, built in the local architectural style of domestic buildings in Ballston Springs (fig. 11). On its grounds, she recorded two gazebos and in the foreground a coach drawn by four horses.

Today, Ballston Springs is known as Ballston Spa. The town lies about 180 miles north of New York City and five miles from Saratoga. Originally a health resort, in the early eighteenth century it attracted people from around the world who gathered there to drink from its mineral springs, which were believed to have healing powers. At the beginning of the nineteenth century, the then-largest hotel in the world, the Sans Souci (1803–87), stood on Front Street. European royalty and the wealthy from many continents visited the

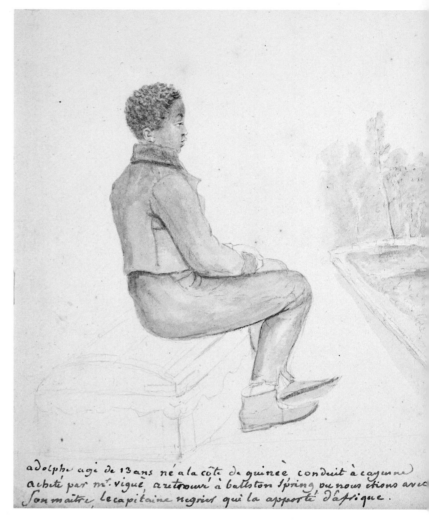

Fig. 50
William Strickland, *View of Ballston Springs, New York, Through the Trees,* ca. 1794. Watercolor, black ink, and graphite on paper; 11 ½ × 17 ⅜ in. (292 × 442 mm), irregular. N-YHS, Gift of the Reverend J.E. Strickland, 1956.145

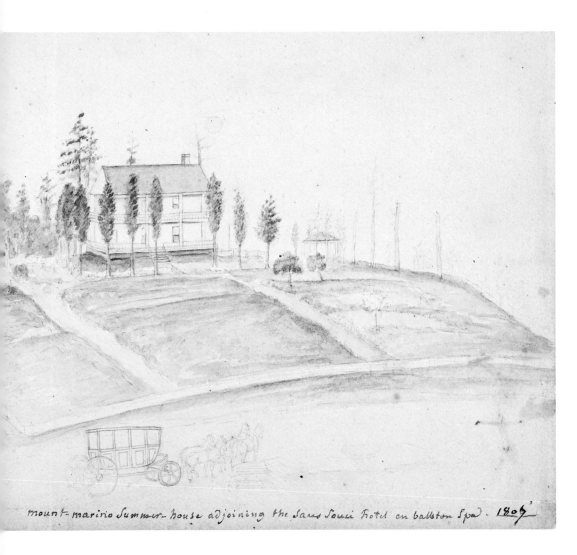

mount-maririo Summer-house adjoining the Sans Souci Hotel en ballston Spa. 1809

hotel and the springs on a regular basis. Around 1807, when the Neuvilles visited, Ballston had a population of about 2,100 people and consisted of approximately 150 households, a considerable number of stores, and other service buildings.

Flowing through the village of Ballston Springs, and dividing it into north and south ends, was the Kayaderosseras Creek. Developers soon utilized the creek's waterpower and built mills and factories near the village. Later, when the railroad entered the scene, the village gradually evolved from a tourist mecca into a full-blown manufacturing town.

Already settlement was leveling the woodlands, as seen in a view of Ballston Springs by the British traveler and aristocrat William Strickland, who decried the wasteful American process of girdling trees to kill them and to easily clear land (fig. 50).[1] Similarly, the baroness depicted the once-forested area of the town (fig. 11) rather than its high-end spa and hotels, glimpsed through the trees in Strickland's watercolor. The baron also criticized the abuse of nature by settlers felling trees, but nevertheless remarked that "this is a land truly full of miracles."[2]

1. Olson 2008, 73–75.
2. *Mémoires* 1888–92, 1: 455; *Memoirs* 1913, 1: 234.

Indian (Oneida or Mohawk?) Woman of Ballston Springs, New York, 1807

Graphite and gray watercolor on paper; 8 ⅛ × 6 ⅜ in. (206 × 162 mm)
Inscribed at lower right in brown ink: *Sauvage de Balston Spring. 1807. Juillet.*
N-YHS, Purchase, 1953.216

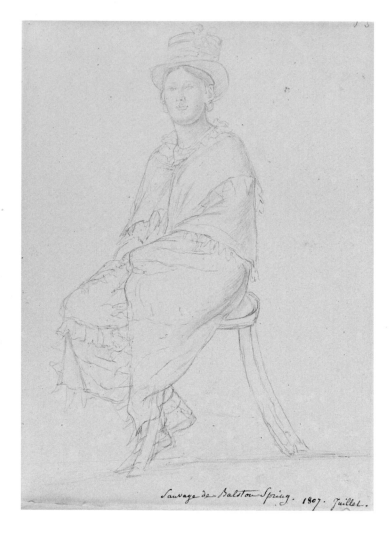

The artist's drawing style in this sheet resembles that of the Neoclassical portraits of Jacques-Louis David,[1] as well as the early, linear portraits of his pupil Jean-Auguste-Dominique Ingres.[2] Neuville doubtless knew the draftsmanship popularized by these iconic French artists of her time. Here she employed it to portray this majestic woman, whose powerful presence caught her eye at Ballston Springs. Unfortunately, she did not identify the woman's tribe (although she did for some sitters in other inscribed drawings), merely indicating that she delineated the portrait in Ballston Springs. At the time, the Mohawk and Oneida were part of the Iroquois Confederacy—also known as the Six Nations or Haudenosaunee—and were all present in the Ballston Springs area. Like many of her peers, Henriette's sitter wears a combination of European clothing—ruffled dress and a high hat embellished with insouciant ribbons—and more traditional Indian articles, such as moccasins, deer or elk leggings, and a blanket robe. The hanging chevron border of her blanket, similar to the ones Henriette rendered in cat. no. 21, identifies the sitter as possibly belonging to one of the same tribes, the Mohawk or Oneida. The baroness also portrayed the woman in a bust-length watercolor (cat. no. 15).

This sheet is highly significant, because it is the only work by Henriette that the baron mentions in his *Memoirs.* Writing at Ballston, he casually noted that at that very moment, "Madame de Neuville" was drawing a buxom young woman of the "country of Atala"—a reference to the romantic novel *Atala* by their lifelong friend François-René de Chateaubriand. The novel *Atala,* which concerns the quasi-fictional Natchez Indians of the Lower Mississippi River, was published in 1801. Whereas Henriette appreciated her sitter's monumentality and costume, the baron claimed that her subject lacked the supposed charm and grace of Atala and other Natchez lauded by the French romantic author, who had visited the United States in 1791 and would publish his *Voyage en Amérique* in 1826.[3]

1. See Pierre Rosenberg and Louis-Antoine Prat, *Jacques-Louis David: Catalogue raisonné des dessins,* 2 vols. (Milan: Leonardo arte, 2002).
2. See Orsanmichele, Florence, *Ingres e Firenze,* exh. cat. (Florence: Centro Di, 1968), 9, 11, 12, 13–17, nos. 8, 10, 11, 13–16, ills. See also Gary Tinterow and Philip Conisbee, eds., *Portraits by Ingres: Image of an Epoch,* exh. cat. (New York: Metropolitan Museum of Art, 1999), for early portraits before 1807.
3. *Mémoires* 1888–92, 1: 453–454; *Memoirs* 1913, 1: 454. For the author's U.S. travels, see François-René de Chateaubriand, *Chateaubriand's Travels in America,* trans. Richard Switzer (Lexington: University Press of Kentucky, 2015), which suggests that the America Chateaubriand portrayed was much more a product of his imagination than of his actual visit.

Bust of an Indian (Oneida or Mohawk?) Woman of Ballston Springs, New York, 1807

Watercolor, graphite, and black chalk with touches of gouache and black and brown ink on paper; 7 ¼ × 5 ¾ in. (184 × 146 mm)
Inscribed at lower center in brown ink: *Sauvage de Balston Spring.*
N-YHS, Purchase, 1953.217

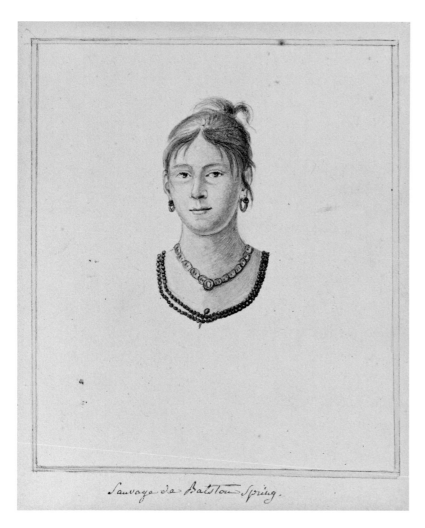

The watercolor's inscription is nearly identical to that of cat. no. 14 and depicts the same American Indian woman, who clearly impressed the baroness. The sitter has shed her high hat and outerwear, including the blanket robe that suggests she may be either Oneida or Mohawk.[1] In both works, she sports an identical necklace at the base of her throat and hoop earrings, both with metal, here described in more detail and in color. In addition, her long double-stranded, reddish bead necklace, fastened with a pin, is visible. In this immediate, close-up portrait, Neuville zeroed in on her face, and depicted her naturalistically, without idealization. Nevertheless, because of her naïve dignity the sitter seems to embody the French literary concept of the noble savage often associated with the *philosophe* Jean-Jacques Rousseau and his *Discourse on the Origins of Inequality Among Men* (1754), although he never used the term to glorify the "natural life." Rousseau was not the first person associated with the stock literary character of the noble savage (*bon sauvage*), whose roots are ancient. As early as the sixteenth century it appears in French literature with Jacques Cartier, the colonizer of Québec, who used it when speaking of the Iroquois, and in English with John Dryden's heroic play *The Conquest of Granada* (1672).[2]

1. Fenton 1954, 126, identifies her as probably a Mohawk, Stockbridge, or Onondaga.
2. For a discussion of the complicated character of the noble savage associated with primitivism, see Ter Ellingson, *The Myth of the Noble Savage* (Berkeley and Los Angeles: University of California Press, 2001).

16

View of Utica from the Hotel, 1807

Gray-brown ink and wash and graphite on paper; 7 5/16 × 12 15/16 in. (186 × 329 mm)
Inscribed at lower right in brown ink: *view of utica from the hotel September 1807.*
New York Public Library, The Miriam and Ira D. Wallach Division of Art, Prints and Photographs: Print Collection, Stokes 1807-E-16b

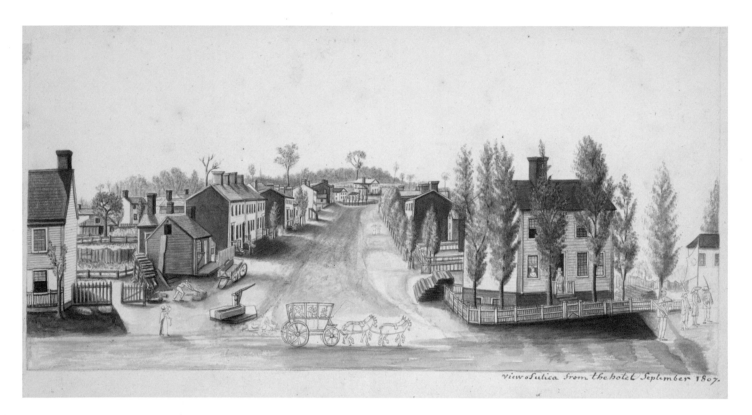

The city of Utica, New York, is located on the Mohawk River in the Mohawk Valley about eighty miles northwest of Albany. When Henriette drew this sheet, Utica was already an expanding village, which would develop rapidly after the opening of the Erie Canal in 1825. Her view, taken from the Holland Land Company Hotel (see cat. no. 17), on the corner of Whitesboro and Hotel streets, looks down a foreshortened Hotel Street and constitutes one of her most ambitious and successful perspectival exercises.[1] The buildings in the right foreground are on the south side of Whitesboro Street. In the center, the baroness lightly sketched in graphite a coach filled with passengers that not only enlivens the scene, but also footnotes the couple's mode of transportation to Utica. It also prevents the viewer's eye from shooting down the perspective orthogonals formed by Hotel Street. At the vanishing point, Henriette drew a house and above it a tree to stop the viewer's gaze, underlining the fact that she was acquainted with the laws of linear perspective, which she rarely employed. Throughout her oeuvre, Neuville demonstrated an interest in modes of transportation, bridges, and engineering technology, combined with a general curiosity about the manner in which the newly minted country was being settled.

1. Deák 1988, 1: 168–169.

17

Holland Land Company Hotel, Utica, New York, 1807

Graphite, black ink, and gray watercolor on paper; 7 ¼ × 7 ⅞ in. (184 × 200 mm)
Inscribed at lower right in brown ink: *utica – 7bre 1807.*
N-YHS, Purchase, 1953.236

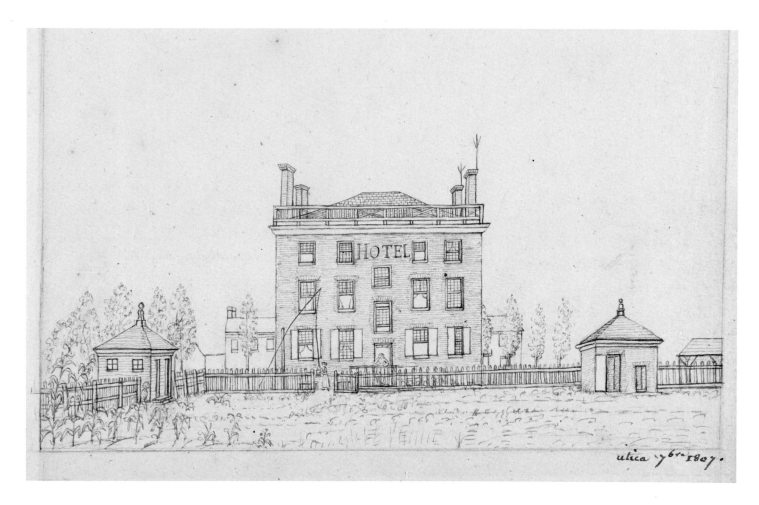

Samuel Hooker and John Hooker, father and brother of the architect Philip Hooker, designed the Holland Land Company Hotel in 1797. It was erected by Gerrit Boon, agent for the Holland Land Company, an unincorporated syndicate of thirteen Dutch investors from Amsterdam that had purchased the greater two-thirds of the vast Phelps and Gorham Purchase of land between 1792 and 1793. The three-story yellow brick building was the first brick structure in the village and stood on the corner of Whitesboro and Hotel streets on the banks of the Mohawk River (see cat. no. 16). In 1805, an unnamed Polish traveler called it a "magnificent hotel," perhaps entranced by the beautiful ballroom on the second floor, which was the site of many fashionable events.[1] In her drawing of its façade, whose blank upper and lower registers are cropped, Henriette included telling details about its architectural features and its grounds and outbuildings, including two lightning rods sprouting from its chimneys. She also recorded the lettering "HOTEL" that had been chiseled above its door in 1798, and that, according to a writer in 1896, "no amount of paint has been able to cover up."[2] Before the War of 1812, the building became the privately owned York House, and later the Atlantic Hotel, prior to its being demolished sometime after 1900.

1. Koke 1982, 2: 192–193.
2. Daniel E. Wager, *A Descriptive Work on Oneida County New York* (Boston: Boston History Company, 1896), 66. See also Blandina Dudley Miller, *A Sketch of Old Utica*, ed. Helen Lincklaen Miller (Utica, NY: L.C. Childs and Sons, 1913), 19–21.

"An Indian and his Squah," after a Print; Utica Church, Utica, New York;
verso: sketch of Niagara Falls (American and Bridal Veil Falls), 1807

Watercolor, black ink, black chalk, and graphite with touches of white gouache on paper; graphite; 6 ⅝ × 13 ⁵⁄₁₆ in. (168 × 338 mm)
Inscribed at lower left in brown ink: – *an indian and his Squah* –; at lower right: *utica church 1807.* –; verso inscribed in graphite with notes
N-YHS, Purchase, 1953.226

Early European perceptions of Indigenous Americans were influenced by ancient myths and preconceptions. One theory that lasted for three hundred years had its inception with Ferdinand Magellan and his entourage's voyage of 1522 and their description of South American Indians as "giants."[1] When the baroness arrived in America, there were no widely disseminated prototypes for representing American Indians, and she is among the first early-nineteenth-century artists to bring an ethnographic interest to bear on their representation—long before Charles Bird King, George Catlin, and Karl Bodmer.

In the left vignette on this sheet, Henriette used for a prototype an engraved frontispiece entitled "Sailor giving a Patagonian Woman some Biscuit for her Child," from the book *A Voyage Round the World*, published in 1767 and reissued in subsequent decades.[2] This volume is an account of Commodore John Byron's voyage of 1764–66 around the world on the ships *Dolphin* and *Tamar*, and his encounters with the South American Indians ("giants") of Patagonia in the region of the Straits of Magellan.[3] Since Neuville reversed the image of the Indian family, she must have consulted the frontispiece in a later edition, possibly the French one, published in Paris in 1807, the same year that she dated her drawing. The engraving includes an English sailor at the left, whom the baroness omitted. In his place she began but abandoned a quick sketch in graphite of another Indian.

Opposite, on the right half of the sheet, Henriette depicted an unrelated scene set in a recently cleared landscape with a few young trees. It includes the Trinity Protestant Episcopal Church, erected in Utica in 1803 from a design by Philip Hooker. The building stood at the corner of Broad and First streets until its demolition in 1927. To the right of the church, Neuville drew a small log cabin with a fenced yard that probably served as the rectory. Since churches were frequently the first large structures erected in villages in western New York and the baroness was a devoted Christian, it is not surprising that she recorded this local landmark.

On the verso of the sheet, the baroness delineated Niagara Falls, which the couple visited after departing Buffalo on September 1, 1807. She captured the majestic power of the American falls, including the Bridal Veil Falls, in this quick sketch made in situ. From her color notes inscribed in graphite, one wonders whether she used this study to execute a more finished watercolor on another sheet, but such a sheet is unknown today.

1. Antonio Pigafetta, *Magellan's Voyage: A Narrative Account of the First Circumnavigation*, trans. R.A. Skelton (New Haven: Yale University Press, 1969), 1: 46–47, 50.
2. "By an Officer on Board the Said Ship," *A Voyage Round the World in His Majesty's Ship The Dolphin, Commanded by the Honourable Commodore Byron* (London: Printed for J. Newbery, in St. Paul's Church-Yard; F. Newbery, in Pater-Noster Row, 1767), frontispiece. See https://archive.org/details/A020088/page/n5.
3. Sturtevant 1980, 331–338; Koke 1982, 2: 194.

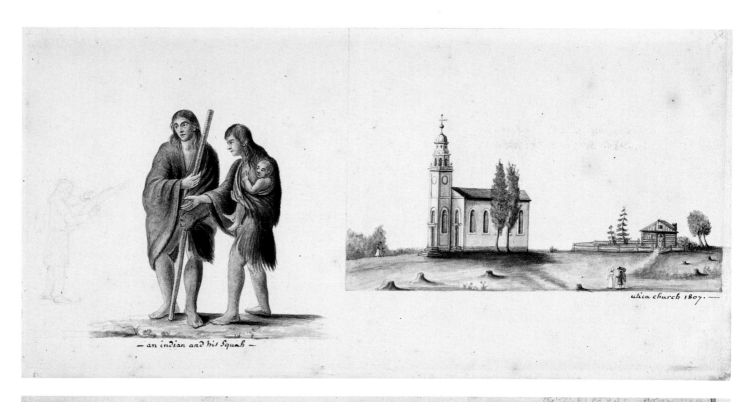

—an indian and his Squah—

utica church 1807.

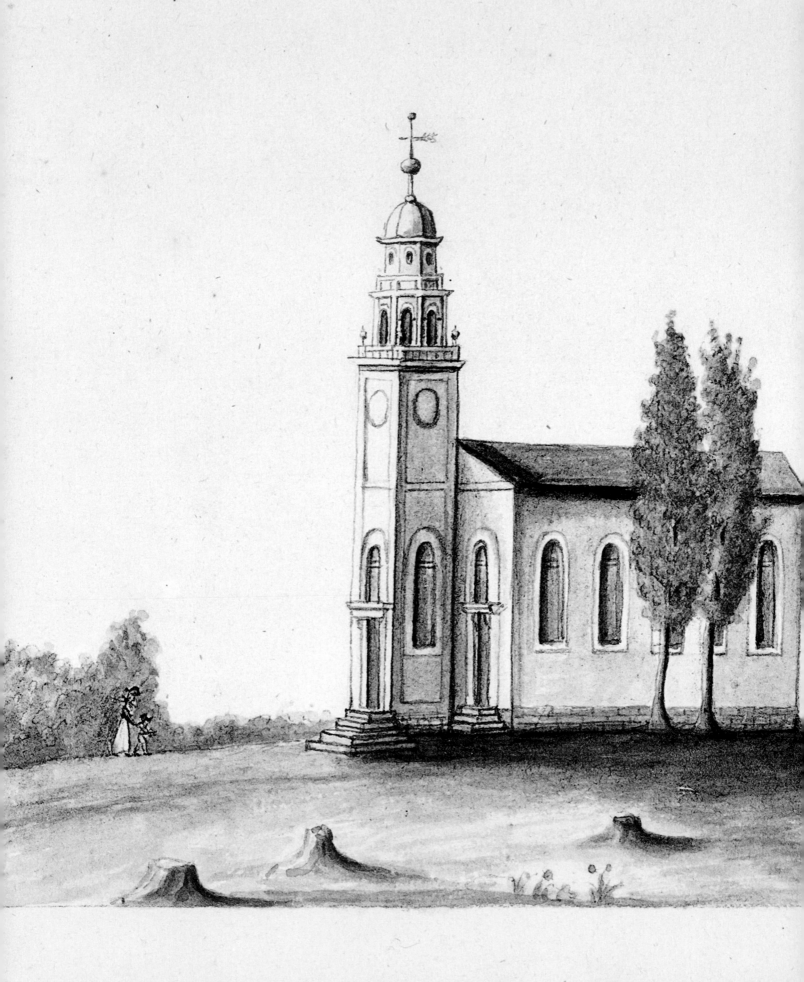

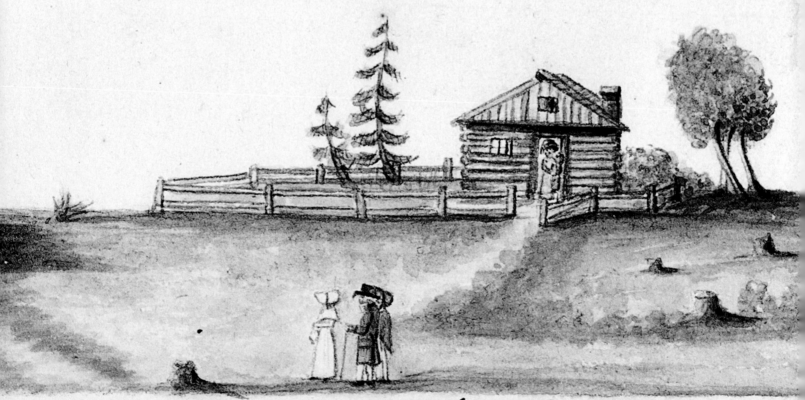

utica church 1807.

19

Mary, a "Squah" of the Oneida Tribe, 1807

Graphite, black chalk, and watercolor on paper; 7 ⅜ × 6 in. (187 × 152 mm)
Watermark: J W[HATMAN]
Inscribed at middle left in brown ink: *mary, Squah of / the oneida tribe = / utica 7bre 1807.*
N-YHS, Purchase, 1953.207

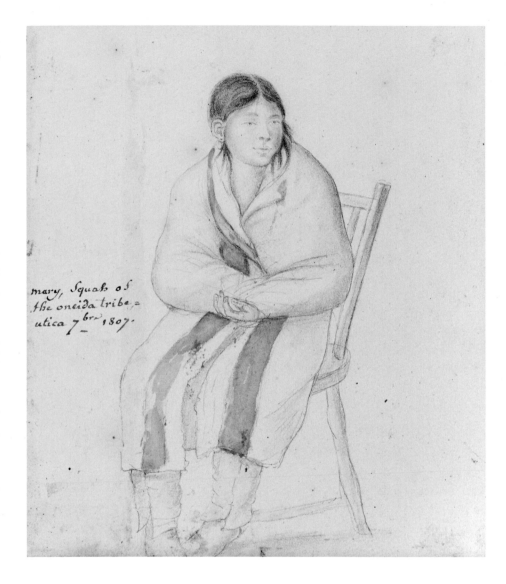

The baroness identified the American Indian woman she depicted in the watercolor as "Mary," belonging to the Oneida tribe. Her clothing—a trade blanket robe with a green stripe and leather leggings, probably deer or elk—suggests that three of the baroness's other drawings of similarly dressed figures may represent members of that tribe (cat. nos. 14, 15, 21).

By further labeling her portrait of Mary with the phonetically spelled term "Squah," the artist attempted to employ an authentic ethnographic term, one historically used for Indigenous North American women.[1] Its use, especially by non-Native Americans, is now considered derogatory and highly offensive, an ethnic and sexual slur. Originally, the term may have derived from Eastern Algonquian language components meaning "woman," which were transliterated into English.[2]

1. For example, François Jean de Beauvoir, Marquis de Chastellux, *Travels in North-America, in the Years 1780, 1781, 1782* (London: G.G.J. and J. Robinson, 1787), 1: 402, used the word thusly: "Beside the savage who spoke French, in this hut, there was a *Squah*, the name given to Indian women. . . ."
2. For a current assessment of this complicated term and its derogatory usage, see https://en.wikipedia.org/wiki/Squaw (accessed May 30, 2018).

Geneva, New York, with a View of Seneca Lake, 1807

Watercolor, graphite, and black chalk with touches of brown ink on paper; 7 × 10 ¼ in. (178 × 260 mm)
Inscribed at lower left of center in brown ink: *vue de geneva et du lac Seneca*; at lower right: *7bre 1807*.; four illegible color annotations in graphite in foreground
N-YHS, Purchase, 1953.228

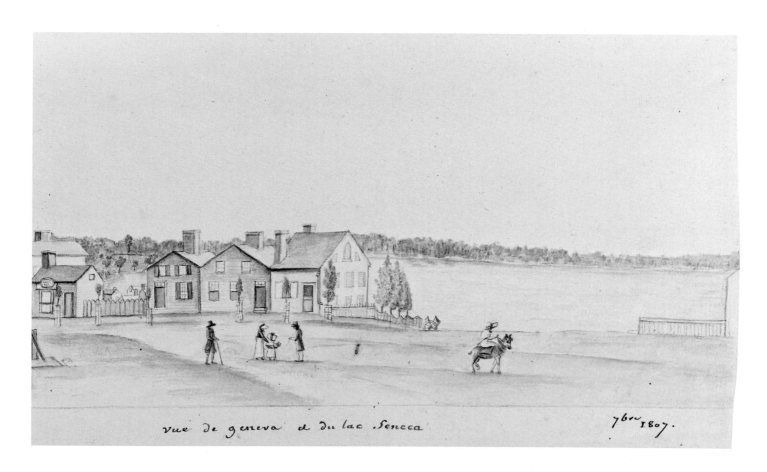

When she drew this sheet, the baroness was in Geneva, New York, on what is now Exchange Street, looking east toward the boat landing on Seneca Lake. Her watercolor ranks as one of the earliest views of the village.[1] Geneva is located in the western part of New York State in the territory of the Seneca tribe, who called it "Kanadesaga." Incorporated in 1806, the village is geographically positioned on the northern outlet of Seneca Lake, the largest of the glacial Finger Lakes in central New York State.

1. Koke 1982, 2: 195, believes it is the second earliest view of the village.

Indian (Oneida, Mohawk, or Seneca?) Family; verso: sketch fragment, 1807

Watercolor, graphite, black chalk, and brown and black ink with touches of gouache on paper; graphite; 5 5/16 × 7 9/16 in. (135 × 192 mm), irregular
Watermark: AMIES
Inscribed at lower left in brown ink: *Envoyé à Mde Boisgrand.*; scratched out inscription at lower right in brown ink: . . . [illegible] *Md S*
N-YHS, Purchase, 1953.215

This processional image is the most complicated of Henriette's fourteen depictions of Indigenous Americans in the Historical Society's collection. She portrayed three adults and three children, two of whom are papooses (from the Algonquian word "papoos," meaning small child), on a September day in 1807. The watercolor has three summary ground lines, which may indicate three different vignettes or, alternatively, the spaces that the six individuals occupy. They are members of one of the western New York tribes, which belonged to the formidable Iroquois Confederacy that had been largely displaced by this time.[1] The male at the right—wearing a scalp lock, nose ring, fur piece on his shoulders, feather headdress, and earrings—looks back over his shoulder. He carries a bow or spear, the spoils of the hunt, perhaps a small deer, and wampum. The two women wear blanket robes with a blue or greenish gray stripe and chevron borders, which also cover their heads. Each has a papoose on her back, carried in a pack frame with burden straps, foreshadowing the later cradleboard. They are accompanied by an older child at the left, adorned with earrings and, like the infants, a scalp lock.[2] All the walking figures wear moccasins and leather leggings tied with garters and ankle straps, about which the baron comments in his *Memoirs*.[3] A floral design decorates the instep of the mature male's moccasins.

The Neuvilles' interest in the various tribes of Indigenous Americans in the Hudson River region and western New York arose as much from their own curiosity as from conversations they had with François-René de Chateaubriand in Cádiz, Spain, before their departure for the New World. The author had visited America earlier and would become a lifetime friend. The baron commented patronizingly in his *Memoirs* on the impressions of the "noble savages" that Chateaubriand's romantic novel *Atala* (1801) had established in some European imaginations.[4] The baron found many to be inebriated and indolent, and their lodgings unkempt, but later he modified this opinion.[5] After the couple had visited Geneva, Batavia, and Buffalo, he praised American Indians and their attire as that of "beaux sauvages."[6] In discussing the division of labor in a family, the baron noted that the females, not the males, did most of the work, cultivating the earth and carrying heavy burdens on their backs.[7] Henriette's watercolor, by contrast, does not complement her husband's observations: instead she represents the women encumbered by babies, and the male, who moves more quickly ahead, as having hunted successfully. In contrast to the vacillating views of her spouse, her interpretations are ultimately sympathetic, inquisitive, and free of any sense of cultural superiority.

1. For Samuel Kirkland's experiences with the Oneida after dealing with them for nearly forty years, see Fenton 1954, 122, who explains in part how the once "noble savage" had fallen from his regard.
2. Fenton 1954, 131, and Koke 1982, 2: 194–195, have interpreted this watercolor as representing two views of the same female (and mother of the family). Fenton comments about the manner in which the papooses are shown as being transported: "most unusual is the arrangement of burden strap and pack-frame, which suggests that the cradle-board came much later."
3. *Mémoires* 1888–92, 1: 459; *Memoirs* 1913, 1: 236. The baron calls them "buckskin shoes."
4. *Mémoires* 1888–92, 1: 458–459. Chateaubriand, like the baron, was an ardent royalist.
5. *Mémoires* 1888–92, 1: 460; *Memoirs* 1913, 1: 236.
6. *Mémoires* 1888–92, 1: 460.
7. Ibid., 458.

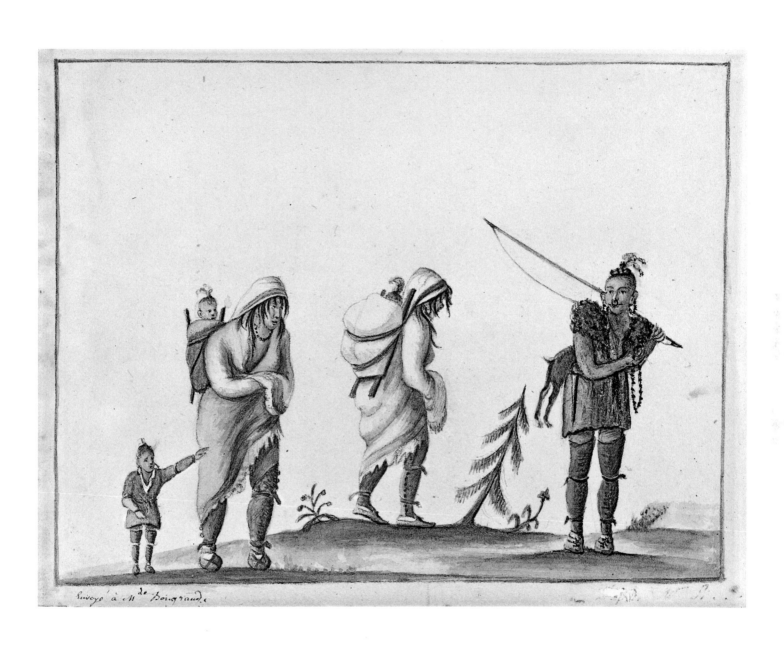

Envoyé à M. de Boingraud.

Church, Amsterdam, New York, 1808

Watercolor, gouache, graphite, black chalk, and brown and black ink on paper; 6 ⅛ × 7 ⅛ in. (156 × 181 mm)
Inscribed at lower right in brown ink: *amsterdam church (montgomery county / may 1808 –*
N-YHS, Watson Fund, 1967.5

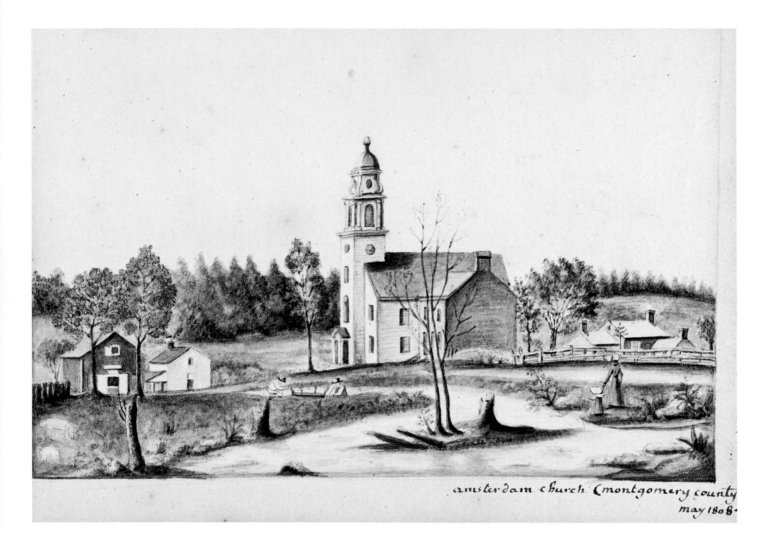

In this watercolor Henriette depicted the Dutch Reformed Church of Amsterdam, a town originally named Veddersburg (Veedersburg), as explained in cat. no. 23, and located near Utica. In 1800, the congregation, which was first organized in 1792 but lacked its own edifice, erected a sanctuary about three miles from Amsterdam at Manny's Corners. However, the village members were dissatisfied with this remote location and therefore the same year built another church on the northwest corner of Main (West Main) and Pleasant (Market) streets in the village, which was known as the Dutch Reformed Church of Veddersburg.[1] Although it was constructed of wood, as evident in Neuville's watercolor, its architectural style, especially the rhythm of its steeple silhouette, depended on Dutch ecclesiastical precedents.

In 1812, after remaining without a pastor for eleven years, the members of the Amsterdam branch reorganized and reunited with its other branch (which had since become affiliated with the Presbyterian Synod) in one organization known as the Presbyterian Church of Amsterdam. In 1832, the congregation constructed a new sanctuary, designated as the Second Presbyterian Church of Amsterdam, and sold the older building to the First Methodist Episcopal Church of Amsterdam, which demolished the structure that the baroness depicted and erected a new one.

1. *History of Montgomery and Fulton Counties, NY* (New York: F.W. Beers, 1878), 92–93.

Amsterdam Ferry, New York, 1808

Watercolor, graphite, and black chalk on paper; 5 ¹¹/₁₆ × 7 ⅜ in. (145 × 187 mm)
Inscribed at lower left in brown ink: *amsterdam ferry (State of new-york.)*; at lower right: *mai 1808.*
Museum of Fine Arts, Boston, Gift of Maxim Karolik for the M. and M. Karolik Collection of American Paintings, 56.361

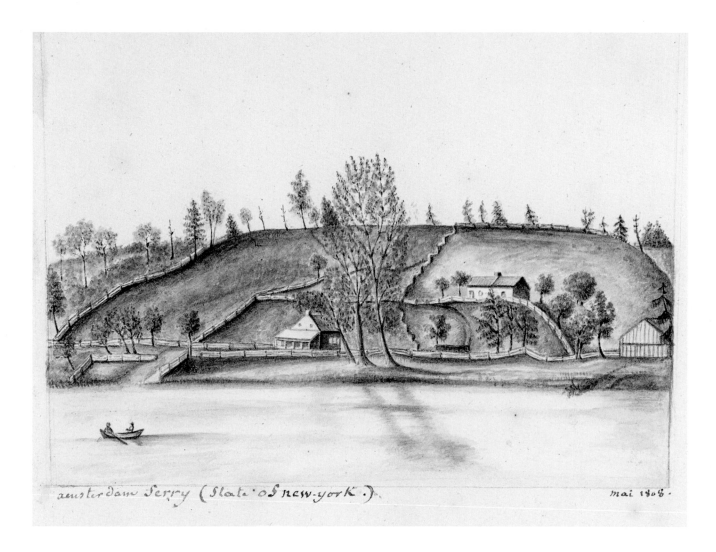

In 1790, Harmanus Vedder started a ferry service that became known as "Vedder's Ferry." It operated until 1835, when John Hoffman purchased it. The ferry was located downriver and east of the hamlet of Amsterdam, which was first called Veddersburg (Veedersburg) after its first permanent settler, Albert H. Veeder, father of Harmanus.[1] By popular vote in 1804, the town's name was changed to Amsterdam in honor of the chief city of Holland, the original home of the ancestors of many residents. Even after 1821, when the Amsterdam Bridge was erected across the Mohawk River, the ferry service continued to operate. Although fascinated with modes of transportation and technological innovation, Neuville recorded the location of the ferry, but not its operation, because she was mid-stream on the ferry when she sketched her composition. Her attention to the reflections of the trees and boat in the water lends a great immediacy and allure to her depiction of the arcadian locale.

1. Nelson Greene, *The Old Mohawk-Turnpike Book* (Fort Plains, NY: Nelson Greene, 1924), 71–87.

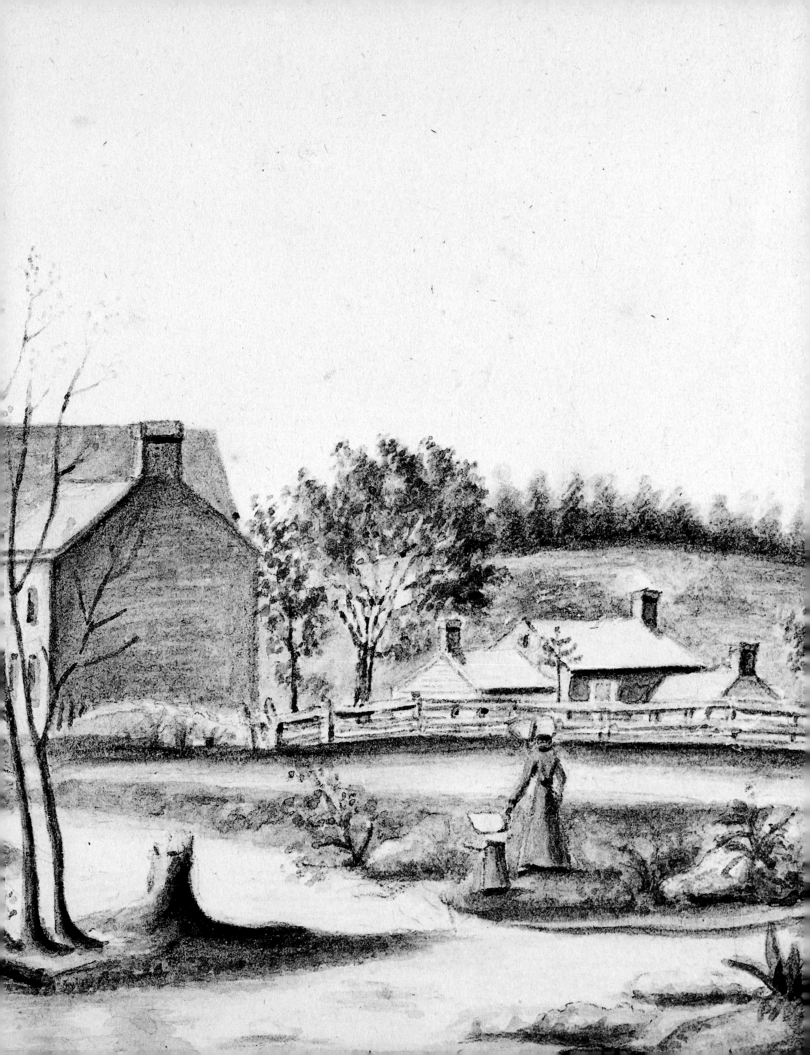

House and Farm near Angelica, New York, 1808

Watercolor, graphite, brown ink, black chalk, and gouache on paper; 12 ⅜ × 18 ½ in. (314 × 470 mm)
Watermark: J WHATMAN / 1801
Inscribed at lower right in brown ink: *7bre 1808.*
N-YHS, Purchase, 1953.208

As early as 1800, Captain Philip Schuyler Church traveled to western New York State to an area that was then in Genesee County (but became part of Allegany County in 1806) to take possession of a large tract of land (a hundred thousand acres). In 1802, together with his surveyor, he planned a village that was laid out with plots in a design reminiscent of Paris, where he had lived as a youth (1783–85), when his father was U.S. envoy to the French government. The plan consisted of a central circular drive with five churches situated around its circumference and a village park at its center, with streets radiating from it to form a star. Church named it after his enchanting, socially connected mother Angelica Schuyler, sister-in-law of Alexander Hamilton and wife of John Barker Church.

The town of Angelica, the oldest in Allegany County, was officially established in 1805. In 1806–07, a number of distinguished French royalist exiles and planters, who had escaped the French Revolution in France and the unrest in the West Indies, settled there, among them Victor Marie du Pont de Nemours and his wife, Joséphine, who would become lifelong friends of the Neuvilles. No doubt the town's layout, reminiscent of the French capital, and the Schuylers' family connections drew other French exiles to Angelica. The village became a nexus of French culture in the New World, partially explaining the Neuvilles' visit in 1808.

The architecture of the farmhouse in Henriette's pastoral scene was characteristic of Genesee County style, preserved today in the Center Village structures of the Genesee County Village & Museum. As the tree stumps that Henriette recorded in the foreground of her watercolor attest, the land had been quickly cleared, although the prosperous farm in her watercolor already had a dovecote to the left of the house, as well as two gazebos and a substantial barn at the right.[1] The well-appointed farmhouse contrasts with the humble log cabin that she recorded during the same visit as "the first cottage of angelica" (cat. no. 30). Both watercolors record the use of a meandering zigzag or snake fence of split rails.

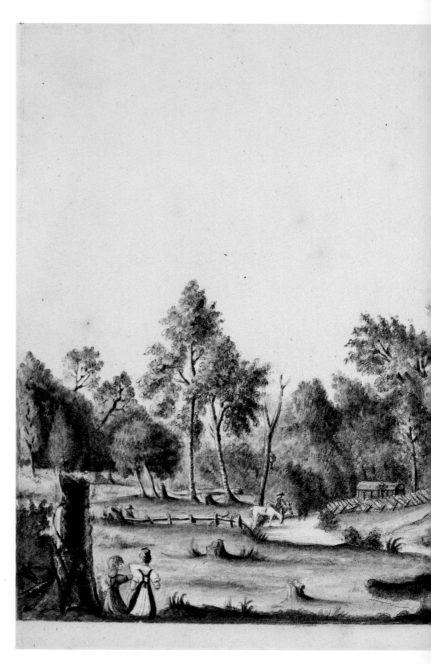

1. Mary Black, "The American Wilderness—Through French Eyes," *Antiques World* 3:6 (April 1981): 72–74, discusses the watercolor, but introduces errors and identifies the farm as belonging to Philip Church without supporting evidence.

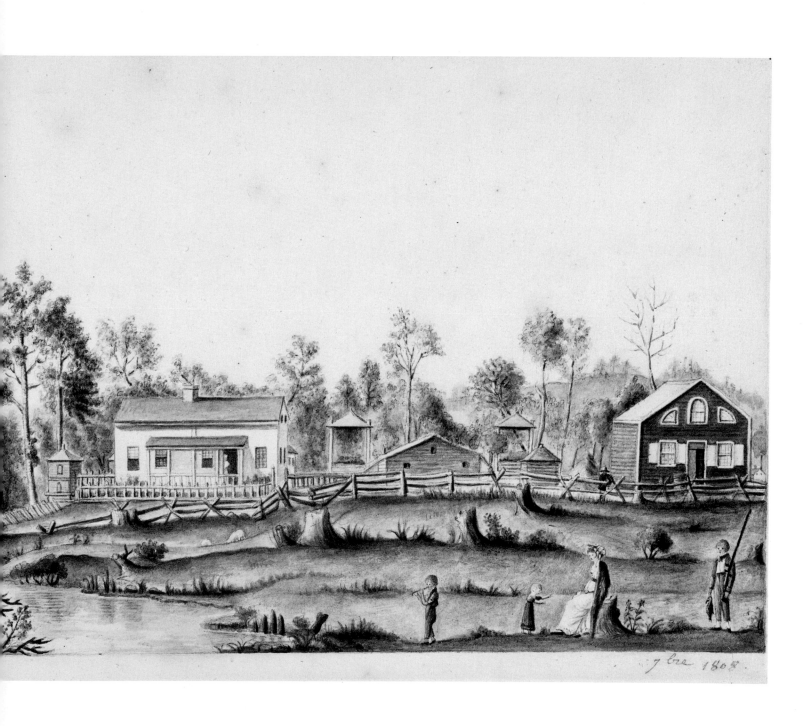

Mrs. John Cochran's House near Palatine, New York, ca. 1808

Watercolor, graphite, black chalk, and gouache on paper; 7 ⁵⁄₁₆ × 6 ⁷⁄₁₆ in. (185 × 163 mm)
Inscribed at lower left in brown ink: *Mis. Cochran's house near Palatine*
Museum of Fine Arts, Boston, Gift of Maxim Karolik for the M. and M. Karolik Collection of American Paintings, 56.360

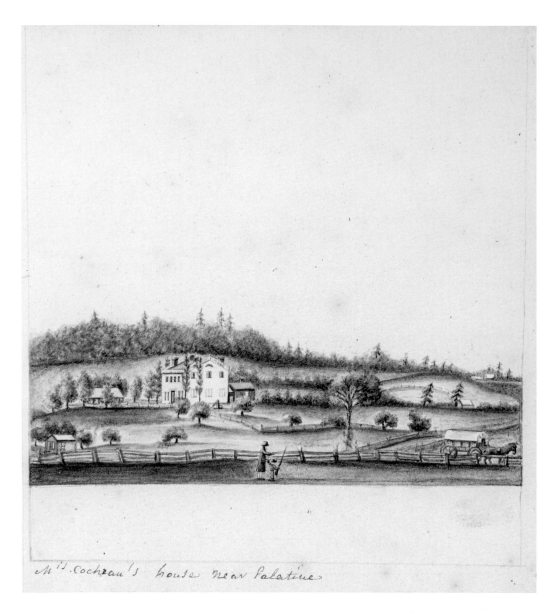

The Cochran house with its four chimneys stood near the old western boundary of the town of Palatine, within sight of the old church and near the Mohawk River.[1] John Cochran, director general of the medical department of the Continental Army and the fourth Surgeon General of the United States Army during the American Revolution, was also president of the Medical Society of New Jersey in 1769–71. In 1772, he established a household near New Brunswick, where he inoculated people for smallpox, at the time a contagious, disfiguring, and often fatal disease that was widely feared.

His practice suggests that he was medically proactive and in the forefront of preventative medicine, which would have endeared him to the baron, who championed the new method of vaccination in France and the United States. Cochran was also a friend of George Washington, who appointed him commissioner of loans in 1790; in 1760 he married Gertrude Schuyler, who is discussed in cat. no. 26. After suffering a stroke, Cochran retired to Palatine, New York, where he died in 1807, which is why Henriette's inscription indicates that the house belonged to his widow.

1. For an early photograph of the house in sad repair, see S.L. Frey, *Following the "Old Mohawk Turnpike"* (St. Johnsville, NY: The Enterprise and News, 1921), 17, ill.

26

Woman and Young Girl; Mrs. John Cochran (Gertrude Schuyler, 1724–1815), 1808

Watercolor, graphite, black chalk, pastel, and black ink on paper; 7 ¼ × 13 ⅜ in. (184 × 340 mm)
Watermark: J WHATMAN / 1801
Inscribed at lower left in brown ink: *amsterdam 20 mai 1808. –*; at lower center: *mrs. cochran. aged 84 years – widow of mr. / cochran*
N-YHS, Purchase, 1953.223

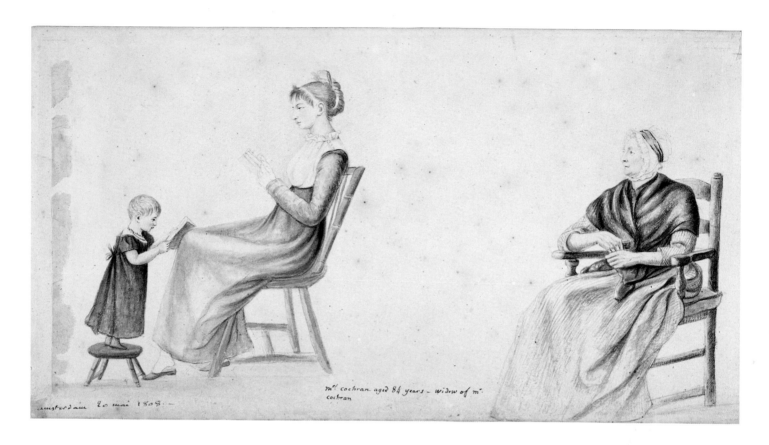

The sheet features two vignettes. At the left, the baroness recorded the interaction between an unknown young mother, who is reading a book, and her daughter, who is learning to read with her book propped on her mother's knees as she balances precariously on a footstool. This scene reveals the Neuvilles' abiding interest in education, which blossomed into the Economical School (*École Économique*), founded and officially established in New York City in 1810 (see cat. no. 44 and "The Neuvilles," pp. 28–29).

On the right half of the sheet, Neuville portrayed the recently widowed Gertrude Schuyler Cochran. She was the only sister of Major General Philip Schuyler and was from the prominent New York Dutch family whose descendants played a critical role in the formation of the United States. Gertrude Schuyler was the eldest child of Johannes Schuyler, Jr., and Cornelia Van Cortlandt Schuyler of Albany, New York. She was the second wife of Pieter S. Schuyler, Jr., and after his death married Dr. John Cochran.[1] The baroness drew this portrait while visiting her house in Palatine, New York, in 1808 (see cat. no. 25).

1. Koke 1982, 2: 198.

Break's Bridge, Palatine, New York, 1808

Watercolor and graphite with touches of white gouache, black ink, and black chalk on paper; 7 ¼ × 12 ¾ in. (184 × 324 mm)
Inscribed at lower left in brown ink: *Palatine Break's Bridge June 1808.*
N-YHS, Purchase, 1953.211

The name that the baroness assigned to the bridge in her inscription, probably meaning "Broken," may reflect her only fledgling abilities with the English language a year after the Neuvilles' arrival in the U.S. Like many visitors to the New World, Henriette was fascinated with technology, especially engineering feats, and how the American wilderness was being settled. In this watercolor, however, she focuses on a bridge over the Mohawk River that had been destroyed by its rushing waters, something not uncommon in early settlements in the area. The couple she painted in the foreground may be the Neuvilles with their pet spaniel dog Volero.

The Mohawk River had a significant impact on the eastern New York region, first with the Iroquois and then with European settlers. From Schenectady to the Hudson River, the Mohawk dropped over two hundred feet in fifteen miles, making navigation difficult. Its tremendous discharge and powerful ice breakups in the spring thwarted efforts to bridge the river in its early history, and even as late as the 1860s, when a railroad bridge crossed the river. Various communities initiated ferry crossings, some with only a simple boat and others with cable ferries. In the winter of 1794–95 at the village of Scotia (south of Ballston Spa and forty miles from Palatine), work began on a bridge at a relatively narrow point, first by building a wooden cable bridge on the ice that would be lifted onto piers. Unfortunately, a thaw opened the river and destroyed the work-in-progress. If successful, it would have been the first long bridge in the thirteen colonies. The first lasting span over the Mohawk River was Burr Bridge, a wooden structure on stone pillars completed in 1808, which spanned the river between Schenectady and Scotia. Today, a bridge at Palatine Bridge connects to the town of Canajoharie in Montgomery County (see cat. no. 28).

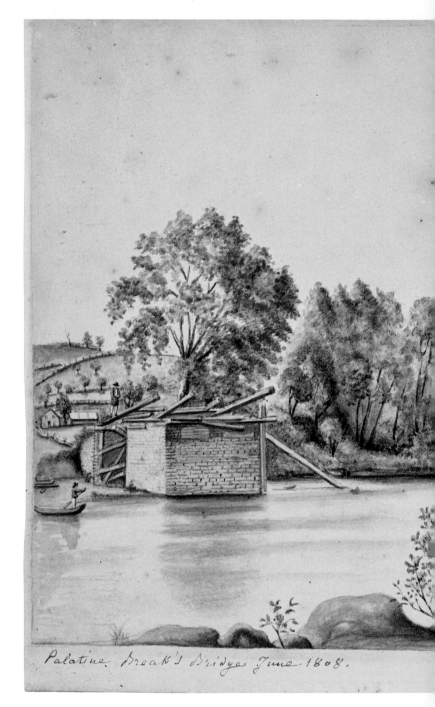

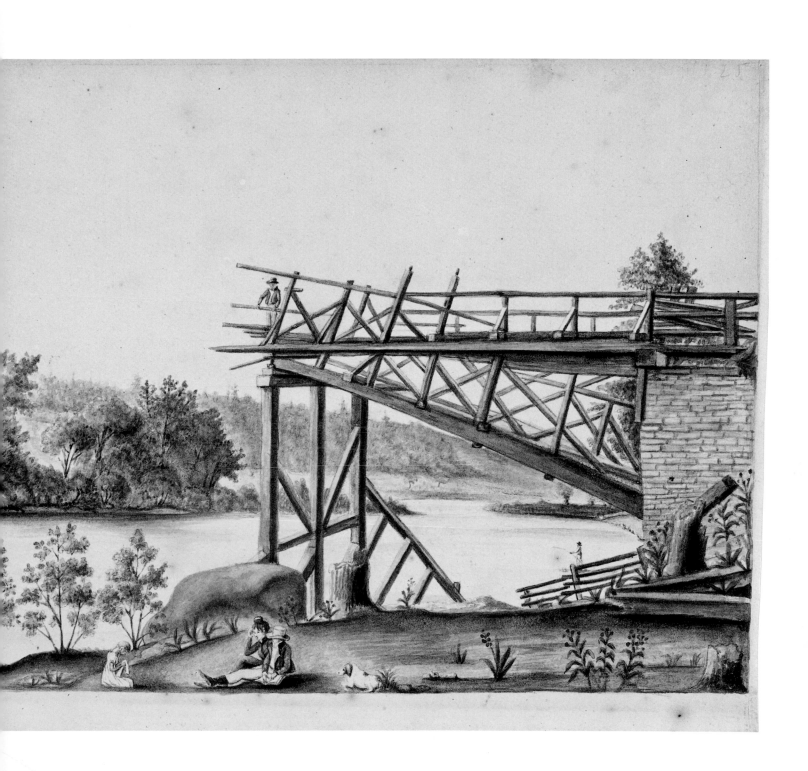

Bridge at Palatine Bridge, New York, with Carriage of DeWitt Clinton, 1810

Watercolor, black chalk, graphite, and black ink on paper; 7 ⁵⁄₁₆ × 6 ⅞ in. (186 × 175 mm)
Inscribed at lower left in brown ink: *Palatine Bridge and Mr Clinton's Carriage.*
Museum of Fine Arts, Boston, Gift of Maxim Karolik for the M. and M. Karolik Collection of American Paintings, 56.359

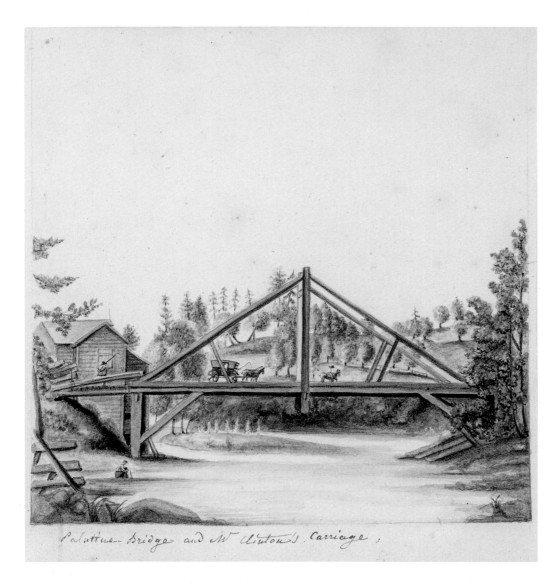

Palatine Bridge is a village in Montgomery County in eastern New York State, west of Amsterdam. The community's name derives from both the Palatinate Germans originating in the Rhineland who settled the area and from the wooden bridge built in 1798 across the Mohawk River, which the baroness has represented.[1] Her reference to "Mr. Clinton" is to DeWitt Clinton, future governor of New York and a president and founder of the New-York Historical Society. In his private "Canal Journal," Clinton recorded being in Palatine on July 6, 1810, on a reconnaissance mission for the Erie Canal.[2] When Henriette painted this watercolor, probably on or near that date, Clinton was mayor of New York City and a board member of the Economical School, and thus a friend of the Neuvilles.

1. Kelly Yacobucci Farquhar, *Montgomery County: Images of America* (Charleston, SC: Arcadia Publishing, 2004), n.p. (but chap. 8). It was the first river bridge constructed west of Schenectady.
2. William W. Campbell, *The Life and Writings of DeWitt Clinton* (New York: Baker and Scribner, 1849), 37.

29

Study of Two Dogs; Palatine Evangelical Lutheran Church, Palatine, New York, 1808

Graphite, watercolor, and black chalk on paper; 7 ¼ × 13 in. (184 × 330 mm)
Inscribed at far left below image in brown ink: *Puck and Volero*; to right below right image: *Palatine Joelly 1808.*
N-YHS, Purchase, 1953.234

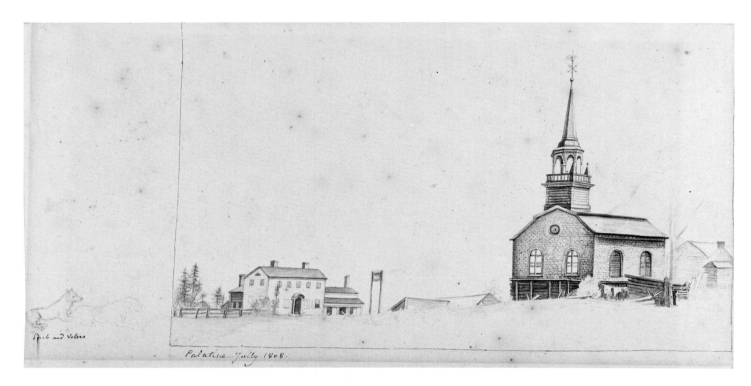

On the right, Neuville drew the grounds and the Palatine Evangelical Lutheran Church building, also known as the Palatine Church (fig. 51). It was constructed of stone in 1770 on the Mohawk Turnpike in Montgomery County. Unlike most other churches in the Mohawk Valley, the British did not destroy it during the Revolutionary War because of the loyalist leanings of its donors. Thus, the edifice is the oldest church building now standing within the limits of Montgomery and Fulton counties.[1] The small, rectangular one-story structure was constructed in a traditional meetinghouse plan with massive stone walls. It was added to the National Register of Historic Places in 1973. The baroness's watercolor preserves its original wooden steeple, crowned by a rooster weathervane, a steeple since replaced with a more complex structure.[2] She rendered its rear façade and grounds rather than its entrance, suggesting that she was more interested in its setting and the environs of the town. In the foreground, she also sketched in graphite a split-rail zigzag fence and probably added the quick graphite sketches of the couple's two dogs, Puck and Volero, at a different moment in time.

Fig. 51
Palatine Evangelical Lutheran Church, Palatine, New York; detail showing original steeple from S.L. Frey, *Following the "Old Mohawk Turnpike"* (St. Johnsville, NY: The Enterprise and News, 1921), cover

1. *History of Montgomery and Fulton Counties, NY* (New York: F.W. Beers, 1878), 92–93, 406.
2. For rooster weathervanes in early America and bibliography on the subject, see Margaret K. Hofer and Roberta J.M. Olson, *Making It Modern: The Folk Art Collection of Elie and Viola Nadelman*, exh. cat. (New York: New-York Historical Society in association with D Giles Limited, London, 2015), 134–135.

The First Settler of Allegany County; First Cottage in Angelica, New York, 1808

Watercolor, graphite, and black chalk on paper; 7 ¾ × 13 in. (197 × 330 mm)
Inscribed below left image in brown ink: *the first inhabitant / or Settler of the / County. / 7bre 1808.*; below right image: *first cottage of angelica Drawn .7bre 1808.*
N-YHS, Purchase, 1953.240

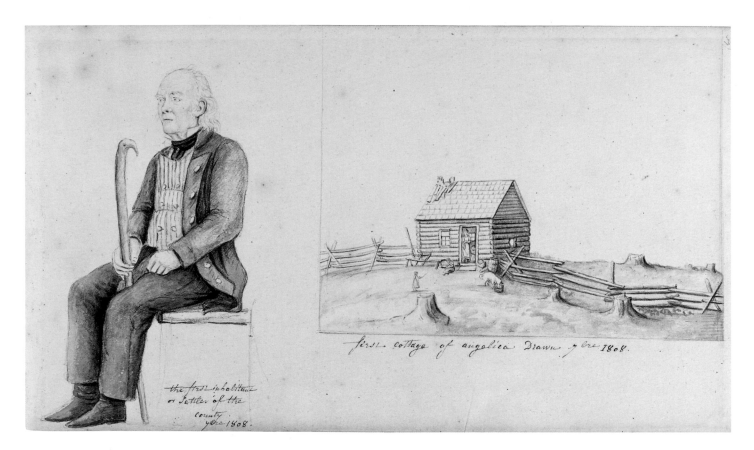

Henriette's pairing of two separate depictions on the same sheet is telling—her endearing portrait of the first settler of Allegany County, a white-haired, dignified man with a Wild Turkey cane head and striped vest and the first "cottage" in Angelica. The juxtaposition reveals that she had a historical interest in documenting settlement by recording individuals and places with precise identifications. In her inscription, the baroness is definitive that the sitter in the left vignette was the first settler of Allegany County. According to existing records, he should be Nathaniel Dike, who in 1795 began a settlement in Elm Valley, about twenty miles from Angelica.[1]

Although the artist frequently used the word "cottage" to signify a small, rustic house, the structure she delineated on the right is really a log cabin erected in a recently deforested landscape with telltale tree stumps marking the foreground. Once again, Henriette could not resist representing children and animals in spontaneous situations and including the zigzag fencing characteristic of the settlements in the area.[2]

1. John S. Minard, *Allegany County and Its People* (Alfred, NY: W.A. Ferguson, 1896), 43–44. See also http://www.alleganyhistory.org/places/towns-and-villages/u-z272/ wellsville246/related-articles27/2362-history-of-elm-valley (accessed May 2018). Koke 1982, 2: 200, identifies the first settlement as the one in Karr Valley in 1796, and without explanation identifies the sitter as one of its four founders, the Reverend Andrew Gray; Da Costa Nunes and Olin 1984, 10, states that the identification of Gray as the earliest settler is tentative, although he was among the early settlers.

2. Koke 1982, 2: 199, without a reference, writes that the log building has been cited as possibly the first home of Moses Van Campen (1757–1849).

31

Eleutherian Mills Residence, Wilmington, Delaware, 1808–10

Brown ink and wash and white gouache over graphite on paper; 7 ¼ × 9 ½ in. (184 × 241 mm)
Hagley Museum and Library, Wilmington, Delaware, 67.16

Éleuthère Irénée du Pont constructed his namesake residence, the Eleutherian Mills, in 1802. The residence was located on land above the gunpowder plant, which had begun operation in 1799 and was owned by E.I. du Pont de Nemours and Company (see also cat. no. 32). The name Éleuthère Irénée derives from two Greek words: "Eleutheros," meaning liberty or freedom, and "Eirene," one of the Hours (*Horae*) and goddess of peace.[1] The baroness delineated in great detail the home's most important elevation, the eastern rear façade, from the opposite bank of Brandywine Creek, as the Brandywine River was then known. She was intrigued by the entire site and its commercial enterprise because she also depicted the gunpowder mills in the foreground and the powder drying house (cat. no. 32). Her representations of such structures are among the earliest portrayals of American industry and appear aimed at capturing Americans' spirit of energy and devotion to progress and, in this case, the success of her expatriate French friends. The artist also included a small child and two men standing at the railing of the "piazza," or porch. Éleuthère is the figure speaking through a trumpet, which he had to communicate with his workmen. To the right of the child is a wooden rocking horse, made by the powder workmen for the Du Pont children. It remained in the family and is still in the residence.[2]

The central-hall plan of the house is typical of the Federal Pennsylvania-Delaware residential style, and its elegant, two-story colonnaded porch provided the Du Ponts a vista of the family business and property. Due to its deliberate siting above the gunpowder mills, however, the house was subject to regular accidental blasts and damage, and thus was rebuilt a number of times. The site is now part of the Hagley Museum and Library, and has been a National Historic Landmark since 1966.[3]

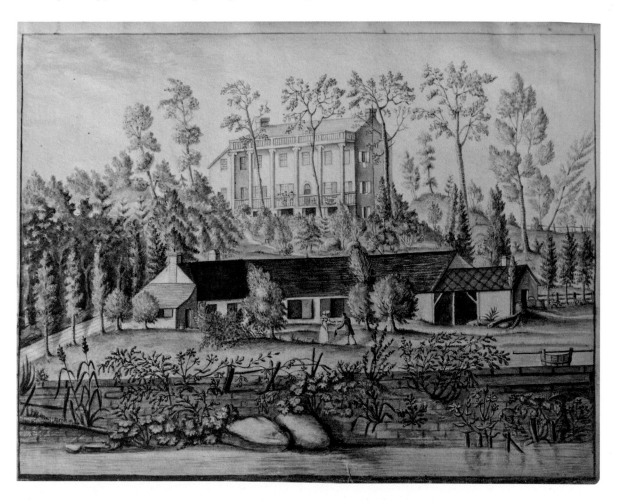

1. Maggie Lidz, *The Du Ponts: Houses and Gardens in the Brandywine, 1900–1951* (New York: Acanthus Press, 2009), 212 n. 5.
2. Maureen O'Brien Quimby, *Eleutherian Mills* (Wilmington, DE: Hagley Museum and Library, 1999), 18.
3. Ibid.; Lidz, *The Du Ponts*, 13–35.

Eleutherian Mills Powder Plant Drying House of E.I. du Pont de Nemours, Wilmington, Delaware, 1810

Black chalk and graphite on paper; 6 ⅛ × 7 ½ in. (156 × 190 mm)
Inscribed at lower center in brown ink: *7bre 1810 Le Séchoir dela Manufacture de Mr. I. Dupont.*
N-YHS, Purchase, 1953.230

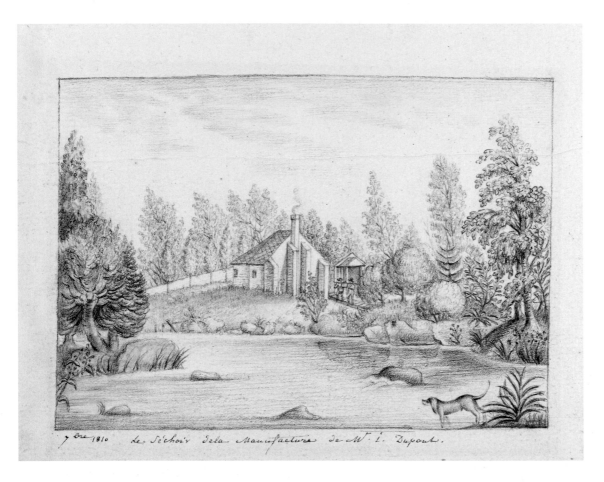

In 1802, two years after he and his family left France to escape the French Revolution, Éleuthère Irénée du Pont established a gunpowder plant on the banks of the Brandywine Creek near Wilmington, Delaware. For the endeavor, he raised capital in France and imported French gunpowder machinery. The location provided the necessities to operate the mill: water power, available timber (willow trees) that could be turned into fine charcoal, and proximity to the Delaware River to facilitate shipments of sulfur and saltpeter, which were the other ingredients for making gunpowder, the earliest known chemical explosive. The Du Pont company became the largest supplier of gunpowder to the United States military and, over time, grew into the largest black powder manufacturing firm in the world. Even though the gunpowder mills closed in 1921, the company diversified to the point where at its peak the family employed around ten percent of Delaware's population. The Du Pont family remained in control of the company through the 1960s. The Eleutherian Mills site is now part of the Hagley Museum and Library, as well as a National Historic Landmark since 1966. See also cat. no. 31.

In this sheet, Henriette presents a monochromatic view of the gunpowder plant's drying shed, also built in 1802, with pastoral Brandywine Creek in the foreground. She drew her view with black chalk, which in its texture and color may have appealed to her as suggesting gunpowder. In her opinion, the Du Pont gunpowder plant represented an exemplary industrial development of the young nation and the harnessing of its natural resources by her exiled friend, who was known as Irénée. It is revealing that her inscription is in French, underlining that she was in the company of her countryman and could use their mother tongue. The Neuvilles seriously contemplated purchasing a country house nearby, but instead chose to settle in New Brunswick, New Jersey (see "The Neuvilles," p. 29).

33
View of Perth Amboy and the Steamboat "Raritan", 1809

Brown ink and wash over graphite on paper; 7 5/16 × 12 1/2 in. (186 × 318 mm)
Inscribed at lower left in brown ink: *Vue D'amboy et du Steam-Boat*; at lower right: *Juillet. 1809.*
New York Public Library, The Miriam and Ira D. Wallach Division of Art, Prints and Photographs: Print Collection, Stokes 1809-D-11

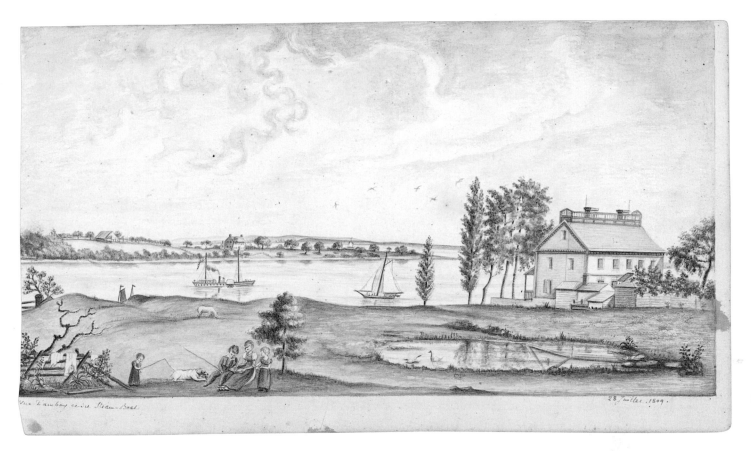

The Lenape tribe of Indigenous Americans called the point on which Perth Amboy, New Jersey, was built "Ompage," meaning level ground. After Scottish colonists settled it around 1684, the new city was named in honor of James Drummond, fourth Earl of Perth, one of the associates of a company of Scottish proprietaries. The Algonquian name also persisted, albeit corrupted to Ambo or Point Amboy, and eventually a combination of native and colonial names emerged in the form of Perth Amboy.

Henriette drew this idyllic location on the Raritan River, one of the major waterways of central New Jersey, which empties into Raritan Bay on the Atlantic Ocean. She included a steamboat and several sailing vessels. Because of her interest in transportation technology, Neuville paid special attention to the namesake steamboat *Raritan*, built in 1808 by the inventor Robert Fulton, which was making runs between New York and New Brunswick on the eponymous river. She drew this novel conveyance only two years after the successful New York City to Albany round-trip run of Fulton's *North River Steamboat*, and the year when

steamboats became commercially viable. It may have been the very steamboat the Neuvilles took to travel from New York City to New Jersey (see "The Neuvilles," p. 29). Gloria Deák has claimed that Henriette's drawing is the earliest known representation of a steamboat in New York waters and has identified the hills in the background as the Navesink Highlands, and the large house on the farther shore as the Billop house in Tottenville, Staten Island.[1] The baroness delighted in recording children playing, and, true to form in this drawing, she represented several in the left foreground near clothes drying on a fence.

1. Deák 1988, 1: 171–172. See also Stokes and Haskell 1932, 88–89.

The Moreau House, Morrisville, Pennsylvania, **1809**

Brown ink and wash, graphite, and black chalk on paper; 7 5/16 × 12 15/16 in. (186 × 328 mm)
Inscribed at lower left in brown ink: *Morice Ville*; at lower right: *2 Juillet 1809*
Museum of Fine Arts, Boston, Gift of Maxim Karolik for the M. and M. Karolik Collection of
American Paintings, 58.920

Victor Marie Moreau (fig. 52)—a French republican and
esteemed general, who helped Napoleon to power but
later opposed him and was exiled—and his wife, Eugénie
Hulot (cat. no. 35)—a confidant of Joséphine Beauharnais
Bonaparte—were expatriate friends of the Neuvilles. The
Moreaus arrived in New York City with their two children in
1805, two years before the Neuvilles. After traveling around
the northeast, they settled in Bucks County, Pennsylvania,
near the Delaware River a few miles from Trenton. In 1807,
they purchased land in Morrisville and lived in a large house
in the grove in which the Founding Father Robert Morris had
resided. Another watercolor, by the Russian diplomat and
artist Pavel Petrovich Svinin, who was later an aide-de-camp
to General Moreau, records the same charming house and
grounds (fig. 13).[1] On Christmas Day 1811, the house burned
down, after which Moreau and his family resided in a brick
building, known as the Ferry House, until 1813, living the
life of a politically exiled country gentleman who especially
enjoyed fishing.[2] When the War of 1812 broke out, President
Madison offered him command of U.S. troops, but Moreau
turned it down. After hearing the news of Napoleon's defeat
and the destruction of the *Grande Armée*, the Russian Czar
Alexander I and the King of Prussia invited the general
to participate in a campaign against Bonaparte. Moreau
accepted and returned to Europe in 1813, dying tragically
soon thereafter, reputedly in the presence of his Russian
aide Svinin, after being mortally wounded at the Battle of
Dresden on August 27. Guillaume Hyde de Neuville wrote the
general's funeral oration, which was read in St. Petersburg
and which Svinin published in a series of popular pamphlets
following his account of the general's last moments and
Moreau's biography.[3]

1. See Svinin 2008, 90, ill.
2. William Watts Hart Davis, *The History of Bucks County, Pennsylvania: From the Discovery of the Delaware to the Present Time* (New York and Chicago: Lewis, 1905), 2: 165.
3. The first American edition is Pavel Petrovich Svinin, *Some Details Concerning General Moreau and his Last Moments* (Boston: Nathanial Willis, 1814). The American editions contain the funeral oration by a "friend of General Moreau," who was none other than the baron. See Yarmolinsky 1930, 45–46, for a listing of the ten editions of this pamphlet, published in Paris, London, and Boston, together with other related publications by Svinin, as well as a separate publication of the "oration of a friend," published in "New-York" by John Forbes in 1814. See also Svinin 2008, 175–176 n. 68. For a contemporary account of Moreau, see Foster 1980, 60–64, 252–253, 301–302. For Svinin's watercolor portrait of Moreau in the Russian Museum, St. Petersburg, see Svinin 1992, pl. 42.

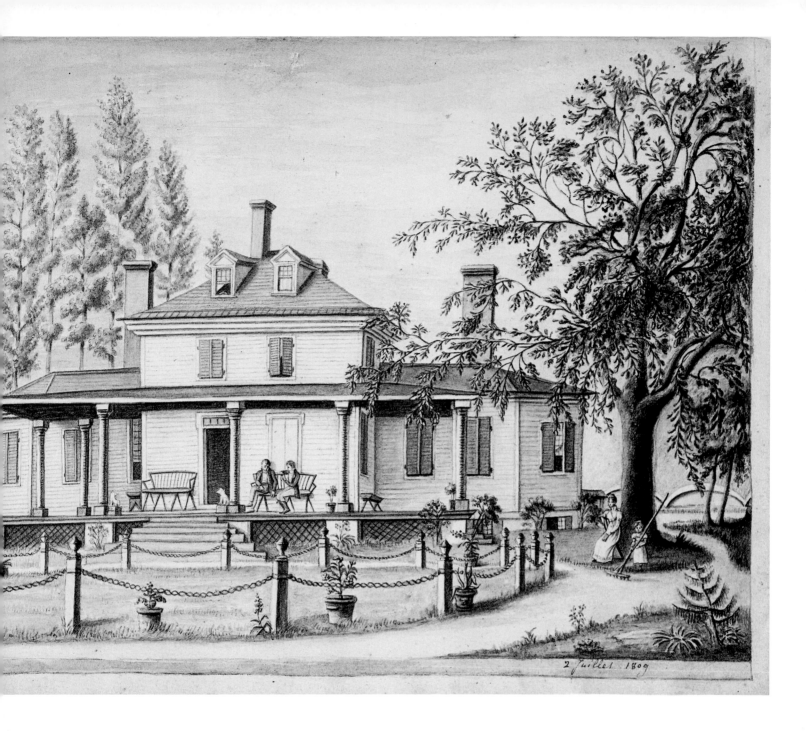

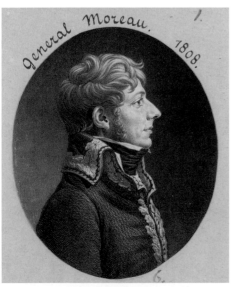

Fig. 52
Charles Balthazar Julien Févret de Saint-Mémin, *General Victor Marie Moreau (1763–1813),* 1808. Engraving; 2 ¹³⁄₁₆ × 2 ⁵⁄₁₆ in. (72 × 59 mm) image. National Portrait Gallery, Washington, DC, Gift of Mr. and Mrs. Paul Mellon, S/NPG.74.39.1.6

Madame Moreau (Alexandrine Louise Eugénie Hulot d'Oseray, 1781–1821), 1808–13

Watercolor, graphite, black chalk, and brown ink with touches of pink pastel on paper; 7 ⅝ × 6 ¼ in. (194 × 159 mm)
Inscribed at lower left in brown ink: *Mde Moreau créole*
N-YHS, Purchase, 1953.278

In 1800, Alexandrine Louise Eugénie Hulot d'Oseray married General Victor Marie Moreau in Paris. She was a celebrated Creole—a French citizen born outside of France—from the island of Martinique and a friend of Joséphine Beauharnais Bonaparte. Reputedly a socially ambitious woman who dominated her husband, she presided over a Paris salon that attracted people discontented with Napoleon's aggrandizement. This so-called "club Moreau" annoyed Napoleon because it encouraged the royalists who sought to bring Louis XVIII to the throne. General Moreau was unwilling either to become a military dictator who would restore the republic or to be a party to an intrigue to restore the monarchy, but Napoleon caught wind of a plot to overthrow him and seized the conspirators, including Moreau. After the judges handed down their sentences in 1804, the then First Consul treated Moreau with a pretense of leniency, commuting his sentence of incarceration in the notorious Temple prison to banishment. Passing through Spain, like the Neuvilles two years later, the Moreaus embarked for America, where they lived in quiet obscurity for some years in Morrisville, Pennsylvania (fig. 13; cat. no. 34), until news came of the destruction of the *Grande Armée* in Russia. Perhaps at the instigation of Madame Moreau, who had returned to France and was ill, the general committed the last and least excusable political error of his career. Negotiating with an old friend in the circle of republican conspirators, he gave advice to the Russians and was called back to Europe by Czar Alexander in 1813, dying soon thereafter at the Battle of Dresden. Fortunately for his military reputation and fame as a patriot, Moreau did not live to fight at Waterloo.

The Neuvilles met the Moreaus at Ballston Springs in 1807. Madame Moreau had come there not so much to improve her health as to divert her mind. The baroness wrote about her in an untraced journal quoted in the baron's *Memoirs*:

> Mme. Moreau, who has been so long expected, has come at last; there was a grand ball in her honour of which she was truly the queen. It was a real pleasure to see her dance, she threw so much grace into the movements. Entertainments spring up under her feet, and her presence has transformed the little watering-place.[1]

The British diplomat Sir Augustus John Foster also noted Madame's love of dancing and her dominating nature, adding that she was "a thorough Royalist and an excellent woman, but one of the most incessant talkers I ever met with."[2] The Moreaus' bliss in 1807 was short-lived, as Madame Moreau shortly received news of her mother's death and was plunged into despair, which deepened when the couple lost their son during the winter of 1808.

Neuville's portrait of Madame Moreau is among her most acute psychological portrayals. She probably drew it after the deaths of Madame Moreau's mother and son had made her unwell. It is the visual embodiment of her written description:

> She despaired of finding happiness in a foreign land. . . . We are filled with regret and memories of the past, as we await the event which is to overshadow our little society . . . and make us feel more than ever that we are poor exiles on a foreign shore. Our gentle and beautiful neighbour is leaving for France, taking her daughter with her. . . . In failing health, sorrowful, retiring, taking no pleasure in society . . . this amiable woman, who in other days was so charming to everyone, is a real source of anxiety to her friends. Some people think her health is merely a pretext; that both husband and wife are weary of exile, and of the sorrows that have befallen them in this part of the world, from the loss of their only son, to the destruction of their house by fire. . . .[3]

In 1815, the Neuvilles were reunited with Madame Moreau in London, at which point Henriette, in her lost journal, noted that Madame Moreau "our fair neighbor of New York [see cat. no. 41] helps me to tend the invalid. . . . [H]er salon is much frequented by French people, who have gathered here, including supporters of the princess [the Duchess of Angoulême]."[4]

1. *Mémoires* 1888–92, 1:470; *Memoirs* 1913, 1:233.
2. Foster 1980, 63.
3. *Mémoires* 1888–92, 1:485; *Memoirs* 1913, 1:250.
4. *Mémoires* 1888–92, 2:85; *Memoirs* 1913, 2:36.

M. de Moreau créole

The Little Gardener of "Morice Ville," the Moreau Estate, Morrisville, Pennsylvania, ca. 1809

Graphite, gray watercolor, and black chalk on paper; 7 ⅞ × 4 ¾ in. (200 × 121 mm)
Watermark: LYDIG & [MESSIER]
Inscribed at lower left in brown ink: *Petit Jardinier. de Morice ville*
N-YHS, Purchase, 1953.285

Once again, in this enchanting sheet the childless baroness displays her delight in children and her ability to capture their endearing candor and fleeting expressions. As her affectionate inscription records, the boy, nearly dwarfed by his hat, may have belonged to the gardener's family of the Moreau estate in Morrisville, Pennsylvania (cat. no. 34).[1] Alternatively, the "Petit Jardinier" may have been a nickname she assigned to him.

1. Koke 1982, 2:203, notes that the work has been dated to ca. 1809 on the basis of Neuville's representation of the Moreau residence in cat. no. 34 dated 1809.

37

Cottage at Perth Amboy, New Jersey, 1810

Black chalk, watercolor, graphite, and brown ink on paper; 5 ⅞ × 6 ⅝ in. (149 × 168 mm)
Inscribed at lower left in brown ink: *22 aoust 1810 cottage à amboy*
N-YHS, Purchase, 1953.212

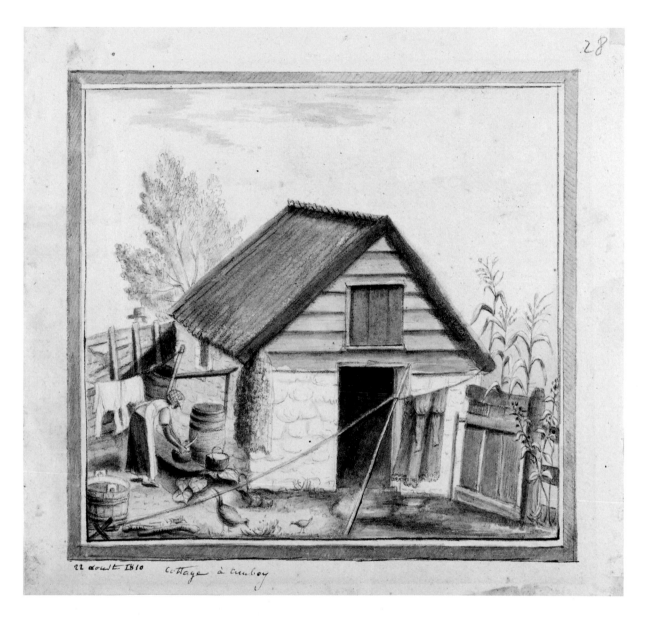

The humble, rustic abode Neuville studied in this monochromatic watercolor belonged to a family of little means. The corn stalks growing to the right behind a fence and the chickens pecking in the foreground suggest a self-sustaining homestead. The woman filling two cooking pots with water from barrels has done laundry in the adjacent washtub—a dress trimmed with lace, and two shirts that may belong to the man wearing a straw hat glimpsed beyond the fence. Henriette, who was keenly interested in occupations and thought the work ethic was noble, here celebrates quotidian labors in the country at Perth Amboy, the steamboat stop where the Neuvilles probably disembarked when they were considering acquiring property in the area (see also cat. no. 33; appx. no. 49, a drawing of St. Peter's Episcopal Church, erected in 1719).

38

Vignette of Presbyterian Church at Princeton, New Jersey, with Girardin and Mercy, 1813

Watercolor and brown ink on paper; 4 ½ × 7 in. (114 × 178 mm)
Inscribed at lower left beside vignette in brown ink: *Mercredi 27 8bre 1813 Princeton's Church.*; at lower right: *Girardin et Mercy*
Princeton University, Firestone Library, Rare Books and Special Collections, Graphic Arts Collection

In this oval vignette format—which, like cat. no. 56, resembles book illustrations—Henriette recorded the construction of the Gothic Revival Presbyterian Church in Princeton, New Jersey, rendering it as built up to the roofline. Begun in 1813 on the south side of the town's main thoroughfare, Nassau Street, the church rose on the foundations of the Presbyterian meetinghouse of 1766, which had been destroyed by fire in late February 1813. The neo-Gothic church was built on a basilica plan with an apse in the form of a half-octagon, and it had galleries on the second floor and neo-Gothic pointed windows. Although constructed of brick, its sanctuary was destroyed by fire in 1835, after which a Greek Revival structure replaced it. The baroness's watercolor is the only surviving image of the Gothic-style church, which ranks as the earliest Gothic Revival Presbyterian church erected in the United States.[1] In front of the edifice, she depicted two children: a young girl named Mercy and a boy named Girardin, perhaps the same youth as in cat. no. 84, identified there as "girardino," the diminutive of Girardin.

1. Virginia and Donald Egbert, "The Gothic Revival Comes to Princeton," *Princeton University Library Chronicle* 29:2 (Winter 1968): 116–117.

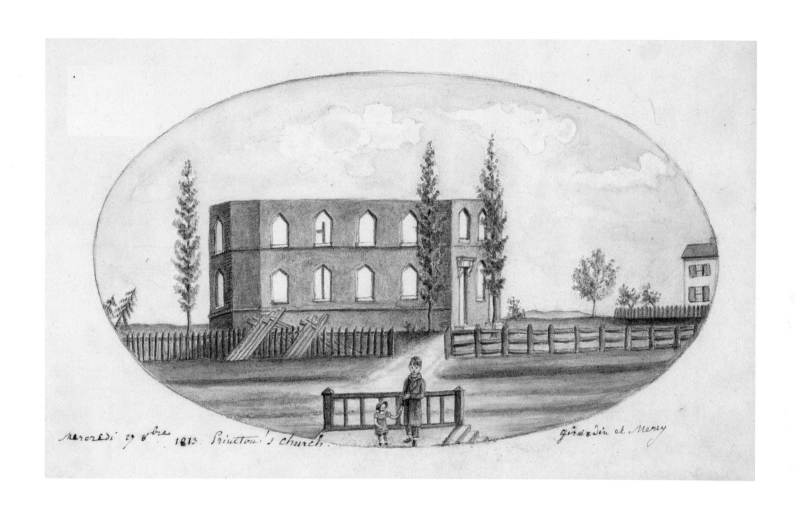

Mercredi 29 9bre 1813. Princton's church.

Girardin et Meray

"The Cottage," New Brunswick, New Jersey, 1813

Watercolor, graphite, black chalk, and brown ink on paper; 6 ¾ × 8 ¼ in. (171 × 210 mm)
Inscribed at lower left in brown ink: *1813 Le Cottage*
N-YHS, Purchase, 1953.203

With great affection, Neuville here portrayed the small house and grounds that the couple owned in then-bucolic New Jersey. In other works, the baroness used the term "cottage" to signify a rustic house, but here, since she capitalized the name, she meant "The Cottage," the couple's small residence on what they termed "The Farm," their property on the Raritan River. Later, the Neuvilles built a larger house, which they named "La Bergerie" (The Sheepfold; see cat. no. 58), but retained "The Cottage."[1] Today, their country residence is commemorated by Neuville Drive, a street that was formerly in Franklin Township but is now in Somerset, near New Brunswick.

The watercolor conveys the Neuvilles' love of the idyllic pastoral life, one that they had savored at the baroness's family château L'Estang outside of Sancerre (figs. 3, 4, 20). Henriette depicted the small but cozy house fitted with green shutters, and its front porch filled with pots of blooming flowers, over which a birdcage hangs. Wearing a straw garden hat, the baron enters the scene through a gate in the picket fence at the right. Their two pet dogs are present: their spaniel, Volero, rests in a doghouse, while Puck cools himself under the porch at the left. The baroness stands in the door watching a young black boy pull a younger white child in a wagon, while a slender woman pumps water from a well at the left. On their farm, the Neuvilles bred Merino sheep, then considered a progressive way to develop the land in animal husbandry (see cat. no. 58; appx. nos. 53, 58).[2] The Neuvilles' Economical School press published a treatise on the raising of Merino sheep, which was linked to an institution in France with royalist symbolism.[3] When they were posted to the nation's capital in 1816, the couple found it more difficult to return to their beloved farm. Therefore they began to announce the sale of this property in 1818,[4] with most of the farm selling by 1819.[5] Transactions for all the parcels of land, presumably including "The Cottage," were complete only by January 1825.[6]

1. There were at least two residences on the Neuville property, according to the letter from Jean Guillaume Hyde de Neuville, Washington, DC, to Robert Morris Boggs, New Brunswick, NJ, October 2, 1818, Papers of Robert Boggs received from and relating to Jean Guillaume Hyde de Neuville, Robert Morris Papers, Box 20, Special Collections and University Archives, Rutgers University Libraries, New Brunswick, NJ.
2. L.G. Connor, "A Brief History of the Sheep Industry in the United States," *Agricultural History Society Papers* 1 (1921): 89, 91, 93–165, 167–97, espec. 102–109.
3. Alexandre Henri Tessier, *A Complete Treatise on Merinos and Other Sheep* (New York: Printed at the Economical School Office by Joseph Desnoues, 1811).
4. Jean Guillaume Hyde de Neuville, Washington, DC, to Robert Boggs, New Brunswick, NJ, on October 2, 1819, Papers of Robert Boggs, Robert Morris Papers, Box 20. The baron wrote that since the farmhouse was sold, the tenants could move temporarily to "The Cottage."
5. Deed of sale, dated only 1819, Papers of Robert Boggs, Robert Morris Papers, Box 20.
6. For boundaries of several lots sold on January 21, 1825, of Neuville and Simond properties, January 22, 1825, see Papers of Robert Boggs, Robert Morris Papers, Box 20.

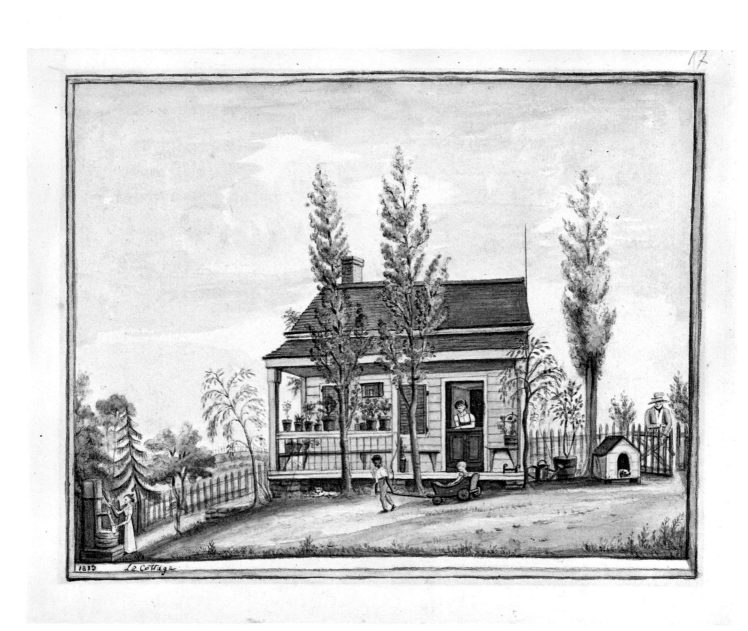

Views of New York City and the Economical School

40

Bridewell Prison, Charity School, and Board of Health at Broadway, Opposite Chambers Street, 1808

Black ink and wash with traces of graphite on paper; 7 5/16 × 13 3/16 in. (186 × 334 mm)
Inscribed vertically along left edge in brown ink: *Bridewell and charity-School Broadway opposite chamber Street – / – February 1808 –*
New York Public Library, The Miriam and Ira D. Wallach Division of Art, Prints and Photographs: Print Collection, Stokes 1809-D-7

New York City's Bridewell took its name from the English prison in London, which had been a royal palace in the reign of King John, but eventually fell into decay and was converted into a prison. New York City's house of correction was built in 1775–76 and during the Revolution served as a British military jail for American captives. About two months after Henriette drew this sheet, the Common Council of New York ordered that public stocks be put up in the yard. Sometime before its demolition in 1838, Bridewell became a debtors' prison.

The baroness's cityscape preserves the appearance of this now-demolished brick building—with its central pediment, two bracketing lateral pediments, and four chimneys—and its architectural setting.[1] To the left of the massive structure is the unfinished City Hall, designed by François Mangin in collaboration with John Macomb, Jr. It was first occupied in 1811, after which its foreground area was reconfigured as a park. The church steeple beyond City Hall at the left belongs to the Brick Church on Beekman Street. The steeple at the right is St. Paul's, while at the extreme right is the cupola of St. Peter's Catholic Church on Barclay Street (see the map in fig. 9). In the right middle ground is a small clapboard structure whose sign identifies it as the Board of Health, which was established by the Common Council on December 9, 1805. In the center middle ground, Neuville represented the Charity School and playground. This school was opened on May 1, 1807, under the direction of the Free School Society. The building adjoined the almshouse and was formerly used as a workshop. The Common Council had granted it to the society on the condition that fifty of the almshouse children would be educated there gratis. The school remained in this location until December 9, 1809, when the first building erected by the society (Free School No. 1) opened at Chatham Street and Park Row. Because no other earlier representations of this institution are recorded, Neuville's sheet is exceptionally important.[2]

The first charity school in New York City, Trinity School, opened in 1709 and was soon joined by other schools intended to provide primary education for the poor. After the Revolution, charity schools proliferated, sponsored by various religious denominations. The mission of the schools was not only to provide a basic education for children of the poor, but also to inculcate religious beliefs and morality through their curricula. By helping students become pious and directing them in moral practice, the supporters of the charity schools believed they could lift them out of poverty. The pupils also received lessons in reading, writing, and arithmetic, and girls learned to sew. Once the children had completed this education, the schools often found positions for them as servants or apprentices. They provided an American model for some of the features of the Neuvilles' Economical School (*École Économique*) discussed in cat. no. 44.

In the foreground, Henriette recorded New York's daily life—passersby chatting, laundry blowing in the wind, a cow roaming, and a pig rooting through garbage.[3] There were hundreds more of such animal vagrants in the City, as many artists and visitors to New York noted. Among them was Baron Axel Leonhard Klinckowström, a Swedish diplomat in the United States during 1818–20. He remarked about the custom of allowing "swine to wander about freely in the streets. In this country these animals are usually big and voracious. . . . Once during the fashionable promenade hour on Broad-way I saw some of these animals rush on the sidewalk, making a sharp contrast with the elegant clothes, and one filthy pig bumped into a well-dressed woman."[4]

Klinckowström painted his own view of Broadway in 1819, a watercolor with City Hall in the right background and pigs sharing the street with tradesmen and elegantly attired people; an etching after it appeared in his atlas.[5]

1. For a stark black ink and wash drawing by Alexander Anderson of the prison's façade without a landscape setting (N-YHS, inv. no. 1910.40), see Olson 2008, 118, fig. 30.1.
2. Stokes and Haskell 1932, 86–87; Deák 1988, 1: 170.
3. See Rock 1979, 102–104. The issue became a major controversy in 1816–18, as tradesmen considered wandering pigs their insurance against starvation during winter months.
4. Klinckowström 1952, 63.
5. Axel Leonhard Klinckowström, *Atlas til Friherre Klinckowströms Bref om de Förenta Staterne* (Stockholm: Eckstein, 1824); see Stokes and Haskell 1932, 102, pl. 46-a. See also Rock 1979, 102–104.

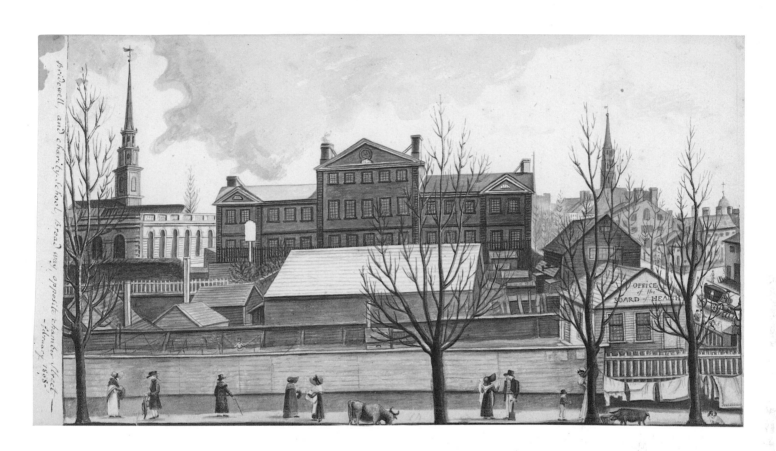

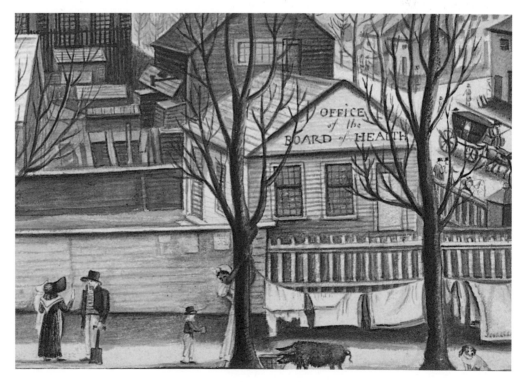

41

The Corner of Warren and Greenwich Streets, in the Snow, 1809

Watercolor, gouache, and graphite on paper; 7 ⅜ × 13 ⅛ in. (187 × 333 mm)
Inscribed below in brown ink: *Le Coin de Waren et de greenwich. Déssiné en Janvier 1809. Pendant la Neige.*
Museum of the City of New York, 52.100.6

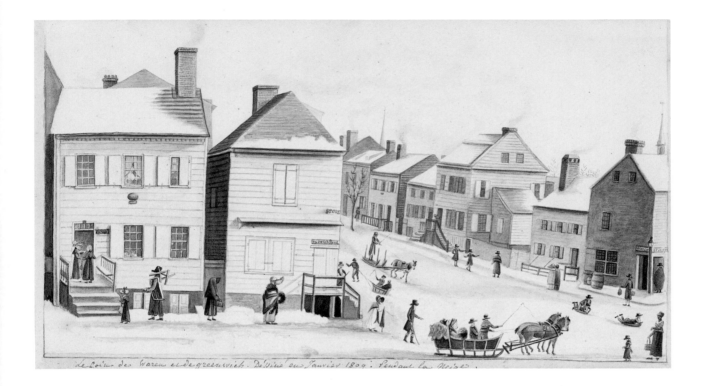

Taking great delight in this frosty January scene, the
baroness recorded a sleigh and children sledding in the
snow-covered streets of what today is Tribeca. Although
perspective was not always her strongest suit, Henriette has
accurately portrayed the oddly angled intersection of the two
streets.[1] The vertically rising chimney smoke signals the day's
low temperatures and little wind. Nothing remains today of
the low clapboard residential buildings that she represented
in her early cityscape. The Neuvilles' friends General and
Madame Moreau lived on Warren Street in 1808, and possibly
for a time in 1809, until they are recorded at 119 Pearl Street in
1810, where they maintained a residence until their return to
France.[2] No wonder that Henriette drew several views in the
neighborhood (see fig. 9).

1. Auricchio 2014, 37.
2. *Longworth's* 1808, 237; 1810, 274. In 1807, the Moreaus first lived at 225 Broadway; *Longworth's* 1807, 267.

Dey Street on the Hudson River, New York City, 1810

Watercolor, graphite, black chalk, black and brown ink, and gouache on paper; 6 × 9 ⅜ in. (152 × 238 mm)
Inscribed at lower left in brown ink: *hudson's River Dey Street*; at lower right: *avril 1810*
N-YHS, Thomas Jefferson Bryan Fund, 1982.5

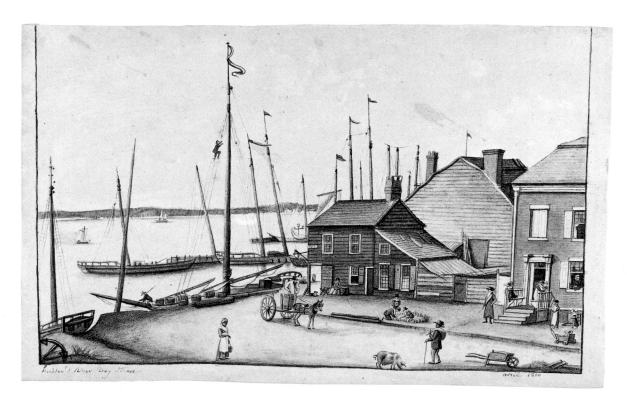

According to *Longworth's* directories, between 1810 and 1814 G.H. Neuville lived at 61 Dey Street, after which his brother Paul took over this residence, as well as the couple's New Brunswick property.[1] It is noteworthy that Henriette is listed jointly on the sale and transfer of the property on July 12, 1815.[2] Today Dey Street is a short lane in lower Manhattan that runs east-west as one block between Church Street and Broadway. Dey originally ran past Greenwich Street to West Street, (see fig. 9) but the western reaches were demolished to make way for the World Trade Center in the late 1960s. The origin of the street's name is ambiguous. Dirck Dey owned much of the property or a half-block in 1743, according to a City Registry map, although his ancestors had owned property in the area since their arrival from Holland in 1641.[3] As the island was built outward with landfill, the street gradually lengthened.

With great topographical accuracy, the baroness recorded the dynamism of the maritime waterfront of the Hudson River at Dey Street near their house, looking toward New Jersey. She also astutely observed boats and ships, their many masts, and architectural details: the energy of this harbor and its street life, including anecdotes that continue to delight— among them a youth climbing the rigging of a ship and a pig roaming.[4] To our twenty-first-century eyes, Neuville's New York of 1810 resembles a small fishing village more than a city, except for the house at the right with its classical doorframe.

1. The Neuvilles' house was on Block 59, Lot 29, the third lot from the corner of Greenwich Street on the south side of the block facing north. The lot was 23 feet wide and 76 feet long, according to New York County, New York, Block Book 7: Blocks 57–61, Block 59 Property Conveyances, p. 6, Manhattan Borough Office of the City Register. *Longworth's* 1810–14 listings, which were published in July, include for the Neuvilles: 1810, 217, G. Hide de Nueville [*sic*] at 61 Dey; 1811, 135, G. Hide de Nueville [*sic*] at 61 Dey; 1812, 228, G.H. Neuville at 61 Dey [p. 76 also lists Nicholas Cruger at the same address]; 1813, 238, G.H. Neuville at 61 Dey; 1814, 203, G.H. Neuville at 61 Dey; then in 1815, 324, P.H. Neuville at 61 Dey, the last New York listing for a Neuville. William Elliot, *Elliot's Improved New-York Double Directory* (New York: William Elliot, 1812), xxvi, also lists Nicholas Cregier [*sic* Cruger] at 61 Dey Street. The Crugers were friends of the Neuvilles and Nicholas evidently lived with them in 1812; see cat. no. 81.
2. New York County, New York, Conveyances Liber 109, 1815, pp. 407–414; Manhattan Borough Office of the City Register, Reel 36 L108p255-L110p95. The lawyer Charles Wilkes was instrumental in negotiations for the sale and transfer of title.
3. New York City Registry, Block 59. The name of the street probably refers to the family that owned the block early on. In city directories, the street, like the family name, was spelled variously: Dyes (1786); Dye's (1787–89); Dye (1790–93); and then Dey (1794).
4. See Rock 1979, 102–104.

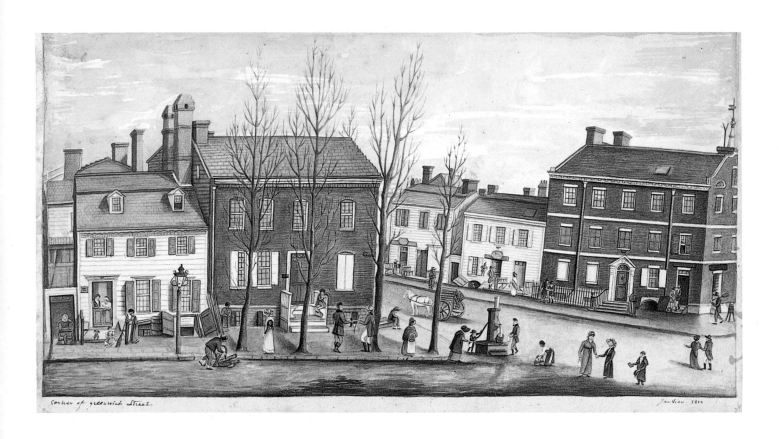

Corner of greenwich street. Janson 1810

43
Corner of Greenwich Street, 1810

Watercolor, graphite, and touches of black ink on paper; 7 5/16 × 12 15/16 in. (185 × 329 mm)
Inscribed at lower left in brown ink: *Corner of greenwich Street*; at lower right: *Janvier 1810*
New York Public Library, The Miriam and Ira D. Wallach Division of Art, Prints and Photographs: Print Collection, Stokes 1810-E-17b

In the baroness's scene, Greenwich Street runs perpendicular to Dey Street in the foreground (see fig. 9). *Longworth's* directories record the Neuvilles as living nearby at 61 Dey Street in 1810–14 (see cat. no. 42). According to the historians Stokes and Haskell, the three-story residence at the extreme right, built by Isaac Stoutenburgh about 1786, belonged to his son John by 1810. It is embellished with a weathervane, drain pipes, an iron fence, and a Federal-style entrance. Behind its roof rises the spire of St. Paul's Chapel. Adjacent to the Stoutenburgh house on Greenwich, the two adjoining houses were owned by Robert Campbell and Leonard De Klyn.

In the center foreground, the large house at the northwest corner of Dey Street, which supposedly belonged to John Dey. He sold it on March 26, 1810, to "James/John Wood," a tin-plate worker with a tin and hardware store, who also owned the adjoining house. The house at the extreme left, only a small portion of which is visible, was owned by Robert Hyslop, a merchant who purchased it in 1785. Both the Dey and Wood houses lay in the present bed of Greenwich Street, which was widened in 1894.[1]

In front of the supposed Dey house, a young New Yorker is framed between two trees as she passes by in her stunning bonnet, while near the cellar hatch stands a solitary Asian man dressed as a gentleman. He may be Punqua Winchong, a Chinese merchant, who was documented in New York and Washington in 1807–08 and 1818. The presence of an individual from China was unusual in the early American republic, long before there was any diplomatic presence, which was only established in 1868. Either Winchong or a compatriot must have made a strong impression on the baroness, who was always attuned to ethnic diversities, inspiring her to paint one of the earliest visual records of a Chinese person in the U.S. A decade later in Washington, Henriette painted another watercolor of a Chinese man dressed in a similar manner (appx. no. 92). More than likely her subject was Punqua Winchong, who attended one of the Neuvilles' famous Saturday night parties on March 28, 1818, and whose presence was recorded by two other attendees.[2] Henriette's curiosity about Chinese culture is demonstrated by her pen and ink study of the chinoiserie Pagoda in the park of the château of Chanteloup (appx. no. 63).

Wood owned the house next to the Dey residence on the left, where a couple stands at a half-open Dutch doorway gazing at their playing child. Neuville's preliminary study for the couple in the Dutch doorway and the adjacent entry with two children instead of a dog and child is sketched on the verso of appx. no. 40. All of the two-story houses on both streets are fronted with spindle-legged "gossip benches."[3] At the corner of Dey and Greenwich is a city water pump, where a boy thrusts hard to fill his bucket while other community residents wait their turn. Nothing remains of this comfortably scaled neighborhood, which is where, two centuries later, the World Trade Center would stand.

1. Stokes and Haskell 1932, 89, notes that much of the property information they cite derives from records provided by the Title Guarantee and Trust Company; Deák 1988, 1: 174.
2. Horace Holley, Washington, DC, to Mary Austin Holley, Boston, MA, March 29, 1818, Clements Library, University of Michigan, Ann Arbor, MI, notes that: "Punqua Winchong, the chinese, was among the crowd, with his chinese costume, and his queer hat. He was persuaded to sing a chinese song, and the people laughed so much I thought he was offended. The singing was very outré, not so good as that of the indians in our parlour last winter." (See also James P. Cousins, *Horace Holley: Transylvania University and the Making of Liberal Education in the Early American Republic* (Lexington: University Press of Kentucky, 2016), 97, who makes several mistakes in his recording of the event.) Louisa Catherine Johnson Adams, Washington, DC, to Abigail Smith Adams, Quincy, MA, March 30, 1818, Adams Family Papers, MHS, writes about the occasion: "I forgot to mention that at Mr. Neuvilles party on Saturday we met a Chinese who favoured us with a Chinese Song which produced such a roar of laughter that the poor man went out of the room crying as Madame de Neuville says "I *have* a shame. I am afraid we somewhat injured the reputation of Washington for politeness...." Thanks to Chase Caldwell Smith for his research on Punqua Winchong.
3. Stokes and Haskell 1932, 89; Deák 1988, 1: 174.

44a

Édouard Bérard Lettering School Sign, from the "Economical School Series", ca. 1808–14

Black chalk, gray watercolor, and graphite with touches of white chalk on light blue paper with deckled edges; 7 ¾ × 6 in. (197 × 152 mm)
Watermark: a goux
Inscribed at lower center in brown ink: *Edouard Bérard*; sign is lettered: *FREN[N written backwards]CH / SCOOL / L'ECOLLE / FRAN[N written backwards]*
N-YHS, Purchase, 1953.274g

44b

Female Student Drawing a Profile Portrait; Seated Man Wearing a Hat, from the "Economical School Series", ca. 1808–14

Black chalk, gray watercolor, and graphite on light blue paper with deckled edges; 7 ⅞ × 6 in. (200 × 152 mm)
Watermark: A Robe
N-YHS, Purchase, 1953.274a

44c

Female Student Writing, from the "Economical School Series", ca. 1808–14

Black chalk, gray watercolor, and graphite on light blue paper with deckled edges; 7 ¾ × 6 in. (197 × 152 mm)
Watermark: Bell
N-YHS, Purchase, 1953.274b

The seven sheets (one with a verso) discussed in this entry, many of them on blue paper typical of the series, belong to a trove of Neuville's life sketches of students at the Economical School (*École Économique*), the couple's major contribution to the history and culture of New York City. Both Neuvilles were directly involved in the local activities of the City's thriving French community during an era when French culture was *le dernier cri*. Beginning in 1808, they participated in the genesis of the Economical School. It was centrally located at 56 Chapel Street in downtown Manhattan, near the Neuvilles' residence and such public magnets as St. Paul's, City Hall, the New York Academy of Fine Arts, Columbia College, and the College of Physicians and Surgeons (for a map, see fig. 9). The school originally listed five board members, including the future baron, who was secretary, and, from contemporary accounts, apparently the motive force in its founding and survival. By June 1809, the school already counted one hundred American and French students. Making friends

44b

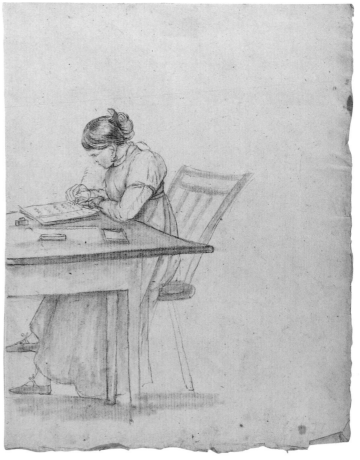

44c

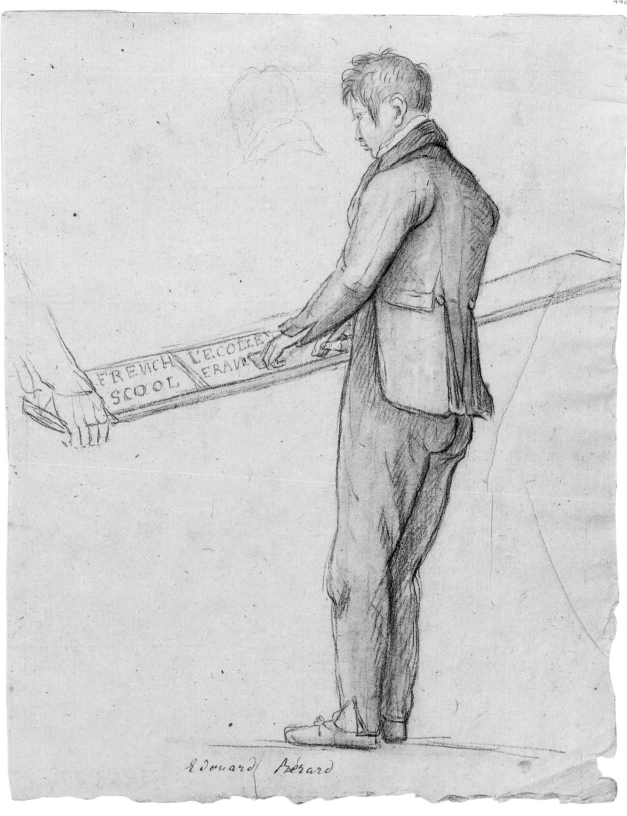

Edouard Agérard

1953.274 C

***Seated Man in Top Hat, from the "Economical School Series"*; verso: male student writing, ca. 1808–14**

Black chalk, gray watercolor, and graphite with touches of white chalk on light blue paper with deckled edges; 7 ½ × 6 in. (190 × 152 mm)
Watermark: A Robe
N-YHS, Purchase, 1953.274c

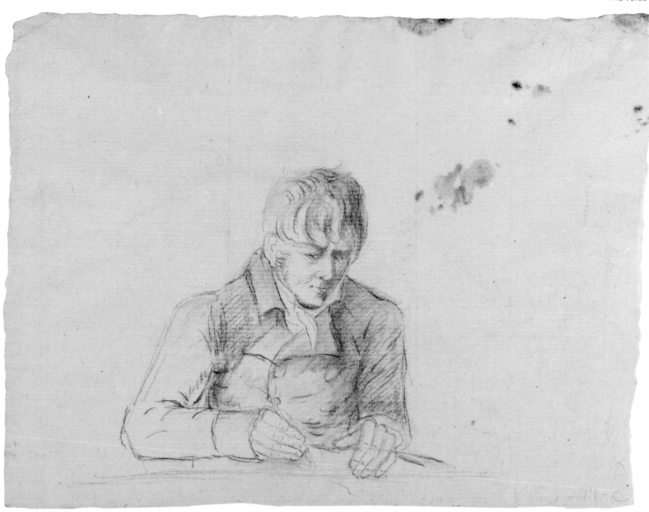

with other émigrés, such as the exiled General Victor Marie Moreau, and important New Yorkers, the baron supported the incorporation of the *École Économique* in 1810 as the Society of the Economical School of the City of New York. Its mission was to educate the children of émigrés, many of them fugitives from uprisings in the French West Indies, and to offer affordable education to children from impoverished homes. The baron admired American education and its charity schools, and wanted to offer the same opportunities for both adults and children. To that end, he and Moreau

taught at the school daily,[1] while the baroness recorded many of its students at work, the only visual evidence of this important early educational institution.[2]

Neuville's seven studies and around a dozen others (appx. nos. 35–46)—the majority of which she drew on a similar blue paper—were accessioned together by the Historical Society as a kind of "Economical School Series." This cache, which originally may have been part of a larger group, demonstrates that the Economical School educated both males and females of all ages. Most charming is Henriette's signature image

1. The baroness may have sketched Moreau reading on the verso of one of her "Economical School Series" (appx. no. 45).
2. For the regulations, see Economical School 1810.

44e

Male Student Writing, from the "Economical School Series", ca. 1810–14

Black chalk, gray watercolor, and graphite on light blue paper with deckled edges; 7 ⅝ × 6 in. (194 × 152 mm)
Watermark: Crown
N-YHS, Purchase, 1953.274f

44f

Two Boys Studying, from the "Economical School Series", ca. 1808–14

Black chalk, gray watercolor, and graphite on light blue paper with deckled edges; 7 ⅞ × 6 in. (200 × 152 mm)
Watermark: a goux
Inscribed at lower right in brown ink: *Economical School*
N-YHS, Purchase, 1953.274h

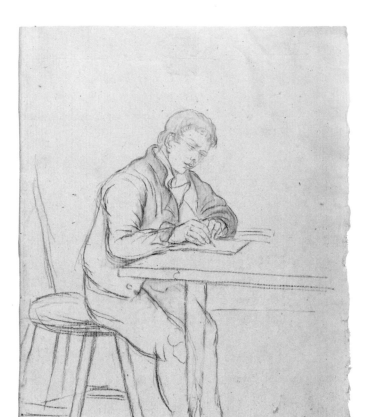

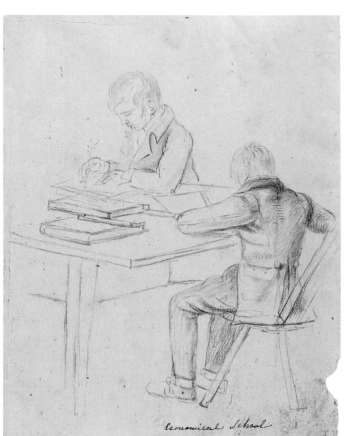

of Édouard Bérard lettering a sign for the school (cat. no. 44a). The baroness represented most of the students in deep concentration—usually seated and reading, drawing, or writing. Others are engaged in more vocational training, such as needlework (sewing, embroidery, and making gowns, a class offered to enrolled female students gratis), or activities related to printing and the school's printing press. Her sketch of the young woman delineating a life-size portrait testifies to the importance the school placed on drawing as part of the

curriculum (fig. 29).[3] As explained in the first essay, by 1811 the Economical School had a separate school dedicated to teaching drawing. The baroness also recorded some younger pupils and adults in more practical occupations, among them several women scrubbing, children sweeping, and a man with a bow saw.

Except for Bérard, a Mr. Dubue (appx. no. 38), and one important student, Amélie Élisabeth du Pont, the identities of most of Henriette's subjects are unknown. Amélie Élisabeth

3. The baroness inscribed and dated it: "Pélagie S… S 1808." Since it is dated 1808, the sheet may record a prelude to the activities of the Economical School or it may be early evidence of its existence.

44g

Male Student Writing, from the "Economical School Series", ca. 1808–14

Black chalk, gray watercolor, and graphite on light blue paper with deckled edges; 6 ¼ × 7 ½ in. (159 × 190 mm)
Watermark: Crown and bell
N-YHS, Purchase, 1953.274p

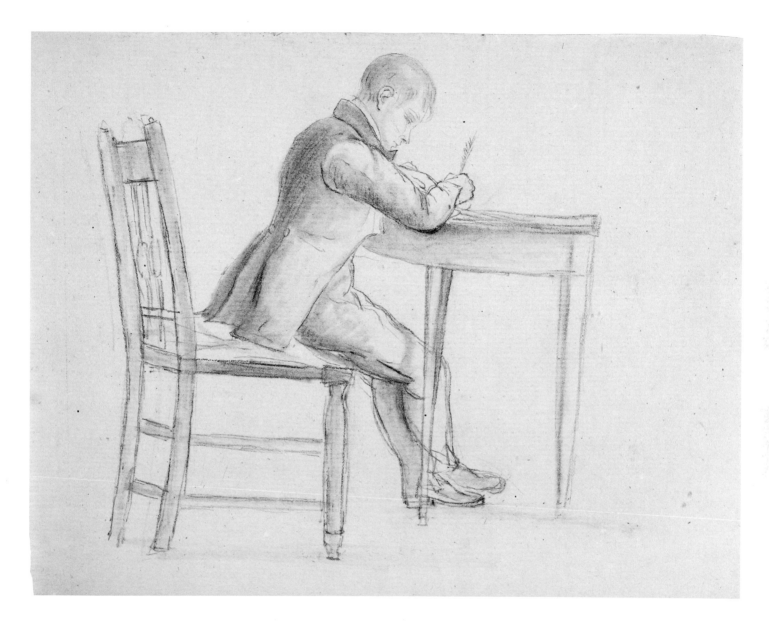

was the daughter of the Neuvilles' friends Victor Marie du Pont de Nemours and his wife, Gabrielle Joséphine de la Fite de Pelleport, and Henriette inscribed her name on two sheets (appx. nos. 46, 47). During 1809–10, Amélie's parents sent their daughter to spend six months in New York City with the Neuvilles in order to improve her education. In a letter of March 7, 1810, the baroness wrote to Mrs. du Pont that the baron and Madame Moreau (cat. no. 35) were taking charge of her daughter's drawing, music, and dance lessons, while

she personally was searching for a "worthy ecclesiastic" to supervise her religious education. This was another pillar of the Economical School's curriculum and its overall goal of moral instruction.[4]

4. Anne Marguérite Joséphine Henriette Rouillé de Marigny Hyde de Neuville, New York, NY, to Joséphine du Pont, place unknown, March 7, 1810, HML, W3-5402; quoted in Watel 1987, 81.

Botanicals, Animals, and Studies after Artworks

45a

Miss Betty Bonnard Seated and Two Studies of Mr. Bonnard; Studies of Wild Geranium (Geranium maculatum) and "Indian Strawberries" (Duchesnea indica), 1808

Graphite, watercolor, and black chalk on paper; 7 ⅜ × 12 ⅜ in. (187 × 314 mm)
Inscribed below left of study in graphite: *Mis Bety Bonnard and Mr Bonnard 1808*; below watercolor images in brown ink: *indian 'straw-berrys. / genessee.*
N-YHS, Purchase, 1953.241

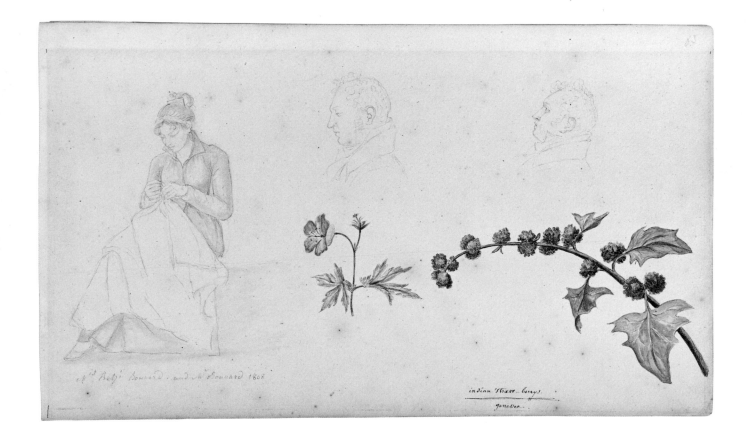

The intellectually curious baroness maintained an interest in natural history characteristic not only of the Enlightenment and its urge to study and classify phenomena, but also of the spirit of Alexander von Humboldt. The German polymath had visited the United States in 1804, meeting with Thomas Jefferson and other American naturalists, en route to Europe after his South American expedition in quest of specimens. Most of Neuville's natural history studies are inscribed in her attempt to identify the species she represented. Henriette harvested her botanical specimens in order to draw them and afterward may have pressed them, a practice of both professional and amateur botanists. Her absorption with

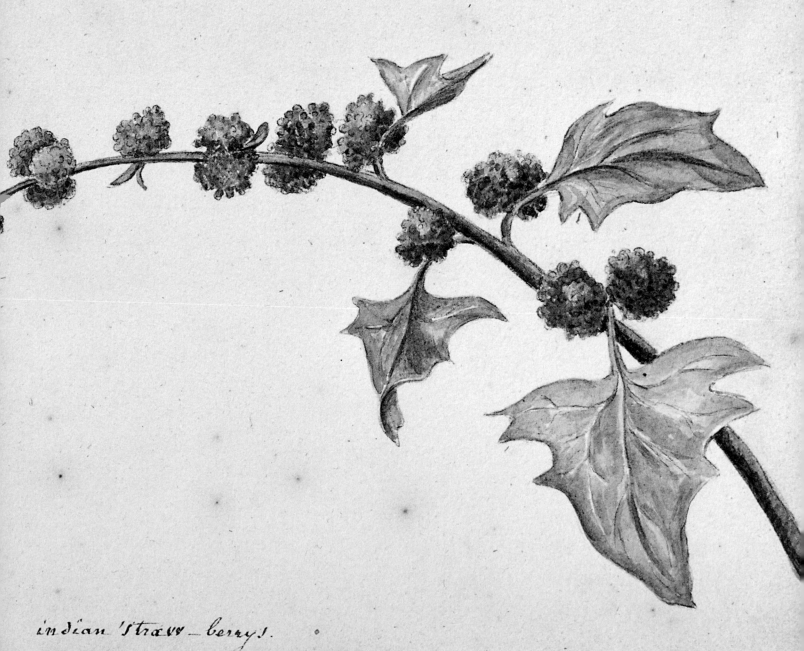

indian 'Straw—berrys.

genessee.

45b

Study of a Tree Trunk with Lichens and Fungi,
1807–14

Watercolor, gouache, and graphite on blue-gray paper, laid on blue paper;
2 ⅞ × 6 ⅝ in. (168 × 730 mm)
N-YHS, INV.14853

45c

Studies of Fruit-Bearing Plants: Wild Black Cherry
(Prunus serotina); Mapleleaf Viburnum (Viburnum
acerifolium); and Thornapple or Hawthorn
(Crataegus species), Genesee, New York, 1807–14

Watercolor, graphite, black chalk, and brown and black ink on paper;
7 ¼ × 13 in. (184 × 330 mm)
Inscribed below each plant from left in brown ink: *indian-cherry* / *genessee*;
Pigen Berry. [over erased graphite] / *genessee*; *thorn apples* / *genessee*
N-YHS, Purchase, 1953.270

45d

Studies of Passion Flower (Passiflora incarnata),
Anise (Foeniculum vulgare), Chokeberry (Aronia
prunifolia), and a Yellow Plum (Prunus americana)
above an Atlantic Cockle Shell, 1807–14

Watercolor, graphite, black chalk, and brown ink with touches of gouache on
paper; 7 ½ × 10 ¾ in. (190 × 273 mm)
Watermark: T G & Co
Inscribed below plants from left in brown ink: *passion's flower.*; *anis*; *Coriander*
N-YHS, Purchase, 1953.266

45b

natural history comes as no surprise because the Neuvilles traveled in circles with like-minded individuals in New York.

The study of natural history was embraced in New York by such individuals as the physician Dr. David Hosack, founder of the Elgin Botanic Garden. This was the first public garden in the United States, the first research institution devoted mainly to the cultivation and study of native plants, and the predecessor of the New York Botanical Garden. The Elgin Garden occupied the site of today's Rockefeller Center and eventually comprised about twenty acres. Humboldt greatly admired Hosack, who played a pivotal role in inspiring Americans to pursue botany and medicine. Owing

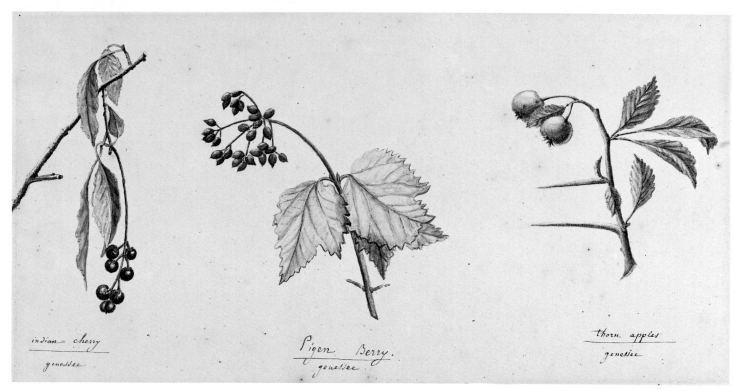

indian cherry

genessee

Pigen Berry.

genessee

thorn apples

genessee

45c

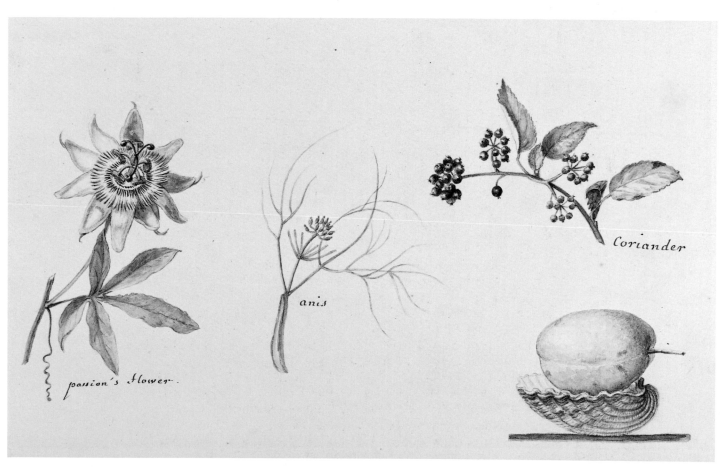

passion's Flower.

anis

Coriander

45d

45e

*Study of a Branch of a Tulip Tree (**Liriodendron tulipifera**), 1807–14*

Watercolor, black chalk, and graphite on paper; 6 × 7 ¼ in. (152 × 184 mm)
N-YHS, Purchase, 1953.267a

to the German's sudden return to Europe, however, the two men never met but only corresponded.

Among Humboldt's other correspondents were Thomas Jefferson, James Madison, and Hosack's friends and patients, Aaron Burr and Alexander Hamilton.[1] Although there is no proof that Hosack knew the Neuvilles, Henriette's friend Louis Simond executed an engraving of the greenhouse and hothouses of the Elgin Botanic Garden (fig. 15). In addition, the baron's interest in medicine and their other mutual friends suggest that the Neuvilles and Hosack probably knew each other, and that the Neuvilles more than likely visited the Elgin Garden. In fact, some of the plants Henriette

1. See Johnson 2018.

45f

Studies of Rice (Oryza glaberrima or sativa) and Leaves of the Sessile Bellwort (Uvularia sessilifolia), 1807–14

Watercolor, brown ink, black chalk, and graphite on paper; 5 ¾ × 8 in. (146 × 203 mm)
Verso inscribed at lower left in graphite: *Branche de riz*
N-YHS, Purchase, 1953.267b

45g

*Study of Rose Gentian (*Sabatia angularis*), Drawn on the Brandywine River, Delaware, 1810*

Black chalk, gray watercolor, and graphite on paper; 7 ½ × 4 ¼ in. (190 × 108 mm)
Inscribed below plant in brown ink: *fleur déssineé sûr les Bords du Brandy-Wine / le. 6 7bre 1810. / Couleur violet tendre les Etamines Jeaunes / ainsi que le Pistil les feuilles d'un verd tend*[cut] */ ou La Dit un très bon — fébrifuge.*
N-YHS, Purchase, 1953.269

represented were ones that Hosack had gathered and was raising, such as the Passionflower (*Passiflora*) in cat. no. 45d.[2] Hosack planted some species for their beauty, but he studied the majority for their medicinal and curative potential, in addition to their promise as sustainable crops for the new nation. Similarly, Henriette noted in her inscription that the Rose Gentian was known to reduce fevers.

The baroness's careful recording of natural phenomena reflects her position among the foremost intelligentsia of the time. For an additional botanical study by her, see appx. no. 68, and for fauna, cat. nos. 46, 61; appx. nos. 53, 58.

2. Ibid., 234.

fleur dessinée sur les Bords du Brandy-Wine
le 6 7bre 1810.
Couleur violet tendre les étamines jaunes
ainsi que le pistil les feuilles d'un verd tend.
on La Dit un très bon fébrifuge.

***Study of a Luna Moth* (Actias luna), 1817**

Watercolor, black chalk, graphite, and gouache on paper; 7 ⅞ × 8 ⅝ in. (200 × 219 mm)
Watermark: FELLOWS / 1814
Inscribed below in brown ink: *Papillon de L'Espèce de l'argus trouvé à Washington au Mois de Mai 1817. Et Sauvé de la Mort d'Louisa*
N-YHS, Purchase, 1953.265

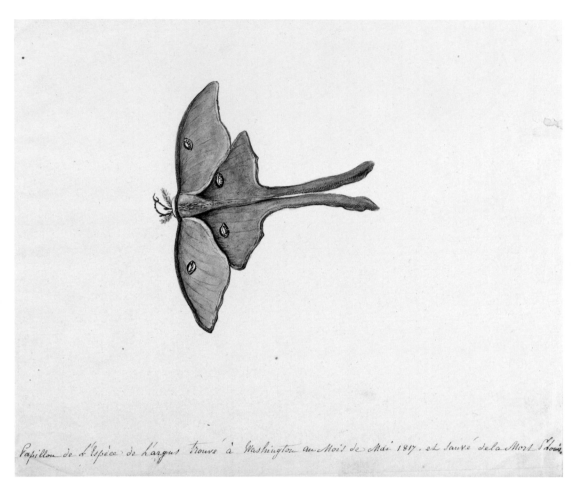

The baroness's interest in naturalistic renderings of flora and fauna carried over into the Neuvilles' residency in Washington, DC, as demonstrated in her watercolor of a female Luna Moth (*Actias luna*), one of the largest moths of North America. She termed it an "argus" because of its eye-like markings, which for her recalled the many-eyed giant of Greek mythology, Argos. On a more personal note in the sheet's inscription, she remarked that the moth was saved by "Louisa," possibly Louisa Catherine Johnson Adams, Henriette's good friend and the wife of Secretary of State John Quincy Adams. Alternatively, she may have been an unidentified Louisa that the baroness mentioned and portrayed thrice, in 1804, 1809, and 1815 (see appx. nos. 1, 51, 61).[1] For a plant that Neuville delineated in the nation's capital, see appx. no. 68.

During their second residence in the U.S., the Neuvilles befriended Jacques-Gérard Milbert, a naturalist and artist. Milbert's love of exploration and travel brought him to America in November of 1815, where he remained for eight years. The baron, in his capacity as Minister Plenipotentiary of France, commissioned him to collect natural history specimens along the Hudson River for King Louis XVIII's collections. After completing this seven-year task, Milbert returned to France in 1823 and presented the impressive number of specimens he had collected (well over seven thousand in fifty-eight shipments) that were destined for the Muséum national d'histoire naturelle in Paris.

1. In 1804 Henriette drew a young girl named Louisa, who is wearing wooden shoes and sewing, and was probably a servant in La Charité (appx. no. 1 verso).

47

Studies after Old Master Drawings of an Ancient Philosopher and a Skull, 1800–05

Black chalk and gray watercolor on paper; 6 ⅛ × 9 ⅞ in. (156 × 251 mm)
Inscribed at lower left in brown ink: *Vieux Dessins retrouvez à Lestang*
N-YHS, Purchase, 1953.810c

The artist's inscription on this ambitious sheet indicates two different facets of the baroness's life that heretofore have been ignored: the Neuvilles had works of art in their possession at the Château de L'Estang near Sancerre, and the artist executed drawings while residing in France at that country home (see "The Baroness," pp. 47–51). In these careful, almost methodical, academic studies after two old master drawings, Henriette employed black chalk, her earliest choice of medium, and related black media, suggesting that she was teaching herself in the time-honored method of copying after earlier masters. She delineated the profile, bust-length, seated ancient philosopher type from an original probably drawn after a sculpture but reminiscent of Plato in David's *The Death of Socrates* (1787), with shading in the background; and she tackled replicating the skull in its challenging frontality and foreshortening. In finishing the latter anatomical study,

she added drama with chiaroscuro modeling and reinforced areas of the skull with darker black lines.

Like other women artists of her time, such as Élisabeth Vigée Le Brun, who was also self-taught but a professional artist, the baroness was not allowed to draw live models in the academic tradition open to men.[1] In place of drawing after the naked male, and as a means to teach herself to draw life studies, Henriette turned to copying works of art at hand. Neither her gender nor the violent course of history in Revolutionary France allowed her to pursue the latent ambition evident in this sheet, so that she resorted in her travels to her visual diary (see "The Baroness," pp. 64–65). The baroness may have executed other similar, ambitious studies that do not survive. Throughout her years in exile, Henriette continued to copy artworks that impressed her.

1. For Vigée Le Brun, see Joseph Baillio, Katherine Baetjer, and Paul Lang, *Vigée Le Brun: Woman Artist in Revolutionary France*, exh. cat. (New York: Metropolitan Museum of Art, 2016).

Hendrick, "Sachem" or Chief of the Mohawks, after a Print; verso: sketch of a man, 1810

Graphite, gray watercolor, and black chalk on paper; graphite; 6 ⅝ × 5 ⅝ in. (168 × 143 mm)
Inscribed below: *the brave and old hendrick. the great Sachem or chief of the / Mohawk. indians one of the Six Nations of the North america / Déssiné chez miss abbey aoust 1810*
N-YHS, Purchase, 1953.264

The baroness's fascination with Indigenous Americans and her studies after works of art are joined in this copy of a print (fig. 53) whose legend ("The brave old Hendrick, the great SACHEM or Chief of the Mohawk Indians. . . .") she partially transcribes. Henriette's inscription also records that she delineated her copy while visiting the house of Miss Abbey/ Abby Sharp (whose identity is unknown; see cat. no. 80), perhaps because the Sharp family owned a copy of the print.

Henriette's subject, Hendrick Theyanoguin—a member of the Big Bear Clan and the Iroquois Confederacy of the Haudenosaunee—was known in English as King Hendrick. He died in the Battle of Lake George in September 1755, fighting the French in defense of British claims to North America, and his death marked the end of an era in Anglo-Iroquois relations. He was the second Mohawk leader named Hendrick and, like his predecessor (Hendrick Tejonihokarawa), had become a Christian and adopted English dress. As a sachem or chief, he stressed cooperation rather than bloody confrontation with New York and Great Britain, like his predecessor.[1] His distinctive identity is underlined by his unusual facial tattoo and long white hair. In his left hand Hendrick holds wampum, the emblem of diplomacy, and in his right he brandishes an unconventional halberd tomahawk, an unpractical type which was only popular for a short time in the eighteenth century. It was a symbol of war and defense, an attitude prized by the Haudenosaunee's British allies.[2]

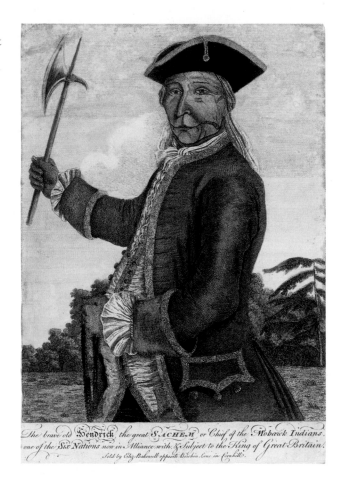

Fig. 53
Unidentified engraver, *The Brave Old Hendrick, the Great Sachem or Chief of the Mohawk Indians*, 1740–55. Hand-colored engraving; 13 ⅞ × 9 ⅝ in. (353 × 244 mm). John Carter Brown Library at Brown University, Providence, RI

1. See Eric Hinderaker, *The Two Hendricks: Unraveling a Mohawk Mystery* (Cambridge, MA: Harvard University Press, 2010).
2. See Scott Manning Stevens, "Tomahawk: Materiality and Depictions of the Haudenosaunee," *Early American Literature* 53: 2 (2018): 495–511, espec. 486–488.

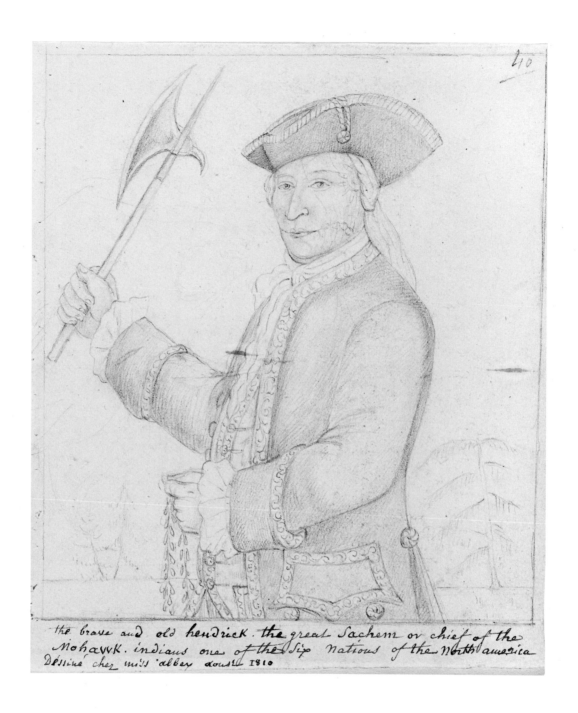

the brave and old hendrick. the great Sachem or chief of the
Mohawk. indians one of the Six nations of the North america
Dessiné chez miss albex dousl 1810

Chief of the Little Osage, after Saint-Mémin, ca. 1807–12

Watercolor, graphite, and black chalk with touches of white gouache on an oval sheet of paper, laid on larger sheet; 7 ¾ × 5 ¼ in. (197 × 133 mm)
N-YHS, Purchase, 1953.214

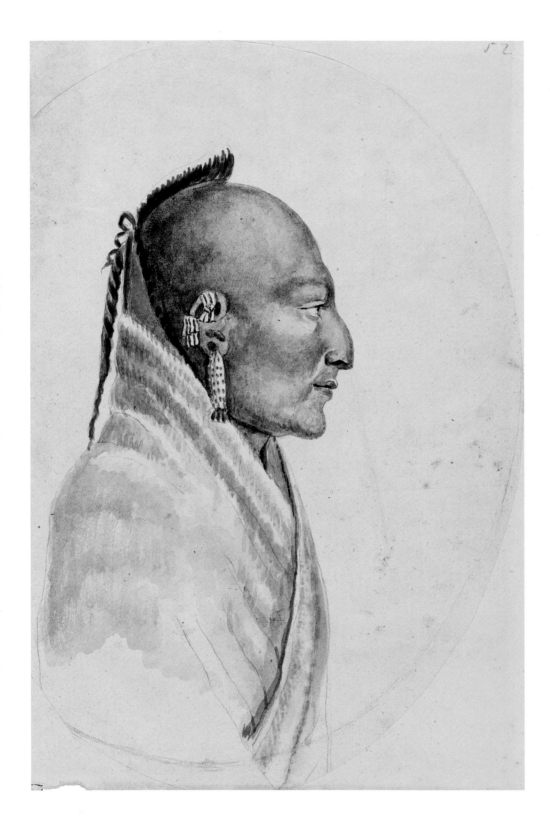

49b

Osage Warrior Wearing a Bird Headdress, after Saint-Mémin, ca. 1807–12

Watercolor, graphite, black chalk, and brown and black ink with touches of white gouache on an oval sheet of paper, laid on larger sheet; 7 ⅞ × 6 in. (200 × 152 mm)
Inscribed at lower center in brown ink: *Savage chef*
N-YHS, Purchase, 1953.213

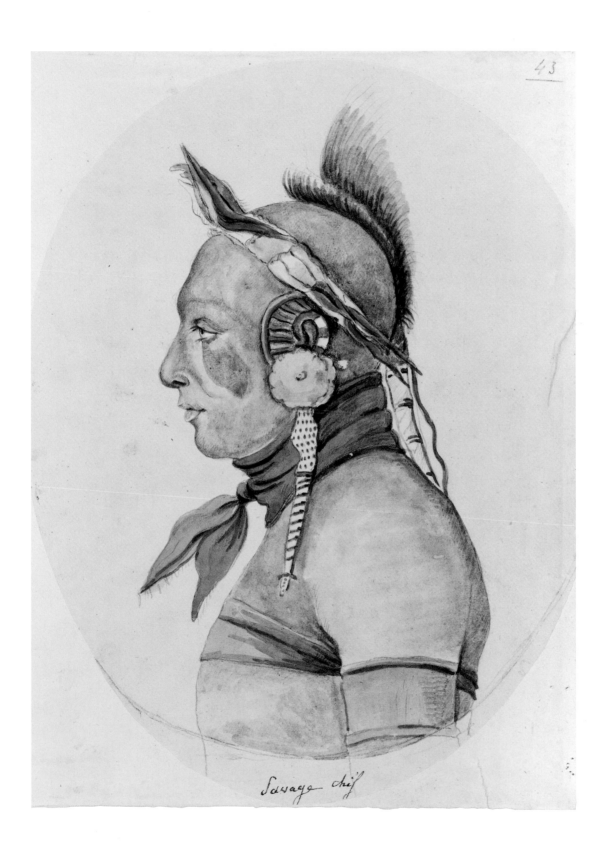

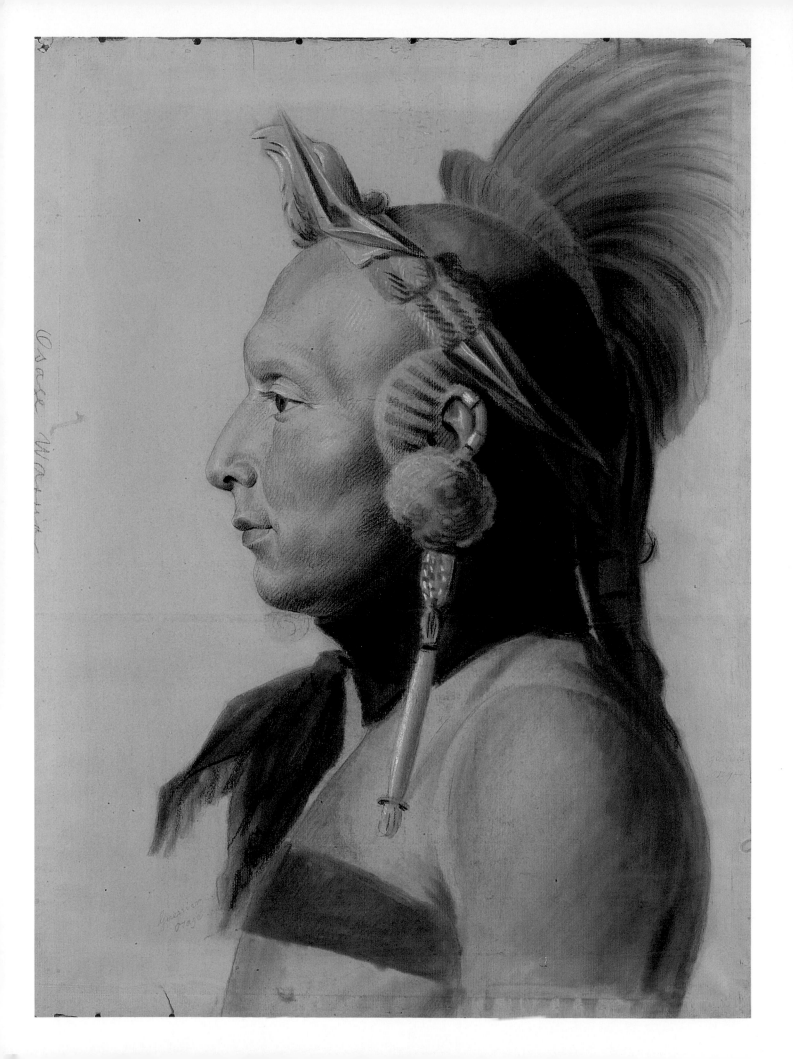

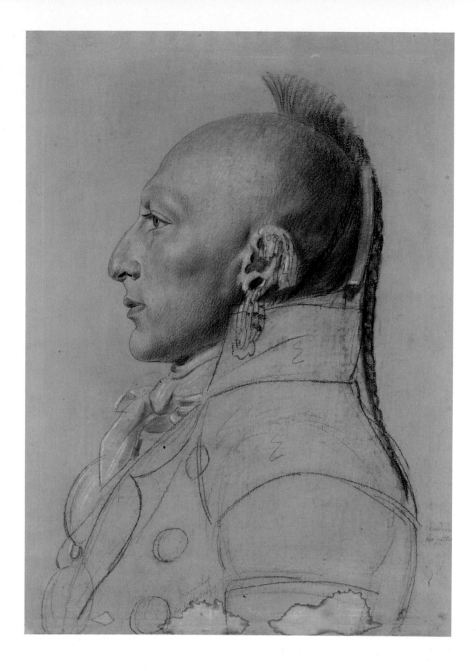

Fig. 54
Charles Balthazar Julien Févret de Saint-Mémin, *Unidentified Osage Warrior Wearing Bird Headdress*, 1807. Charcoal with stumping, Conté crayon, black pastel, and black and white chalk on pink prepared paper, nailed over canvas to a wooden strainer; 23 × 17 in. (584 × 432 mm). N-YHS, Elizabeth DeMilt Fund, 1860.91

Fig. 55
Charles Balthazar Julien Févret de Saint-Mémin, *Unidentified Osage (Chief of the Little Osage)*, 1804. Charcoal with stumping, black pastel, black and white chalk, and Conté crayon over graphite on pink prepared paper, nailed over canvas to a wooden strainer; 22 ¾ × 16 ¾ in. (578 × 425 mm). N-YHS, Elizabeth DeMilt Fund, 1860.93

Like the baroness, Charles Balthazar Julien Févret de Saint-Mémin was an exiled French aristocrat. He lived and worked in New York City and various other cities on the eastern seaboard from 1793 until the fall of Napoleon in 1814, and was one of the most elegant and accomplished of all Federal portraitists. He was also a clever marketer, making portraits in different sizes and for various prices. Using two recent inventions, he employed the physiognotrace to take life-size profiles, and he reduced them with the aid of a pantograph to produce multiple engraved visages one-tenth life-size.[1] Among Saint-Mémin's unique works are nine stunning life-size, bust-length portrayals of Plains Indians (figs. 54, 55)—eight in the N-YHS—six men and two women—all with a common provenance from the artist.[2] Saint-Mémin also painted six smaller related watercolors (figs. 56–58), which swell the number to fifteen portrayals of these Indigenous Americans.[3] These works are universally recognized as among the earliest and most accurate portraits of American Indians. Unlike some works by Neuville, they are not full-length portraits and do not show the sitters in their environment.

Saint-Mémin's subjects were Plains Indians from lands acquired by the U.S. government in the Louisiana Purchase (1803), who were sent to Washington, DC, in three delegations from 1804 through 1807. Celebrities of the moment, they visited

1. See Miles 1994; Olson 2008, 101–111.
2. For the life-size portraits, eight in the N-YHS (inv. nos. 1860.90–97), see Miles 1994, 261, no. 123 (fig. 7:21); 269–270, no. 161 (fig. 7:22); 287, nos. 246, 247 (figs. 7:19, 7:20); 365–366, no. 633 (fig. 7:24); 366, no. 635 (fig. 7:26); 368, no. 644 (fig. 7:16); 389, no. 745 (fig. 7:17); 435–436, no. 975 (fig. 7:18).
3. For these watercolors, one in the N-YHS (inv. no. 1954.101), see ibid., 270, no. 162 (fig. 7:23); 366, nos. 634 (fig. 7:25), 636 (fig. 7:27); 367, no. 637 (fig. 7:30); 389, no. 746 (fig. 7:28); 436, no. 976 (fig. 7:29).

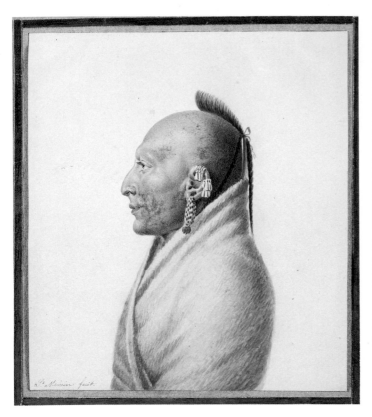

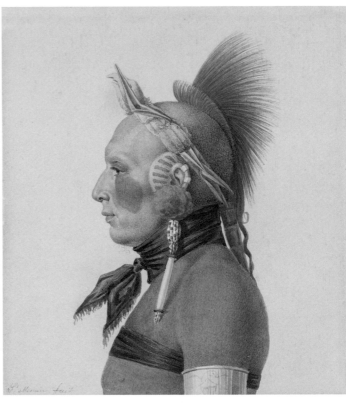

the nation's capital with great fanfare, beginning in July 1804, continuing in late 1805–06, and ending in late 1806–07, when the itinerant Saint-Mémin was also present. The purpose of these diplomatic missions was to meet President Thomas Jefferson to establish trade relations and rights to land.

All but one of Saint-Mémin's six watercolors of the Plains tribesmen enjoy a provenance from the English heirs of Sir Augustus John Foster, then secretary of the British legation to the United States (1805–07), who wrote at some length about these Native American delegations.[4] The five watercolors formerly in Foster's collection depict the same individuals represented in five of the Historical Society's life-size drawings. The artist probably reduced their size with his pantograph before finishing them in watercolor, painting them either for sale or to be engraved and published. Indeed, the five watercolors may all be related to Meriwether Lewis's commission in 1807 for Indian likenesses to illustrate his forthcoming book, which remained unpublished at his premature death.[5] Saint-Mémin also made at least one other reduced copy after one of the five watercolors in Foster's possession—now in a private collection (the sixth)—which the artist may have taken back to France with him.[6]

Fig. 58
Charles Balthazar Julien Févret de Saint-Mémin, *Osage Warrior*, 1804–06. Watercolor and graphite on off-white paper; 7 ¼ × 6 ⁷⁄₁₆ in. (184 × 164 cm). Metropolitan Museum of Art, New York, The Elisha Whittelsey Collection, The Elisha Whittelsey Fund, 1954, 54.82

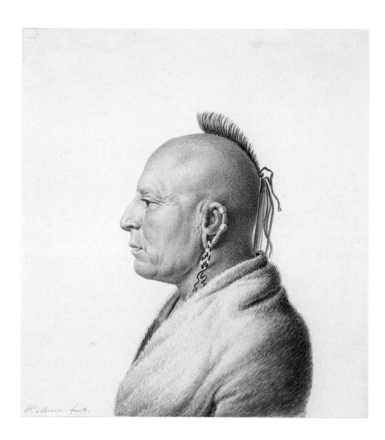

Saint-Mémin's watercolors attracted much admiration. Neuville created versions of two, as seen here, and the Russian artist and diplomat Pavel Petrovich Svinin copied the same pair (figs. 59, 60). How were the Russian and the baroness able to duplicate Saint-Mémin's watercolors? Svinin served in Philadelphia as secretary to the Russian Consul-General in the United States (1811–13) when Foster was Great Britain's Minister Plenipotentiary to the United States (1811–12).[7] Neuville may have copied Svinin's versions, as has been suggested, but more likely both artists copied Saint-Mémin's original watercolors in Foster's collection separately (figs. 56, 57), because Neuville's two are closer to the originals than those of her Russian counterpart. Both artists traveled in diplomatic circles, thus facilitating their replication.[8]

Neuville drew ovals around both subjects, framing her sitters and cropping their torsos. However, like Svinin (fig. 59), she reversed the watercolor of the chief of the Little Osage (fig. 56) in order to have the sitters face each other as pendants. Two alternative scenarios could explain this situation: either both Svinin and Neuville flipped the image in their copy of the chief of the Little Osage independently or, more likely, they both replicated another model other

4. Some of Foster's letters and papers are held by the Manuscript Division of the Library of Congress, Washington, DC, including a five-volume draft entitled "Notes on the United States of America, 1805–1812." It is a later version of a draft held by the Huntington Library, San Marino, CA. See Foster 1980, 22–43, for his comments on Indian visitors to Washington. Foster recounts visits to his house by several Indians, including one who came to have his portrait painted by the French miniaturist David Boudon. See also Dorothy Wollon and Margaret Kinard, "Sir Augustus J. Foster and 'The Wild Natives of the Woods,' 1805–1807," *William and Mary Quarterly* 9:2 (April 1952): 191–214; Foster 1980.

5. Olson 2008, 110, allies the artist's Indian watercolors plus the artist's watercolor portrait of Meriwether Lewis (N-YHS, inv. no. 1971.125; ibid., 18, fig. 5) to this commission; Miles 1994, 148, however, believes that Saint-Mémin's duplicate of one of the life-size Delaware Indians (ibid., 146, fig. 7:19) was for the Lewis commission and implies that the others were lost.

6. Miles 1994, 367, no. 637 (fig. 7:30).

7. See Avery 2002, 347–351. See also Yarmolinsky 1930.

8. Koke 1982, 2: 211.

Fig. 59
Pavel Petrovich Svinin after Saint-Mémin, *The Chief of the Little Osage*, ca. 1811–12. Watercolor and black chalk on off-white wove paper; 8 ¼ × 6 ¼ in. (210 × 159 mm). Metropolitan Museum of Art, New York, Rogers Fund, 1942, 42.95.31

Fig. 60
Pavel Petrovich Svinin after Saint-Mémin, *An Osage Warrior*, ca. 1811–12. Watercolor, black chalk, and gum arabic on white wove paper; 8 ¼ × 6 ³⁄₁₆ in. (210 × 157 mm). Metropolitan Museum of Art, New York, Rogers Fund, 1942, 42.95.30

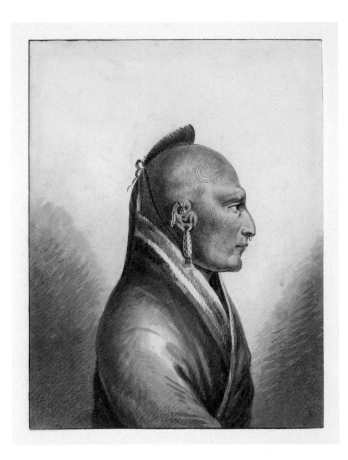

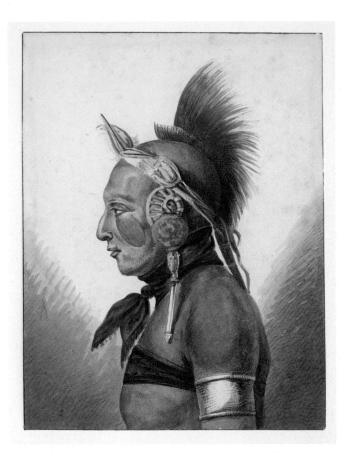

than Foster's. It may have been a watercolor painted in reverse by Saint-Mémin or a hand-colored print, as both artists copied from prints.[9] Furthermore, Svinin added many embellishments absent in both Saint-Mémin's originals and Neuville's copies, such as tattoos and a nose-ring piercing. The Russian also painted the blanket robe worn by one sitter in dark gray tones with blue and pink stripes, unlike the off-white blankets with pink and greenish-gray stripes in the original and Neuville's copy. In addition, Svinin added strongly shaded lower areas to both of his copies, creating a halo effect around the sitters' profiles. As for the Osage warrior wearing a bird headdress, Neuville's version is again closer to Saint-Mémin's small watercolor model (fig. 57).

Curiously, Svinin included the Osage warrior with a bird headdress in another watercolor, a landscape with three full figures in a canoe, to enrich his recollections of America in

his *Voyage pittoresque aux États-Unis de l'Amérique par Paul Svignine en 1811, 1812, et 1813.*[10] Svinin represented himself in the center of the canoe wearing a high hat. Exploring the wilderness with him are two American Indians: at the left the aforementioned warrior with the bird headdress, his visage reversed (fig. 61), and at the right a second Indian, perhaps after another watercolor by Saint-Mémin portraying Cachasunghia, known only in a life-size version in the N-YHS.[11] We know that Svinin might have painted his copies in a narrow window of time—probably between his arrival in the United States in 1811 and Foster's departure in 1812—but there is no way of determining when Neuville painted hers. It is also possible that the baroness may have copied Saint-Mémin's watercolors before they came into Foster's possession.

Fig. 61
Pavel Petrovich Svinin, *Two Indians and the
Artist in a Canoe*, ca. 1811–13. Watercolor
and graphite on white wove paper;
5 13/16 × 8 ½ in. (148 × 216 mm).
Metropolitan Museum of Art, New York,
Rogers Fund, 1942, 42.95.33

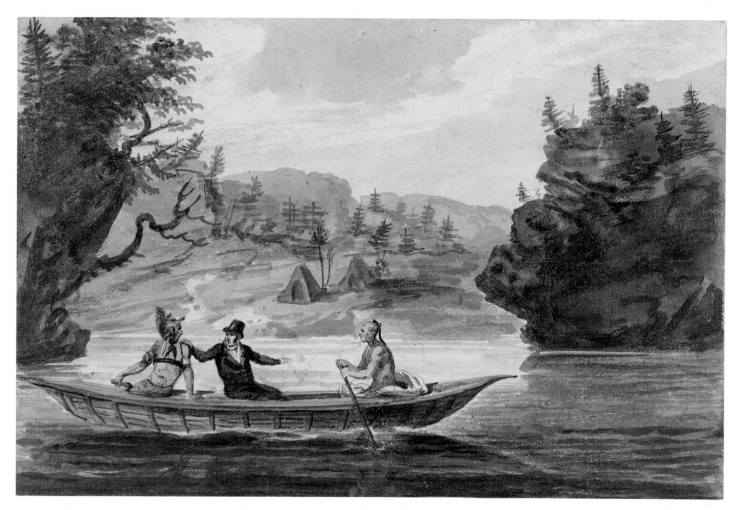

9. In fact, Svinin's watercolor of Indian pots (Metropolitan Museum of Art, New York, inv. no. 42.95.32) is after a print, perhaps by Alexander Anderson, as published in James Foster, "A Letter on Indian Antiquities of the Western Country," *Medical and Philosophical Register* (1812): 2: 397, ill. For another version in the Russian Museum, St. Petersburg, see Svinin 1992, pl. 66. See also Yarmolinsky 1930, 32, which notes that, alternatively, Svinin's watercolor (pl. 31) may have provided the model, but also implies that it was probably a copy. One of Svinin's views of Niagara Falls (ibid., p. 25, pl. 39, Metropolitan Museum Art, New York, inv. no. 42.95.40) was painted after a print by William Bartlett, which was based on a watercolor by Alexander Wilson, and published with a poem by Wilson; see Alexander Wilson, "The Forresters; A Poem: Descriptive of a Pedestrian Journey to the Falls of Niagara, in the Autumn of 1804," *Port Folio* 3:3 (March 1810), opp. p. 183, ill.
10. For another version in the Russian Museum, St. Petersburg, see Svinin 1992, pl. 56.
11. N-YHS, inv. no. 1860. 90; Miles 1994, 261, no. 123 (fig. 7:21).

Cherokee Man, 1820

Watercolor, black ink, black chalk, and graphite with touches of gouache on paper; 11 ⅛ × 7 ¼ in. (282 × 184 mm)
Watermark: D AMES
Inscribed at lower center in brown ink: *Cherokee / 1820 Mr Martin*
N-YHS, Purchase, 1953.218

Fig. 62
Detail and title page of Jacques-Gérard Milbert, *Itinéraire pittoresque du fleuve Hudson et des parties latérales de l'Amérique du Nord*, 1828–29. N-YHS Library

The Cherokee man whom the baroness depicted in profile wears a white blanket robe with red, blue, and green stripes. He holds a bow and arrows with blunt ends and no fletching for hunting birds.[1] The artist identified either the subject, the source on which her watercolor was based, or its owner, as "Mr. Martin." The unidentified prototype, which was most likely a print, was also copied by her friend, the naturalist and artist Jacques-Gérard Milbert, in his *Itinéraire pittoresque du fleuve Hudson et des parties latérales de l'Amérique du Nord* (*Picturesque Itinerary of the Hudson River and the Peripheral Parts of North America*).[2] Milbert had come to America in 1815, and he remained for eight years, publishing his bound portfolio of fifty-four lithographic plates, based on wash drawings, with two separate volumes of text, after he returned to France in 1828–29. He copied the same prototype as did Neuville (but in reverse) as one of the lithographed vignettes at the lower right in the title page frame of the bound portfolio of plates (fig. 62).[3]

Following his arrival in New York City, Milbert first supported himself with portrait painting and later founded the Academy of Drawing and Painting with John Vanderlyn and the miniaturist Louis Antoine Collas at 21 Park Place.[4] This partnership was short-lived, because in 1816 Milbert was hired to assist in the six-month survey for the construction of the Champlain-Hudson Canal. When the canal was completed, he began collecting specimens for the natural history museum and botanic garden in Paris, an enterprise under the supervision of the baron as Minister Plenipotentiary of France, which eventually constituted fifty-eight shipments of 7,868 animals, plants, rocks, and minerals. As further discussed in the first essay of the catalogue (p. 33) and cat. no. 46, Milbert was a good friend of the Neuvilles.

The Cherokee, whose language is part of the Iroquois language group, are an Indigenous people from the southeastern woodlands. They were agrarian and considered by early European settlers as one of the "Five Civilized Tribes." After the Louisiana Purchase, they were among the tribes that sent delegations to Washington, DC, to cede land and negotiate with the U.S. government. The Cherokee were among the first, if not the first, major non-European ethnic group to become American citizens, in a treaty of 1817.

1. Sturtevant 1980, 341–342.
2. See Deák 1988, 1: 197–202; 2: nos. 299.1–299.53, ills.; Philip J. Weimerskirch, "Two Great Illustrated Books about the Hudson River: William Guy Wall's *Hudson River Port Folio* and Jacques-Gérard Milbert's *Itinéraire pittoresque du fleuve Hudson*," in Caroline Mastin Welsh, ed., *Adirondack: Prints and Printmakers* (Syracuse, NY: Adirondack Museum/ Syracuse University Press, 1998), 25–44; Olson 2008, 129–131.
3. See Deák 1988, 2: no. 299, ill.
4. Weimerskirch, "Two Great Illustrated Books," 187 n. 16, cites an advertisement for the academy in the *New York Evening Post*, May 1, 1815.

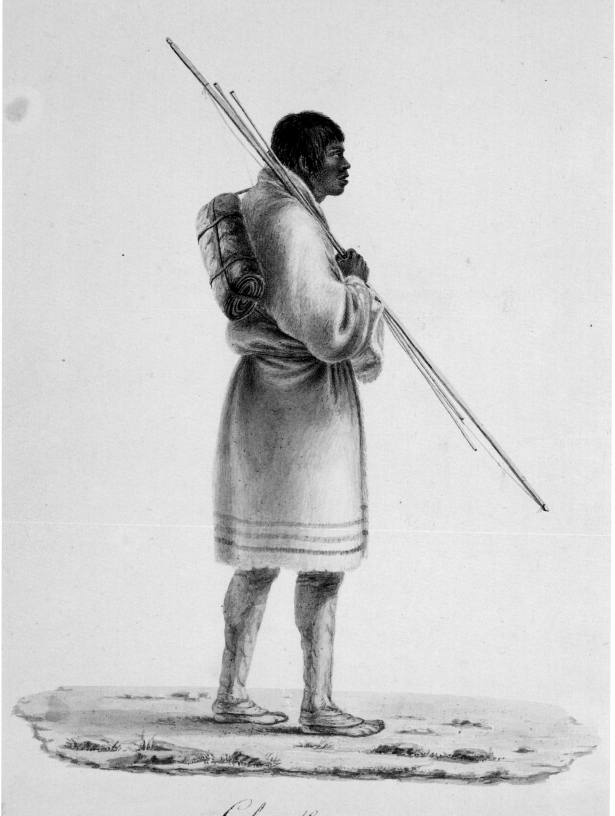

Cherokee

1820 Mr Martin

51

Vignette with Trees, after William Gilpin; verso: wagon in Amsterdam, New York, 1808–15

Black ink wash and graphite on paper; graphite and black chalk; 6 ⅞ × 5 ⅝ in. (175 × 143 mm)
Verso inscribed at lower left in brown ink: *Waggon D'amsterdam 1808.*
N-YHS, Purchase, 1953.205

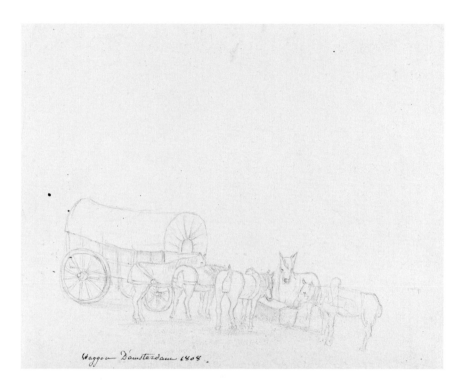

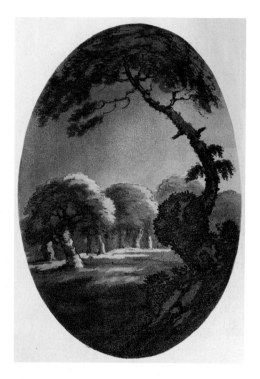

Fig. 63
William Gilpin, *Vignette with Trees,*
etching and aquatint in *Remarks on
Forest Scenery, and Other Woodland
Views* (London: R. Blamire, 1791), vol. 1,
pl. opp. p. 5. Thomas J. Watson Library,
Metropolitan Museum of Art, New York

Although Neuville dated the verso of this sheet 1808, and indicated that in Amsterdam, New York, she sketched the covered wagon with five horses eating at a trough, there is no indication when she delineated the incomplete recto. With its vignette format and landscape dominated by a large *repoussoir* tree at the right, her composition type is similar to legions of illustrations, often included in books rather than as independent prints. Compare it, for instance, to a vertically oriented stipple engraving in an oval format by John Raphael Smith after George Morland; it is dated 1788 and features a representation of a lady seated in a landscape under a large tree at the right, whose branches hug its frame in a manner similar to Neuville's.[1]

Whereas Henriette's landscape vignette echoes Romantic Sublime sentiments about nature like the Smith engraving, it more closely reflects ideas of nature perfected, as in the theory and works of the Reverend William Gilpin. In fact, on this sheet the baroness began copying an aquatint vignette in one of the editions of Gilpin's immensely popular drawing manual: *Remarks on Forest Scenery, and Other Woodland Views* (fig. 63).[2] Louis Simond, her artistic mentor—who designed three horizontal oval landscape vignettes for the membership certificates of the United States Military Philosophical Society (1808), the Literary and Philosophical Society of New York (ca. 1815), and the N-YHS (ca. 1821)[3]—may have supplied her with Gilpin's model. Alternatively, she may have decided to consult the manual on her own. In any case, she never completed her version of Gilpin's composition, although she also consulted that same source but more creatively for cat. no. 53 (see also figs. 23, 24, 65).

1. British Museum, London, inv. no. 1878.0511.914. See http://www.britishmuseum.org/research/collection_online/collection_object_details.aspx?objectId=1615466&partId=1&searchText=Raphael+Smith+after+George+Morland&page=1.
2. See Bermingham 2000, 111–113, fig. 97, for a discussion of Gilpin's various manuals.
3. Shadwell 1974, figs. 3, 6, 7.

"Welch Girl" and "Welch Beggar Woman," Related to Louis Simond's "Journal of a Tour and Residence in Great Britain", 1815

Graphite, black chalk, and gray watercolor on paper; 8 × 9 ⅜ in. (203 × 238 mm)
Watermark: Cut and illegible
Inscribed at lower left in brown ink: *D'après Mr Simond*
N-YHS, Purchase, 1953.810a

"Highlanders," Related to Louis Simond's "Journal of a Tour and Residence in Great Britain", 1815

Graphite on paper; 7 ½ × 9 ½ in. (190 × 241 mm)
Inscribed at lower left in brown ink: *id. id.*
N-YHS, Purchase, 1953.810b

During his residence in England, Louis Simond published his two-volume *Journal of a Tour and Residence in Great Britain during the Years 1810 and 1811, by a French Traveller.* It was a very popular book, and the first English edition of 1815, published in Edinburgh, was followed by a New York edition published by the author in 1815 and given several printings. The next year a French translation was published in Paris and Strasbourg. Then, in 1817, a second edition appeared in Edinburgh, together with a French translation.[1] Simond objected to the high finish of the prints in the first English edition, which was repeated in the French translation, and therefore he re-etched the plates himself for the second edition, the one related to the baroness's "Welch" and "Highlanders" sketches. In an advertisement for the second edition in the beginning of its first volume, Simond wrote: "N.B.–The Author etched himself the plates of the second edition; although unpractised in the art, he thought the intention and spirit of his own drawings would be best understood by himself."

We know that Henriette was involved with its publication in some capacity from the contents of a letter sent to the baroness, then in France, by the French diplomat Alexandre Maurice Blanc de Lanautte, Count of Hauterive. Hauterive was a mutual friend of the Neuvilles and the Simonds and had been overseeing the French editions with the printer. Writing from Paris on November 9, 1815, he asked Henriette to have the baron send his own copy of the English version to the printer to aid in resolving the problems with the "illustration plates."[2]

Neuville's two graphite drawings relate to three of the unnumbered plates in Simond's *Journal of a Tour*—"Welch Girl" (opposite page 276), "Welch Beggar Woman" (opposite page 274), and "Highlanders" (opposite page 394)—in the first volume (fig. 64). Neuville's summary modeling of the forms and many other details suggest that she did not copy Simond's book plates in either edition but rather his original drawn models during the months in 1815 when she resided with the Simonds in London.

Fig. 64
"Welch Girl," "Welch Beggar Woman," and "Highlanders," from Louis Simond, *Journal of a Tour and Residence in Great Britain* (Edinburgh: James Ballantyne for Archibald Constable; London: Longman, Hurst, Rees, Orme, and Brown, 1817), vol. 1, opp. pp. 276, 274, 394, respectively. UCLA, Southern Regional Library Service, Los Angeles

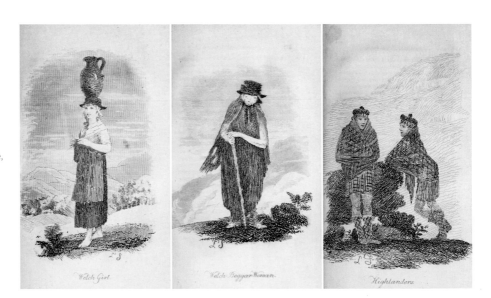

1. Both the 1815 and 1817 editions were published for Archibald Constable, Edinburgh, and Longman, Hurst, Rees, Orme, and Brown, London, although the 1815 edition was printed by George Ramsay, while the second with Simond's own etched plates was printed by James Ballantyne. The two printings of the French edition were published in Paris and Strasbourg by Truettel et Würtz in 1816 (translation of the first edition) and 1817 (translation of the second edition).
2. N-YHS Library, Baron and Baroness Hyde de Neuville Collection, 1815–1837 (AHMC-Hyde de Neuville, Jean Guillaume and Anne).

52a

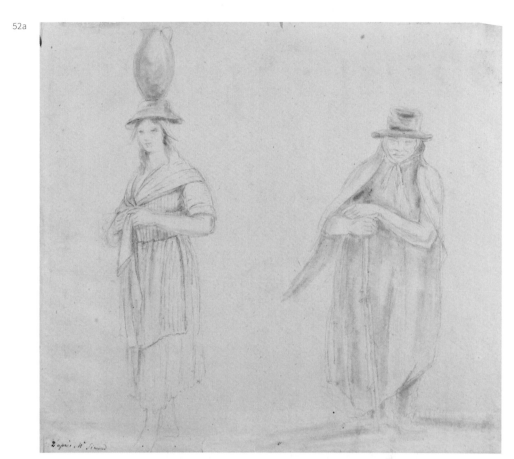

52b

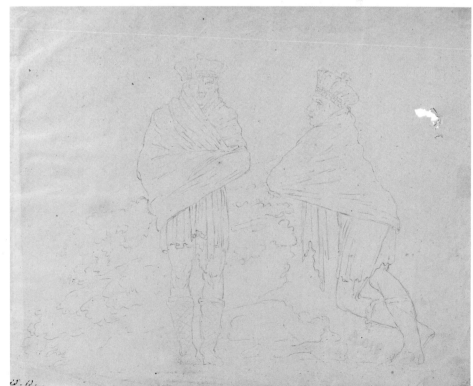

Vignette with Three Horses, after William Gilpin, 1808–15

Gray watercolor, black ink, black chalk, and graphite on paper; 6 ¾ × 8 ½ in. (171 × 216 mm)
Inscribed at lower center below vignette in brown ink: *D'après Mr S . . .*
N-YHS, Purchase, 1953.286

Neuville's incomplete inscription ending with an ellipsis on this equestrian vignette implies that she copied the composition from a work either by or in the possession of her artist friend and mentor Louis Simond. The model is from an edition of William Gilpin's ever-popular drawing manual *Remarks on Forest Scenery, and Other Woodland Views*, first published in 1791 (fig. 65).[1] The baroness transformed the rectangular, foldout composition in Gilpin's treatise into a flattened oval vignette and also added two pine trees at the right from another Gilpin plate, the one opposite page 89 in the first volume of his manual (fig. 24 repeated at the right). For another composition that the baroness drew after Gilpin, see cat. no. 51.

Repeat of Fig. 24
William Gilpin, *Vignette with Two Pine Trees*, etching and aquatint in *Remarks on Forest Scenery, and Other Woodland Views* (London: R. Blamire, 1791), vol. 1, pl. opp. p. 89. Thomas J. Watson Library, Metropolitan Museum of Art, New York

Fig. 65
William Gilpin, *Sylvan Landscape with Three Horses*, etching and aquatint in *Remarks on Forest Scenery, and Other Woodland Views* (London: R. Blamire, 1791), vol. 2, pl. opp. p. 255. Thomas J. Watson Library, Metropolitan Museum of Art, New York

1. William Gilpin, *Remarks on Forest Scenery, and Other Woodland Views* (London: R. Blamire, 1791), 2: pl. opp. p. 255. See Bermingham 2000, 111–113, fig. 97, for a discussion of Gilpin's manuals.

D'après N. S...

Interlude: New Haven, then England, Italy, and France

54
House, New Haven, Connecticut, **1813**

Watercolor, black chalk, graphite, and black and brown ink on paper; 7 ¼ × 10 in. (184 × 254 mm)
Inscribed at lower left in brown ink: *New-haven 10 août 1813.*
N-YHS, Purchase, 1953.231

Although the baroness inscribed the day when she executed the watercolor (August 10, 1813), she did not identify what attracted her to this white frame house. She drew it during the couple's hiatus of several months in New Haven, Connecticut, while they awaited news of Napoleon's predicted fall and the restoration of the monarchy with King Louis XVIII. The Neuvilles may have lodged across the street from this well-appointed residence, which is surrounded by a white picket fence and adorned with shutters on its ground-floor windows, but there is no evidence to that effect. Ever observant, Henriette recorded ripe corn growing to the right outside the fence. Among the captivating transient moments she depicted in her scene are the women strolling at the far left, one with a parasol, a boy pulling a wagon transporting a younger child, and a youth and man flying a whimsical kite at the right.

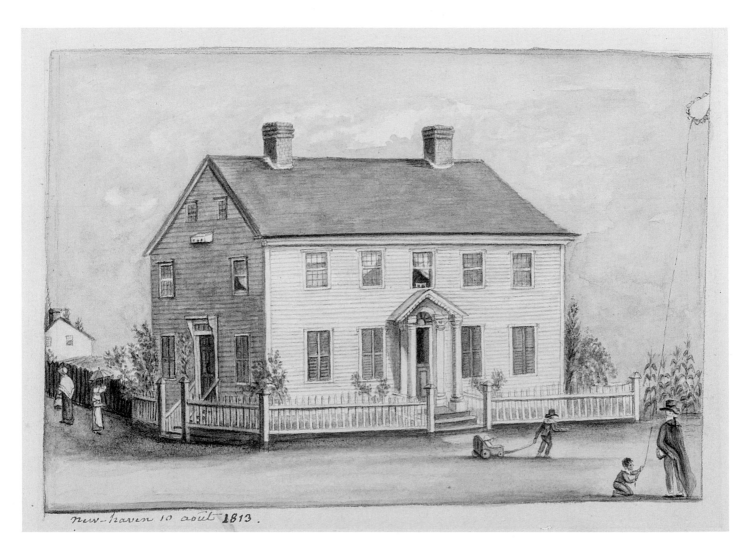

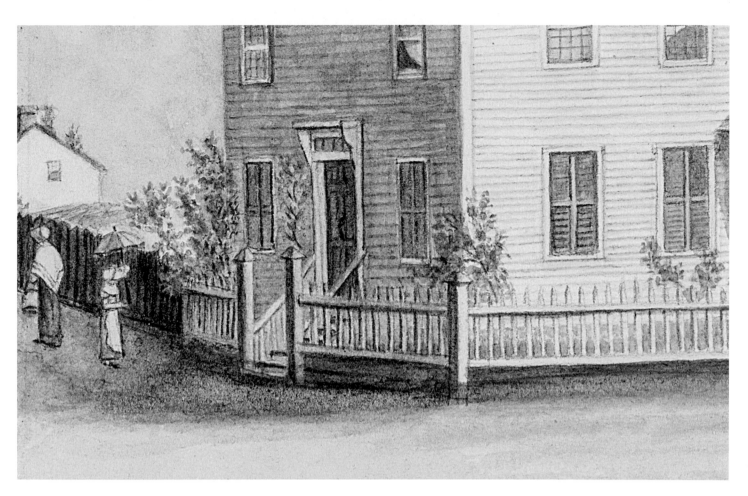

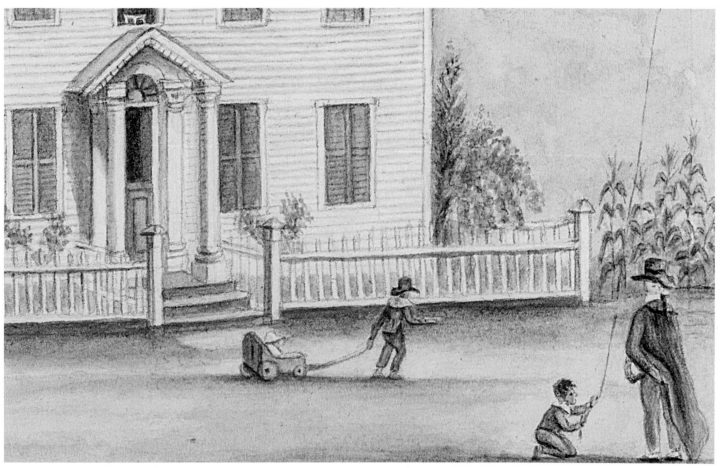

55a

Wax Figure of Daniel Lambert at Mix's Museum and Columbian Gardens, New Haven, Connecticut, 1813

Watercolor, graphite, black chalk, and gouache on paper; 8 × 13 in. (203 × 330 mm)
Inscribed at left side in brown ink: *daniel Lambert / aged 39 years, / who died / in Stamfort (England) / on the 28th june 1809. / his coffin measured, 6 feet 4 in / 'long. / 4 feet, 4 inches, Wide, / and / 2 feet 4 inches high. / at his death he weighed 739, pounds / he measured 3 yards 4 inches / Round the body; / and / 1, yard 1, inch, Round / the leg.;* at lower right in brown ink: *new-haven, mix's museum. august 30 1813.*
N-YHS, Purchase, 1953.287b

55b

Wax Figures of Inhabitants of Prince William Sound or a Return from the Hunt at Mix's Museum and Columbian Gardens, New Haven, Connecticut, 1813

Watercolor, graphite, and black chalk with touches of black and brown ink and gouache on paper; 7 ¾ × 11 ⅛ in. (197 × 283 mm)
Inscribed at lower center in brown ink: *Sauvages en cire du Museum de Mr Mix. 1813 7bre*
N-YHS, Purchase, 1953.287c

As the Neuvilles' first residency in America was winding down in the summer and fall of 1813 and they awaited returning to France after the Bourbon Restoration, the couple stayed for several months in New Haven, Connecticut. Among the sites they visited was Mix's Museum and Columbian Gardens, located at the east end of Court Street, where it flourished from 1805 to 1820 (fig. 66). John Mix functioned as the P.T. Barnum of the town, and one citizen complimented his entertainment center as "the Castle Garden of New Haven."[1] Mix's was indeed a mixture of educational and sensational material. Its intellectual component was a museum of natural and artificial curiosities and specimens, which was adjacent to an amusement park—a combination beer hall, ice cream parlor, and garden, where exotic birds nested in fruit trees. For a twenty-five-cent admission fee, visitors could see the museum's full-size wax figures, taxidermied animals, fossils, rocks, minerals, and other fascinating objects. They could also explore the grounds and diversions of the Columbian Gardens, which included public baths, magic lantern displays, a camera obscura, a cosmorama of world cities, and, by 1819, an example of the just-invented velocipede. After Mix's death in 1820, his widow briefly operated the complex, but she died the same year, at which point the property went up for sale. After it closed, the collections were dispersed and the gardens sold for a housing development. Fire destroyed the old museum building on August 21, 1851.[2] As an entertainment center in a Puritan stronghold, it established a

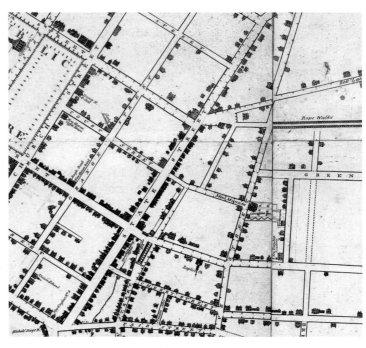

Fig. 66
Detail of a plan of New Haven with Mix's Museum, engraved and published by Amos Doolittle, 1824. Courtesy of Boston Rare Maps, Southampton, MA

Fig. 67
Anne Marguérite Joséphine Henriette Rouillé de Marigny Hyde de Neuville, *View of the New Haven Mountains, New Haven, Connecticut*, 1813. Graphite with line in brown ink on paper; 6 ⅞ × 12 ⅛ in. (175 × 308 mm). N-YHS, Purchase, 1953.271 (appx. no. 59)

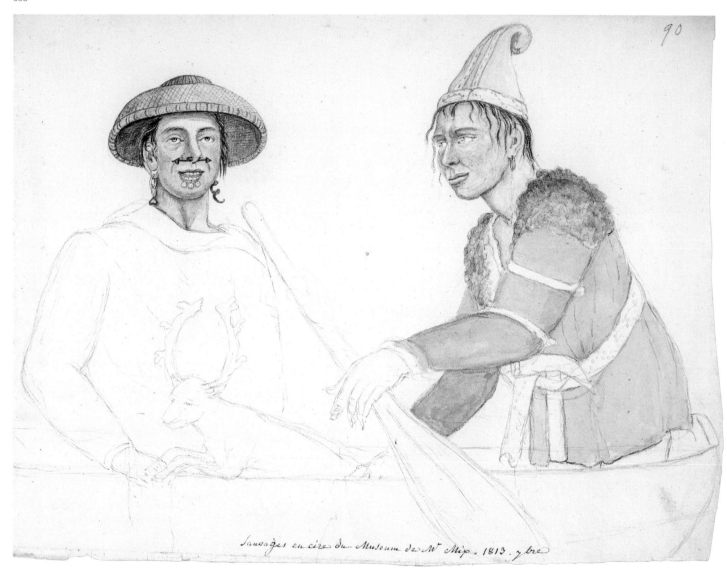

90

Sauvages en cire du Museum de M.r Mip. 1813. 7bre

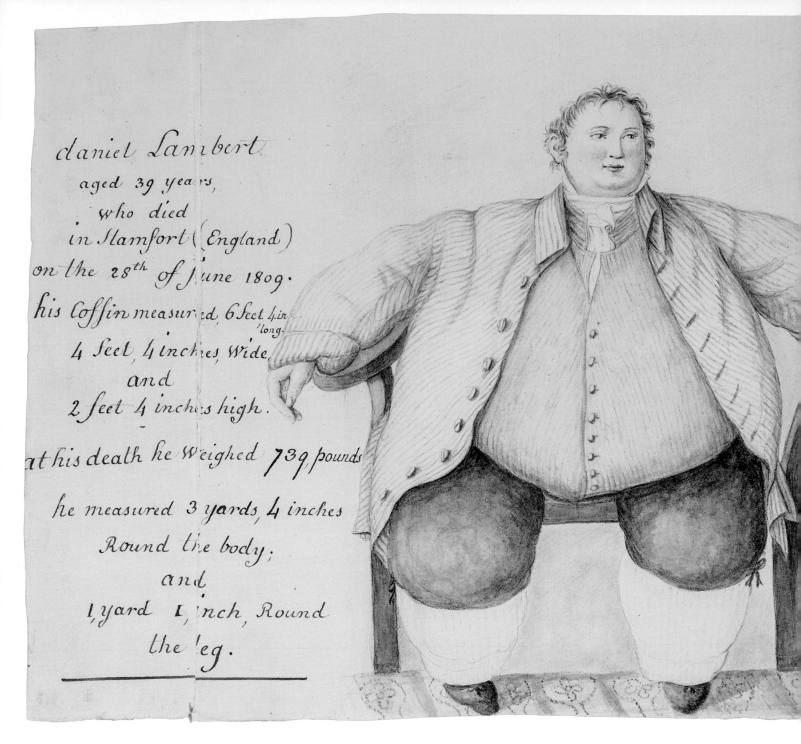

daniel Lambert
aged 39 years,
who died
in Stamfort (England)
on the 28th of June 1809.
his Coffin measured, 6 feet 4 in
long.
4 feet, 4 inches, wide,
and
2 feet 4 inches high.

at his death he weighed 739 pounds

he measured 3 yards, 4 inches
Round the body;
and
1 yard 1 inch, Round
the leg.

tradition for public attractions before a legitimate theater was built in New Haven in 1860.

In the first of the two watercolors in this entry, Neuville represented one of Mix's most sensational wax figures, who resembled a natural history specimen for her: Daniel Lambert, an Englishman famous for his girth and weight, an astounding 739 pounds. Lambert was termed "one of the wonders of the world," and seeing "this mountain of wax was considered worth the price of admission for the Museum."[3] His effigy is listed as no. 11 in the Mix Museum catalogue published in

1812—"WAX FIGURES, (AS LARGE AS LIFE)." In her second watercolor the baroness represented the male and perhaps the female Indigenous Americans listed as nos. 12 and 13 in the Mix catalogue ("Likenesses and dresses of a Male and Female, inhabitants of Prince William Sound on the North West Coast") or combined no. 12 with no. 20 ("Indian returning from hunting in his bark canoe with his Game"). The wax figures of Indians reveal the advanced nature of North American exploration, while her depictions of them reflect Henriette's enduring curiosity about various ethnic groups and their customs and clothing.

89

ew. haven, mix's museum. august 30 1813.

The remaining twenty-two wax figures listed in the 1812 catalogue of Mix's Museum illuminate, by contrast, the baroness's choice of subjects and the eclectic nature of this Federal-era museum. They included (paraphrasing Mix's listings): George Washington in uniform mounted on his horse, the Old Charger; the Genius of America weeping over Washington's tomb; the Goddess of Liberty feeding the American Eagle; Judith and her maid with the bleeding head of Holofernes; Othello, the Moor of Venice, in the act of murdering Desdemona; Delilah, Samson, and the Barber; Jube, the Musician, playing a hand organ; an Aged American "Cobler" [*sic*], at work on his bench; Male and Female Chinese Mandarins; American Dwarfs; Pompey: a Negro; and Cupid, God of Love. New characters in wax were substituted over time, as documented in later newspaper notices.

The unpaginated 1812 catalogue also lists the museum's paintings, which were mostly battle scenes, as well as a twenty-one-foot-long painting of a sea monster, together with stuffed beasts, birds, fishes, serpents, and reptiles, punctuated by "a large live rattle snake." This list concludes with an offer to buy objects that might be "of interest."[4] The baroness was obviously taken by the place and also drew the surrounding hills as seen from its terrace (fig. 67). She inscribed the sheet in brown ink: "3 Montagnes de new haven vues dela terrasse de Mr Mixe" ("3 mountains of New Haven viewed from the terrace of Mr. Mix").

1. See https://bostonraremaps.com/inventory/amos-doolittle-new-haven/ (accessed April 17, 2018).
2. See Arthur W. Bloom, "Science and Sensation, Entertainment and Enlightenment: John Mix and the Columbian Museum and Gardens," in *Pleasure Gardens*, ed. Stephen M. Vallillo and Maryann Chach (New York: Theatre Library Association, 1998), 33–49.
3. Ibid., 46.
4. John Mix, *A Catalogue of a Part of the Curiosities, Both Natural and Artificial, Contained in the Museum in New-Haven* (New Haven, CT: Joseph Barber, 1812), n.p. The Whitney Library, New Haven Museum, holds some manuscripts related to the Mix Museum.

Vignette of Yale College, New Haven, Connecticut, 1813

Watercolor, graphite, black chalk, and brown ink on paper; 7 ⅝ × 6 ⅝ in. (194 × 168 mm), whole sheet
Watermark: Powder horn and illegible script
Inscribed at center below vignette in brown ink: *1813 Yale-. College new-haven*
N-YHS, Purchase, 1953.235

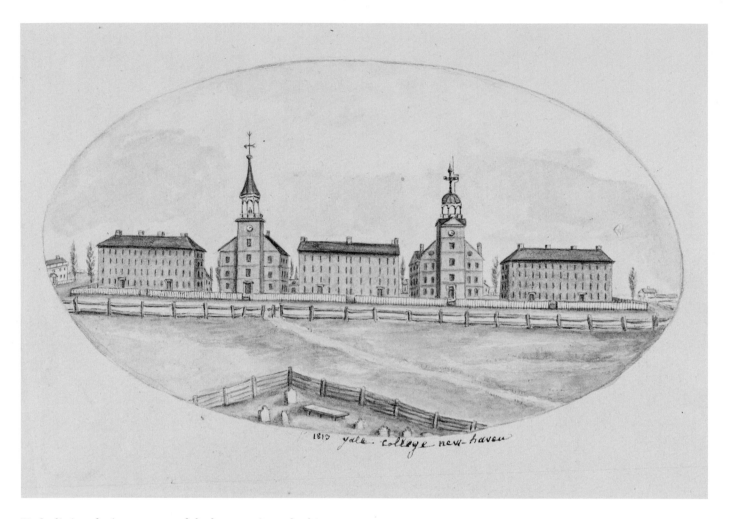

Underlining the importance of the baroness's work, this
watercolor view of Yale College has been termed the best
of the early extant drawings of Yale College because the
earlier eighteenth-century views relegate its buildings to
the background.[1] It is also noteworthy that in her watercolor
Henriette not only stressed the architecture but also
delineated in the foreground a corner of the old burying
ground on the Green and, at the extreme left, a building that
was probably the college president's house.[2] Like her scene at
Princeton (cat. no. 38), her watercolor's format recalls those
used by artists, designers, and printmakers of the time for
vignette illustrations.

1. Frank Monaghan, "The American Drawings of Baroness Hyde de Neuville," *The Franco-American Review* 1 (Spring 1938): 220.
2. Da Costa Nunes and Olin 1984, 26, suggests it was the house of the Yale College president Timothy Dwight IV.

57

Lighthouse, New Haven, Connecticut, **1813**

Graphite, gray watercolor, and black chalk on paper, mounted on card; 7 × 10 in. (178 × 254 mm)
Inscribed at lower center in brown ink: *Light-house de new haven fin 7bre 1813 St Léger et Jhon Strasser.*
N-YHS, Purchase, 1953.232

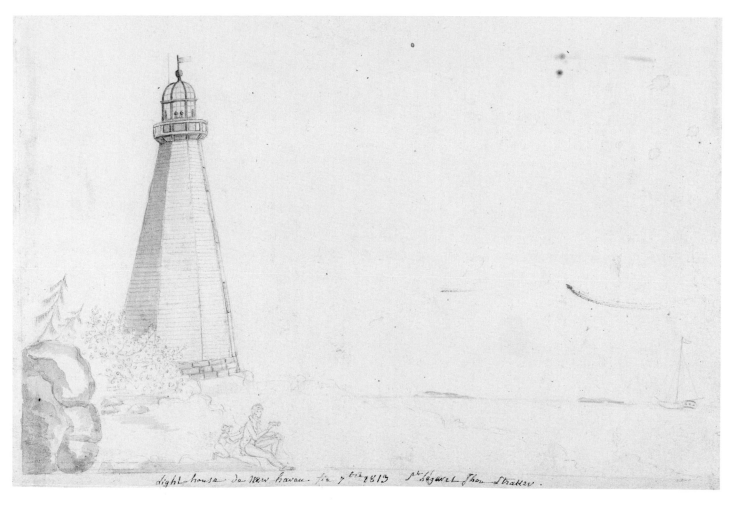

Five Mile Point Light, also known as Five Mile Lighthouse or Old New Haven Harbor Lighthouse, is a U.S. lighthouse in Long Island Sound on the east coast of New Haven, Connecticut. Located at the entrance to New Haven Harbor, it is about five miles from downtown New Haven. Neuville drew the original wooden lighthouse, a thirty-foot-tall octagonal tower with eight oil lamps and reflectors. It was built in 1805 by Abisha Woodward, an architect from New London, Connecticut, known for his early lighthouses. The structure was replaced in 1847 by a new eighty-foot octagonal tower, which still exists within Lighthouse Point Park, but was deactivated in 1877. According to the artist's ink inscription, the Neuvilles visited the beacon at the end of September.[1] In the left foreground Henriette drew a seated young man, who is holding an eyepiece or spyglass to look at a distant boat and perhaps about to commence sketching, while a boy uses his back as an easel to support his drawing.

1. "St Léger" may refer to a relative the baron mentions in his *Memoirs*: Saint-Léger de la Rue; *Mémoires* 1888–92, 2: 37, 67, 99; 3: 257 n. 1. (He became known as Theodoro Estevam Hyde de Neuville de Larue [ca. 1799–1871], later Viscount of Saint-Léger and Marquis of Bemposta-Subserra [1835–36]; *Mémoires* 1913, 2: 188.) Thanks go to Alex Mazzitelli for pursuing his identity. The identity of John Strasser remains unknown.

"La Bergerie," New Brunswick, New Jersey, 1814

Watercolor, black chalk, graphite, black and brown ink, and white gouache on paper; 6 ½ × 9 ⅜ in. (165 × 238 mm)
Inscribed at lower left in faded brown ink: *Winter to 1814 and Snow.*
N-YHS, Thomas Jefferson Bryan Fund, 1982.6

Henriette drew the façade and yard of the large house on the couple's property in New Brunswick, which they had acquired in 1811. Nearby was a smaller house they referred to as "The Cottage" (cat. no. 39). They named the larger residence "La Bergerie" (The Sheepfold) to signal the baron's involvement in raising Merino sheep. He was attracted to this progressive way of developing the land via animal husbandry, and Henriette studied several Merinos in separate graphite sketches (appx. nos. 53, 58).[1] Possibly reflecting the baron's influence at the Economical School, its press also published a treatise on Merino sheep (see also cat. no. 44).[2]

The name the Neuvilles bestowed on the larger house on their New Jersey property imitated that of the Bergerie nationale de Rambouillet, which King Louis XVI created in 1783. Dedicated to raising and maintaining traditional sheep breeds, such as the Merino, it was located in the park of the Château de Rambouillet. The sheepfold soubriquet for their house was thus a *double entendre*, alluding both to the sheep raised there and to the baron's royalist sympathies.

The sprouting vines on the Neuvilles' pergolas flanking the entrance of the house, together with the newborn Merino lambs in the foreground, one of them nursing, suggest that

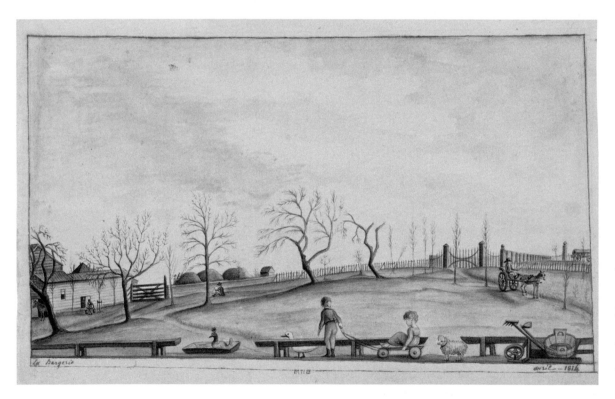

Fig. 68
Anne Marguérite Joséphine Henriette Rouillé de Marigny Hyde de Neuville, *"La Bergerie," New Brunswick, New Jersey,* 1814. Watercolor, black chalk, and gouache on paper; 6 ¹¹⁄₁₆ × 9 ¹³⁄₁₆ in. (170 × 250 mm). Musée franco-américain du château de Blérancourt (appx. no. 72)

1. The baron's brother Paul, who followed him into exile in America, was involved with the Merinos and placed a sales advertisement in the New Brunswick *Fredonian,* June 2, 1814, offering half-blooded ewes, pregnant by full-blooded Merinos.
2. Alexandre Henri Tessier, *A Complete Treatise on Merinos and Other Sheep* (New-York: Printed at the Economical School Office by Joseph Desnoues, 1811). See also L.G. Connor, "A Brief History of the Sheep Industry in the United States," *Agricultural History Society Papers* 1 (1921): 89, 91, 93–165, 167–197, espec. 102–109.

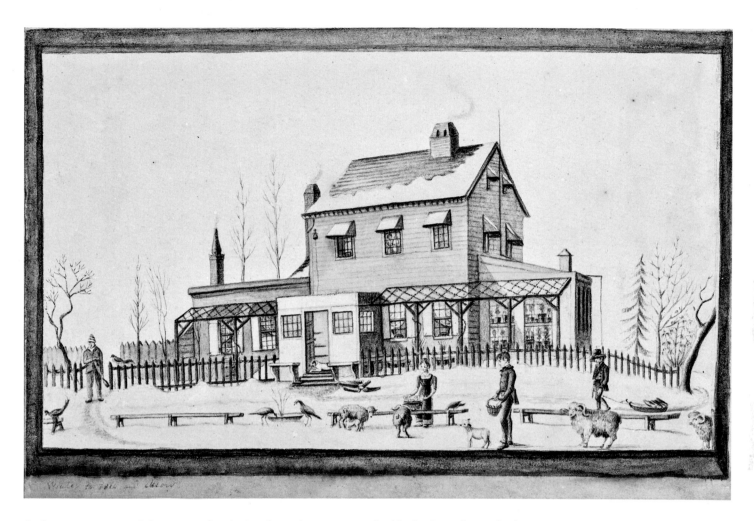

the baroness executed the watercolor during late winter or an early spring marked by a late-season snowfall. While there is snow on the ground, smoke rising from the chimney, and a man pulling a sled, the figures are not dressed for winter and the snow is melting under moderate temperatures, most noticeably on the house's roof. The house's right wing, which functioned as a greenhouse, is filled with potted plants ready to be put outdoors, like those Neuville rendered in her view of "The Cottage." Above that wing a lightning rod points skyward, while one of the couple's dogs (Puck or Volero) lazes in the covered entry to the house.

In a watercolor inscribed "La Bergerie / avril 1814" (fig. 68), the baroness recorded another view of the property from inside the large house looking out at the entrance gate and the panoramic grounds. So sensitively has she rendered the scene that one can feel the sap rising in the trees and see the landscape beginning to tinge with green, as children and a lamb gambol in the foreground in front of split-log benches. These are the same benches that the artist showed in front of the house in the watercolor featured in this entry. Seen together, the two works with their similar dimensions form a dynamic inside/outside, shot-reverse-shot pair. Perhaps the baroness painted them as an *aide-mémoire* or even an *au revoir* to the Neuvilles' beloved New Jersey retreat. In 1814, when she painted the works, the couple knew they would soon be leaving America.

View off Montauk Point, Long Island, New York, from the "Amigo Protector", 1814

Watercolor, black chalk, graphite, and brown ink on paper; 6 ½ × 8 in. (165 × 203 mm)
Inscribed below in brown ink: *amigo Protector - Long island Montauk-point. Last Land / 22 May.*; at lower right: *Liverpool. / 6 Juillet.*
N-YHS, Purchase, 1953.263

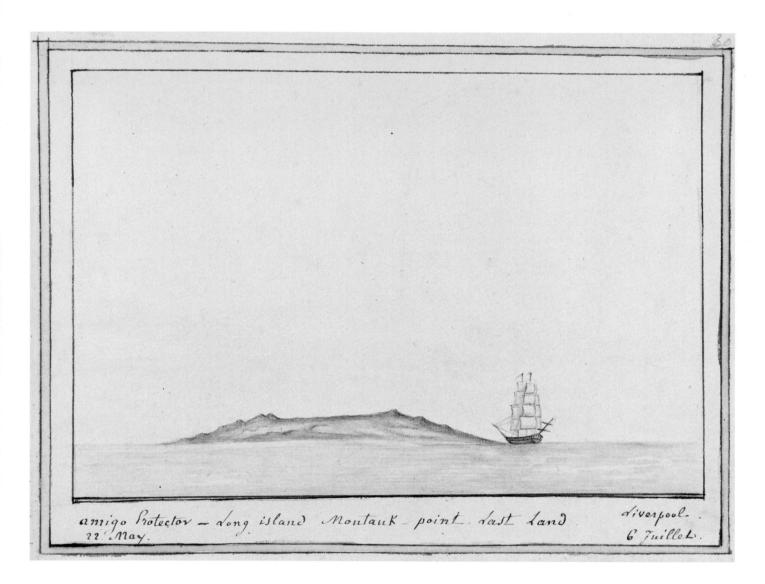

According to the artist's brown ink inscription, Neuville recorded her last view of America looking back as the couple sailed to France via England on the Portuguese ship *Amigo Protector.* Henriette inscribed the sheet "Long island Montauk-point. Last Land." The ship departed from New York after delays, but from May 24 until the wee hours of May 27 it sheltered in Long Island Sound to avoid the threat of privateers.[1] Because of her other inscription at the lower right, noting the destination of Liverpool and the date of arrival as July 6, the drawing may be a nostalgic recollection of their departure from the United States. The couple actually arrived in Liverpool on July 8. Therefore it seems likely that Henriette sketched the composition with Montauk Point in graphite and black chalk aboard ship and finished and/ or inscribed it at a later time. Alternatively, she may have sketched the composition on another sheet of paper, and then worked it up in this watercolor, commemorating their departure from America before starting a new chapter of their lives in England. The relatively elaborate framing lines also suggest that she wanted to preserve the milestone moment not only in her memory but also as a more permanent remembrance in watercolor.

1. *Poulson's American Daily Advertiser*, May 26, 1814; *Newburyport Herald*, June 10, 1814.

Mexican Sailor Aboard the "Amigo Protector", 1814

Watercolor, black chalk, gouache, graphite, and touches of red pastel on paper; 7 ½ × 6 ¼ in. (190 × 159 mm)
Inscribed below in brown ink: *Mattelot Mexicain de L'amigo Protector Juin 1814 –*
N-YHS, Purchase, 1953.283

Without landscapes or buildings to study while on board
the *Amigo Protector*, Neuville's eye was caught by a Mexican
sailor (*matelot*). She was always alert to the subtleties of
ethnicity and was perhaps intrigued by his swarthy good
looks—curly hair, walleyed or wandering right eye (divergent
strabismus), and a single earring. Portraying him in a
frontal position, her choice of pose seems forthright rather
than iconic. She also documented a "tropical" dramatic
performance aboard the *Amigo Protector*, appropriately
involving Neptune, the Greco-Roman god of the sea (fig. 69),
inscribing the sheet: "La Mascarade du tropique Neptune
et Sa Cour amigo Protector 1814." At the lower right of the
tableau, she also sketched the Mexican sailor in exactly
the same position as in her finished watercolor, providing
invaluable evidence that she sometimes drafted her first ideas
as preparatory sketches for her more finished watercolors.

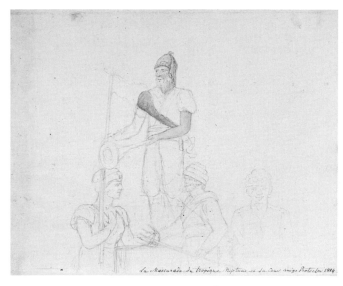

Fig. 69
Anne Marguérite Joséphine
Henriette Rouillé de Marigny
Hyde de Neuville, *Tropical
Masquerade: Neptune and His
Court on the "Amigo Protector"*,
1814. Graphite, watercolor, and
black chalk on paper;
6 ⅞ × 8 ⅛ in. (175 × 206 mm).
N-YHS, Purchase, 1953.287d
(appx. no. 60)

61

Study of Two Sea Creatures (Aboard the "Amigo Protector"), 1814

Watercolor, black chalk, brown ink, and graphite with touches of gouache on paper; 5 ⅜ × 7 ⅛ in. (137 × 181 mm)
Inscribed below in brown ink: *Espéce D'anguille de Mer Prise sûr une Pièce de Bois qui en Etoit toute couverte. / amigo Protector. Juin 1814.*
N-YHS, Purchase, 1953.261

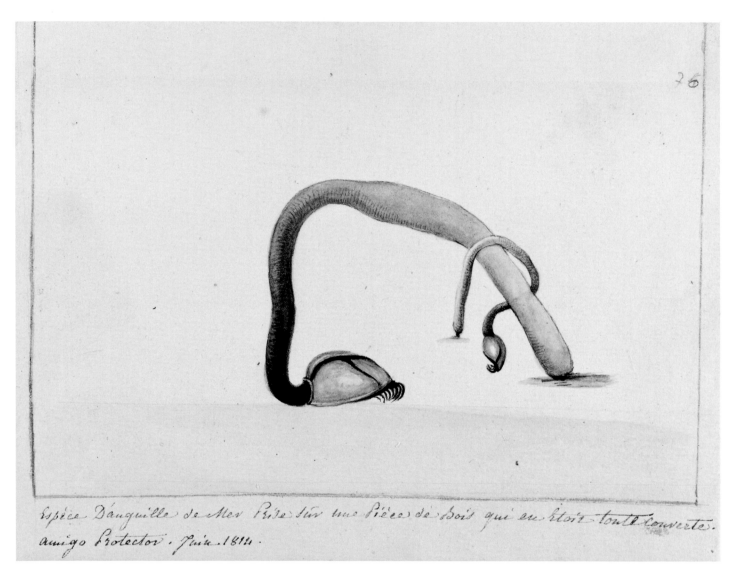

On the high seas, the baroness maintained her interest
in botanical life and natural history by drawing these
two curious sea creatures, which she termed in French an
"eel species." Rather, they are a type of Pelagic Gooseneck
Barnacle (*Lepas anatifera*). This hermaphroditic species
has a cosmopolitan distribution and lives in tropical and
subtropical seas worldwide. It often attaches itself to objects
carried into colder seas by currents, such as the North
Atlantic Drift, and thus is found in places distant from its
place of origin and in waters too cold for it to reproduce.

Lighthouse on the English Coast near Liverpool, England, 1814

Watercolor, graphite, black chalk, and brown ink with touches of pink gouache on paper; 6 ¼ × 7 ½ in. (159 × 190 mm)
Inscribed below in brown ink: *Phare Sûr les Côtes D'angleterre Près de Liverpool amigo Protector. Juillet 1814*
N-YHS, Purchase, 1953.262

From the decks of the *Amigo Protector*, Henriette recorded the third lighthouse on a sheet in the N-YHS collection, the one that guided her arrival in England on July 8, 1814. The baroness was drawn to lighthouses, as she was to bridges. Called the New Brighton or Perch Rock Lighthouse, this sentinel was situated at the confluence of the River Mersey and Liverpool Bay on an outcrop off New Brighton, known locally as Perch Rock. The name derives from an early perch—a timber tripod supporting a lantern first erected in 1683 as a crude beacon—that allowed ships to pass the rock safely. Henriette documented a later, more

developed transitional site that included buildings for defense. With the Port of Liverpool's rapid development in the nineteenth century, the old system provided inadequate light. Construction of the present tower, which is decommissioned, began in 1827 by Tomkinson & Company. Like her view of Montauk Point (cat. no. 59), Henriette probably sketched the composition in graphite and finished it later, when she added framing lines and the inscription to record more permanently this memorable turning point in her life, the end of the Neuvilles' exile.

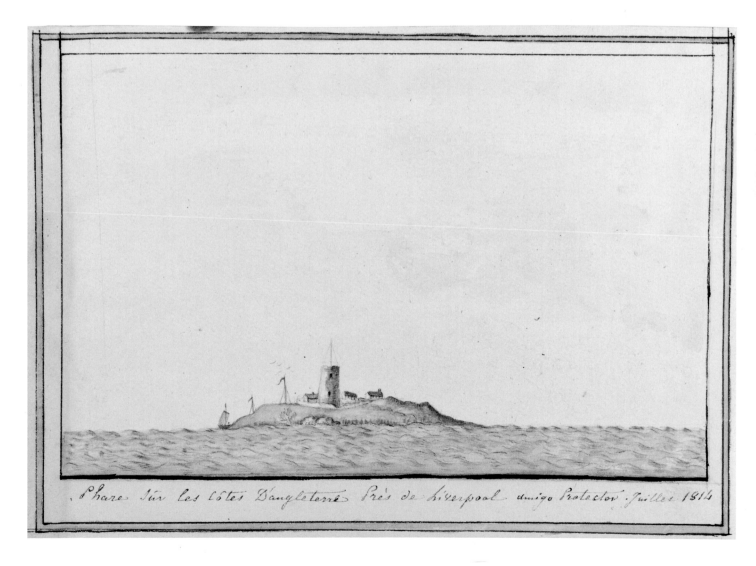

Common House in Brighton, England, with the Royal Pavilion, 1815

Watercolor, graphite, black and brown ink, black chalk, and white gouache on paper; 6 ⅜ × 7 ⅝ in. (162 × 194 mm)
Inscribed below in brown ink: *Common' house in Brighton. opposite to the New. Inn, the first days of Jully. 1815 after the Son's Departur*
N-YHS, Thomas Jefferson Bryan Fund, 1982.7

In July of 1815, the Neuvilles visited the seaside resort of Brighton, located in East Sussex on the southeast English Channel coast. By then, Brighton had morphed into a spa town and somewhat risqué pleasure resort, patronized by royalty and fashionable Regency high society. It was renowned for its splendor and the highly individual character of its architecture. By labeling the semi-detached house she portrayed in this watercolor as a "Common house," the baroness meant that these two-family houses were characteristic of Brighton's domestic architecture (some examples of this distinctive Georgian style survive today). Rising three stories, her semi-detached house has a full-height canted bay with one multi-light window on each story, and its second story has separate crowning canopies, a feature observed today in a house at 46 Grand Parade.[1] Both houses have entries articulated with classical frames, and the sign on the entry floor of the left house identifies it as the office or

surgery of a physician named Hollinson. Henriette lavished great attention on details in the watercolor, which extended even to the textures of the bricks of the buildings, the sidewalk, and the street and its curbs. She also recorded at least one other three-story residence, one with a ground-floor commercial space, in this popular resort town (appx. no. 76).

Looming over the scene in the right background is the dome of the Brighton or Royal Pavilion. Begun in 1787, it was built in three stages as a royal residence for George, Prince of Wales, who in 1811 became Prince Regent, and in 1820 King George IV. Using the exotic Indo-Islamic style prevalent in nineteenth-century India, the architect John Nash redesigned it between 1815 and 1822 and extended the Pavilion to the form it enjoys today (fig. 70).[2] Henriette recorded the dome of the initial project just before Nash's modification, making her watercolor greatly significant.

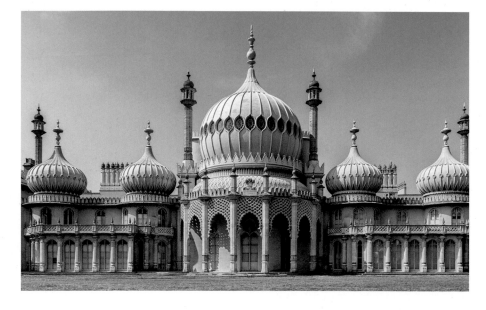

Fig. 70
Royal Pavilion, Brighton

1. See https://www.google.com/search?q=46+Grand+Parade+Brighton&client=firefox-b-1&source=lnms&tbm=isch&sa=X&ved=0ahUKE wjO3Jus1_LdAhVSpFkKHXWEC0MQ_AUIECgD&biw=1154&bih=526#imgrc=wv5kz5TtbRlexM (accessed October 6, 2018).
2. See John Dinkel, *The Royal Pavilion Brighton* (London: Scala/Philip Wilson, 1983); Jessica M.F. Rutherford, *The Royal Pavilion, Brighton: The Palace of George IV* (Brighton: Brighton Borough Council, 1995).

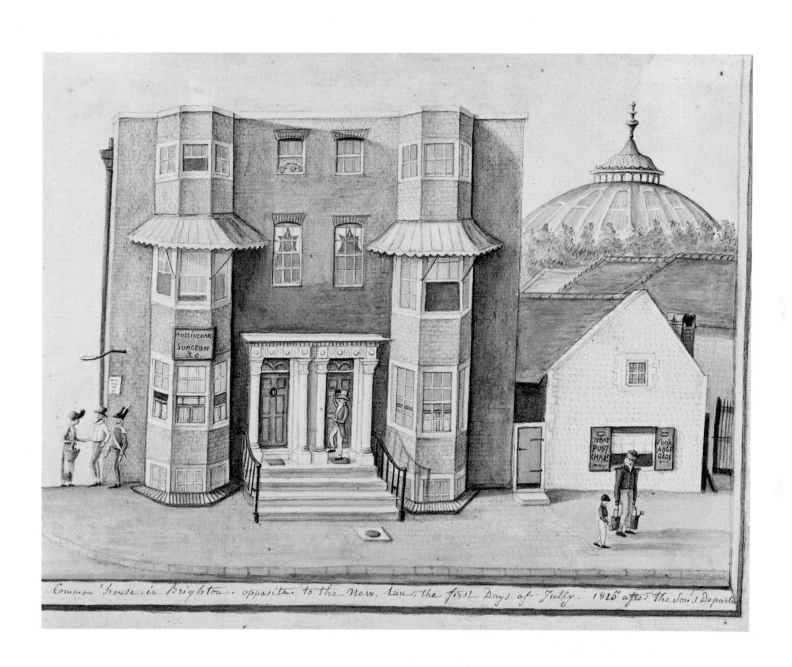

Common house in Brighton, opposite to the New Inn, the first Days of July. 1815 after the Son's Departure

64a

Kensington Gardens, London, with Guard on Horseback and Pedestrians, 1815

Watercolor, black chalk, graphite, black ink, and gouache on paper, laid on paper;
5 ¾ × 4 ⅛ in. (146 × 105 mm), irregular
Inscribed below in brown ink: *Life guards at horse Back.*
N-YHS, PECO Foundation Fund for Drawings, 2018.21.3

64b

Kensington Gardens, London, with Queen Anne's Alcove (1705) by Sir Christopher Wren, Guard, and Pedestrians, ca. 1815

Watercolor, black chalk, graphite, and gouache on paper, laid on paper;
5 ¾ × 4 ⅛ in. (146 × 105 mm), irregular
Inscribed below in brown ink: *une alcove de Kensington's gardens. horse guards.*
N-YHS, PECO Foundation Fund for Drawings, 2018.21.4

64c

Visitors and Guards at Kensington Gardens, London, 1815

Watercolor, black chalk, graphite, and gouache on paper, laid on paper;
5 ¼ × 4 in. (133 × 102 mm), irregular
Inscribed below in brown ink: *1815. anglois. Dessinez à Kensington. chez Mde. Saltarelli.*
N-YHS, PECO Foundation Fund for Drawings, 2018.21.5

64d

Kensington Gardens, London, with Guard and Pedestrians, 1815

Watercolor, black chalk, graphite, gouache, and black ink on paper, laid on paper;
5 ¼ × 3 ⅞ in. (133 × 98 mm), irregular
Inscribed below in brown ink: *anglois id. id.*
N-YHS, PECO Foundation Fund for Drawings, 2018.21.6

In these four small sheets Neuville shows her eye for people in public spaces: Londoners strolling near Kensington Gardens, whose guards and their rituals still mesmerize tourists today. The quartet constitutes a small series that is unique in its format and design within her oeuvre, although she later executed a trio of small occupational scenes in Brest (appx. nos. 64–66). From the inscription on cat. no. 64c, we can date the group to 1815, when the Neuvilles were in temporary residence in the cosmopolitan center for about four months. During the time they resided in London or its suburb Richmond—from March to July— the baron returned periodically to France to accept honors and re-establish his position with the monarchy.

Kensington Gardens were once the private walled gardens of Kensington Palace, immediately to the west of Hyde Park in west central London. One of its features was a garden pavilion known as Queen Anne's Alcove, which bears her coat of arms just below the peak of its roof. Designed by Sir Christopher Wren in 1705 for the southern boundary of the queen's formal south garden, the structure was originally sited against the park wall at Dial Walk. But in 1867 a London builder paid to have it moved near the Lancaster Gate entrance to Hyde Park (fig. 71).[1] The baroness's second watercolor of the quartet (cat. no. 64b) preserves its original location.

Both the Life and Horse guard units were official protectors of the English monarch. In the early nineteenth century, the Horse Guards wore blue uniforms, whereas the Life Guards' uniforms were red, the opposite of Henriette's inscription on 64a. However, on 64b she correctly identified the Horse Guard wearing a blue uniform. The role of the Life and Horse Guards was largely ceremonial, to accompany the monarch as armed personnel in parades and other public events, but both regiments could be deployed into active

Fig. 71
Sir Christopher Wren, "Queen Anne's Alcove," 1705. Hyde Park, London

service like the troops who fought at the Battle of Waterloo in 1815. The petite size of these four watercolors belies the artist's powers of observation: she captures the most nuanced details of costume, such as the parasols and bonnets, and the deportment and social interactions among individuals.

In her inscription on cat. no. 64c, Henriette noted that she drew the works at the house of Madame Saltarelli. Her friends were most likely Mr. and Mrs. N. Saltarelli, who lived at 11 Portman Street on Portman Square near Kensington Gardens in 1814–15. Mr. Saltarelli was a hosier by profession.[2]

1. See https://www.royalparks.org.uk/parks/kensington-gardens/things-to-see-and-do/memorials,-fountains-and-statues/queen-annes-alcove (accessed July 3, 2018).
2. *Post Office Annual London Directory* 1814, 280. The London directories list the couple as living at the same address, beginning in 1808 and spelling their name Salterelli.

Life guards at horse back.

64a

une alcove de Densington's gardens horse guards.

64b

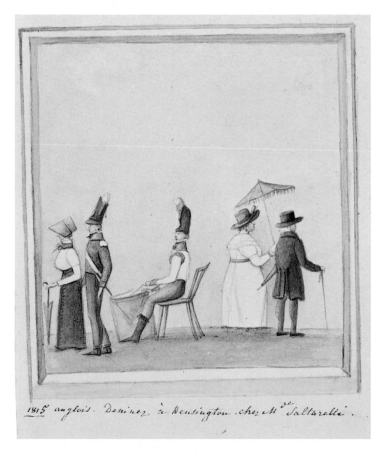

1815 anglois. Denines à Densington chez Mᵈᵉ Saltarelli.

64c

anglois id. id.

64d

The Hyde de Neuville Residence, No. 10 Rue d'Antin, Paris, 1816

Watercolor, graphite, and black ink with touches of gouache on paper, laid on blue paper; 7 ⅛ × 9 ¼ in. (181 × 235 mm), irregular
Inscribed at lower left in brown ink: *Rue D'antin.*; at lower right: *avril. 1816*
N-YHS, PECO Foundation Fund for Drawings, 2018.21.7

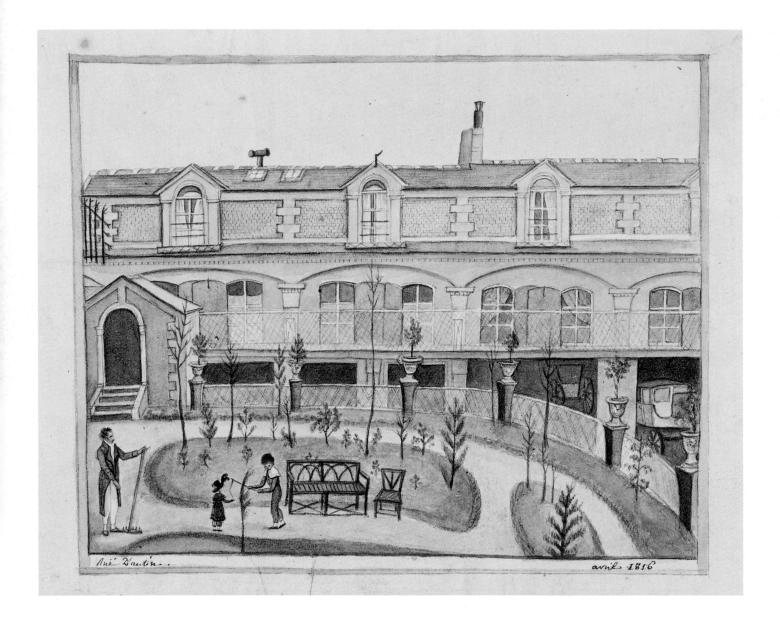

The building that Henriette drew no longer exists. It was located on the same fashionable block, but on the opposite side of the street, as the elegant townhouse at No. 3, designed by Jean-Baptiste Leroux in 1770–72, where Napoleon Bonaparte and Joséphine de Beauharnais were married in 1796. The Parisian directories record the Neuvilles as residing at 10 rue d'Antin in 1816.[1] The address no longer exists and a late-nineteenth-century building stands on the site. The older building that formerly housed No. 10 no doubt was demolished during the restructuring of the area and the widening of avenue de l'Opéra to create a dramatic thoroughfare leading to Charles Garnier's Second Empire opera house (1861–75).

Henriette drew the interior garden and façade of the three-story structure, which from the carriages parked in the lowest level must have been the modest carriage house, albeit a building that exuded charm. By contrast, the grander buildings on the opposite side of the rue d'Antin date from the late eighteenth century and consist of four or five taller stories. True to her character, in this watercolor the baroness lavished attention on the potted plants and the children playing but also on the articulation of the architectural façade, brick by brick, and shutter by quoin, which reveals her advances in articulating architectural structures (see appx. no. 17). In her affectionate scene, the artist celebrated her happiness at being back in France.

1. M.J.D., *Almanach de 25,000 adresses de Paris, pour l'année 1816* (Paris: C.L.F. Panckoucke et al., 1815), 320. Listed as Hyde de Neuville but mistakenly listed at "r. d'Anjou. 10." instead of d'Antin.

To the Capital: Diplomats in Washington, DC

66a

The Hyde de Neuville Cabin on the "Eurydice", 1816

Watercolor, graphite, black chalk, and black and brown ink with touches of gouache on paper; 7 ½ × 9 ¾ in. (191 × 248 mm), irregular
Inscribed at lower left in brown ink: *cabane de L'Eurydice Pt 16 Mai 1816 arrivez le 15 Juin au Soir*
N-YHS, Purchase, 1953.224

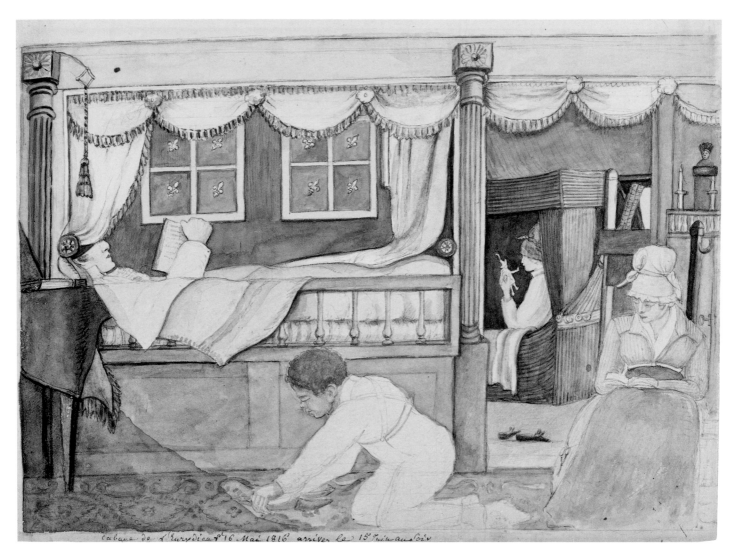

cabane de L'Eurydice Pt 16 Mai 1816 arrivez le 15 Juin au Soir

After the baron's appointment as French Minister Plenipotentiary, the couple set sail on May 16, 1816, for the United States on the French ship *Eurydice*. The baroness documented aspects of the twenty-nine-day voyage in two highly finished watercolors with discerning views of their quarters on board. The baron's rather spacious accommodation included an elaborate berth, in which Henriette depicted her husband in profile, reclining and reading. Behind the bed are two square windows or cabinets decorated with the Bourbon fleur-de-lis. Symbolic of the French monarchy, the fleur-de-lis underlines Guillaume's political allegiances and the sponsorship for his new post as a minister of France. He is accompanied by a black youth,[1]

who is polishing the baron's shoes, and two unidentified female figures wearing caps. One relaxes in a chair reading a book, while the other in the background sits in a canopied berth, perhaps partly suspended like a hammock, and holds a doll with a feathered hat. The cabin's elegant appointments—such as the curtained beds, drapery swags, and classicizing columns—reveal that the couple traveled in comfort and relatively high style. The baroness also drew her own private berth in their cabin in which she portrays herself reclining, wearing a turban, while an unidentified young girl reads to her to pass the long hours at sea. She wears three-tiered drop earrings set with gemstones, which became fashionable with the onset of the Empire, that

Baroness Hyde de Neuville's Berth on the "Eurydice", 1816

Watercolor, graphite, black chalk, and brown and black ink on paper; 3 ½ × 5 ⅜ in. (89 × 137 mm)
N-YHS, Purchase, 1953.222

contrast with the more spartan hoops she wore in her earlier self-portrait (cat. no. 1).

In a letter that her husband included in his *Memoirs*, Henriette described their crossing:

> Though our passage was a short twenty-nine days, it was as stormy as if it had been winter. We passed two icebergs, one after another which added reality to the illusion. . . . We saw these floating mountains of ice in the distance, lit up with countless fires under the rays of the sun. After a final storm, as we were nearing the land, we entered New York Harbor on the 15th of June. The frigate had been signalled the evening before, and was almost immediately surrounded by little boats bringing our friends to greet us. . . . We should have liked to disembark at once, but it was due to the Representative of France to be received with greater ceremony.[2]

1. The young man's identity is uncertain.
2. *Mémoires* 1888–92, 2: 194–195; *Memoirs* 1913, 2: 76.

67

The Corner of F Street Washington, DC, **1817**

Watercolor, graphite, and black ink on paper; 7 ⅜ × 11 ⁵⁄₁₆ in. (187 × 288 mm), irregular
Inscribed at lower left in brown ink: *Le coin de F. Street Washington vis-à-vis Notre Maison été de 1817.*
New York Public Library, The Miriam and Ira D. Wallach Division of Art, Prints and Photographs: Print Collection, Stokes 1817-E-17a

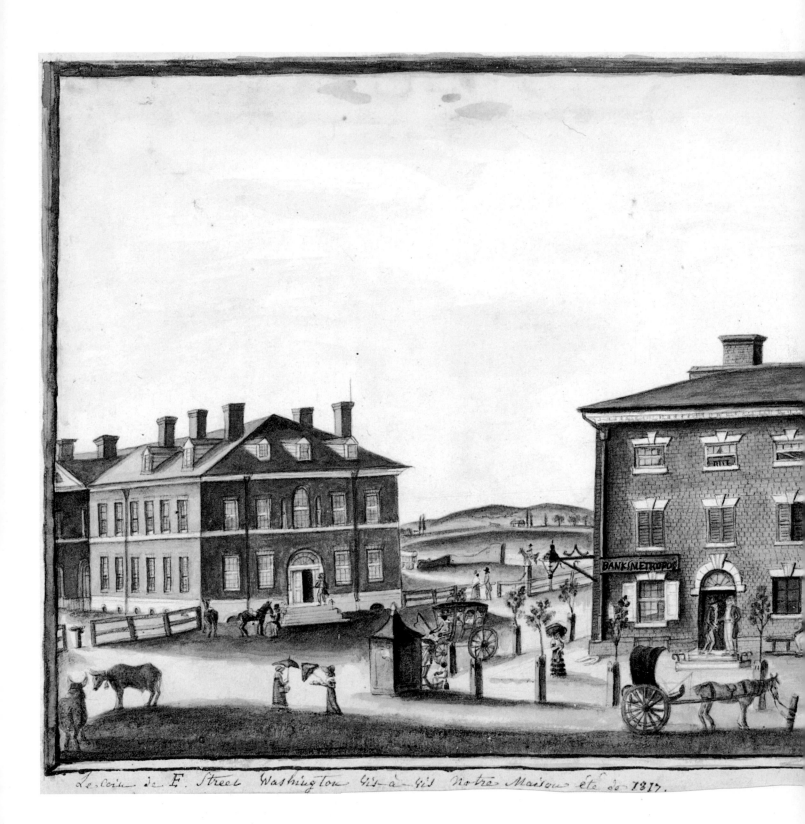

Henriette drew this view opposite the house where the Neuvilles were residing in the nation's capital in 1817. It was the year that James Monroe was inaugurated as fifth president of the United States and the baron was serving as French Minister Plenipotentiary under King Louis XVIII. The baroness depicted the ambassadorial residence in another watercolor, which is inscribed below its framing line: "Our house washington city F. Street 1818" (fig. 18; appx. no. 73). In this residence the Neuvilles held their weekly Saturday night suppers, parties that replaced Dolley Madison's Wednesday jams. From a letter we know that in the French minister's residence "there were some good engravings [perhaps drawings or watercolors as many people included them under the umbrella of "engravings"] in the rooms, and one excellent painting, a portrait of Louis XVIII."[1] Notwithstanding the presence of large and handsome government buildings, Washington City still had an undeveloped, village-like character (see cat. nos. 68, 69, 72, 73). Note the two cows that the baroness depicted in her watercolor, grazing in the lower left foreground on F Street, one of the city's principal thoroughfares and its most fashionable avenue.[2] Running perpendicular to it here between two buildings is 15th Street. On this sheet the baroness captures the transience of contemporary street life in Washington opposite their house during the summer of 1817, delineating two types of private carriages, children playing, and moments of social interchange.

The three-story building at the right-hand corner, identified by the lettering on its façade ("Bank Metropol"), is the Bank of the Metropolis, which today houses the Bank of America. It is the oldest extant commercial structure in the capital's downtown area. Built in 1801, it was first known as Rhodes' Hotel, and later the Indian King Tavern. In 1814, it served as the headquarters for the British command during the War of 1812 and the invasion of Washington, which climaxed with the burning of the President's Residence or White House and the Treasury. The structure immediately behind it has been identified as "Hoban's Little Hotel."[3] The building in the left-hand corner is the Treasury Department, erected after its predecessor was torched, but accidentally destroyed by fire in 1833. The F Street front of the Treasury stood on a line with the south front of the White House and occupied a portion of the land covered by the southern part of the present Treasury Building.[4]

1. Horace Holley, Washington, DC, to Mary Austin Holley, Boston, MA, March 29, 1818, Clements Library, University of Michigan, Ann Arbor, MI.
2. Leah R. Giles, "Entertaining a New Republic: Music and the Women of Washington, 1800–1825" (M.A. Thesis, University of Delaware, 2011), 34.
3. William Ryan and Desmond Guinness, *The White House: An Architectural History* (New York: McGraw-Hill, 1980), pl. 14.
4. Stokes and Haskell 1932, 99–100; Deák 1988, 1: 205.

Washington City, 1820

Watercolor and graphite with touches of black ink on paper; 5 ¹³⁄₁₆ × 9 ⁵⁄₈ in. (147 × 245 mm)
Inscribed at lower left in brown ink: *Washington City 1821 June – Esquissé en 1820*
New York Public Library, The Miriam and Ira D. Wallach Division of Art, Prints and Photographs: Print Collection, Stokes 1820-E-16a

In 1820, Washington, DC, was known colloquially as
Washington City. According to this work's inscription, the
baroness first drew the ambitious architectural composition
during the Neuvilles' residency in the nation's capital before
she and her husband, then Minister Plenipotentiary, returned
briefly to France—from May 1820 to February 1821. She may
have outlined the architecture first on this paper as a sketch
(*esquisse*) or on a separate sheet that she consulted when
executing this finished panorama, sometime in June 1821, after
their return to the capital. The rather sparsely settled town
was characterized wonderfully by Abigail Adams in 1800: "The
Presidents House is in a beautiful situation . . . a wilderness
at present. . . ."[1] Another foreign visitor to Washington
City at this time was the Swedish diplomat Baron Axel
Leonhard Klinckowström, who, like the baroness, recorded
his experiences, including his visits to the White House, in
pictures and prose.[2]

At the center of the watercolor is the north façade of the
President's Residence, designed in 1792–93 by James Hoban and
rebuilt by him after its destruction by the British on August
4, 1814. It earned the moniker "White House" in 1798, when
it was covered with a limestone wash to protect its porous
stones from the extremes of freezing weather. The protective
coating was refreshed periodically until 1818, when it was
painted with white lead pigment.[3] Flanking the President's
Residence are four other important public buildings, designed
in a similar Federal style. The State Department is in the left
foreground, with the Treasury Department in the background;
the War Department is in the right foreground with the
Navy Department behind it.[4] When the White House and the
Treasury and Navy buildings were reconstructed in 1815–16,
after being torched by the British, Benjamin Henry Latrobe
designed the elliptical road in front of the executive mansion to
link the structures.[5] The State and War Department buildings
were designed and erected in 1818–19 with Ionic porticos and
classical pediments to harmonize with the architecture of the
President's Residence.[6]

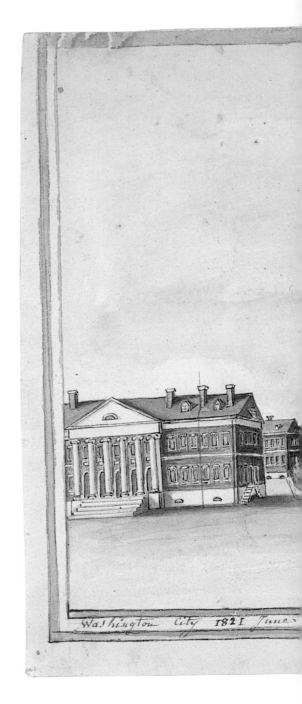

1. Abigail Adams, Washington, DC, to Mary Cranch, Weymouth, MA, November 21, 1800; Abigail Adams, *New Letters of Abigail Adams 1788–1801*, ed. Steward Mitchell (Boston: Houghton Mifflin, 1947), 257.
2. Klinckowström 1952.
3. White House Historical Association 1992, 27.
4. William Seale, *The White House: The History of an American Idea* (Washington, DC: American Institute of Architects, 1986), 66, notes the ruins of "Jefferson's and Latrobe's failed archway survive between the east wing against the house and the Treasury. . . . Pennsylvania Avenue is soon to be cut through, before the White House fence." This carriage arch failed due to frost damage and the premature removal of centering.
5. See also Stokes and Haskell 1932, 104.
6. White House Historical Association 1992; Patrick Phillips-Schrock, *The White House: An Illustrated Architectural History* (Jefferson, NC: McFarland, 2013). See also Deák 1988, 1: 216–217; Jeffrey A. Cohen and Charles E. Brownell, *The Architectural Drawings of Benjamin Henry Latrobe*, 2 vols. (New Haven: Yale University Press for the Maryland Historical Society and the American Philosophical Society, 1994), 2, pt. 1: 491–506.

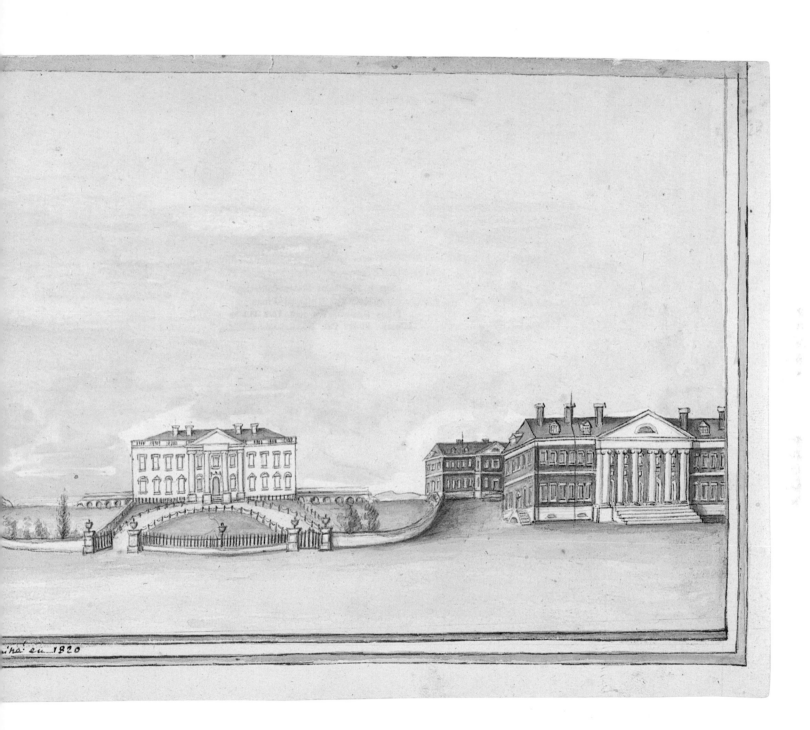

en 1820

69a

***Entrance Gate to the White House Garden,
Washington, DC, 1818***

Graphite and gray watercolor on paper; 6 ½ × 6 ½ in. (165 × 165 mm)
Watermark: G & R MUNN / 1815
Inscribed below in brown ink: *1818 Porte du Jardin du Palais du Président du Côté dela
Pensylvania avenue.*
N-YHS, Purchase, 1953.237

69b

***Entrance Gate to the White House Garden with
Pennsylvania Avenue, Washington, DC, 1821***

Graphite and black chalk with touches of white chalk on paper, laid on blue paper;
7 ⅞ × 10 ½ in. (200 × 267 mm)
Inscribed at lower left in brown ink: *Pensylvanian avenue Washington et La Porte du
Jardin du Prèsident. 1821*
N-YHS, Purchase, 1953.233

Thomas Jefferson, the first president to occupy the President's Residence or White House for two full terms (1801–09), had ambitious plans for the building and its grounds. He envisioned colonnaded terraces for service areas at the east and west sides and entrusted his friend, the British Neoclassical architect Benjamin Henry Latrobe, who had immigrated to America and was one of the country's first professional architects, with their construction. Latrobe, who was architect of the U.S. Capitol, also installed two water closets, finished the grand staircase, and enclosed the grounds with a stone wall. Moreover, he designed and built a triumphal gate at the southeast entrance to the grounds.[1]

Neuville's two drawings of the entrance gate to the White House gardens, their most prominent feature, date from 1818 and 1821. Her studies are the only known works with any detail that preserve views of the gardens in the first two decades of the century and that include parts of Latrobe's flanking stone walls. Based on Roman triumphal arch prototypes, the larger central arch was flanked on each side by a smaller arch and crowned by an attic. This attic story was decorated with Roman Republican and Jacobin emblems—fasces, or bundled rods with axes, which Roman lictors carried as a sign of their office, surmounted by Phrygian caps, also known as liberty caps.

The artist drew the smaller, earlier sheet from Pennsylvania Avenue looking from below and at a greater distance into the White House grounds. The gate's central opening is festively decorated with tree branches and its side entries are closed with grillwork. Henriette's vantage point afforded a view of its flanking willow trees. Later, John Vanderlyn included both the willows and the arch in the left background in his portrait of George Washington (fig. 72). In her more ambitious, later sheet, Neuville drew the gate from inside the garden with the central doors opening inward, a

blocking course crowning its attic, and a curtain hanging in the lower right arch. Her point of view allowed a dramatic perspective from the garden through the central arch down Pennsylvania Avenue, a parade view underscored by two flanking *allées* of poplar trees on each side. The vista comes to a climax at the Capitol building, still under reconstruction and without its central dome, but with an adjacent flagpole.[2] Charles Bulfinch, who took over as architect of the Capitol after Latrobe, would add a copper-covered wooden dome. The baroness also depicted two Indigenous Americans outside the garden at the right of the central arch, and a painted sign at the left, which appears to feature a portrait head of George Washington. The gate was demolished in 1859 during the expansion of the Treasury.[3]

Fig. 72
Detail of John Vanderlyn,
George Washington (1732–1799),
1834. Oil on canvas;
92 × 62 in. (235.7 × 157.6 cm).
Collection of the U.S. House of
Representatives, Washington,
DC, 2005.017

1. White House Historical Association 1992, 27.
2. In the text of *Voyage pittoresque aux États-Unis de l'Amérique*, the Russian diplomat and artist Pavel Petrovich Svinin selected the U.S. Capitol in reconstruction without a dome as the first of the eight American buildings he deemed important; he commented that when completed, it "will certainly be the foremost building in the United States." Svinin 2008, 134.
3. William Seale, *The White House: The History of an American Idea* (Washington, DC: American Institute of Architects, 1986), 47.

69a

1818 Porte du Jardin du Palais du Président du Côté de la Pensylvania avenue.

69b

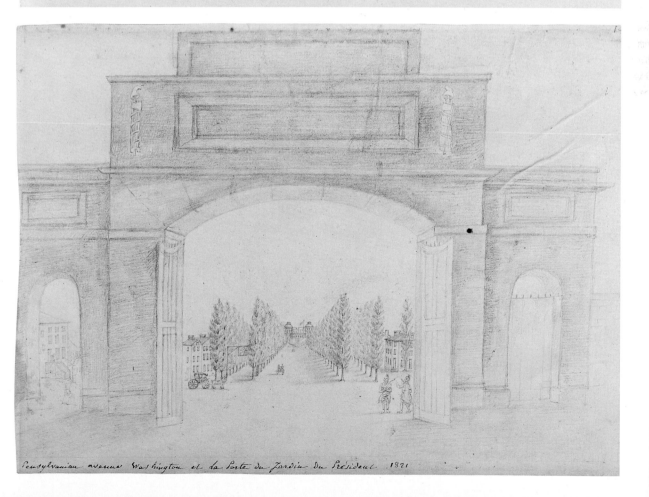

Pensylvanian avenue Washington et La Porte du Jardin du Président. 1821

Tomb of Washington at Mount Vernon, Virginia, 1818

Watercolor, graphite, black chalk, and brown ink on paper; 5 ¹³/₁₆ × 7 ³/₈ in. (148 × 187 mm)
Inscribed below in brown ink: *tombe du Grand Washington au Mont Vernon Nous L'avons visiteé Le 22. Juin 1818. avec Mr. de St. Crécy*[?].
Colonial Williamsburg Foundation, Abby Aldrich Rockefeller Folk Art Museum, Gift of Abby Aldrich Rockefeller

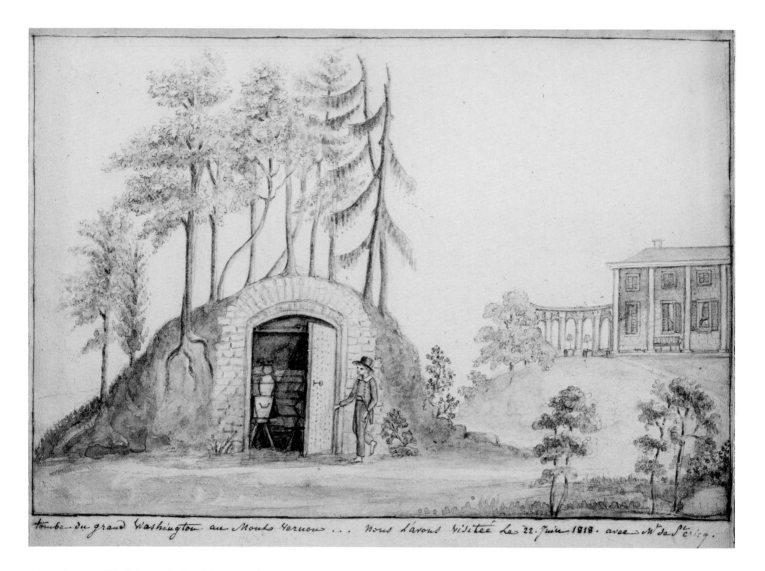

After George Washington's death in 1799, his remains were interred in an early family burial vault at his estate of Mount Vernon. During the Neuvilles' second residency, the national hero's original tomb became a de rigueur tourist visit. The picturesque and romantic site, featuring a tree-covered hillock, was a pilgrimage destination depicted by, among many others, Rubens Peale and Pavel Petrovich Svinin (after a print).[1] Unlike other artists, Neuville included a view of the main house with its veranda overlooking the Potomac River at the upper right, as well as a very anecdotal incident: a caretaker opens the vault's wooden door to reveal stacks of coffins belonging to the Washington family. In 1831, a new Washington family tomb was constructed and all the bodies were transferred to the new vault. Da Costa Nunes and Olin claim that Henriette's watercolor is the only known view of the original family tomb with its door open.[2]

1. Metropolitan Museum of Art, New York, inv. no. 42.95.44. Svinin executed his watercolor after an engraving of Washington's tomb that was reproduced in "The Pennsylvania Academy of the Fine Arts," in *Port Folio* 4:6 (appended to the December 1810 issue), opp. p. 23, ill. See Yarmolinsky 1930, pl. 43; Svinin 1992, pl. 43, for another version in the Russian Museum, St. Petersburg.
2. Da Costa Nunes and Olin 1984, 29.

Indian War Dance for President Monroe, Washington, DC, 1821

Watercolor, graphite, black and brown ink, and gouache on paper; 7 ⅝ × 12 in. (194 × 305 mm)
Inscribed at lower center in brown ink: *Danse Militaire des Sauvages devant Le President J. Monroe 1821*
Colonial Williamsburg Foundation, Abby Aldrich Rockefeller Folk Art Museum, Gift of Abby Aldrich Rockefeller

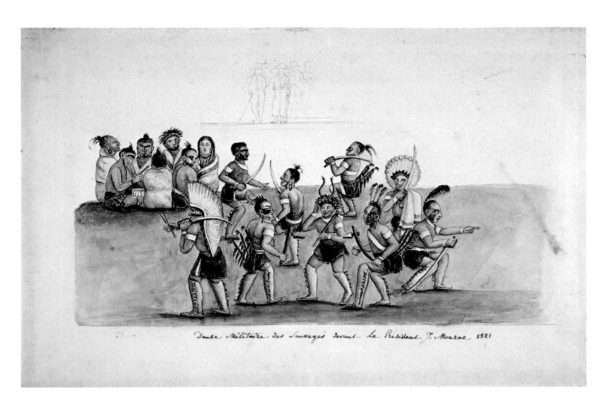

Neuville's scene records the "Indian War Dance" performed during the visit of a delegation of sixteen leaders of the Plains Indian tribes—Pawnee, Omaha, Kansa, Ottoe, and Missouri—to President James Monroe on November 29, 1821. As part of Monroe's efforts to "civilize" and resettle Indigenous Americans, he entertained the Indians at the White House. They were only one of a number of Indian groups brought to the nation's capital during the 1820s and 1830s. Henriette was in attendance, and in her recording of the event she included portraits of specific visitors. Among the likenesses is the woman sitting in the group at the left, identifiable as Hayne Hudjihini (Eagle of Delight), one of the five wives of half-chief Shaumonekusse (Prairie Wolf), depicted in the horned headdress, who died shortly thereafter of measles contracted on the visit. Later, Charles Bird King also painted the couple. William Faux, a British traveler residing in Washington and one of the few people to comment negatively about the baron, wrote about the occasion:

> There was a notice in the papers that the Indians would dance and display their feats in front of the President's house on a certain

day, which they did to at least 6,000 persons. They shewed their manner of sitting in council, their dances, their war whoop. . . . They were in a state of perfect nudity, except a piece of red flannel round the waist and passing between the legs. They afterwards performed at the house of his Excellency M. Hyde de Neuville. They were painted horribly, and exhibited the operation of scalping and tomahawking in fine style. The Otta half-chief and his squaw have taken tea with and frequently visited us.[1]

It has been suggested that in the upper background Neuville lightly sketched in graphite Monroe with his four companions, among them the baron wearing a feathered bicorne hat.[2] The cordial relationship between the Francophile Monroes and the Neuvilles explains their presence at this occasion, which the baroness could not resist commemorating in watercolor.[3]

1. William Faux, *Memorable Days in America* (London: W. Simkin and R. Marshall, 1823), 381.
2. Nina Fletcher Little, *The Abby Aldrich Rockefeller Folk Art Collections: A Descriptive Catalogue* (Boston and Toronto: Little, Brown, 1957), 152, reads it as a tricorne.
3. For the baron's comments on the Monroes, see *Mémoires* 1888–92, 2: 197–198, 490; *Memoirs* 1913, 2: 77–78, 111.

F Street, Washington, DC, 1821

Watercolor, graphite, black chalk, and black ink with touches of gouache on paper; 7 ½ × 9 ¾ in. (190 × 248 mm)
Watermark: D AMES
Inscribed below in brown ink: *Washington F. Street Maison de Mlle b*[L?] *27. Septembre 1821. Last night in Mr. Forest' house.*
N-YHS, Thomas Jefferson Bryan Fund, 1982.4

Interrupting their Washington residency, the Neuvilles returned briefly to France when Guillaume was awarded the title of baron. They departed on May 30, 1820, and returned on February 9, 1821, disembarking in Norfolk, Virginia. That same year, on an Indian summer afternoon, Henriette recorded the frame homes with their white picket fences and the quotidian activities of her neighborhood on F Street, the city's most fashionable avenue.[1] Her appreciation of children's play is again pronounced, as is her portrayal of a racially mixed population. She may have drawn these figures from the French ambassador's residence (fig. 18; appx. no. 73). A few months after their return to Washington when the ambassador's residence required renovation, the Neuvilles took up residency in what is known today as the Stephen Decatur House, which John Quincy Adams referred to as "Mrs. Decatur's house" (appx. no. 96).[2]

Henriette's inscription on this damaged sheet is washed and unclear but seems to say that the previous night she was entertained in the house of a "Mr. Forest," probably Colonel Uriah Forrest, an early mayor of Georgetown who built his house in 1788 and died in 1805. The Neuvilles' host therefore would have been a Forrest descendant or William Marbury—a successful businessman and one of the "Midnight Judges" appointed by President John Quincy Adams—who purchased the historic residence known today as the Forrest-Marbury house and located in the reconfigured capital city at 3350 M Street NW in Georgetown.

1. Leah R. Giles, "Entertaining a New Republic: Music and the Women of Washington, 1800–1825" (M.A. Thesis, University of Delaware, 2011), 34.
2. John Quincy Adams, Washington, DC, to Louisa Catherine Johnson Adams, Washington, DC, August 2, 1821, Adams Family Papers, MHS. See De Kay et al. 2018, 220, 312–315.

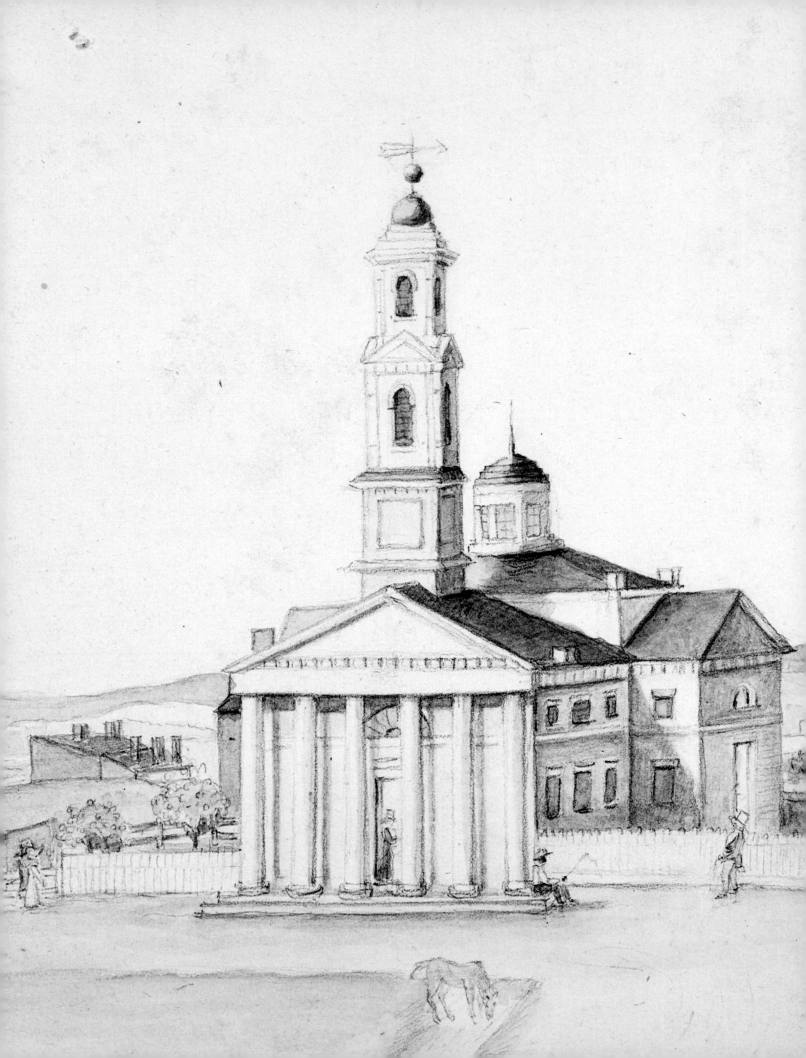

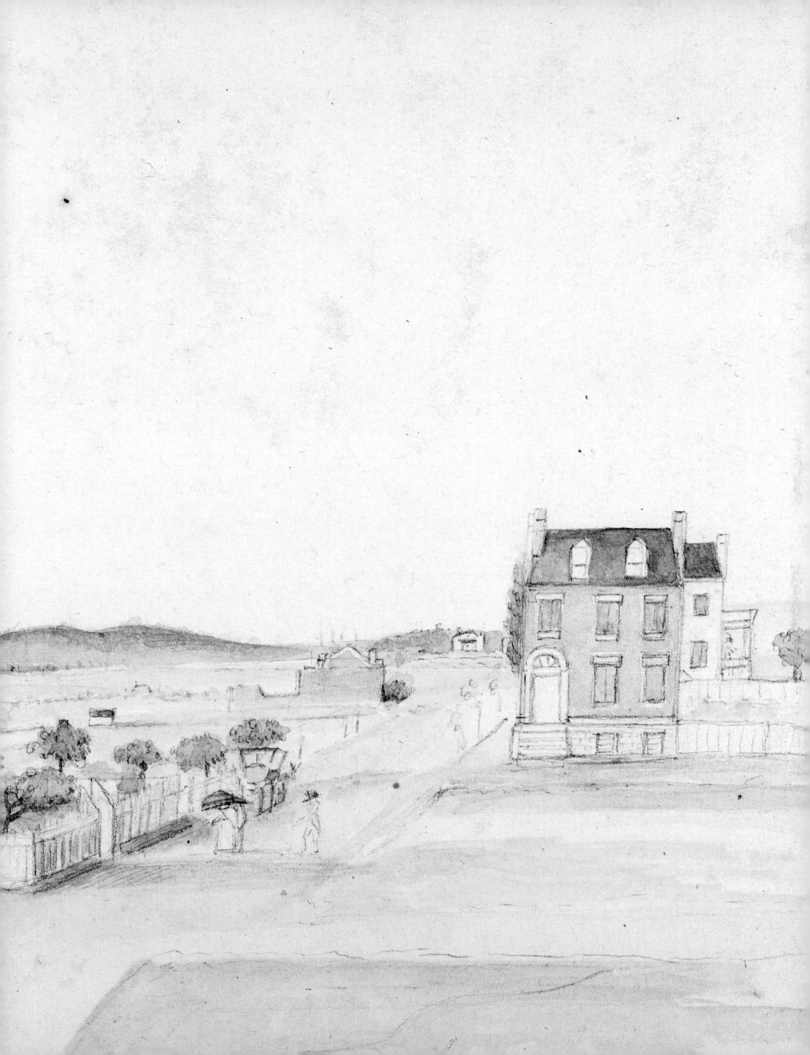

St. John's Church, Washington, DC, 1822

Watercolor, graphite, and black chalk with touches of brown ink on paper; 6 ¼ × 10 in. (159 × 254 mm)
Inscribed below in brown ink: *St Jhon's church Président Square Washington Mr R. Cutts et Mis graham's houses. 1822 – Juillet.*
N-YHS, Purchase, 1953.227

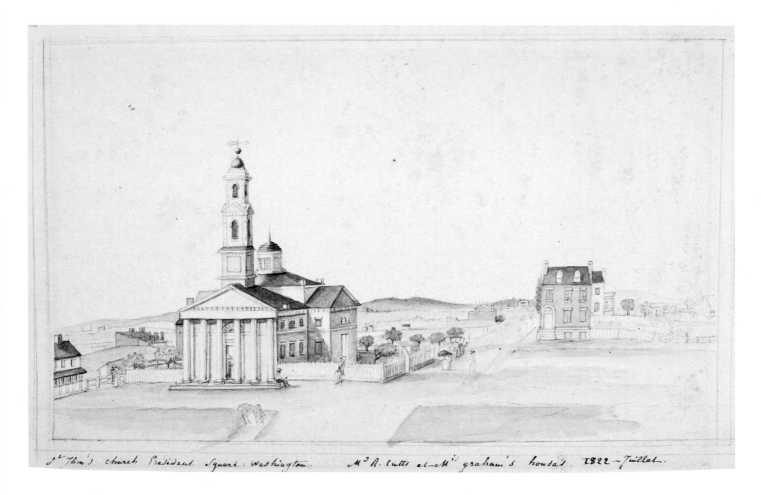

Neuville's bird's-eye view of Lafayette Square features one of the most prominent buildings in the capital at the time: St. John's Episcopal Church, situated on the northwest corner of 16th and H streets and designed by Benjamin Henry Latrobe.[1] The church, known colloquially as the "Church of the Presidents," was erected in 1816 as a centrally planned Greek cross. Later, in 1820–22, it was modified by extending one arm to form a Latin cross, as Neuville has portrayed it. At the left, she drew a farmhouse, which typified the then-rural character of the nation's capital. In the middle distance, at the northwest corner of Madison Place and H Street, the baroness recorded the two-and-a-half-story townhouse built in 1818 by Richard Cutts for himself and his wife, Anna Payne Cutts, sister of Henriette's friend Dolley Madison.[2] The building later passed to Dolley's husband, James Madison, as payment on a debt. After his demise in 1836, it was occupied by his widow from 1837 until Dolley's death, during which time it was an epicenter of Washington's social life. Not surprisingly, Dolley Madison's funeral was held in nearby St. John's Church, where she had been a member. The Cutts-Madison house still stands, although greatly altered from its original appearance. Behind it, at the corner of H and 15th streets, Neuville depicted the house of Mrs. John Graham, widow of the Chief Clerk of the State Department, who died in 1820.

1. Jeffrey A. Cohen and Charles E. Brownell, *The Architectural Drawings of Benjamin Henry Latrobe*, 2 vols. (New Haven: Yale University Press for the Maryland Historical Society and the American Philosophical Society, 1994), 2, pt. 1: 661–669. See also Koke 1982, 2: 212.
2. For Dolley Madison, see Allgor 2006.

Portraits of a Diverse and Changing Nation

74

Seneca? Man, **1807**

Watercolor, black chalk, graphite, and black and brown ink on paper; 6 ½ × 4 ¹⁵⁄₁₆ in. (165 × 125 mm)
N-YHS, Purchase, 1953.206

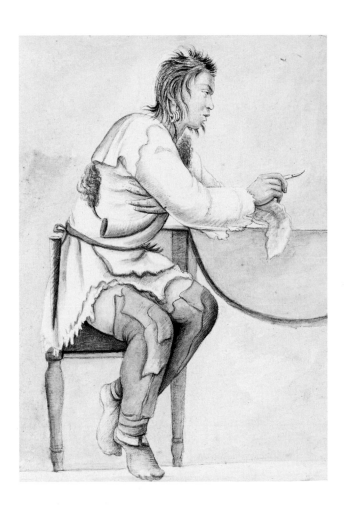

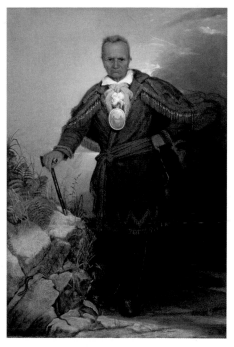

Fig. 73
Robert Weir, *Red Jacket (Sagoyewatha, ca. 1750–1830)*, 1828. Oil on canvas; 30 ½ × 20 ¼ in. (77.5 × 51.4 cm). N-YHS, Gift of Winthrop Chandler, 1893.1

Neuville's watercolor was formerly identified as a representation of Red Jacket. This identification evolved from her husband's description in his *Memoirs* of an Indian chief who was linked to the famous Seneca Indian chief of western New York called Red Jacket. His name derived from the succession of jackets he wore, beginning with the first one given to him by a British officer during the Revolutionary War. In his adulthood, his oratorical skills won him another title, Sagoyewatha, Keeper Awake.

In 1807, during the couple's trip in upstate New York, the baron mentioned seeing a chief who may indeed have been Red Jacket: "The chief Read Jaret [*sic* Red Jacket] is no better housed than the rest; he was engaged in making shoes of deer skin called *mocassins*, and he readily accepted the money offered him."[1] The activity of the chief in the baron's description seems similar to that of the subject in Henriette's watercolor. Seated at a table and dressed in a deer- or elk-skin shirt, moccasins, and patched leather leggings, he holds a knife in one hand with a strangely crooked finger and a piece of buckskin in the other. His right earlobe has been elongated and pierced by three rings, and a powder horn is slung under his right arm. However, Neuville's sitter does not wear a red jacket, and his facial features and hair do not resemble those of the sitter in Robert Weir's portrait of the Seneca chief (fig. 73). In addition, none of the portraits of Red Jacket show him with the ear modifications of her sitter, who also appears to be a younger man.

1. *Mémoires* 1888–92, 1: 459. Fenton 1954, 131, notes that the baron's description tantalizes us with this identification; Koke 1982, 2: 195, accepts it with only a question mark.

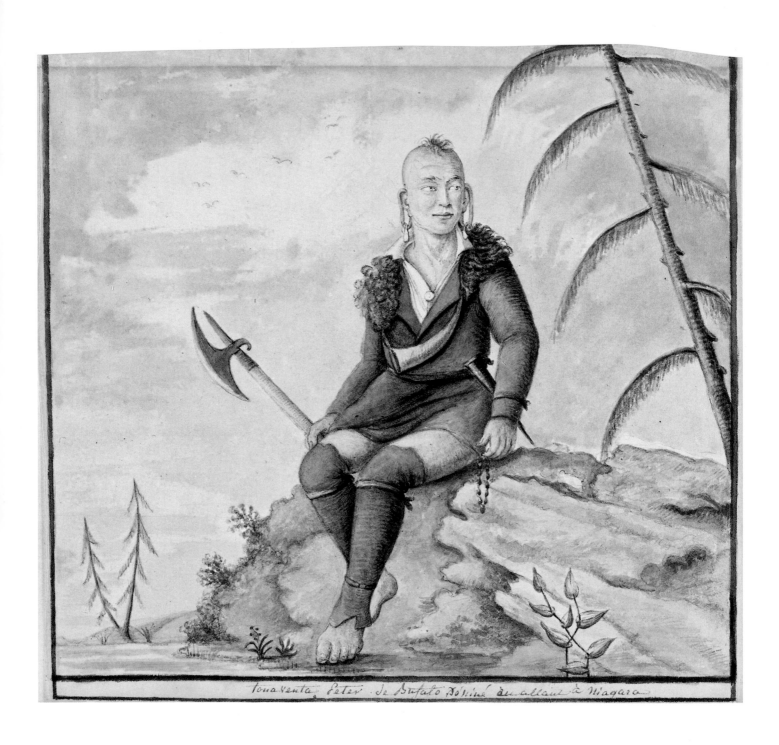

Tonaventa Peter. De Bufalo Do'niné au allant à Niagara

Peter of Buffalo, Tonawanda, New York, 1807

Watercolor, graphite, black chalk, and brown and black ink with touches of gouache on paper; 7 ½ × 9 in. (190 × 229 mm)
Inscribed at lower center in brown ink: *tonaventa Peter. de Bufalo Déssiné en allant à Niagara*
N-YHS, Purchase, 1953.220

Several different explanations have been offered regarding
Neuville's identification of her sitter, whom she calls
"Peter of Buffalo" in her inscription. The most logical
and literal addresses her entire inscription, together with
the chronology of the Neuvilles' tour as recounted by the
baron in his *Memoirs*. The baroness may have met the
sitter on the morning of September 1, 1807, when the couple
departed Buffalo on the early leg of their grand tour of
America.[1] The sheet's inscription notes that the baroness
drew him on the way to Niagara that same day. The word
"tonaventa" probably refers to nearby Tonawanda, New
York, where she recorded his likeness. It was the location
of the Tonawanda Seneca Reservation. William Fenton has
unconvincingly suggested that the sitter may be Tall Peter of
Buffalo Creek—there was also a Buffalo Creek Reservation
belonging to the Seneca Nation—whereas Richard Koke
noted that the Mohawk descendant Ethel Brant Montour,
an Iroquois biographer, examined the watercolor in
1955 and suggested that it represented the Seneca chief
Peter Blacksnake.[2]

Neuville's sitter has elaborately manipulated ear lobes,
each pierced with one earring, which, like his bare feet, are
traditional for Seneca tribesmen. He wears hybrid apparel:
a linen undershirt, a fur piece around his shoulders, and
leggings with garters, and he carries hunting gear—a trade ax
with a flared blade known as a halberd tomahawk,[3] a knife,
and a powder horn—as well as a string of wampum, denoting
his authority and peace. In the foreground, the baroness
included several plants growing in her stylized outdoor
setting. The one she placed most prominently in the right
foreground and described more specifically is a Milkweed
plant (*Asclepias syriaca*) with ripe pods or a Perfoliate
Bellwort (*Uvularia perfoliata*),[4] which reveals her budding
interest in native botanical species.

1. *Mémoires* 1888–92, 1: 460.
2. Fenton 1954, 132–133; Koke 1982, 2: 192.
3. Sturtevant 1980, 340; Scott Manning Stevens, "Tomahawk: Materiality and Depictions of the Haudenosaunee," *Early American Literature* 53: 2 (2018): 486–488.
4. Fenton 1954, 133.

Seneca "Squah" and Papoose, Western New York, **1808**

Graphite, watercolor, and black chalk on paper; 7 ⅜ × 5 ⅞ in. (187 × 149 mm)
Inscribed below in brown ink: *Squah of Seneca tribe with his papou. / aoust. 1808.*
N-YHS, Purchase, 1953.209

For a discussion of the baroness's use of the term "squah,"
which she employs in an attempt to be ethnographically
authentic, see cat. no. 19. Henriette's use of the term "papoose"
is correct. The American English word derives from the
Algonquian "papoos," meaning young child. Its present
meaning is a Native American child, or even more generally
any child, and frequently is used as a term of endearment.
In 1643, Roger Williams first recorded the word in *A Key
into the Language of America* as a term deriving from the
Narragansett, an Algonquian tribe.[1] Like "squaw," today
the word "papoose" can carry negative connotations and it
may also refer to a child carrier. In Neuville's watercolor, the
toddler stands on his mother's lap, affectionately wrapped
in her blanket robe with its irregular edgings, his right arm
resting on her shoulder.

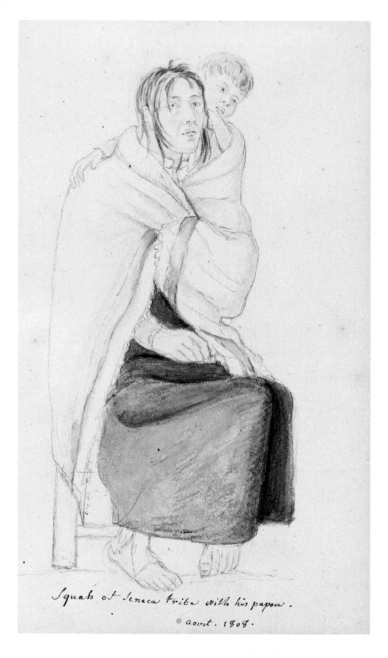

1. Roger Williams, *A Key into the Language of America* (Providence, RI: John Miller, 1827; reprint of London: Gregory Dexter, 1643), 110.

77

Fair Indian Man of the Buffalo Tribe, Canisteo, New York, **1808**

Watercolor, graphite, and black chalk with touches of black ink and white gouache on paper; 7 ¼ × 7 ¼ in. (184 × 184 mm)
Watermark: [J] WHATMAN / 1801
Inscribed at lower right in brown ink: *the fair-indian / of the buffalo tribe / drawn to canisteo 8bre / 1808 –*
N-YHS, Purchase, 1953.219

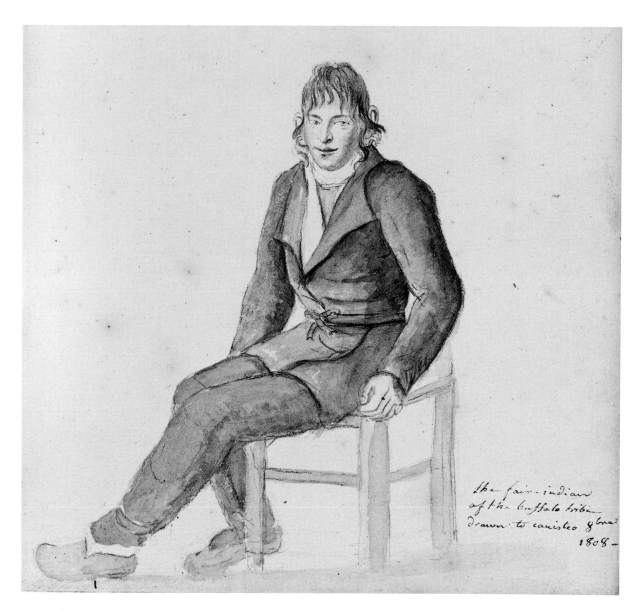

Canisteo is in Steuben County, New York, which was part of the territory controlled by the Seneca Indians, the westernmost nation of the Iroquois League, in the late eighteenth century. Their major villages were at Canisteo and Painted Post. Henriette may have identified her sitter as belonging to the "buffalo tribe" because, like Peter (cat. no. 75), he was a Seneca with similar ear modifications, further adorned with three hoop earrings in each ear. In addition, her inscription may allude to the Buffalo Creek Reservation of the Seneca. By using the term "fair," the baroness may have recognized his handsome looks, which she documented in her portrayal. Alternatively, "fair" could mean that he appeared to be of a mixed racial background. He sports a hybrid combination of Iroquois and non-native costume and, unlike Peter of Buffalo, apparently wears shoes rather than moccasins. William Fenton has suggested that he may be a half-blood son of Mary Jemison—who was captured and lived with the Seneca—perhaps her son Jesse or grandson Jacob, who attended Dartmouth College in 1816.[1]

1. Fenton 1954, 134–35; Koke 1982, 2: 200–201.

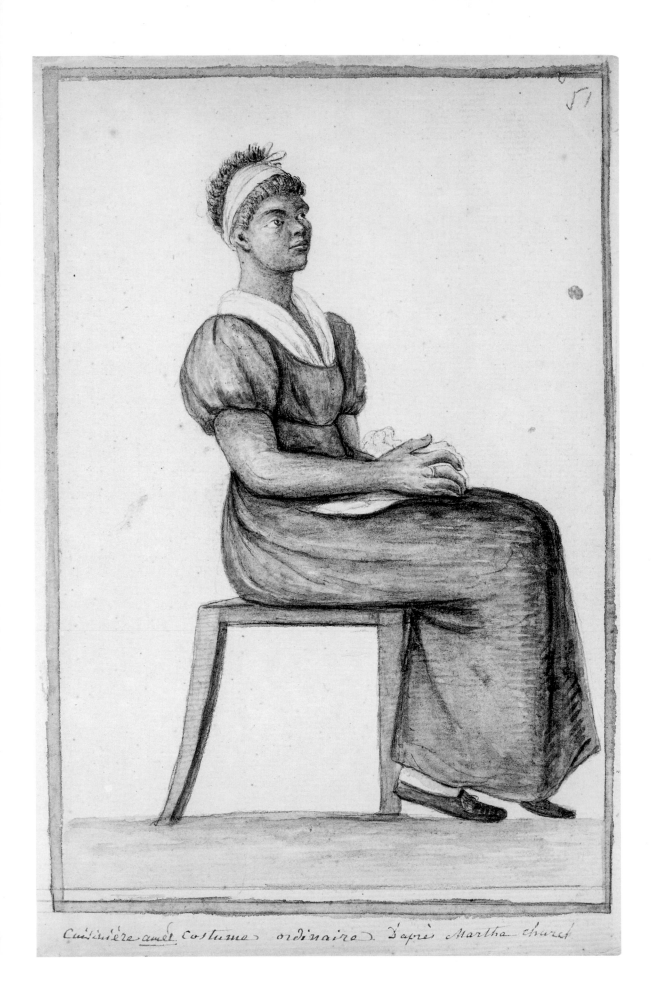

Cuisinière amet Costume ordinaire. D'après Martha Church

Martha Church, Cook in "Ordinary" Costume; verso: study of a child, 1808–10

Watercolor, graphite, black chalk, brown and black ink, and touches of white gouache on paper; graphite; 8 ½ × 5 ½ in. (216 × 140 mm)
Inscribed below in brown ink: *Cuisinière amer. costume ordinaire D'après Martha church*
N-YHS, Purchase, 1953.276

Henriette's inscription identifies the sitter as a cook named Martha Church, dressed in everyday attire. Unfortunately, we know nothing more about her except that the baroness also drew her young niece (cat. no. 79). In both sympathetic portraits, Neuville endowed her sitters with great dignity, suggesting that she valued good work, whether it involved reading, studying, sewing, cooking, or scrubbing. There is, however, no way to determine whether Church, a black woman, was a free domestic or a slave, or whether she was of Caribbean or African descent.

The baroness must have been aware of the artistic tradition of occupational portraits, sometimes referred to as "Cries." For over three centuries, various sets of "Cries" recorded images of urban culture with its tradesmen and itinerant street vendors. Their origins can be traced back to the seventeenth-century Bolognese genre tradition of Annibale Carracci,[1] followed by English and French examples.[2] With the explosion of journalism and printing in the late eighteenth century, many editions of "The Cries of London" were published, most of them as small pamphlets made for children. They influenced nineteenth-century American editions and the occupational watercolors of the 1830s by Nicolino Calyo, on which one later printed edition is based.[3] Along with the desire to depict the artisanal diversity of the metropolis, Calyo's "Cries" reflect a growing middle-class taste for more socially conscious images. A similar note is sounded much earlier in several watercolors by the baroness.

Neuville's watercolors also date from the period of the Italian artist and illustrator Bartolomeo Pinelli and his vernacular scenes of occupations. Pinelli's images were widely circulated in watercolor albums (from 1807) and engravings (from 1809) that were published not only in Italy but also in England and France.[4] The Italian artist's illustrations feature street vendors and domestic scenes in a folkloric celebration of regional customs. Their unpretentious print and watercolor-over-graphite media and the proportions of their figures resemble those of Nicolino Calyo and of the baroness. Moreover, Pinelli's nationalistic sentiments, and Calyo's revolutionary republican beliefs—which led to his immigration to the United States—are in harmony with certain post-Enlightenment ideas of the Neuvilles. At the very least, their works, like the baroness's egalitarian watercolors, reflect the enlarged awareness of social classes and occupations in an increasingly urbanized world.

1. The Carracci "Cries" were published by G.M. Mitelli in 1660 (*Di Bologna l'arti per via d'An.ibal' Ca.raci*) and reissued.
2. See Marguerite Pitsch, *Essai de catalogue sur l'iconographie de la vie populaire à Paris au XVIIIe siècle* (Paris: A. and J. Picard, 1952); Karen F. Beall, *Kaufrufe und Strassenhändler / Cries and Itinerant Trades: Eine Bibliographie / A Bibliography*, trans. Sabine Solf (Hamburg: E. Hauswedell, 1975), 18–23; Vincent Milliot, *Les "Cris de Paris," ou, le peuple travesti: Les représentations des petits métiers parisiens (XVIe–XVIIIe siècles)* (Paris: Publications de la Sorbonne, 1995). For the English, see Dorothea D. Reeves, "Come Buy! Old Time Street-Sellers of London and Paris and Their Cries," *Harvard Library Bulletin* 20:2 (1972): 158–175. See also Sean Shesgreen, *The Cries and Hawkers of London: Engravings and Drawings by Marcellus Laroon* (Stanford, CA: Stanford University Press, 1990). They were issued through the eighteenth century. See also idem, "The Cries of London in the Seventeenth Century," *Papers of the Bibliographical Society of America* 86:3 (1992): 269–294.
3. *The Cries of New-York* (New York: John Doggett, Jr., 1846). For Calyo's watercolor "Cries," see Olson 2008, 196–199.
4. For Pinelli's first extant engraved series, *Nuova raccolta di cinquanta motivi pittoreschi e costumi di Roma*, see Giovanni Incisa della Rocchetta, *Bartolomeo Pinelli*, exh. cat. (Rome: Museo di Roma, 1956), 61–62; Maurizio Fagiolo and Maurizio Marini, *Bartolomeo Pinelli, 1781–1835, e il suo tempo*, exh. cat. (Rome: Centro iniziative culturali Pantheon and Rondanini galleria d'arte contemporanea, 1983), 300. See also Roberta J.M. Olson, "Bartolomeo Pinelli: An Underestimated Ottocento Master," *Drawing* 2:4 (1980): 73–78; eadem, "An Album of Drawings by Bartolomeo Pinelli," *Master Drawings* 39:1 (2001): 12–44.

Scrubwoman, Jean or Jenny, Niece of Martha Church, **1808–10**

Watercolor, black chalk, and graphite with touches of white gouache on paper with stitching along left margin; 7 ½ × 6 ½ in. (190 × 165 mm)
Inscribed below in brown ink: *costume. de. Scrobeuse . . d'après Jene nièce de Martha church*
N-YHS, Purchase, 1953.251

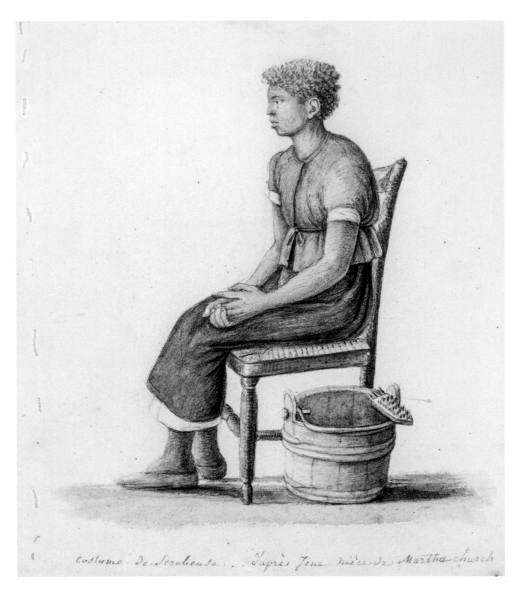

From the artist's inscription we know that the sitter is a scrubwoman and the young niece of Martha Church (cat. no. 78). Showing her in profile, Henriette carefully depicted her features and costume, as well as the texture of her wooden scrub bucket and brush. She also sketched three scrubwomen in action at the Economical School (appx. nos. 38v, 40, 46v). Like her portrayal of Martha, Neuville's portrait of this dignified cleaning woman, whose ethnic heritage and status remain obscure, honors good work in the tradition of the "Cries" (see cat. no. 78). In his *Memoirs*, the baron expressed similar admiration for the virtue of work and the American women who were an inspiration for their French counterparts: "Too often in Europe, we have only false ideas. A well-dressed girl would be ashamed to make her own butter, or employ herself in the kitchen. Here, it is quite different. Nobody feels it any disgrace to do useful work. The pretty farmer's wife, whom you find at her embroidery, or reading Young's *Night Thoughts*, goes out, none the less, to milk her cow. . . ."[1]

1. *Mémoires* 1888–92, 1: 457; *Memoirs* 1913, 1: 236.

80

Miss Abbey Sharp; Suguey and Susan; Study of a Chair, **1809**

Graphite, black chalk, and watercolor on paper; 7 ¼ × 12 ½ in. (184 × 318 mm)
Inscribed at lower left in brown ink underlined: *Miss abbey Sharp*.; directly below in graphite: *Suguey and Susan*;
below in brown ink: [cut off]*oy 7bre 1809*
N-YHS, Purchase, 1953.253

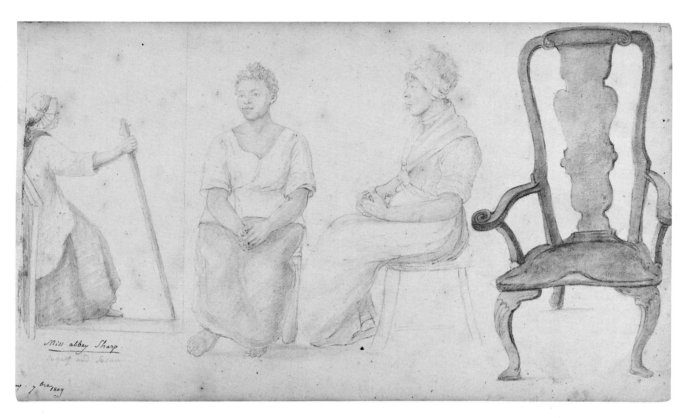

Given their proportional relationships, most likely Neuville drew these four separate studies on at least two different occasions in New Jersey or New York. Her likeness of Miss Abbey Sharp at the left (who may the "Miss Abbey" referred to in cat. no. 48) is proportionately smaller than the other three studies, and the artist drew a framing line around her portrayal to indicate a different time and place. The elderly, bespectacled woman wearing a white domestic cap is seated and holds a walking stick.

In the center of the sheet, the baroness portrayed two larger black women, both seated and identified only as "Suguey" and "Susan" (who wears a scarf in her hair). From their attire, the two women worked as domestics, but it is unknown whether they were enslaved or free women, or whether they were of African or Caribbean heritage. Nevertheless, it is clear that the baroness found them fascinating and sympathetic individuals, especially the younger Suguey, whom she portrayed frontally.

At the right in yet another scale, Henriette lavished great care on her study of a large armchair in brown watercolor and ink. Since perspective was not her strength, her portrayal lends the chair a kind of skewed dynamism. This Early Georgian armchair, dating between 1725 and 1740, has horizontally scrolled arms, cabriole legs with shell-carved knees, and pointed or slipper feet. Its splat is more complex than is typical of American chairs, while its crest rail with carved volutes is common in English chairs.[1]

1. Thanks go to Philip Zimmerman and Margaret K. Hofer for their stylistic analysis of the armchair.

Angelica Cruger (1805–1826) in Formal Dress, 1809

Watercolor, black chalk, graphite, and black and brown ink on paper; 7 ¼ × 6 ⅛ in. (184 × 156 mm)
Inscribed at lower right in brown ink: *1809*; at lower left: *costume D'Enfant D'après angélica Cr*[uger]. . . .
N-YHS, Purchase, 1953.252

Angelica Cruger was the daughter of Bertram Peter Cruger and Catharine "Kitty" Church. The Crugers were friends of the Neuvilles and Victor Marie du Pont de Nemours and his wife Joséphine, as well as of Thomas Jefferson. They may have met the Neuvilles in Angelica, New York. Young Angelica, the sitter, was the granddaughter of Angelica Schuyler Church (see cat. no. 24). *Longworth's* directory lists her father's brother, Nicholas Cruger, as residing with the Neuvilles at 61 Dey Street in 1812.[1] According to the inscription on the baroness's view of Angelica's home in Bloomingdale (fig. 74)—"Maison de Mr. et Mde. Cruger au Bloomingdale ou nous avons Passé avec eux aoust 1819, 7bre. et F. 26 8bre"—the Neuvilles visited the family at their suburban residence three times in 1819.

Dutch settlers originally christened the area known in the Neuvilles' time as Bloomingdale Village "Blomendaal" (valley of the flowers). When the British moved in, the area became Bloomingdale. In 1703, an early highway called Bloomingdale Road was built, which eventually ran through the village, today's Upper West Side. By 1900, Bloomingdale Road had become Broadway. During the Neuvilles' residence it was an idyllic yet fashionable suburban place to live.

As the baroness notes in her inscription on this sympathetic portrait, Angelica wears the formal attire of a young child, including a bead necklace and modish white mitts on her arms, which Henriette shaded to give them volume. Her apricot-colored dress is trimmed in brown chevron rickrack at the hem, collar, and sleeves, accented with a bow. Guileless, she sits demurely on a stool and gazes with well-mannered composure directly at the viewer, her hands resting in her lap.

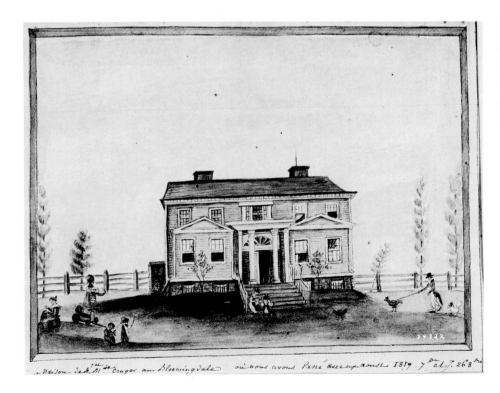

Fig. 74
Anne Marguérite Joséphine Henriette Rouillé de Marigny Hyde de Neuville, *Home of Mr. and Mrs. Cruger at Bloomingdale, New York*, 1819. Watercolor on paper; 5 ¼ × 7 ¼ in. (133 × 184 mm). Formerly Kennedy Galleries, New York (appx. no. 93)

1. *Longworth's* 1812, 76, 228, respectively, lists Nicholas Cruger and G.H. Neuville at 61 Dey Street. *Elliot's . . . Directory* 1812, xxvi, lists Nicholas Creiger [*sic* Cruger] at the same address.

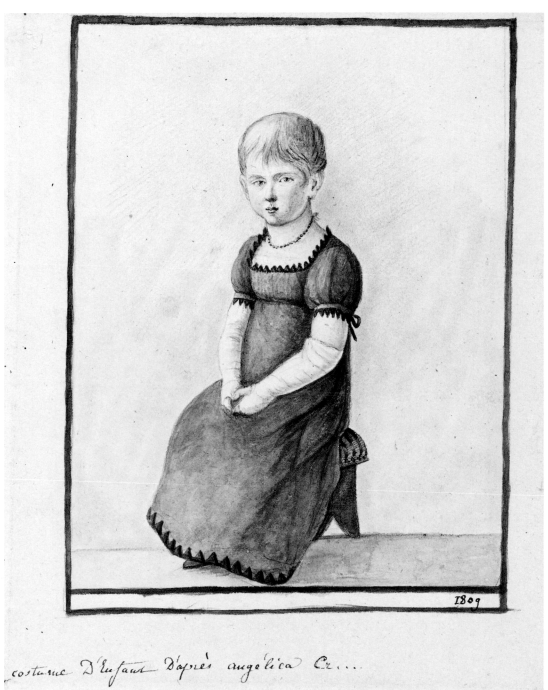

costume D'Enfant D'après angelica Cz...

82a

Louis Simond (1767–1851), 1810–15

Watercolor, graphite, and black chalk with touches of brown ink on
heavy paper; 8 ½ × 6 ¾ in. (216 × 171 mm)
Inscribed at lower left in brown ink: *Mr Simond id*
N-YHS, Purchase, 1953.254

82b

Mrs. Louis Simond (Frances Wilkes, 1753/63?–1820), 1810–15

Watercolor, pastel, and graphite with touches of black ink on
heavy paper with remnants of blue paper adhering to its verso;
7 ⅞ × 6 ½ in. (200 × 165 mm)
Inscribed at lower left in brown ink: *Mde Simond D'áprès Reynolds*
N-YHS, Purchase, 1953.255

82c

Mrs. Simond Sewing, with Collaged Profile Bust of George Washington, 1808–20

Graphite and gray watercolor with touches of black chalk on paper, with collaged
overlay; 7 ½ × 6 ¾ in. (191 × 171 mm); 1 ⅞ × 1 ¼ in. (48 × 32 mm)
Inscribed at lower left in brown ink: *Md S. . . .*; on collaged sheet at upper left in
brown ink: *Gal W. . .*
N-YHS, Purchase, 1953.250ac

Mr. and Mrs. Simond were intimate friends of the Neuvilles. Both couples were residents of New York City and also maintained homes in New Jersey. The Simonds' house was also on Easton Turnpike in New Brunswick, adjacent to the Neuvilles' property. Henriette recorded their arcadian country residence and grounds, and perhaps herself and Madame Simond, in a watercolor that she dated May 1809 (appx. no. 88). In addition, the Neuvilles resided for several months with the Simonds after their move to London in 1815 (see cat. no. 64). Henriette's half-length pendant portraits of the couple facing each other demonstrate her respect and fondness for them.

The French-born Louis Simond lived in New York from 1790 to 1815, except for the years 1810–11, when he was traveling in Great Britain.[1] He was a merchant, auctioneer, and the owner of a company engaged in West India trade, L. Simond & Co., located at No. 65 Greenwich Street. By 1814, the business seems to have been dissolved. It is likely that Simond's company, like other commercial enterprises extensively committed to foreign trade, failed in 1813 owing to the War of 1812. He and his wife, Frances Wilkes Simond, lived at 57 Broadway.[2] The Neuvilles considered the couple American, and some directories even list Simond with the anglicized first name of Lewis. Simond was a godparent to William Macadam Wilkes, a son of Charles Wilkes, his brother-in-law and a treasurer of the N-YHS. Simond's travels in Europe after 1815 resulted in illustrated books recounting his peregrinations in Italy and Switzerland, where he would spend the last three years of his life, dying in Geneva. A distinguished amateur painter, illustrator, and art critic, Simond became a member of the New-York Historical Society in 1812. He designed the vignette of Henry Hudson's *Half Moon*, which was later engraved by Asher B. Durand for the Historical Society's membership diploma, as well as the vignette of the Hudson

River for the Literary and Philosophical Society of New York.[3] The baroness regarded him as an artistic mentor and copied some of his illustrations (cat. no. 52).[4] In this candid portrait, she portrayed her friend engaging the viewer directly while holding a palette and brushes to signify his artistic vocation and its importance to her.

The American-born Frances Wilkes Simond, sister of the Neuvilles' lawyer Charles Wilkes, married Louis Simond at Trinity Church in New York City on July 30, 1791. She also served as godmother for James Fenimore Cooper's wife on her baptism (baptismal records of May 17, 1792, Trinity Church). In the pendant to her husband's portrait (cat. no. 82b), Neuville portrayed her friend seated on a French *fauteuil*, wearing a turban-like kerchief over her hair and a fur stole around her shoulders.[5] Her inscription, alluding to the British painter Sir Joshua Reynolds (*D'áprès Reynolds*), means that she posed her sitter, seated in an armchair, like a half-length Reynolds portrait in the grand manner with the background drapery swept up on a diagonal. It might suggest a date of 1815 when the baroness lived with the Simonds in London.

In Henriette's other, more casual portrait of Frances Simond, the third of this trio (cat. no. 82c), she represented her friend in her boudoir, intently sewing near a dressing table and mirror; in front of her is another table on which rest a book and scissors. At the upper left, the artist collaged onto the main support a small oval piece of paper containing a profile portrait of George Washington. She may have copied this portrait from a print in the couple's possession. For another portrait by the baroness of Mrs. Simond, who died in Paris, see appx. no. 30. The baroness also depicted Frances Wilkes Simond's nieces, Charlotte and Fanny Wilkes, perhaps in New Jersey at either the country house of the Neuvilles or their aunt and uncle (appx. nos. 54, 55).

1. Dunlap 1834, 1: 141–142, includes Simond briefly in his history of American art, stating he was from Switzerland and praising him as being self-taught, but noting that his support of Trumbull was his critical downfall.
2. Joseph Alfred Scoville, *The Old Merchants of New York City* (New York: Carleton Publisher, 1865), 100.
3. Shadwell 1974, figs. 6, 7.
4. For Louis Simond, see ibid., 174–175; N-YHS 1974, 2: 737–738, no. 1987, ill.
5. For Frances Wilkes Simond, see N-YHS 1974, 2: 738, no. 1898, ill.

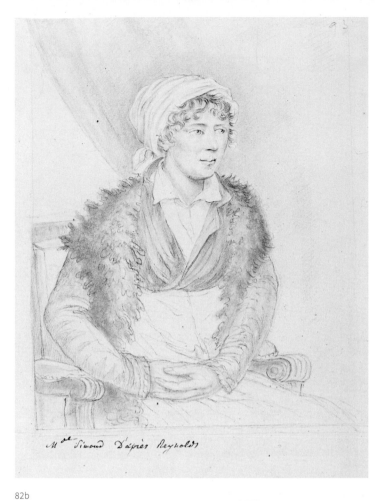

82b

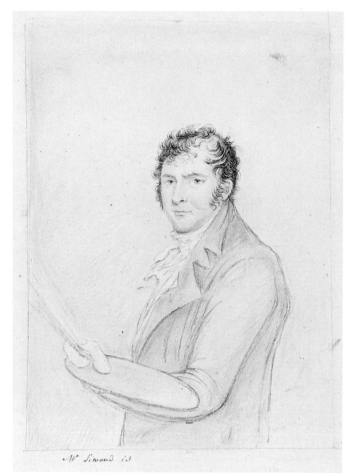

82a

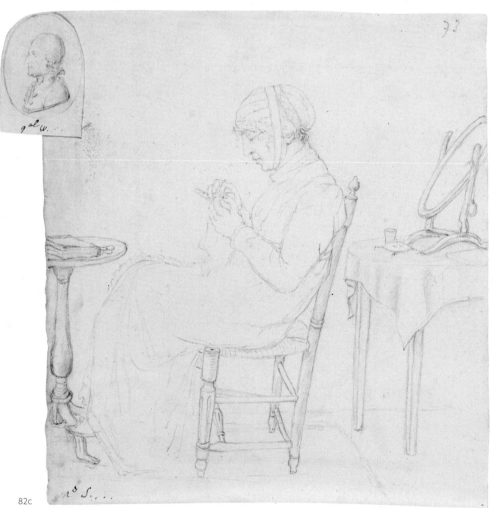

82c

233

Mulatto Woman in Half Dress, 1809–14

Watercolor, graphite, black chalk, and touches of black and brown ink and pink pastel on paper; 5 ¾ × 4 ⅝ in. (146 × 117 mm)
Inscribed below image within balustrade in brown ink: *mulâtresse en Demi Parure*.
N-YHS, Purchase, 1953.279

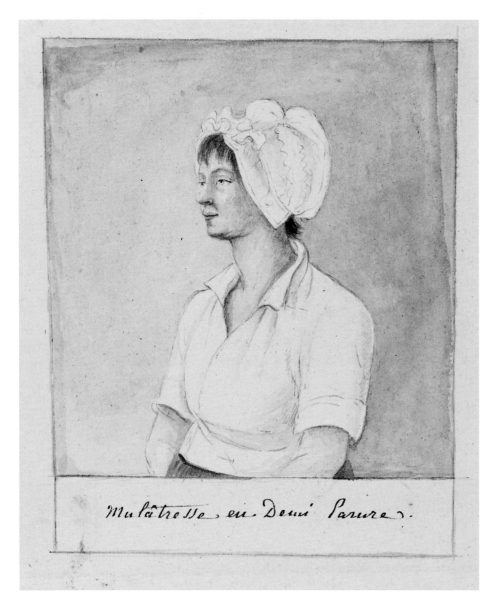

Henriette identified the sitter of this half-length portrait as a mulatto (in French, *mulâtresse*), a term not in use today. In the early nineteenth century the French word in Neuville's inscription described a woman of mixed racial heritage, both black and white.[1] The baroness also employed another term that is no longer in common usage to characterize her costume: "half dress" (*demi parure*). During the late eighteenth and early nineteenth centuries, the term was applied to both men and women. Half dress fell between "full dress," which was the most elaborate attire worn in the late evening to very formal events, and "undress," which was very casual or informal wear for the home. Half dress, or afternoon dress, was a kind of catch-all costume that could also be worn to more informal social occasions like dinners with family or for an afternoon stroll. The type of cap recorded by the baroness was also a fixture of a woman's domestic costume. She applied a brown wash to set off the white of her sitter's costume, as she did in cat. no. 86.

1. The English term "mulatto" is derived from the Spanish and Portuguese *mulato*, whose origin is uncertain. Some dictionaries and scholarly works trace the word to the Arabic term *muwallad*, which means a person of mixed ancestry. See Jack D. Forbes, *Africans and Native Americans: The Language of Race and the Evolution of Red-Black Peoples* (Champaign: University of Illinois Press, 1993), 145.

Girardino, 1812

Watercolor, graphite, and black chalk with touches of pink pastel on paper; 7 ¾ × 6 ½ in. (197 × 165 mm)
Inscribed at lower center in brown ink: *girardino 1812*
N-YHS, Purchase, 1953.280

In her inscription, the baroness identified the youth only as "girardino," which may be the diminutive of the masculine name Girardin. See also cat. no. 38 for a vignette set in Princeton that she drew the following year and inscribed "Girardin." Unfortunately, the seated young man cannot be fully identified, although he seems to be about eleven years old. If he is the same individual she included in the Princeton vignette, he may have been a New Jersey resident. Seated on a stool in profile looking to the right, the young man, attired in half dress for the daytime, wears a frock coat with metal buttons over an apricot waistcoat and long trousers.

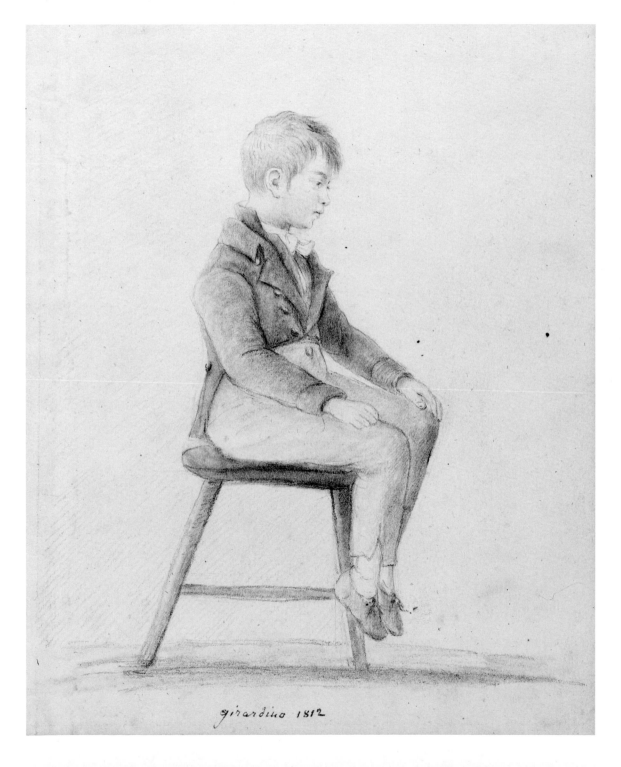

girardino 1812

Chambermaid Reading, 1809–14

Watercolor, graphite, brown ink, black chalk, and touches of white gouache on paper; 8 ¼ × 5 ½ in. (210 × 140 mm)
Inscribed at lower center in brown ink: *chambre Maid..*
N-YHS, Purchase, 1953.281

True to her penchant for depicting people engrossed in reading, Neuville has shown the unknown chambermaid posed in the act, holding up a book with brown covers in both hands. The sitter's hair is bound with a narrow pink ribbon, and she wears a white muslin frock with an accordion-pleated collar, chevron trim on its short sleeves, and a decorative border along its hem. White bows embellish her delicate, dark slippers. As she sits for the baroness, she poses rather self-consciously, as though a soldier at attention, on a substantial ladder-back chair with a rush seat.

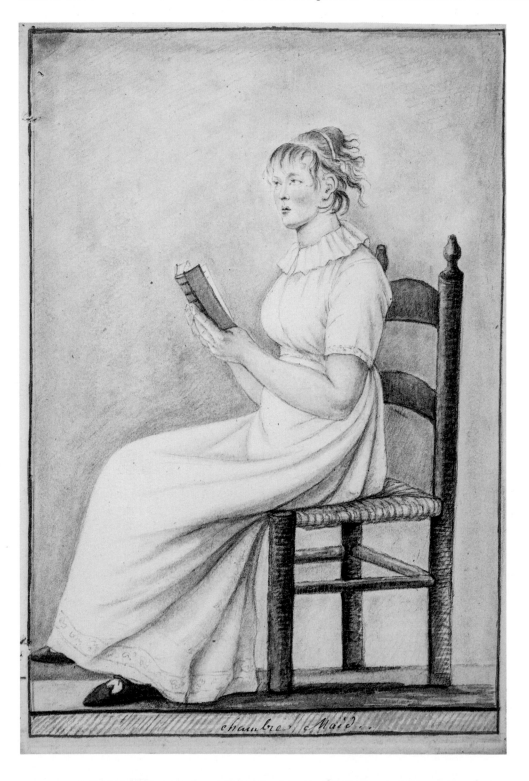

86

Joséphine, The Little Italian, New York, **1813**

Watercolor, black chalk, pastel, and graphite on paper; 7 ⅛ × 5 ½ in. (181 × 140 mm)
Inscribed below in brown ink: *Joséphine (La Petite italienne) Newyork. 1813*
N-YHS, Purchase, 1953.282

When she assigned her sitter, Joséphine, the diminutive nickname of "The Little Italian," the baroness—ever conscious of her subjects' ethnic backgrounds—affectionately noted her Italian ancestry, probably because of her blonde hair, which was unusual for most Italians. She used the French variant of her name rather than the Italian "Giuseppina," most likely because it was the baroness's own third name and one that ran in her family. With her hands genteelly folded, the adolescent sits on a studded traveling trunk, perhaps indicating that she has just arrived in the melting pot of New York City, which was fast becoming an international center. Joséphine wears a dark empire-waist dress with a broad, ruffled collar and drop earrings with three tiers of gemstones, a style fashionable after Napoleon's coronation in 1804, and one worn by the baroness herself in a watercolor she painted in 1816 (cat. no. 66b).

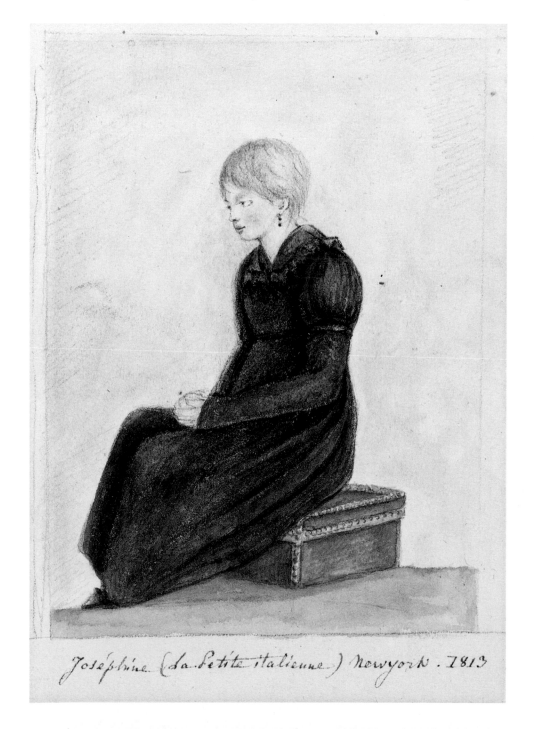

Joséphine (La Petite italienne) Newyork . 1813

Young Girl in Full or Fancy Dress, 1809–15

Watercolor, graphite, and black chalk with touches of brown and black ink and reddish gouache on paper; 7 ⅝ × 5 ⅛ in. (194 × 130 mm)
Inscribed at lower left in brown ink: *Petite fille Parée*
N-YHS, Purchase, 1953.284

As Henriette recorded in her inscription, this portrait focuses on the full or fancy dress for evening worn by the youthful sitter, whose identity is unknown, but who is clothed in the sartorial splendor of the day. Her white muslin, empire-waist dress with tiered short sleeves, embellished with a green bodice band, is complemented by the unbleached white cotton mitts covering her arms, fashionable ca. 1790–1810. In addition to her still-modish hoop earrings, similar to those worn by the baroness early in the nineteenth century (cat. no. 1), she sports at least three rings, two gray armbands with gold clasps, two short bead necklaces, and a third longer bead necklace from which hangs a large, gold pendant or locket. The sitter's formal attire and elegant accoutrements contrast with her understated coiffure and the simple rush-seated chair on which she sits, her hands decorously clasped in her lap.

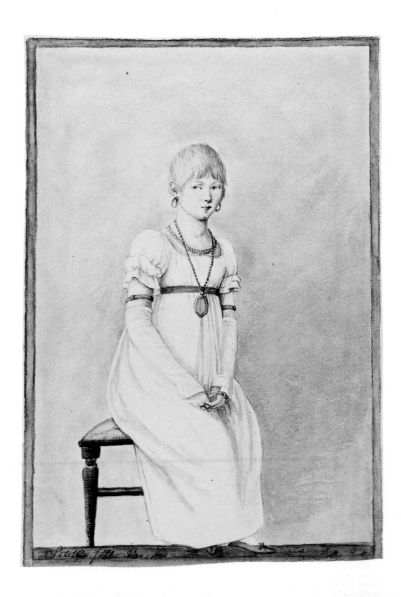

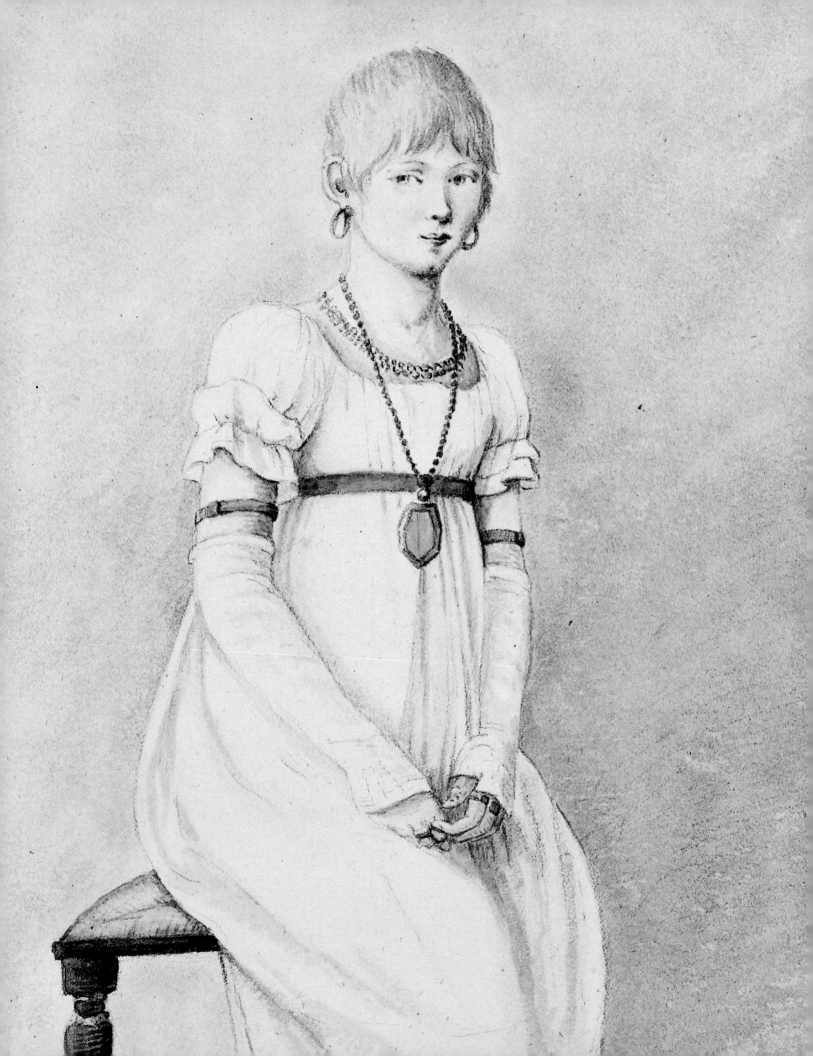

Bridge June 1808.

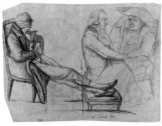

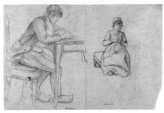

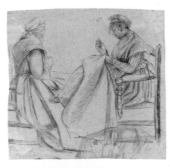

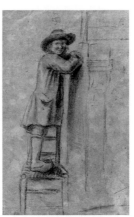

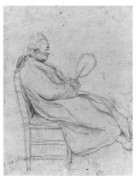

1.
Three Figure Studies; verso: boy in
wooden shoes writing; seated girl
sewing, 1804
Black chalk with stumping, Conté
crayon, and gray watercolor on beige
paper; 8 ⅝ × 11 ¼ in. (219 × 285 mm),
irregular
Inscribed at lower right of center
in brown ink: *La charité 1804*; verso
inscribed at lower left of center:
Gouiguot; and at lower right of
center: *Louisa*
N-YHS, Gift of Mark Emanuel, 2018.42.1

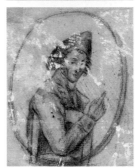

3.
Lisette and Fanchette Sewing; verso:
study of a Roman sculpture of a veiled
woman, ca. 1800–06
Black chalk with stumping and gray
watercolor on beige paper; 7 ½ × 7 ⅞ in.
(191 × 200 mm), irregular
Watermark: Fleur-de-lis [partially cut]
Inscribed at lower left in black chalk:
Lisette et Fanchette
N-YHS, Gift of Mark Emanuel, 2018.42.6

5.
*Boy Wearing Wooden Shoes Standing
on a Chair*; verso: oval portrait of a
man in a tricorne hat, ca. 1800–06
Black chalk with stumping, gray
watercolor, and touches of red chalk
and Conté crayon on beige paper;
8 ³⁄₁₆ × 5 in. (208 × 127 mm)
N-YHS, Gift of Mark Emanuel, 2018.42.8

7.
*Seated Elder Man Wearing Dressing
Gown and Holding a Paddle Fan*,
ca. 1800–06
Black, red, and white chalk with
watercolor on paper; 8 ¼ × 6 ¼ in.
(210 × 159 mm), irregular
Watermark: illegible
N-YHS, Gift of Mark Emanuel, 2018.42.10

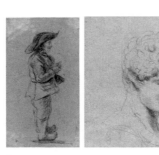

8.
Man Reading a Book; verso: study
of a sofa, ca. 1800–06
Black and red chalk, blue pastel, and
touches of gray watercolor on paper;
red chalk; 7 ¼ × 6 ¼ in. (184 × 159 mm),
irregular
Watermark: illegible
N-YHS, Gift of Mark Emanuel, 2018.42.11

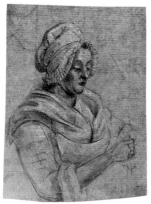

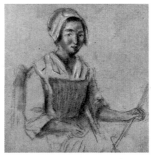

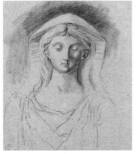

2.
*Woman with Downcast Eyes Wearing
Cap*, ca. 1800–06
Black, white, and red chalk with
stumping and gray watercolor
on beige paper; 4 ½ × 3 ½ in.
(114 × 89 mm), irregular
N-YHS, Gift of Mark Emanuel, 2018.42.5

4.
*Woman in Country Costume Holding a
Staff*, ca. 1800–06
Black, white, and red chalk with
stumping and gray watercolor
on beige paper; 4 ½ × 4 ⁵⁄₁₆ in.
(127 × 110 mm), irregular
N-YHS, Gift of Mark Emanuel, 2018.42.7

6.
*Boy in Profile Wearing a Hat and
Wooden Shoes*; verso: partial study
after antique male head, ca. 1800–06
Black chalk, gray watercolor, and
touches of red chalk and Conté crayon
on beige paper; black chalk; 7 ½ × 4 ⅜ in.
(191 × 111 mm), irregular
N-YHS, Gift of Mark Emanuel, 2018.42.9

9.

*Seated Elder Woman Wearing
Spectacles and Sewing*, ca. 1800–06
Black chalk, graphite, and gray
watercolor on paper; 5 ⅝ × 5 ¾ in.
(143 × 146 mm), irregular
N-YHS, Gift of Mark Emanuel, 2018.42.12

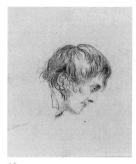

12.

Head of a Young Man in Profile; verso:
sketch, ca. 1800–06
Black chalk on blue paper; 5 ⅛ × 4 ¼ in.
(130 × 108 mm), irregular
N-YHS, Gift of Mark Emanuel, 2018.42.16

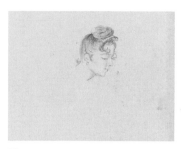

15.

*Head of a Young Woman Wearing an
Earring and a Comb in her Chignon*,
ca. 1800–10
Black chalk and gray watercolor on
paper; 4 ½ × 5 ½ in. (114 × 140 mm),
irregular
N-YHS, Gift of Mark Emanuel, 2018.42.18

17.

*House with Gardens in Fleury (Aude),
France*, 1805–06
Watercolor, black chalk, and pastel on
paper, laid on another sheet, attached to
a partial blue sheet, with framing strips;
5 ¹³⁄₁₆ × 8 in. (148 × 203 mm), irregular
Inscribed below on support in
graphite: *Fleury 180*
N-YHS, Gift of Mark Emanuel, 2019.8.1

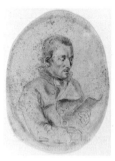

10.

Portrait of a Man Reading, ca. 1800–06
Black chalk, pastel, and gray
watercolor on paper, laid on partially
lined blue paper; 6 × 4 ½ in. (152 × 114
mm), irregular oval
N-YHS, Gift of Mark Emanuel, 2018.42.13

13.

*Copies of Two Classical Sculptures:
Reclining Etruscan Woman with Oil
Lamp or Fan and Vulcan at his Forge*,
1800–05
Black chalk and graphite on paper;
6 ³⁄₁₆ × 4 ³⁄₁₆ in. (157 × 106 mm)
N-YHS, Purchase, 1953.287g

16.

Seated Boy Holding a Book; verso:
architectural floor plan, ca. 1800–10
Black chalk, gray watercolor, and graphite
with touches of red chalk on paper;
graphite; 7 ⁵⁄₁₆ × 4 ½ in. (188 × 114 mm),
irregular
Watermark: Partial branch with fruit
N-YHS, Gift of Mark Emanuel, 2018.42.19

18.

*Constance, Switzerland: View from
Swabia on the Opposite Side of the
Rhine Bridge*; verso: sketch of Madame
Guitton holding infant Joséphine, 1805
Black chalk, gray watercolor, and
graphite on paper; 7 ⅛ × 10 ¹⁵⁄₁₆ in.
(181 × 279 mm)
Inscribed below in graphite: *1805.
Constance Vu dela Suabe de l'autre
Côté du Pont du Rhin.*; verso inscribed:
Mde Guiton et Joséphine 1805
N-YHS, Gift of Mark Emanuel, 2019.8.2

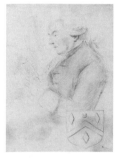

11.

*Guillaume Hide Reading and Study
of the Hyde de Neuville Coat of Arms*,
ca. 1800–06
Black, white, and red chalk and gray
watercolor on parchment; 5 ¼ × 4 in.
(133 × 101 mm), irregular
N-YHS, Gift of Mark Emanuel, 2018.42.14

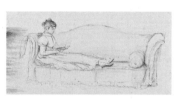

14.

*Young Woman Reading and Reclining
on a Divan*, ca. 1800–07
Black chalk, gray watercolor, and
gray gouache on paper; 2 ¾ × 5 ⅜ in.
(70 × 137 mm), irregular
N-YHS, Gift of Mark Emanuel, 2018.42.17

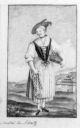

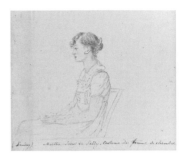

19.
Vignettes of Man and Woman in Swiss Canton Costume, after an Unknown Source, c. 1805
Watercolor, graphite, and brown and black ink on paper; 5 9/16 × 6 ¾ in. (141 × 171 mm)
Inscribed at lower center in brown ink: *Paysan et Paysanne du Canton de Schwitz.*
N-YHS, Gift of Mark Emanuel, 2019.8.3

21.
The Tomb of the Scipios near Tarragona, Spain, after an Unknown Source, 1806
Watercolor and brown ink over graphite on paper, laid on another sheet to the right of 2019.8.4; 4 ¾ × 4 in. (121 × 101 mm), irregular
Inscribed below on support in brown ink: *. Tombeau Des Scipions prés Tarragone 1806*
N-YHS, Gift of Mark Emanuel, 2019.8.5

24.
Luisita Reading, 1807
Graphite on paper; 7 ¼ × 5 ⅛ in. (184 × 130 mm)
Inscribed at lower right in brown ink: *Luisita. 7bre / 1807 –*
N-YHS, Purchase, 1953.247

27.
Martha, Sister of Sally, in Chamber Maid's Dress, 1807–14
Graphite and black chalk with touches of watercolor on paper; 7 ½ × 5 ⅞ in. (190 × 149 mm), whole sheet
Inscribed below in brown ink: *(Sunday). Martha Soeur de Sally. Costume de femme de chambre*
N-YHS, Purchase, 1953.245

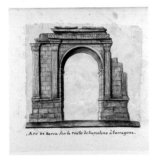

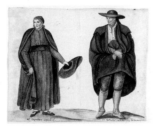

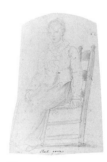

20.
The Arc de Berà on the Route from Barcelona to Tarragona, Spain, after an Unknown Source, 1806
Watercolor and brown ink over graphite on paper, laid on another sheet to the left of 2019.8.5; 4 13/16 × 5 7/16 in. (122 × 137 mm), irregular
Inscribed below on support in brown ink: *. Arc De Barca Sur la route de barcelone à tarragone.*
N-YHS, Gift of Mark Emanuel, 2019.8.4

22.
Spanish Chaplain and Catalan Laborer, after an Unknown Source, 1806–07
Watercolor, brown and black ink, and pastel on heavy paper with remnants of another sheet on the verso; 7 ¼ × 8 11/16 in. (184 × 221 mm)
Inscribed at lower left: *el capellan español.*; at lower right: *el labrador catalan con la capa de el*[?]
N-YHS, Gift of Mark Emanuel, 2019.8.6

25.
Mr. de Ponthieu: An Old Coxcomb, ca. 1807–14
Black chalk, gray watercolor, and graphite on paper; 6 ⅞ × 5 ¾ in. (175 × 146 mm), irregular
Inscribed at lower right of center: *Mr de Ponthieu at Mr. Sim. an old coxcomb.*
N-YHS, Gift of Mark Emanuel, 2018.42.22

28.
Young Woman in a "Short Gown"; verso: two figures, one drawing and one with a wheelbarrow, 1807–14
Graphite, black chalk, and gray watercolor on paper; graphite; 7 ½ × 5 in. (190 × 127 mm)
Inscribed at lower center in brown ink: *Short gown.*
N-YHS, Purchase, 1953.248

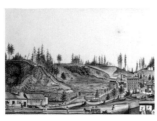

23.
Ballston Springs, New York, 1807
Watercolor on paper; 7 × 9 ¾ in. (178 × 248 mm)
Inscribed at lower left in brown ink: *Balston Spring, Juillet 1807*
N-YHS, Gift of an anonymous donor, 1947.449

26.
Elie-Anne, Clermont, New York, 1807–14
Graphite, black chalk, and gray watercolor on paper; 7 ½ × 4 ⅞ in. (190 × 124 mm)
Inscribed at lower center in brown ink: *Elie-anne, Clermont.*
N-YHS, Purchase, 1953.287f

29.
Seated Young Black Woman; verso:
young girl reading a story to two
children, ca. 1807–14
Graphite, black chalk, and gray
watercolor on paper; 7 ⅝ × 5 ½ in.
(194 × 140 mm), irregular
N-YHS, Gift of Mark Emanuel, 2018.42.20

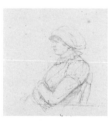

30.
Madame Simond (1753/63?–1820),
1807–15
Black chalk, graphite, and gray
watercolor on paper; 4 ⅛ × 4 ¾ in.
(105 × 121 mm)
Watermark: LOR[cut TAYLOR?]
Inscribed at lower center in brown ink:
Mde S. . . .
N-YHS, Purchase, 1953.250b

31.
Young Girl Wearing a Pinafore, 1807–10
Graphite on paper; 7 ¼ × 4 ½ in.
(184 × 114 mm)
Inscribed at lower left in brown ink:
Petite américaine
N-YHS, Purchase, 1953.256

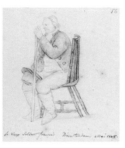

32.
*The Old French Soldier of Amsterdam,
New York*, 1808
Watercolor, pastel, graphite, and
black chalk on paper; 5 ⅜ × 4 ¾ in.
(137 × 121 mm)
Inscribed below in brown ink: *Le
Vieux Soldat François D'amsterdam
Mai 1808.*
N-YHS, Purchase, 1953.246

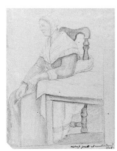

33.
*Mistress Pratt at Amsterdam, New
York*, 1808
Black chalk, watercolor, and graphite
on paper; 7 × 5 in. (178 × 127 mm)
Watermark: C WH[cut] / 180[cut]
Inscribed at lower right in brown ink:
mistress pratt at amsterdam / 1808.
N-YHS, Purchase, 1953.277

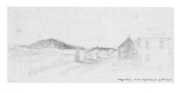

34.
A Street in Owego, New York, 1808
Graphite, gray watercolor, and
black chalk on paper; 7 ⅜ × 12 ⁵⁄₁₆ in.
(187 × 313 mm)
Inscribed at lower right in brown ink:
*owego-village – Sur la Susquehannah
– 17 8bre 1808. –*
N-YHS, Purchase, 1953.225

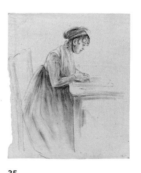

35.
*Pélagie Drawing a Portrait, from the
"Economical School Series"*, 1808
Black chalk, gray watercolor, graphite,
and pink gouache on blue paper; 7 ⅞
× 6 ⅝ in. (200 × 168 mm), irregular
Inscribed at lower right in graphite,
partially erased and illegible: *Pélagie
S. . S 180?* [rewritten]
N-YHS, Gift of Mark Emanuel, 2018.42.21

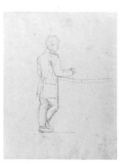

36.
*Standing Boy, from the "Economical
School Series"*, ca. 1808–14
Black chalk and graphite on light blue
paper with deckled edges; 7 ¾ × 6 in.
(197 × 152 mm)
Watermark: a goux
N-YHS, Purchase, 1953.274d

37.
*Eight Figure Studies, from the
"Economical School Series"*; verso:
study of a boy, ca. 1808–14
Graphite and black chalk on light blue
paper with deckled edges; 4 ⅜ × 7 ½ in.
(111 × 190 mm)
N-YHS, Purchase, 1953.274e

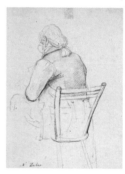

38.
*Mr. Dubue with a Reading Glass, from
the "Economical School Series"*; verso:
woman scrubbing, ca. 1808–14
Black chalk, gray watercolor,
and graphite on light blue paper
with deckled edges; 7 ¾ × 6 in.
(197 × 152 mm)
Watermark: A Robe
Inscribed at lower left in brown ink:
Mr Dubue
N-YHS, Purchase, 1953.274i

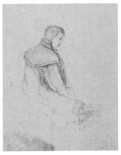

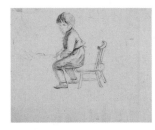

39.
Young Man in Profile; Man Using a Bow Saw, from the "Economical School Series"; verso: three figure studies, ca. 1808–14
Black chalk, gray watercolor, and graphite on light blue paper with deckled edges; 7 ⅝ × 6 in. (194 × 152 mm)
N-YHS, Purchase, 1953.274j

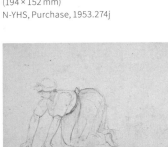

40.
Woman Scrubbing, from the "Economical School Series"; verso: various cart and figure studies including one for cat. no. 43, ca. 1808–14
Black chalk, graphite, and gray wash on light blue paper; 6 ⅛ × 7 ¾ in. (156 × 197 mm)
Watermark: Bell-flower
Verso inscribed at lower left in brown ink illegibly
N-YHS, Purchase, 1953.274k

41.
Small Boy Sitting Down, from the "Economical School Series", ca. 1808–14
Black chalk, gray watercolor, and graphite on light blue paper with deckled edges; 6 × 7 ½ in. (152 × 190 mm)
Watermark: illegible
N-YHS, Purchase, 1953.274L

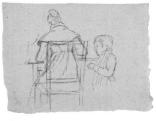

42.
Seated Woman and Boy, from the "Economical School Series", ca. 1808–14
Black chalk with a touch of gray watercolor on light blue paper with deckled edges; 5 ⅝ × 7 ⅝ in. (143 × 194 mm)
N-YHS, Purchase, 1953.274m

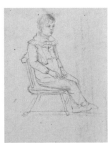

43.
Seated Boy, from the "Economical School Series", ca. 1808–14
Graphite, black chalk, and gray watercolor on light blue paper; 7 ¼ × 5 ⅜ in. (184 × 137 mm)
Watermark: a goux
Verso inscribed vertically in brown ink: *the earth is a . . . [all crossed out] / our lord ascended into heaven / notre Seigneur est monté au ciel*; below in graphite: *monté / é*
N-YHS, Purchase, 1953.274n

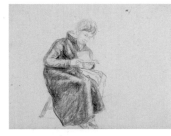

44.
Female Student Reading, from the "Economical School Series", ca. 1808–14
Black chalk, gray watercolor, and graphite on light blue paper with deckled edges; 6 ¼ × 7 ½ in. (159 × 190 mm)
Watermark: A Robe
N-YHS, Purchase, 1953.274o

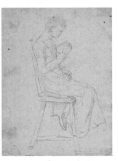

45.
Female Student Reading, from the "Economical School Series"; verso: man (Victor Moreau?) reading and figure studies, ca. 1808–14
Graphite and gray watercolor on light blue paper with deckled edges; 7 ¾ × 5 ⅞ in. (197 × 149 mm)
Watermark: A Robe[cut]
N-YHS, Purchase, 1953.274q

46.
Amélie Élisabeth du Pont (1796–1869) Sewing, from the "Economical School Series"; verso: scrubwoman, ca. 1809–10
Graphite and black chalk on light blue paper; graphite; 7 ½ × 5 ¾ in. (190 × 146 mm)
Inscribed at lower left in brown ink: *Amélie*; below (added later): *new york*
N-YHS, Purchase, 1953.274r

47.
Amélie Élisabeth du Pont (1796–1869), ca. 1809–10
Graphite on beige paper; 7 ⅞ × 4 ⅞ in. (200 × 124 mm)
Inscribed at lower left in brown ink: *amélie*
N-YHS, Purchase, 1953.274s

La Pagode de M. de Choiseul à Chanteloup.

48.

Passaic Bridge, Totowa, New Jersey,
1809
Graphite, black chalk, and brown
watercolor on paper; 7 ¼ × 9 ⅞ in.
(184 × 251 mm)
Inscribed at lower right in brown ink:
*Passaic Bridge 24 Juin 1809. Jour de
St Jean*
N-YHS, Purchase, 1953.244

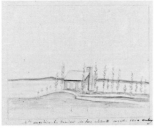

49.

*St. Peter's Church, Perth Amboy, New
Jersey,* 1809
Watercolor, graphite, and brown ink
on paper; 7 ⅛ × 9 ½ in. (181 × 241 mm)
Watermark: Powder horn with
crossed strap [Kool or Honig?]
Inscribed below in brown ink: *Mde
angelica C. Window. in her absence
august 1809 amboy*
N-YHS, Purchase, 1953.273

50.

Evelina, 1809
Graphite and gray wash on paper;
8 × 6 ⅛ in. (203 × 156 mm)
Inscribed at lower center in brown ink:
Evelina 1809
N-YHS, Purchase, 1953.210

51.

Louisa Reading; verso: study of a
woman, 1809
Graphite and gray watercolor on
paper; 8 ⅛ × 6 ¼ in. (206 × 159 mm)
Inscribed at lower left in brown ink:
Louisa. 1809
N-YHS, Purchase, 1953.249

52.

*Young Woman at Bachelor Hall, New
Brunswick, New Jersey,* 1810
Graphite, black chalk, and gray
watercolor on paper; 6 ½ × 4 ½ in.
(165 × 114 mm)
Inscribed at lower center in brown ink:
Bachelor-hall . . 9. 7bre 1810.
N-YHS, Purchase, 1953.243

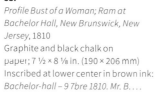

53.

*Profile Bust of a Woman; Ram at
Bachelor Hall, New Brunswick, New
Jersey,* 1810
Graphite and black chalk on
paper; 7 ½ × 8 ⅛ in. (190 × 206 mm)
Inscribed at lower center in brown ink:
Bachelor-hall – 9 7bre 1810. Mr. B. . . .
N-YHS, Purchase, 1953.259

54.

*Charlotte and Fanny Wilkes Reading,
Perth Amboy, New Jersey,* 1810
Graphite and black chalk with
touches of gray watercolor on
paper; 7 ¾ × 7 ½ in. (197 × 191 mm),
irregular
Watermark: Powder horn
Inscribed at lower left of center in
graphite: *Miss Charlote et Miss Fanny
Wilkes amboy 1810*
N-YHS, Gift of Mark Emanuel, 2018.42.23

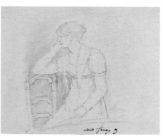

55.

Fanny Wilkes Seated on a Chair,
ca. 1810
Black chalk, graphite and gray
watercolor on paper; 4 ¼ × 5 ½ in.
(108 × 140 mm), irregular
Inscribed at lower left of center in
brown ink: *Miss Fanny y.*
N-YHS, Gift of Mark Emanuel, 2018.42.24

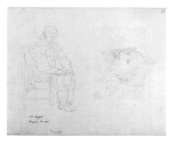

56.

*Seated Old Beggar, "La Bergerie,"
New Brunswick, New Jersey; Head of a
Bearded Man,* 1811
Graphite on paper, once mounted on
a page with a card announcing the
commencement of Columbia College
in 1813; 8 × 10 in. (203 × 254 mm)
Watermark: T G & Co
Inscribed at lower center in brown ink:
old beggar / bergerie N 1811
N-YHS, Purchase, 1953.287a

57.

Study of an "Unusual Man", 1811
Graphite on paper; 7 ¾ × 6 ⅜ in.
(197 × 162 mm), whole sheet
Inscribed at lower center in brown
ink: *Homme rare / qui se rappele qu'on
lui a prêté de l'argent / et qui se croit
obligé à un peu de reconnoissance /
envers ceux qui lui ont rendre Service.
/ – newyork 1811. –*
N-YHS, Purchase, 1953.275

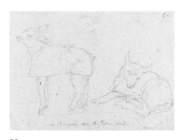

58.
Sheep at "La Bergerie," New Brunswick, New Jersey, 1812
Graphite and black chalk on paper;
4 × 5 ¼ in. (102 × 133 mm)
Watermark: T G & Co
Inscribed below in graphite: *La Bergerie 1812 le [la?] Japon verd.[?]*
N-YHS, Purchase, 1953.258

59.
View of the New Haven Mountains, New Haven, Connecticut, 1813
Graphite with line in brown ink on paper; 6 ⅞ × 12 ⅛ in. (175 × 308 mm)
Inscribed at lower left in brown ink:
3 Montagnes de new haven vues dela terrasse de Mr Mixe.
N-YHS, Purchase, 1953.271

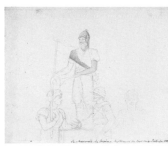

60.
Tropical Masquerade: Neptune and His Court on the "Amigo Protector", 1814
Graphite, watercolor, and black chalk on paper; 6 ⅞ × 8 ⅛ in. (175 × 206 mm)
Inscribed at lower right in brown ink:
La Mascarade du tropique Neptune et Sa Cour amigo Protector 1814.
N-YHS, Purchase, 1953.287d

61.
Louisa Seated, 1815
Graphite on paper; 7 ¼ × 5 ⅛ in.
(184 × 130 mm)
Watermark: J KOOL [device]
Inscribed at lower center in brown ink:
Louisa hotel Sinet[?] 1815.
N-YHS, Purchase, 1953.287e

62.
Man Seated on a Divan Reading; verso:
Miss Julia G. reading, ca. 1815–16
Graphite, gray watercolor, and black chalk on paper; graphite and black chalk; 7 ½ × 9 ⅛ in. (190 × 251 mm)
Watermark: AMIES
Inscribed along left edge vertically in brown ink: *Madam hyde de Neuville / rue d'Antin no. 10*; verso inscribed: *Mis Julia G*
N-YHS, Purchase, 1953.260

63.
The Pagoda (1775–78) in the Park of the Château of Chanteloup of Étienne François de Choiseul, after an Unknown Source, 1815–21
Brown and black ink over graphite on paper; 8 × 6 1/16 in. (204 × 154 mm)
Inscribed below in brown ink: *La Pagoda de Mr. Choiseul à Chanteloup*
N-YHS, Gift of Mark Emanuel, 2019.8.7

64.
Inhabitant of Landerneau, Brittany, and Heads of the Dead in Boxes, 1816
Watercolor, black chalk, brown ink, and graphite on heavy paper;
4 7/16 × 3 3/16 in. (113 × 82 mm)
Inscribed below in brown ink: *Paysan des landerneau têtes de Mort / May 1816 / conserveés dans Des Boites.*
N-YHS, Gift of Mark Emanuel, 2019.8.8

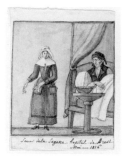

65.
Catholic Sister of La Sagesse and Patient in the Hospital of Brest, France, 1816
Watercolor, black chalk, and graphite on heavy paper; 4 1/16 × 3 3/16 in.
(112 × 82 mm)
Inscribed below in brown ink: *Soeurs dela Sagesse hopital de Brest / Mai—1816*
N-YHS, Gift of Mark Emanuel, 2019.8.9

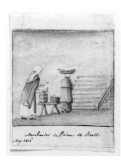

66.
Fish Mongers of Brest, France, 1816
Watercolor, black chalk, and graphite on paper; 4 5/16 × 3 ¼ in. (109 × 83 mm)
Inscribed below at left in brown ink:
Marchandes de Poisson de Brest / May 1816
N-YHS, Gift of Mark Emanuel, 2019.8.10

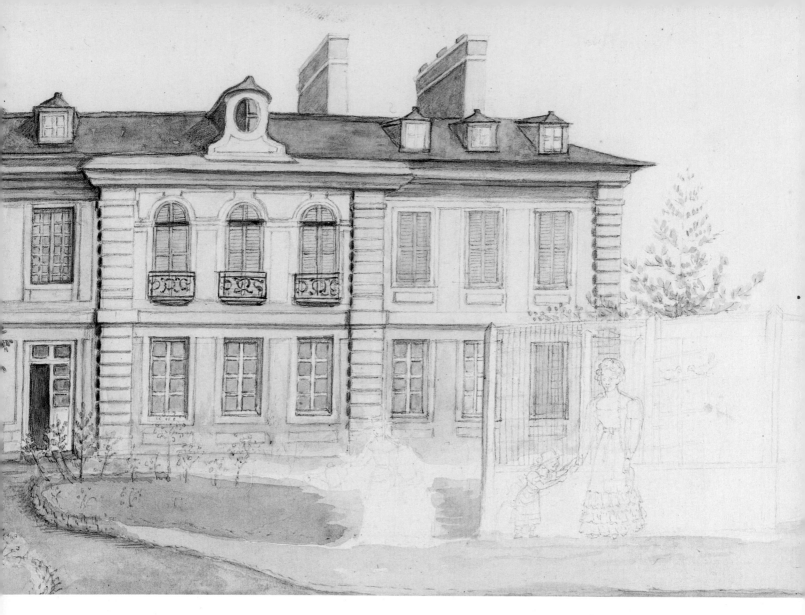

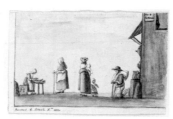

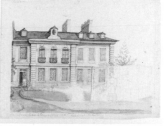

67.
"Savant" Aboard the "Eurydice", 1816
Watercolor, black chalk, and graphite
on paper; 5 × 3 ⅜ in. (127 × 86 mm)
Inscribed below oval in brown ink:
*Le Savant de L'Eurydice qui croit /
que L'Eau du Canal de Bahama /
est bouillante.*
N-YHS, Purchase, 1953.257

68.
*Three Plant Studies (Acorn and Oaks,
Weeping Willow, and Small Flower) and
a Sketch of a Landscape with Bridge*
(above), 1816
Upper sketch: graphite; botanicals:
watercolor, black chalk, and graphite
with touches of brown ink on paper;
7 ½ × 7 ¼ in. (190 × 184 mm)
Inscribed at lower left in dark brown ink:
chêne et Saule Pleureur:; at lower right:
*Petite fleur qui annonce Egallement
le Printems / et L'hyver Par la Double
Végétation. / elle est inodore, Epanouie
elle offre des Etamines / Jeaunes Sûr des
Petales Blanches. / Washington 1816.
– Donneé Par Mr Coréa de Sera* [José
Francisco Correia da Serra, Portuguese
botanist and diplomat]
N-YHS, Purchase, 1953.268

69.
The Poor in Brest, France, 1820
Brown ink and wash over graphite
on heavy p aper, laid on blue paper;
3 ⅞ × 6 1/16 in. (99 × 154 mm)
Inscribed below at lower left in
brown ink: *Pauvres à Brest Xbre 1820*;
inscribed on sign at upper right: *Rue
de / la Marine*
N-YHS, Gift of Mark Emanuel, 2019.8.11

70.
*Hôtel de la Chancellerie, Versailles,
with Marie-Thérèse Glué d'Espinville
Hyde de Neuville (1789–1855), Isabelle
Hyde de Neuville (1819–1874), and Two
Other Figures*, ca. 1821
Watercolor, graphite, and black chalk
on heavy paper, laid on blue paper;
7 9/16 × 10 3/16 in. (192 × 259 mm)
Inscribed at lower left in graphite: *La
chancelerie à Versailles Mde Paul et
Isabelle*
N-YHS, Gift of Mark Emanuel, 2019.8.12

**Musée franco-américain
du château de Blérancourt**

Stephen Decatur House Collection

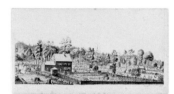

71.

The Du Ponts' House, Angelica, New York (Maison des Du Pont de Nemours à Angelica), 1808
Watercolor, black chalk, and gouache on paper; 7 ⁵/₁₆ × 13 in. (185 × 330 mm)
Inscribed at lower right in brown ink: *angelica 7bre 1808*
Musée franco-américain du château de Blérancourt

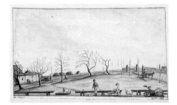

72.

"La Bergerie," New Brunswick, New Jersey, 1814
Watercolor, black chalk, and gouache on paper; 6 ¹¹/₁₆ × 9 ¹³/₁₆ in. (170 × 250 mm)
Inscribed at lower left in brown ink: *La Bergerie*; at lower right: *avril 1814*
Musée franco-américain du château de Blérancourt

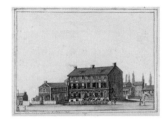

73.

House of the Ambassador of France in Washington, DC (Maison de l'Ambassadeur de France à Washington), 1818
Watercolor, black chalk, and gouache on paper; 6 ⅛ × 8 ⅜ in. (156 × 212 mm)
Inscribed at lower left in brown ink: *Our house washington city Γ. Street 1818*
Musée franco-américain du château de Blérancourt

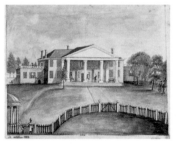

74.

Montpelier, House of James Madison, Virginia (Maison de James Madison à Montpelier, Virginie), 1818
Watercolor, black chalk, black ink, and gouache on paper; 7 ⅛ × 8 ⅛ in. (182 × 225 mm)
Inscribed at lower left in brown ink: *12 octobre 1818*
Musée franco-américain du château de Blérancourt

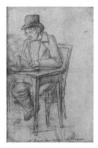

75.

Man Writing, 1800–05
Black chalk and gray watercolor on beige paper; 11 ¾ × 8 ¾ in. (298 × 222 mm)
Inscribed at lower center in brown ink: *W faisant des cartes historiques*
Gift of Harry Shaw Newman, National Trust for Preservation, White House Historical Association (Decatur House Collection), Washington, DC

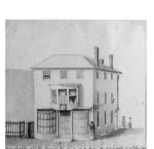

76.

House in Brighton, England, 1815
Watercolor, graphite, white gouache, black chalk, and brown ink on paper; 6 ¼ × 6 ¾ in. (159 × 171 mm)
Inscribed below in brown ink: *house Brighton after the Depart of the Son he go to France the 27 June night in a Fisher' Boat*
Gift of Harry Shaw Newman, National Trust for Preservation, White House Historical Association (Decatur House Collection), Washington, DC

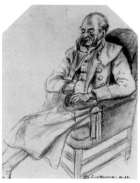

77.

Man Seated in Chair in Villeneuve, 1793
Graphite and brown chalk; 8 × 5 in. (203 × 127 mm)
Inscribed at lower right in ink: *fait a Villeneuve en 93.*
Formerly Kennedy Galleries, New York

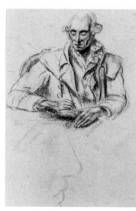

78.

Man Reading Book in Villeneuve, with a Profile Sketch of the Face of the Venus de Milo, ca. 1793
Charcoal and brown chalk; 8 × 5 ¼ in. (203 × 133 mm)
Formerly Kennedy Galleries, New York

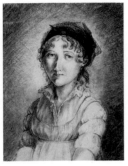

79.
Self-Portrait (1771–1849), ca. 1800–10
Black chalk on paper; 5 ¼ × 4 ½ in.
(133 × 114 mm).
Formerly Kennedy Galleries, New York

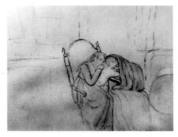

82.
Scene on board "L'Alerte"—Two Girls,
1806
Graphite; 5 ½ × 7 ½ in. (140 × 190 mm)
Formerly Kennedy Galleries, New York

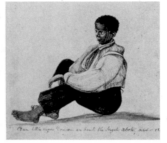

85.
*Dan, Drawn on Board the Frigate
"L'Alerte"*, 1806
Watercolor; 6 × 6 ½ in. (152 × 165 mm)
Formerly Old Print Shop, New York

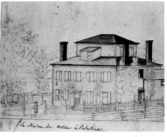

87.
The House of the Thief at Palatine,
ca. 1808–10?
Graphite, ink, and wash; 4 ½ × 5 ⅛ in.
(114 × 130 mm)
Inscribed at lower center in ink: *La
Maison du voleur à Palatine*
Formerly Kennedy Galleries, New York

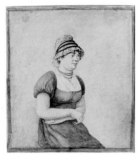

80.
A Woman with Folded Arms,
ca. 1800–10
Watercolor; 5 ¾ × 4 ¾ in. (146 × 121 mm)
Formerly Kennedy Galleries, New York

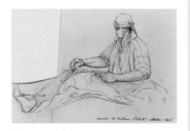

83.
*Scene on board "L'Alerte"—Sailor Mending
a Sail*, 1806
Black chalk; 7 × 10 in. (179 × 254 mm)
Inscribed at lower right in ink: *ouvrier
du vaisseau L'alerte octobre 1806.*
Formerly Kennedy Galleries, New York

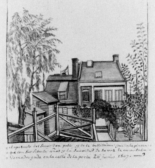

86.
Home of "Senor Pablo" on Pearl Street,
1807
Watercolor; 5 ½ × 5 in. (140 × 127 mm)
Inscribed below in wash: *=el aposento
del Senor don Pablo y de le bellissima
guadalupiana= / =que con sus
sensenta años y la suavidad de la voz le
encantaba= / demadrugada en la calle
de perla 26 junio 1807.–*
Formerly Kennedy Galleries, New York

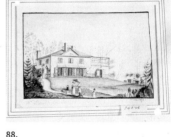

88.
*Mr. Simond's House, New Brunswick,
New Jersey*, 1809
Brown ink wash; 5 × 7 ¼ in. (127 × 184 mm)
Inscribed at lower left in graphite: *Mr.
Simon's house*; at lower right in ink: *1e
Mai 1809*
Formerly Kennedy Galleries, New York

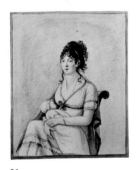

81.
Mme. Guitton Louyon?—"Happy Time",
1805
Watercolor; 6 ¼ × 5 in. (159 × 127 mm)
Inscribed at lower right: *Mme. Guitton
Louyon—"Happy Time"—1805*
Formerly Kennedy Galleries, New York

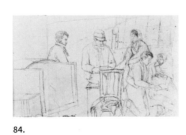

84.
Scene on board "L'Alerte"—Passengers,
1806
Black chalk; 7 ¼ × 12 in. (184 × 305 mm)
Inscribed at lower right in ink: *octobre
1806*
Formerly Kennedy Galleries, New York

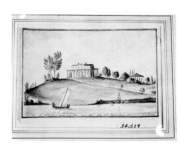

89.
*Mr. Waddington's House on the East
River*, 1814
Watercolor; 5 ⅛ × 7 ¾ in. (130 × 184 mm)
Inscribed below in ink: *May . 1814
Mr. Waddington's house. East. River.
near hell gate and Long island, Late
excursion of Mr.[…ain.?]*
Formerly Kennedy Galleries, New York

90.
Newhaven, Drawn During Stay in "Prison", 1815
Watercolor; 6 ¼ × 5 ¾ in. (159 × 146 mm)
Inscribed below in ink: *new-haven drawn during my prison in Jully .4 to Jully the 8 in Bridge inn. (Smith). 1815*
Formerly Kennedy Galleries, New York

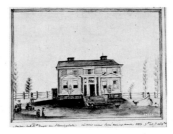

93.
Home of Mr. and Mrs. Cruger at Bloomingdale, New York, 1819
Watercolor; 5 ¼ × 7 ¼ in. (133 × 184 mm)
Inscribed below in ink: *Maison de Mr. et Mde. Cruger au Bloomingdale ou nous avons Passé avec eux aoust 1819, 7bre. et F. 26 8bre*
Formerly Kennedy Galleries, New York

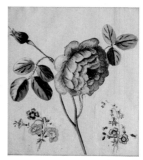

95.
Alessandro Malaspina (1754–1810)
Heraclitus and Democritus
Black chalk on paper; 4 ⅝ × 4 ⅝ in. (118 × 118 mm)
Inscribed by Neuville at lower left in brown ink: *Donné Par Mr Melaspine.*; above in black chalk: *héraclite*; below upside down: *Démocrite*.
N-YHS, Purchase, 1953.287h

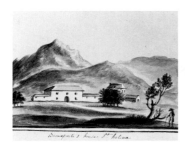

91.
The Briars on St. Helena (Napoleon's Residence October–December 1815), after 1815
Black ink and wash on paper; 5 × 6 ½ in. (127 × 165 mm)
Inscribed at lower center in ink: *Buonaparte's house St. helena*
Formerly Kennedy Galleries, New York

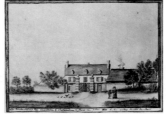

94.
"Les Fouchardières" near Courtalain and Châteaudun, France, 1820
Watercolor; 5 ½ × 7 ½ in. (140 × 191 mm)
Inscribed below in ink: *Les Fouchardières près Courtalin & Chateaudun 10 jours en 7bre 1820 h.t. entree du Côté du Bois.*
Formerly Old Print Shop, New York

96.
E. Vail [possibly Eugene Vail (1795–1843)]
The Stephen Decatur House, Washington, DC, 1822
Watercolor and black ink on paper; 4 ⅜ × 7 ½ in. (111 × 190 mm)
Inscribed by Neuville below in brown ink: *Maison du Commodore Stephen Decatur Washington June 1822 By Mr. E. Vaile*
National Trust for Preservation, White House Historical Association (Decatur House Collection), Washington, DC

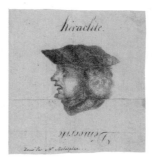

97.
Unidentified artist
Three Flower Studies, before 1822
Watercolor on three sheets of paper, collaged onto paper; 8 ³⁄₁₆ × 7 ⅝ in. (208 × 194 mm)
National Trust for Preservation, White House Historical Association (Decatur House Collection), Washington, DC

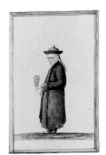

92.
Chinese Man Drawn from Memory, Washington, DC, 1817
Watercolor; 8 × 4 ¾ in. (203 × 121 mm)
Inscribed[?]: *Chinois dessine de Memoire, Washington 1817.*
Formerly Old Print Shop, New York

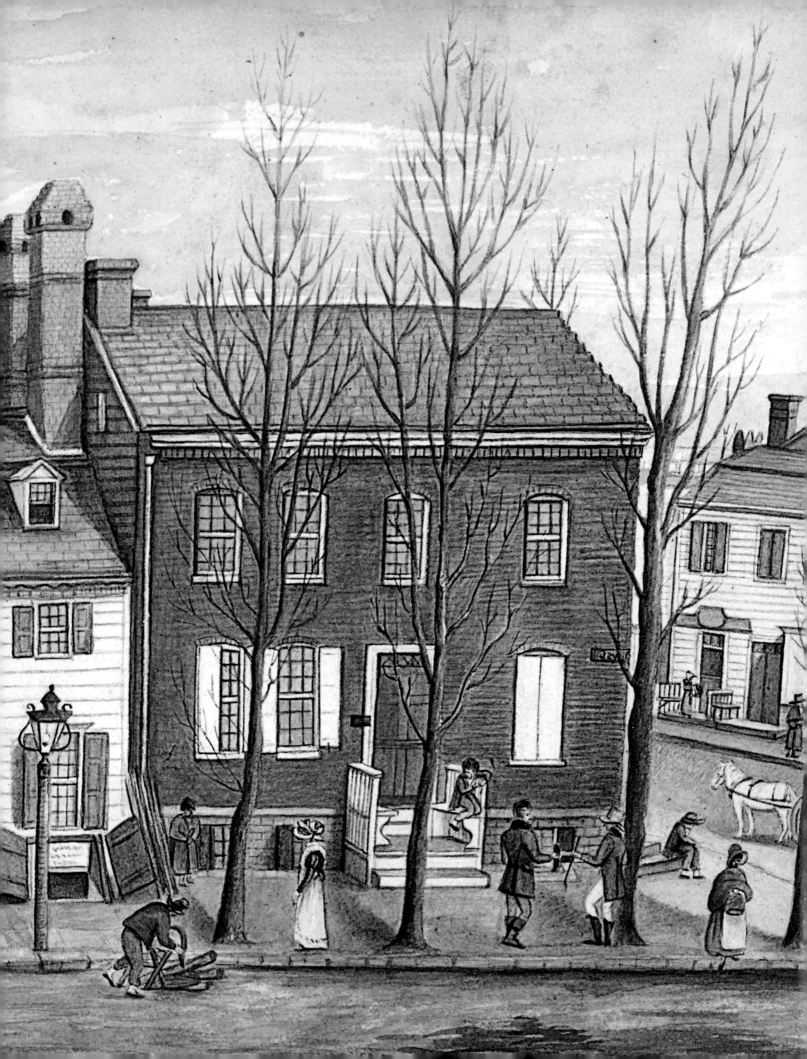

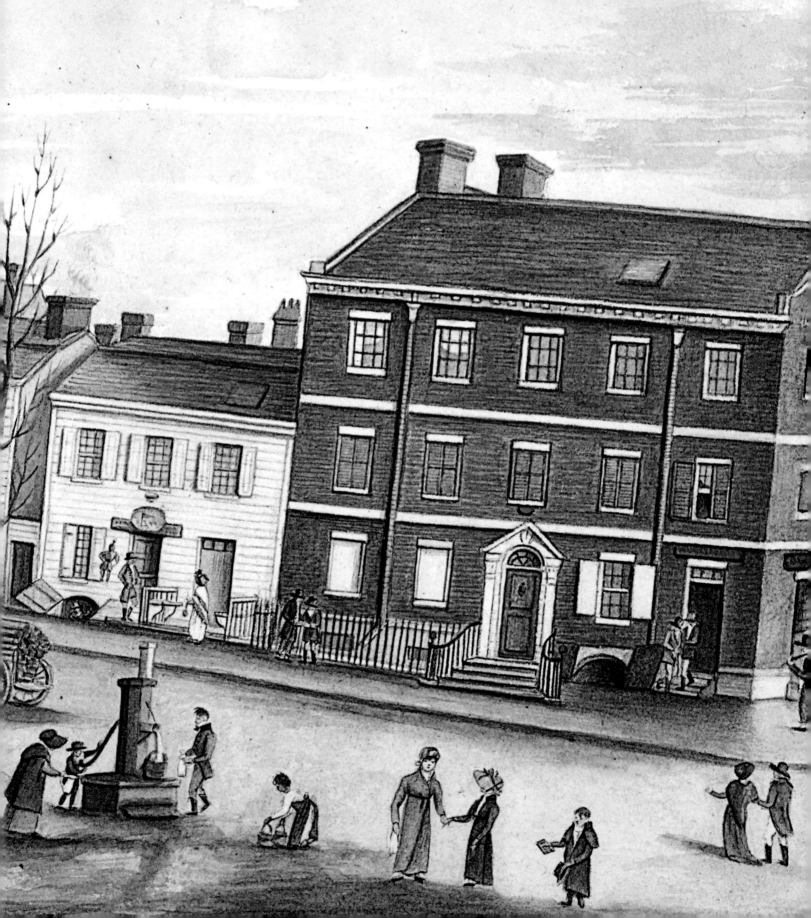

CHRONOLOGY FOR THE NEUVILLES

1771

March 10: Anne Marguérite Joséphine Henriette Rouillé de Marigny is born in Sancerre (Cher), France. She is raised in Paris and known as Henriette.

1776

January 24: Jean Guillaume Hide (Hyde) is born in La Charité-sur-Loire (Nièvre), between Sancerre and Nevers, France. He is the son of Guillaume Hide, from an English family that had emigrated with the Stuarts after the rebellion of 1745.

July 4: U.S. Congress approves the Declaration of Independence.

1789

April 30: George Washington is inaugurated for the first time as the first American president (1789–97).

July 14: The French Revolution begins with the storming of the Bastille. King Louis XVI and his family leave Versailles for Paris, leading to the downfall of the monarchy.

Henriette and her father flee Paris for Sancerre, while her mother remains in Paris.

1793

January 21: King Louis XVI is executed.

May: Jean Guillaume Hide, Henriette's fiancé, successfully defends the royalist Pierre Maugue, and is denounced by Joseph Fouché, Minister of Police, before a Revolutionary tribunal in Nevers.

September 5: The Reign of Terror begins— named for its execution of an estimated forty thousand people, including Robespierre, whose execution on July 28, 1794, concludes this blood bath.

September 22: The First French Republic is established.

1794

August 23: Henriette marries Jean Guillaume Hide (Saturday, 6 Fructidor, An 2).

1795

The Directory (1795–99), a committee of five, succeeds the Jacobin government.

1797

The baron is tenuously linked to the royalist plot to assassinate Napoleon. He evades arrest while others are detained at the Temple prison in Paris. He travels under the name Charles Loiseau, and participates in defending the conspirators. He also plans and assists the escape of M. du Broc, detained in the prison in Nièvre, and hides him at his mother's house for six months.

March 4: John Adams inaugurated as second U.S. president (1797–1801).

1798

An order is issued for the baron's arrest. The Neuvilles hide in Paris under the alias of Roger in a fourth-floor room in the rue de la Verrerie in the Marais. After nine months there, the proscription is withdrawn and they move to the rue de la Université, the residence of Henriette's parents.

1799

November 9: The Consulate (1799–1804) is formed by then-general Napoleon Bonaparte after the coup of 18 Brumaire, and he becomes First Consul.

The baron travels to London on royalist matters and returns to Paris following the successful coup by Napoleon. The baron and Talleyrand fail in negotiations with Bonaparte about the fates of the conspirators. The baron stays in Jersey and London, trying to arrange support and safe haven for the royalists.

1800

May: The baron is in Brittany, Jersey, and London, negotiating for the royalists, while the baroness and the baron's brother Paul are arrested and imprisoned in the Temple owing to the baron's involvement in circulating the pamphlet "Les Adieux à Bonaparte." The baroness is soon released.

November 9: The baron returns to Paris.

December: The Neuvilles flee Paris for Nièvre and Sancerre, remaining in hiding.

1801

March 4: Thomas Jefferson is inaugurated as third U.S. president (1801–09).

1802

May: The baroness's father dies. The couple spends several months in La Rochelle under the alias Villeret.

1804

The baron is outlawed for his alleged part in an attempt to assassinate Napoleon, the so-called "English" or "Pichegru Conspiracy" (1803–04).

May 18: Bonaparte is crowned Emperor Napoleon I.

From her mother-in-law's home in Nièvre, the baroness makes several trips to Paris to plead with Napoleon and others to pardon her husband.

1805

April: The Neuvilles escape via the Loire River from La Charité-sur-Loire.

May-September: The couple lives at "Fonbonne" in Couzon (near Lyon) under the alias of Roland, where the baron, as Dr. Roland, practices medicine and is recognized for his promotion of vaccines for smallpox.

September: The Neuvilles travel to Switzerland, staying in Lausanne and Constance.

November 3: Without an escort, the baroness pursues Napoleon, seeking a pardon for her husband, as the general battles through Germany to victory at Austerlitz.

December 5: In Vienna, Henriette hears the news of Napoleon's victory and awaits his return. She is received by the emperor, who orders their property appropriated for the state, but she convinces him to allow them to keep L'Estang if they go into exile in America.

1806

January 6: The baroness reunites with her husband at Constance.

March 12: The Neuvilles leave France for Barcelona, Spain, bound for exile in America.

September 3: In Barcelona, the couple embarks for the U.S., but their ship *L'Alerte* is attacked by pirates, and they spend several months in Cádiz, Spain.

1807

Beginning of April: The Neuvilles meet François-René de Chateaubriand in Cádiz on his return from Jerusalem and form a lifelong friendship.

May 2: The couple sets sail on the American frigate *Golden Age*.

June 20: They arrive in New York City.

July 10: The Neuvilles begin a tour up the Hudson River through Albany to Ballston Springs.

September 1: The couple visits Niagara Falls.

December: The Embargo Act of 1807, signed by President Jefferson, forbids American ships from trading in all foreign ports.

1808

The Neuvilles establish residency in New York City, staying for a period on Warren Street with Napoleon's former general, Victor Marie Moreau, who was exiled with his wife after turning on Bonaparte. The Neuvilles summer in western New York in Angelica, befriending the Du Ponts. They visit Canisteo, Geneva, Buffalo, Batavia, Amsterdam, and Utica, also passing through American Indian settlements in the region.

1809

March 4: James Madison is inaugurated as fourth U.S. president (1809–17).

The Neuvilles reside in New York City, eventually settling on Dey Street. They visit then-popular New Jersey bayside and river retreats by steamboat.

The baron becomes one of the founders, organizers, and secretary of the Economical School (*École Économique*) of New York City, an institution for educating and training French émigrés and refugees in America.

1810

January 24: The baron becomes a member of the Philo Medical Society of New York.

March 14: The Economical School is incorporated by the New York State Legislature.

July: The baron is listed as residing at 61 Dey Street in *Longworth's* for 1810 and 1811, as "Hide de Nueville [*sic*], G." He continues to be listed in 1812–14, as "Neuville, G.H." His brother Paul is listed at the same address in 1815.

July 16: The Common Council of New York City approves the school board's petition for a building or rooms to conduct classes and for support from the city.

1811

The Neuvilles purchase a country estate, "The Farm," in New Brunswick, New Jersey, where the baron plans to raise Merino sheep, a progressive form of animal husbandry.

1812

June 18: The War of 1812 begins, extending Britain's war with France to North America.

1813

July: The Neuvilles sojourn in New Haven, Connecticut, in anticipation of Napoleon's fall, which will allow their return to France. They also spend time in New Brunswick in late 1813 and early 1814.

1814

April 4: Napoleon is defeated by a coalition of nations, abdicates his rule, and is exiled to the island of Elba on May 4. The Bourbon dynasty is restored under Louis XVIII as King of France.

May: The Neuvilles return to New York City, and the baron resigns his position at the Economical School.

May 21: They depart New York City on the Portuguese ship *Amigo Protector*.

July 8: The couple disembarks in Liverpool, England.

July 10: They arrive in London.

July 20: The Neuvilles return to Paris for the first time since leaving France in 1806.

August 20: They visit London and stay with the Simonds in Richmond outside of London, although the baron travels periodically to France.

August 24: British troops burn the White House, the Capitol, and other government buildings in Washington, DC, after the defeat of American troops at the Battle of Bladensburg in Maryland.

October 8: The couple departs for Italy on a secret mission to the courts of Turin and Florence to present letters from Louis XVIII about curtailing the activities of the Barbary pirates and unmasking Napoleon's plans for escape from Elba.

October 14: The Neuvilles arrive in Turin, and through November 12 visit Florence, Livorno, Cavigliano, Modena, and Tortona before returning to Paris.

1815

February 18: The War of 1812 ends and transatlantic trade resumes.

March 20-July 8: The "Hundred Days" follow Napoleon's escape from Elba (February 26) to France, when he attempts to rally supporters. In this period the Neuvilles reside with the Simonds in Richmond, travel to Brighton, and visit Newhaven in East Sussex in July.

May 20: The baron is elected a Knight of the Legion of Honor.

June 18: The Battle of Waterloo is Napoleon's final defeat.

July 7: Napoleon is exiled to St. Helena. The "Second Restoration" of the Bourbon monarch Louis XVIII begins.

July 16: The baron, having returned to France alone, is made an Officer of the Legion of Honor (while the baroness, in Richmond, is unaware that he is safe).

July 25: Henriette joins the baron in Paris where he has been appointed to the Chamber of Deputies.

1816

January 14: The baron is appointed Minister Plenipotentiary of France to the United States.

March 4: James Monroe is inaugurated for the first time as fifth U.S. president (1816–25).

April 8: The baroness is presented at court

May 16: The Neuvilles sail to the U.S. from Brest, France, on the French ship *Eurydice*.

June 15: They arrive in New York and stay at the Washington Hotel at 19th Street and Broadway. The couple then proceeds first to their country home in New Brunswick, after which the baron travels to Washington, DC, to present his credentials and establish his diplomatic residence.

1818

October 18: The Neuvilles visit Dolley and James Madison at Montpelier, their Virginia estate.

1819

October: The Neuvilles, originally scheduled to depart for France, board the ship *Stephanie* in New York City, but the baron is called back to Washington to serve as an intermediary between Spain and the U.S. in the negotiations over ownership of Florida.

November-December: The baron helps negotiate the Adams-Onís Treaty (The Transcontinental Treaty), which cedes Florida to the U.S. and defines U.S. boundaries with New Spain.

1820

May 30: The Neuvilles set sail for France from Annapolis, Maryland, on the French corvette *La Seine*.

July 1: They arrive at Lorient, France, and continue to Paris.

October 12: The baron is reappointed Minister Plenipotentiary to the United States and named ambassador to Brazil, a post that never materializes.

October 29: The couple leaves for Brest to board a ship for America.

December 14: They embark for the U.S. for the final time on the French ship *Tarn*.

1821

February 9: The Neuvilles arrive in Norfolk, Virginia.

February 22: The couple attends President Monroe's important ball.

May 1: The baron is named a Commander of the Legion of Honor.

August: The Neuvilles move into the Stephen Decatur House in Washington, DC, and make additions to the residence.

November 29: The couple attends the "Indian War Dance" at the White House with President Monroe. The performance is repeated at the Neuvilles' residence.

1822

August 13: The Neuvilles depart the U.S. for the last time on the American ship *Sir Brother's*.

October 25: In Paris the baron is elevated to Grand Officer of the Legion of Honor.

1823

July 6: The baron is appointed ambassador to Portugal by Louis XVIII.

August: The Neuvilles move to Lisbon.

1824

April 30: The baron helps avert a coup d'état attempted by the military at Bemposta Palace in Lisbon. Consequently, King João VI of Portugal bestows on him the title Count of Bemposta.

June 8: In Paris the baron is awarded the Grand Cross of the Legion of Honor.

September 16: Charles X is crowned King of France, the last of the senior line of the Bourbon dynasty.

1825

January 23: The Neuvilles return to Paris.

1826

The couple resides in Paris during the Chamber of Deputies session, in which the baron serves, while the baroness attends social events.

1828

March 3: The baron is appointed Minister of the Marine (Navy).

March 10: While in Paris, the baroness severely injures herself in a fall and is briefly threatened with amputation of her broken right leg.

1830

June 22: The Neuvilles settle more permanently at their country estate L'Estang near Sancerre, but continue to winter in Paris.

July 3: The baron is elected to the provincial assembly at Nevers.

July 26: In the July Revolution the House of Bourbon is overthrown by the liberal Orléans monarchy. Charles X abdicates and leaves for England with his family.

August 9: Louis-Philippe, known as "the citizen king," becomes the constitutional monarch of the French.

1832

March: During a horrific cholera outbreak, the baron becomes ill.

June 5–6: "The June Rebellion" or "Paris Uprising of 1832," an anti-monarchist revolt, breaks out.

June 16: The baron is arrested and again detained, but briefly, following this insurgency in Paris.

1836

The baron sells the Neuvilles' Parisian hôtel in the Faubourg-du-Roule and takes an apartment for the couple in the townhouse of the Countess de L'Espine.

May 3: The baron visits the exiled King Charles X and his family in Prague.

1848

February 21-December 2: The Revolution of 1848 ends the Orléans monarchy, and Louis-Philippe's abdication leads to the creation of the Second Republic in France.

1849

September 14: The baroness dies at L'Estang, near Sancerre, and is buried in the crypt of the small chapel in the château's park.

1857

May 28: The baron dies in Paris and is interred with his wife at L'Estang.

DOCUMENTS AND CORRESPONDENCE RELATING TO THE ARTIST

1. Archival Documents in France for the Hyde de Neuvilles

Capitalization and punctuation of the sources roughly follow the original documents. See Frequently Cited Sources for abbreviations.

Anne Marguérite Joséphine Henriette Rouillé de Marigny

Born in Sancerre on March 10, 1771, to Étienne Jacques Rouillé de Marigny, a wealthy salt tax collector of Sancerre, and the aristocrat Marie Joséphine Busson de Villeneuve.
Archives départementales et patrimoine du Cher, Sancerre Registres paroissiaux et état civil (1766–1780), 3E1035, 308–309, no. 135.

Died in Sancerre at the Château de L'Estang, September 14, 1849.
Archives départementales et patrimoine du Cher, Sancerre Registres décès (1843–52), 3E2402, 386, no. 200.

Jean Guillaume Hyde de Neuville

Born under the name Jean Guillaume Hide, in La Charité-sur-Loire on January 24, 1776, to Guillaume Hide and Marie Roger.
Nièvre Conseil Départemental, Etat Civil, La Charité, Paroisse de Saint Pierre, Registre des Baptêmes, Mariages, et Sépultures (8 janvier 1771–20 décembre 1780), 4E59 art. 21, 51–52.

Died in Paris, May 28, 1857.
Archives de Paris, Fichiers de l'état civil reconstitué, Hyardin-Hymbert, V3E/D 764, no. 21.

Marriage

Anne Marguérite Joséphine Henriette Rouillé de Marigny married Jean Guillaume Hyde de Neuville (married under the name Guillaume Étienne Hide) in Sancerre on August 23, 1794. The witnesses were Marie Roger, the groom's mother and his guardian; Étienne La Rue, the groom's brother-in-law and manufactory owner; Étienne Jacques Rouillé, the bride's father; Pierre Jean Rouillé, the bride's paternal uncle; and Étienne Busson Villeneuve, the bride's maternal uncle.
Archives départementales et patrimoine du Cher, Sancerre Registres paroissiaux et état civil (1793–96), 3E1037, 192–194, no. 87–88.

Château de L'Estang Property Records

Conseil départemental du Cher, direction des Archives départementales et du patrimoine, pour l'inventaire général du patrimoine culturel (Ministère de la Culture), reference IA18002582.

2. Property Dispersal in the United States

For the sale of 61 Dey Street, New York, NY, see Block Book 7: Blocks 57–61, Block 59 Property Conveyances, 6; and Property Conveyances Liber 109, 1815, 407–414, Reel 36 L108p255-L110p95. Manhattan Borough Office of the City Register, New York, NY.

For the dispersal of New Jersey property, see Papers of Robert Boggs received from and relating to Jean Guillaume Hyde de Neuville, Robert Morris Papers, Box 20, and Jean Guillaume Hyde de Neuville letters received (Ac. 738). Special Collections and University Archives, Rutgers University Libraries, New Brunswick, NJ.

3. Correspondence between Baroness Hyde de Neuville and Dolley Madison*

Anne Marguérite Joséphine Henriette Rouillé de Marigny Hyde de Neuville, Washington, DC, to Dolley Payne Todd Madison, Montpelier, VA, October 22 [1818]. Princeton University Library, Manuscripts Division, Department of Rare Books and Special Collections, Princeton, NJ.

Dolley Payne Todd Madison, Montpelier, VA, to Anne Marguérite Joséphine Henriette Rouillé de Marigny Hyde de Neuville, Washington, DC, October 25, 1818. Princeton University Library, Manuscripts Division, Department of Rare Books and Special Collections, Princeton, NJ.

Dolley Payne Todd Madison, Montpelier, VA, to Anne Marguérite Joséphine Henriette Rouillé de Marigny Hyde de Neuville, Washington, DC, February 8, 1819. Collection of Russell Clayton, Marietta, GA.

Anne Marguérite Joséphine Henriette Rouillé de Marigny Hyde de Neuville, Paris, France, to Dolley Payne Todd Madison, Montpelier, VA, July 20, 1820. Dolley Payne Madison Papers, LoC.

Anne Marguérite Joséphine Henriette Rouillé de Marigny Hyde de Neuville, Lisbon, Portugal, to Margaret Bayard Smith, Washington, DC, November 30, 1823. Margaret Bayard Smith Papers, LoC.

Dolley Payne Todd Madison, Montpelier, VA, to Anne Marguérite Joséphine Henriette Rouillé de Marigny Hyde de Neuville, Paris, France, July 28, 1830. Dolley L. Maass, White Plains, NY.

*Each letter can be accessed on *The Dolley Madison Digital Edition*, ed. Holly C. Shulman (Charlottesville: University of Virginia Press, Rotunda, 2004): http://rotunda.upress.virginia.edu/dmde/default.xqy.

4. Correspondence between Baroness Hyde de Neuville and Others

Mathieu Jean Felicité Montmorency, Viscount of Montmorency-Laval, Paris, France, to Anne Marguérite Joséphine Henriette Rouillé de Marigny Hyde de Neuville, Richmond, England, July 17, 1815.[1]

Alexandre Maurice Blanc de Lanautte, Count of Hauterive, Paris, France, to Anne Marguérite Joséphine Henriette Rouillé de Marigny Hyde de Neuville, Paris, France, November 9, 1815. N-YHS Library.

Anne Marguérite Joséphine Henriette Rouillé de Marigny Hyde de Neuville, to Louisa Catherine Johnson Adams, Washington, DC, August 7, 1819. Adams Papers, MHS.

Anne Marguérite Joséphine Henriette Rouillé de Marigny Hyde de Neuville, New York, NY, to Margaret Bayard Smith, Washington, DC, September 15, 1819. Margaret Bayard Smith Papers, LoC.

Margaret Bayard Smith, Washington, DC, to Anne Marguérite Joséphine Henriette Rouillé de Marigny Hyde de Neuville, New York, NY, May 25, 1820. Margaret Bayard Smith Papers, LoC.

5. Correspondence from Baroness Hyde de Neuville to Joséphine du Pont

"New-town" to place unknown, [Fall 1808?], HML W3-5392

Place unknown to Angelica, NY, January 27, 1809, HML W3-5395

Places unknown, March 7, 1810, HML W3-5402

New York, NY, to place unknown, July 31, 1810, HML W3-5403

Morrisville, PA, to Wilmington, DE, September 15, 1810, HML W3-5405

Places unknown, [Fall 1810?], HML W3-5406

Places unknown, October 20, 1810, HML W3-5407

Places unknown, December 11, [1810?], HML W3-5408

Places unknown, January 13, 1811, HML W3-5409

Place unknown to Wilmington, DE, September 16, 1811, HML W3-5411

[New York, NY?], to place unknown, December 30, 1811, HML W3-5412

Places unknown, May 25, 1813, HML W3-5416

Places unknown, n.d. [Summer 1813], HML W3-5417

[New York, NY?], to "Louviers," near Wilmington, DE, November 18, 1813, HML W3-5423

New Brunswick, NJ, to Wilmington, DE, March 18, [1813], HML W3-5432

Aboard ship at New York, NY, to [Wilmington, DE?], May 23, [1814], HML W3-5436

Paris, France, to Wilmington, DE, August 26, [1815], HML W3-5455

New York, NY, to Wilmington, DE, June 19, [1816], HML W3-5464

New Brunswick, NJ, to Wilmington, DE, June 26, [1816], HML W3-5465

[Washington, DC?], to Wilmington, DE, September 13, 1816, HML W3-5468

[Washington, DC?], to Wilmington, DE, July 16, 1817, HML W3-5478

[Washington, DC?], to Wilmington, DE, August 16, 1817, HML W3-5480

[Washington, DC?], to Wilmington, DE, September 11, [1817], HML W3-5482

[Washington, DC?], to Wilmington, DE, October 28, 1817, HML W3-5483

Washington, DC, to Mrs. Sadler's, Cortland [sic] Street, New York, NY, May 17, [1818], HML W3-5490

Washington, DC, to Wilmington, DE, April 31 [sic], 1819, HML W3-5505

Places unknown, July 30, [1819], HML W3-5510

New York, NY, and Washington, DC, to Wilmington, DE, n.d./October 25, 1819, HML W3-5515

Paris, France, to Wilmington, DE, August 12, 1820, HML W3-5525

French Legation (Portland), Washington, DC, to Wilmington, DE, November 5, 1821, HML W3-5532

French Legation, Washington, DC, to Wilmington, DE, November 21, 1821, HML W3-5533

[Washington, DC], to place unknown, January 2, [1822], HML W3-5534

French Legation, Washington, DC, to Wilmington, DE, February 18, 1822, HML W3-5538

Washington, DC, to Wilmington, DE, April 4, 1822, HML W3-5542

Washington, DC, to Wilmington, DE, April 24, 1822, HML W3-5543

Washington, DC, to Wilmington, DE, June 10, 1822, HML W3-5544

French Legation (Portland), Washington, DC, to Wilmington, DE, July 13/15, [1822], HML W3-5546

New York, NY, to "Louviers," July 15/18, 1822

Paris, France, to Brandywine, DE, September 28, 1822, HML W3-5547

Sancerre, France, to [Wilmington, DE], November 20, 1822, HML W3-5548

[Sancerre or Paris?, France] to Wilmington, DE, February 11, 1823, HML W3-5551

Lisbon, Portugal, to Wilmington, DE, July 2, 1824, HML W3-5556

Versailles, France, to Wilmington, DE, July 28, 1825, HML W3-5557

Places unknown, n.d. [1827?], HML W3-5560

[Paris, France, to Wilmington, DE], July 4, 1828, HML W3-5563

[Paris, France], to Wilmington, DE, April 13, 1832, HML W3-5573

[Sancerre or Paris?, France] to Wilmington, DE, June 6, 1832, HML W3-5574

L'Estang near Sancerre, France, to Wilmington, DE, June 25, [1832], HML W3-5599

Paris, France, to Wilmington, DE, January 1833, HML W3-5578

[Sancerre?, France, to Wilmington, DE], May 11, 1834, HML W3-5583

Paris, France, to Wilmington, DE, May 27, 1835, HML W3-5585

Year cannot be ascertained:

Places unknown, n.d. "jeudi soir", HML W3-5594

Places unknown, n.d. [1806–1809], HML W3-5595

Places unknown, n.d. "27 jeudi soir", HML W3-5596

Places unknown, n.d. "July 16", HML W3-5597

New Brunswick, NJ, to Wilmington, DE, n.d. "December 27", HML W3-5598

6. N-YHS Archival Material

Baroness Hyde de Neuville, MS copy of poem by "Theodore" published in *Journal des Dames*, November 1810, p. 405. Baron and Baroness Hyde de Neuville Collection, 1815–1837, Manuscripts and Archives, N-YHS.

7. Quotations from Lost Letters and Journals of the Baroness in *Mémoires/Memoirs*

Mémoires 1888–92, 1: 381–382, autumn 1802, letter to her aunt: describing the journey to La Rochelle.
Memoirs 1913, 1: 183–184.

Mémoires 1888–92, 1: 403–414, letter to the baron composed between December 5, 1805, and January 6, 1806, describing the journey to Vienna to petition Napoleon on behalf of the baron.
Memoirs 1913, 1: 198–206.

Mémoires 1888–92, 1: 416, journal, late December to early January 1806, following her audience with Napoleon.
Memoirs 1913, 1: 207.

Mémoires 1888–92, 1: 470, journal, 1808, comments about Madame Moreau.
Memoirs 1913, 1: 233.

Mémoires 1888–92, 1: 485, journal, 1812, laments Madame Moreau's departure from the U.S.
Memoirs 1913, 1: 250.

Mémoires 1888–92, 2: 37–40, journal, long entry about their travels through Italy, ending November 6, 1814.
Memoirs 1913, 2: 13–15.

Mémoires 1888–92, 2: 84–86, journal, May 1815, in London, about seeing Madame Moreau and the baron's return to London.
Memoirs 1913, 2: 36–37.

Mémoires 1888–92, 2: 88, journal, May 29, 1815, in London, about her husband leaving London for Ghent, to meet "Madame" [Marie-Thérèse of France, Duchess of Angoulême].
Memoirs 1913, 2: 37.

Mémoires 1888–92, 2: 123, journal, ca. July 15, 1815, the baroness meets the Duchess of Angoulême in church, both worried about the baron. She then receives a letter from the Viscount of Montmorency-Laval assuring her that her husband is safe in Paris.
Memoirs 1913, 2: 55.

Mémoires 1888–92, 2: 188, journal, 1816, laments the political tribulations in France during the two years following her departure from America.
Memoirs 1913, 2: 176–178.

Mémoires 1888–92, 2: 189–191, journal, April 8, 1816, describes the baroness's and Madame Moreau's presentation to Marie-Thérèse, Duchess of Angoulême.

Mémoires 1888–92, 2: 194–196, journal, June 15, 1816, describes their arrival in New York City and New Brunswick, NJ, and their journey to Washington, DC.
Memoirs 1913, 2: 76–77.

Mémoires 1888–92, 2: 398–400, journal, May 17, 1819, her opinions of her husband's mission in America.

Mémoires 1888–92, 2: 404–405, journal, November 13 and December 5, 1819, comments regarding their U.S. departure for the baron's possible appointment to Spain.

Mémoires 1888–92, 2: 446–447, journal, April 24-July 1, 1820, describes their departure from America and arrival July 1 at Lorient, France.
Memoirs 1913, 2: 99.

Mémoires 1888–92, 2: 473–476, journal, November 14-December 1, 1820, difficult voyage from Rochefort to Brest, France.
Memoirs 1913, 2: 108–109.

Mémoires 1888–92, 3: 150–154, letter, April 29, 1824, from Lisbon, relates her experience during the revolt against the constitutional monarchy.
Memoirs 1913, 2: 149–151.

Mémoires 1888–92, 3: 179–180, journal, after April 30, 1824, relates the attempted departure of Manuel Inácio Martins

Pamplona Corte Real, Count of Subserra, on the *Lively* following the April 30 revolution.
Memoirs 1913, 2: 171–172.

Mémoires 1888–92, 3: 185–187, journal, early May 1824, relates the arrival of the king and princesses at Bemposta after arrests and invasion of the palace by the military.
Memoirs 1913, 2: 195–196, journal[?].

Mémoires 1888–92, 3: 194–196, letter[?], following May 26, 1824, describes the ball on board the *Santi Petri* in honor of the king, princesses, and the diplomatic corps.
Memoirs 1913, 2: 195–196, journal[?].

Mémoires 1888–92, 3: 281–283, journal, June 16, 1825, describes coronation parties.

Mémoires 1888–92, 3: 314–316, journal, discusses the 1826 Session of Deputies, daily social life, and salons.

Mémoires 1888–92, 3: 319, journal, late 1826, personal opinions.

Mémoires 1888–92, 3: 495–498, journal, June 16-July 10, 1832, reports the baron's arrest, with her transcription of a letter he sent to her and entries regarding his incarceration.

8. Archival Journals and Published Diaries, Journals, and Accounts of the Baroness

John Quincy Adams, *Memoirs of John Quincy Adams*. Ed. Charles Francis Adams (Philadelphia: J.B. Lippincott, 1875), 5: 136–138 (June 2, 1820).

Louisa Catherine Johnson Adams Journal. Adams Papers, MHS. 1817 (December 17, 27, 28); 1818 (January 3, 19, 30, March 11); 1819 (December 24); 1820 (March 8, April 6, 22, May 24, 25, 27, June 2); 1821 (July 20); 1822 (July 22, August 2, 19).

Gouverneur Morris, *The Diaries of Gouverneur Morris*. Vol. 2, *New York, 1799–1816*. Ed. Melanie Randolph Miller (Charlottesville: University of Virginia Press, 2018), 519 (November 25, 1807), 638 (May 13, 1810), 641 (June 6 and 8, 1810), 869 (June 17, 1816).

William Seaton, *William Winston Seaton of the "National Intelligencer," A Biographical Sketch*. Ed. Josephine Seaton (Boston: James R. Osgood, 1871), 143 (May 1819), 145 (December 1819).

9. Letters that Mention the Baroness
(most given without locations)

Élisabeth Françoise Sophie Lalive de Bellegarde, Countess of Houdetot, France, to Thomas Jefferson, Washington, DC, August 16, 1806. Thomas Jefferson Papers, LoC.

Jean-Guillaume Hyde de Neuville to Thomas Jefferson, Washington, DC, December 22, 1807. Thomas Jefferson, Papers, LoC.

John Trumbull, Washington, DC, to Thomas Jefferson, Monticello, VA, March 3, 1817. NA. See Thomas Jefferson, *The Papers of Thomas Jefferson, Retirement Series*, ed. J. Jefferson Looney (Princeton: Princeton University Press, 2014), 11: 166–167.

Horace Holley, Washington, DC, to Mary Austin Holley, Boston, MA, March 29, 1818. Clements Library, University of Michigan, Ann Arbor, MI. See James P. Cousins, *Horace Holley: Transylvania University and the Making of Liberal Education in the Early American Republic* (Lexington: University Press of Kentucky, 2016), 97.

Louisa Catherine Johnson Adams to Abigail Smith Adams, March 30, 1818. Adams Papers, MHS.

Jean Guillaume Hyde de Neuville to James Madison, December 3, 1818. James Madison Papers, LoC.

James Madison to Jean Guillaume Hyde de Neuville, December 9, 1818. James Madison Papers, LoC.

Louisa Catherine Johnson Adams to John Adams, December 10, 1818. Adams Papers, MHS.

Louisa Catherine Johnson Adams to John Adams, December 25, 1818. Adams Papers, MHS.

Louisa Catherine Johnson Adams to Mary Catherine Hellen Adams, September 3, 1819. Adams Papers, MHS.

Jean Guillaume Hyde de Neuville to James Madison, October 25, 1819. James Madison Papers, LoC.

James Madison to Jean Guillaume Hyde de Neuville, November 17, 1819. James Madison Papers, LoC.

Jean Guillaume Hyde de Neuville to John Quincy Adams, March 21, 1820. Adams Papers, MHS.

Louisa Catherine Johnson Adams to Charles Francis Adams, February 19, 1821. Adams Papers, MHS.

James Monroe to James Madison, May 19, 1821. James Madison Papers, LoC.

Louisa Catherine Johnson Adams to George Washington Adams, July 2, 1821. Adams Papers, MHS.

John Quincy Adams to Louisa Catherine Johnson Adams, August 2, 1821. Adams Papers, MHS.

Ellen Wayles Randolph Coolidge to Thomas Jefferson, December 12, 1821. Private Collection, Founders Online Archive.

John Quincy Adams to Louisa Catherine Johnson Adams, June 25, 1822. Adams Papers, MHS.

John Quincy Adams to Louisa Catherine Johnson Adams, July 5, 1822. Adams Papers, MHS.

Louisa Catherine Johnson Adams to John Quincy Adams, July 8, 1822. Adams Papers, MHS.

James Madison to Jean Guillaume Hyde de Neuville, December 19, 1828. James Madison Papers, LoC.

James Madison to William Cabell Rives, June 16, 1829. James Madison Papers, LoC.

James Madison to William Cabell Rives, June 16, 1829. James Madison Papers, LoC.

James Madison to Michael Esperance Hersant, July 26, 1830. James Madison Papers, LoC.

Endnotes

1. Faugeras 2003, 146–147, reproduces the letter without mentioning the collection.

Abbreviations

The following abbreviations are used in the endnotes and also in the text for frequently cited institutions or bibliographical sources.

BMFA: Boston Museum of Fine Arts

HML: Hagley Museum and Library, Wilmington, DE

MHS: Massachusetts Historical Society, Boston, MA

LoC: Library of Congress, Washington, DC

NA: National Archives, Washington, DC

N-YHS: New-York Historical Society

N-YHS Library: New-York Historical Society Library

NYPL: New York Public Library

Frequently Cited Bibliographical Sources

In the essays and catalogue entries, the baron's *Memoirs* are referred to with the English title. They were originally published in French and translated into English in an abridged edition. Instead of listing them below under Hyde de Neuville, they are found under: *Mémoires* 1888–92 and *Memoirs* 1913.

The following list, organized alphabetically by the author's last name, indicates a source cited three or more times in different essays and/or entries. Otherwise, the first reference is given in full, and a second reference presents the author's surname and a shortened title.

Adams 1875
Adams, John Quincy. *Memoirs of John Quincy Adams*. 5 vols. Ed. Charles Francis Adams. Philadelphia: J.B. Lippincott, 1875.

Allgor 2000
Allgor, Catherine. *Parlor Politics: In Which the Ladies of Washington Help Build a City and a Government*. Charlottesville: University of Virginia Press, 2000.

Allgor 2006
Allgor, Catherine. *A Perfect Union: Dolley Madison and the Creation of the American Nation*. New York: Henry Holt and Company, 2006.

Auricchio 2014
Auricchio, Laura. "The Baroness Hyde de Neuville and the Sidewalks of New York, 1807–14," in *Women, Femininity and Public Space in European Visual Culture, 1789–1914*. Ed. Temma Balducci and Heather Belnap Jensen. Farnham, England, and Burlington, VT: Ashgate, 2014, 35–45.

Avery 2002
Avery, Kevin J. *American Drawings and Watercolors in the Metropolitan Museum of Art*. Vol. 1, *A Catalogue of Works by Artists Born before 1835*. Exh. cat. New York: Metropolitan Museum of Art; New Haven and London: Yale University Press, 2002.

Avery and Fodera 1988
Avery, Kevin J., and Peter L. Fodera. *John Vanderlyn's Panoramic View of the Palace and Gardens of Versailles*. New York: Metropolitan Museum of Art, 1988.

Balston 1998
Balston, John Noel. *The Whatmans and Wove Paper: Its Invention and Development in the West: Research into the Origins*. West Farleigh, Kent: J.N. Balston, 1998.

Bermingham 2000
Bermingham, Ann. *Learning to Draw: Studies in the Cultural History of a Polite and Useful Art*. New Haven and London: Yale University Press, 2000.

Bower 1996
Bower, Peter. "The Evolution and Development of 'Drawing Papers' and the Effect of This Development on Watercolor Artists, 1750–1850," in *The Oxford Papers: Proceedings of the British Association of Paper Historians Fourth Annual Conference Held at St. Edmund Hall, Oxford University, 17–19 September 1993*. Ed. Peter Bower. London: British Association of Paper Historians, 1996, 61–74.

Boyer Lewis 2012
Boyer Lewis, Charlene M. *Elizabeth Patterson Bonaparte: An American Aristocrat in the Early Republic*. Philadelphia: University of Pennsylvania Press, 2012.

Chapman 2017
Chapman, Caroline. *Eighteenth-Century Women Artists: Their Trials, Tribulations, and Triumphs*. London: Unicorn, 2017.

***Château de Lestang* 2018**
Château de Lestang: Étude historique et architecturale. 2 vols. Paris: Recherches et Études Appliquées, 2018.

Cowdrey 1953
Cowdrey, Mary Bartlett. *American Academy of Fine Arts and the American Art-Union, 1816–1853*. 2 vols. New York: New-York Historical Society, 1953.

Da Costa Nunes and Olin 1984
Da Costa Nunes, Jadviga, and Ferris Olin. *Baroness Hyde de Neuville: Sketches of America, 1807–1822*. Exh. cat. New York and New Brunswick, NJ: The New-York Historical Society and Jane Voorhees Zimmerli Art Museum, Rutgers State University of New Jersey, 1984.

De Kay et al. 2018
De Kay, James Tertius, et al. *The Stephen Decatur House: A History*. Washington, DC: The White House Historical Association, 2018.

Deák 1988
Deák, Gloria. *Picturing America, 1497–1899: Prints, Maps, and Drawings Bearing on the New World Discoveries and on the Development of the Territory That is Now the United States*. 2 vols. Princeton: Princeton University Press, 1988.

Deák 1989
Deák, Gloria. "Banished by Napoleon: The American Exile of Baron and Baroness Hyde de Neuville." *The Magazine Antiques* 136:5 (1989): 1148–1157.

Dunlap 1834
Dunlap, William. *History of the Arts of Design in the United States*. 2 vols. New York: George P. Scott, 1834.

Economical School 1810
Economical School, New York. *Regulations of the Economical School*. New York: n.p., 1810.

Faugeras 2003
Faugeras, Jacques. *Hide de Neuville: Irréductible adversaire de Napoléon Bonaparte*. Paris: Guénégaud, 2003.

Fenton 1954
Fenton, William. "The Hyde de Neuville Portraits of New York Savages in 1807–1808." *New York Historical Society Quarterly* 38:2 (1954): 119–137.

Foster 1980
Foster, Augustus John. *Jeffersonian America: Notes on the United States of America, Collected in the Years 1805–6–7 and 11–12*. Ed. Richard Beale Davis. Westport, CT: Greenwood Press, 1980 (1st edition San Marino, CA, Huntington Library, 1954).

Foster 1997
Foster, Kathleen A. *Captain Watson's Travels in America: The Sketchbooks and Diary of Joshua Rowley Watson, 1772–1818*. Philadelphia: University of Pennsylvania Press, 1997.

Harkett 2014
Harkett, Daniel. "Mediating Private and Public: Juliette Récamier's Salon at L'Abbaye-aux-Bois," in *Women, Femininity and Public Space in European Visual Culture, 1789–1914*. Ed. Temma Balducci and Heather Belnap Jensen. Farnham, England, and Burlington, VT: Ashgate, 2014, 47–64.

Kelley 2006
Kelley, Mary. *Learning to Stand and Speak: Women, Education, and Public Life in America's Republic*. Chapel Hill: University of North Carolina Press, 2006.

Jaffe 1975
Jaffe, Irma B. *John Trumbull, Patriot-Artist of the American Revolution*. Boston: New York Graphic Society, 1975.

Johnson 2018
Johnson, Victoria. *David Hosack, Botany, and Medicine in the Garden of the Early Republic*. New York and London: Liveright, 2018.

Klinckowström 1952
Klinckowström, Axel Leonard. *Baron Klinckowström's America, 1818–1820*. Evanston, IL: Northwestern University Press, 1952.

Koke 1982
Koke, Richard J. *American Landscape and Genre Paintings in the New-York Historical Society*. 3 vols. New York: New-York Historical Society in association with G.K. Hall, 1982.

Lewis 1999
Lewis, Jan. "Politics and the Ambivalence of the Private Sphere: Women in Early Washington, DC," in *A Republic for the Ages: The United States Capitol and the Political Culture of the Early Republic*. Ed. Donald R. Kennon. Charlottesville: University Press of Virginia, 1999, 122–151.

Longworth's
Longworth, David. *Longworth's American Almanac, New-York Register, and City Directory. . . .* New York: David Longworth, 1806–22.

***Mémoires* 1888–92**
Hyde de Neuville, Jean Guillaume. *Hyde de Neuville: Mémoires et souvenirs du Baron Hyde de Neuville*. 3 vols. Ed. Viscountess Pauline Henriette Hyde de Neuville Bardonnet. Paris: E. Plon, Nourrit, 1888–92.

***Memoirs* 1913**
Hyde de Neuville, Jean Guillaume. *Memoirs of Baron Hyde de Neuville: Outlaw, Exile, Ambassador*. 2 vols. Trans. and abridged by Frances Jackson. London and Edinburgh: Sands, 1913.

Miles 1994
Miles, Ellen G. *Saint Mémin and the Neoclassical Profile Portrait in America*. Washington, DC: Barra Foundation and National Portrait Gallery, Smithsonian Institution Press, 1994.

Morris 2018
Morris, Gouverneur. *The Diaries of Gouverneur Morris*. Vol. 2, *New York, 1799–1816*. Ed. Melanie Randolph Miller. Charlottesville: University of Virginia Press, 2018.

N-YHS 1974
New-York Historical Society. *Catalogue of Portraits in the New-York Historical Society*. 2 vols. New Haven and London: Yale University Press, 1974.

Olson 2008
Olson, Roberta J.M. *Drawn by New York: Six Centuries of Watercolors and Drawings at the New-York Historical Society*. Exh. cat. New York: New-York Historical Society in association with D Giles Limited, London, 2008.

Pomeroy et al. 2012
Pomeroy, Jordana, et al. *Royalists to Romantics: Women Artists from the Louvre, Versailles, and Other French National Collections*. Exh. cat. London: Scala; Washington, DC: National Museum of Women in the Arts, 2012.

Rock 1979
Rock, Howard B. "A Delicate Balance: The Mechanics and the City in the Age of Jefferson." *The New-York Historical Society Quarterly* 63:2 (April 1979): 93–114.

Shadwell 1974
Shadwell, Wendy J. "Louis Simond, Amateur Artist." *The Magazine Antiques* 105:1 (January 1974): 174–179.

Shelley 2002
Shelley, Marjorie. "The Craft of American Drawings," in Kevin J. Avery, *American Drawings and Watercolors in the Metropolitan Museum of Art*. Vol. 1, *A Catalogue of Works by Artists Born before 1835*. Exh. cat. New York: Metropolitan Museum of Art; New Haven and London: Yale University Press, 2002, 28–78.

Smith 1906
Smith, Mrs. Samuel Harrison. *The First Forty Years of Washington Society*. Ed. Gaillard Hunt. New York: Charles Scribner's Sons, 1906.

Stebbins 1976
Stebbins, Theodore E., Jr. *American Master Drawings and Watercolors: A History of Works on Paper from Colonial Times to the Present*. New York: Harper and Row, 1976.

Stokes 1915–28
Stokes, Isaac Newton Phelps. *The Iconography of Manhattan Island, 1498–1909*. 6 vols. New York: R.H. Dodd, 1915–28.

Stokes and Haskell 1932
Stokes, Issac Newton Phelps, and Daniel C. Haskell. *American Historical Prints*. New York: New York Public Library, 1932.

Sturtevant 1980
Sturtevant, W.C. "Patagonian Giants and Baroness Hyde de Neuville's Iroquois Drawings." *Ethnohistory* 27:4 (1980): 331–348.

Svinin 1992
Svinin, Pavel Petrovich. *Traveling Across North America, 1812–1813*. New York: Harry N. Abrams; St. Petersburg: Izokombinat "Khudozhnik RSFSR," 1992.

Svinin 2008
Svinin, Pavel Petrovich. *A Russian Paints America: The Travels of Pavel P. Svin'in, 1811–13*. Ed. Marina Swoboda and William Benton Whisenhunt. Montreal and Kingston: McGill-Queen's University Press, 2008.

Watel 1987
Watel, Françoise. *Jean-Guillaume Hyde de Neuville, 1776–1857: Conspirateur et diplomate*. Paris: Direction des archives et de la documentation, Ministère des affaires étrangères, 1987.

White House Historical Association 1992
White House Historical Association. *The White House 1792–1992: Image in Architecture*. Washington, DC: American Architectural Foundation, 1992.

Yarmolinsky 1930
Yarmolinsky, Avrahm. *Picturesque United States of America, 1811, 1812, 1813, Being a Memoir on Paul Svinin, Russian Diplomatic Office, Artist, and Author* New York: W.E. Rudge, 1930.

Zagarri 2007
Zagarri, Rosemarie. *Revolutionary Backlash: Women and Politics in the Early American Republic*. Philadelphia: University of Pennsylvania Press, 2007.

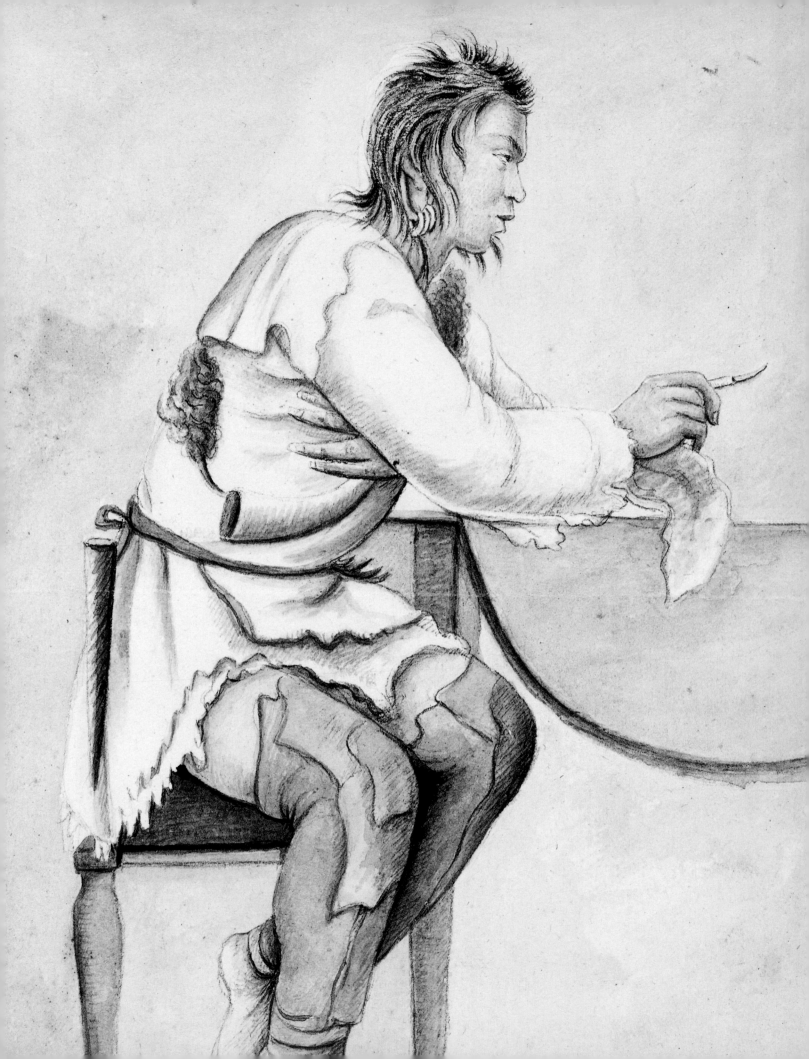

INDEX

Page numbers in *italics* refer to the illustrations. All artworks are by Hyde de Neuville unless otherwise noted

264

PHOTOGRAPHY CREDITS

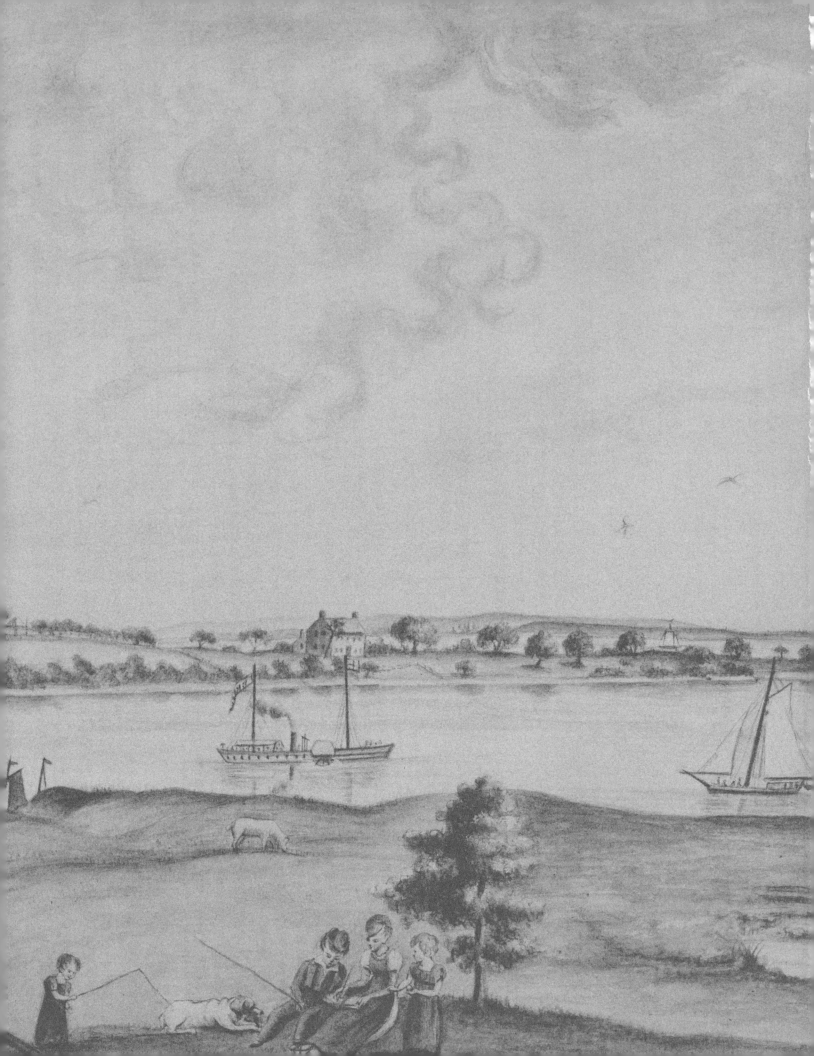